SONIC FACTION

RE

SONIC FACTION
Audio Essay as Medium and Method

Edited by

Justin Barton, Maya B. Kronic, and Steve Goodman

URBANOMIC

Published in 2024 by
URBANOMIC MEDIA LTD,
THE OLD LEMONADE FACTORY,
WINDSOR QUARRY,
FALMOUTH TR11 3EX,
UNITED KINGDOM

The *Sonic Faction* project was originally presented at Iklectik on 14 July 2022
and was subsequently developed as an exhibition and event at KARST Contemporary
Arts, Plymouth, 4 and 8–11 February 2023.

A playlist has been created to accompany this book,
bringing together many of the works referred to in the text.
See https://www.youtube.com/user/urbanomic/playlists

BRITISH LIBRARY CATALOGUING-IN-PUBLICATION DATA

A full catalogue record of this book is available
from the British Library

ISBN 978-1-915103-12-3

Distributed by the MIT Press, Cambridge, Massachusetts
and London, England

Type by Norm, Zurich
Printed and bound in the UK by
Short Run Press

www.urbanomic.com

RE

REDACTIONS

Redaction is the process of preparing source material for publication, implying both recall, distillation, and a settling of accounts (*Redigere*—to bring back, reduce down, call in).

Urbanomic's **REDACTIONS** reprocess live dialogues, rewriting, reconstructing, and reassembling archives of past events.

The original participants are invited to revisit, rethink, and refine their contributions, which are occasionally supplemented by additional resources to further extend the discussion—a montage of collective research in progress.

SONIC FACTION

Audio Essay as Medium and Method

URB ANO MIC KARST

SONIC FACTION

Contents

Ben Borthwick

Foreword

When Urbanomic came to me with the idea of presenting *Sonic Faction: Audio Essay as Medium and Method* at KARST, their recent listening event at Iklectik in London offered a readymade model, but it also raised the question: How and why would it make sense as a KARST project?

There are a number of compelling answers to this question, not least that it would offer audiences in the South West of the UK the chance to engage with the audio essay, a narrow but deep channel of production which—as the introduction to this volume establishes—lingers in the darker, more remote recesses of artistic practice. Additionally, it would reconnect KARST and our audiences with our long-established commitment to crossovers between contemporary art, sound, and experimental music (notably through our commissions with Outlands). Furthermore, even though the event took place in February 2023, it still felt very much in the shadow of the Covid era. Lockdowns, restrictions on public gatherings, collective anxiety, and amnesia about what it means to come together in time and space to share in a collective experience were still very much in the public consciousness, generating a powerful desire for such experiences, but also a lingering reluctance to leave the house and participate in them.

Another question was how presenting this project at KARST would challenge the artists by creating an opportunity to push their ideas beyond what had previously been possible—and in doing so, help us interrogate our own assumptions about how and why we, as an organisation, programme. It offered KARST an opportunity to test the idea that a week-long installation could be something between an exhibition and a deconstructed version of a listening or screening event, offering parallel temporalities where audiences would be able to experience the work on their own terms.

The tried and tested format for film screenings is an event followed by a discussion. Until the 1990s, artists' films were almost exclusively presented through programmed screenings, often including a public conversation with the artists. The advent of consumer video projectors repositioned artists' film in relation to the gallery by foregoing the structured temporal and collective experience of time-based work as event in favour of durational installation. While this made such work more accessible to those unable to attend a one-off screening (usually held in the evening or at weekends), it also had the effect of atomising what had been a collective audience.

While the primacy of the visual seems as if it would make the transition of artists' films into the gallery relatively straightforward, general audiences remain reticent in regard to video installation: as often as not, people will put their head into a darkened space only to move on without entering, there are complaints about uncomfortable seating, almost nobody puts on the headphones offered as a solution to managing sound spill, and so on.

As for sound-based work, with the visual removed or rendered secondary, questions around how to install become very complicated very quickly. From a technical and budgetary point of view, there is the question of how to manage the bleed of sound between spaces when headphones are ruled out and constructing bespoke soundproofed walls is not an option. For *Sonic Faction*, our solution was to supplement two existing spaces in the gallery created for showing film and video with a third ad hoc space, using sound baffles to construct a makeshift wall concealed by a blackout drape. The result was three spaces with their own discrete pools of sound which flowed out into the large empty gallery, which became a sonic estuary where different volumes converged and mixed to create a new entity.

Having located them physically, the wider question became how to situate these works in the discursive space of contemporary art itself? In many ways Patrick Keiller's 1994 feature film *London* is a useful reference here, with its emphasis on the psychogeographic monologue supported by a collage of cutaway shots that keep the eye distracted enough to listen. While Keiller's model is clearly cinematic, James Coleman's installations from the 1980s and 90s use slide projectors to fragment the cinematic image, shifting the emphasis from the visual to the aural as spoken-word exchanges between characters are

punctuated by the arrhythmic clunking sounds of the slide projectors. Florian Hecker, who has cited Coleman as an influence, is at the purist end of the sound art spectrum, but in his 2012 installation *Chimerization* he introduced vocal elements that continuously teeter on the edge of meaning and dissolution, fragmenting language into matter while challenging visitors to engage deeply with the material properties of sound and language.

Spoken word monologues have become integral to contemporary art, so much so that perhaps the familiar disembodied voice of radio is a more useful reference for the audio essay than film. In a series of works that relate to his film installations in the late 1990s and early 2000s, Knut Åsdam used the radio play to explore the relationship between urban space and subjectivity. His sound piece *Filter City Audio* (2002) was both broadcast on Norwegian national radio and contained within a 'soft' architectural space made of theatre blackout, which dampens sound spill without eliminating it altogether (an approach which inspired the *Sonic Faction* installation of Mark Fisher and Justin Barton's *On Vanishing Land* [2006]).

More recently, artists including Heather Phillipson, Maria Fusco, and Freya Dooley have used the narrative and formal properties of language and spoken word as central elements of their practices. While Phillipson and Dooley's audio is usually a component part of visually rich installations, Fusco's *Master Rock* (2015) fits the audio essay category perfectly. Co-commissioned by Artangel and BBC Radio 4, it explores the history of the Ben Cruachan Power Station, sited deep within a mountain in the Scottish Highlands. The piece was recorded inside the cave, lending its narrative a site-specific sonority, and one of the three voices narrates the mountain's own perspective. *Master Rock* was broadcast on national radio, published as a book, presented at Collective Gallery, and is available as a download. This work does not have fixed form or criteria for its reception, but adapts to various modes of display and distribution—like the *Sonic Faction* audio essays, it might be experienced while sat on gallery benches or wearing headphones, ritualistically played on a turntable at home, or heard on a Bluetooth speaker while cooking dinner.

While radio is, as often as not, absorbed as a passive backdrop, the audio essay does not, however, make for easy listening. Stripping back the visual creates a demanding durational experience where a tension emerges between following

the flow of complex spoken-word texts and allowing oneself to be immersed in sound. For me, one of the powerful sensations of this mode of experience is that consistent focus gives way to a tendency to oscillate between the conceptual spaces created through language and the embodied feeling of being absorbed into sound and space. It is therefore ironic that these two dreamlike states often lull me into a third, occasionally nodding off only to wake with a start, resuming the narrative in a non-sequential way that seems entirely consistent with the audio essay's form.

Staging a listening event with panel discussion followed by a week-long gallery installation made it clear how these two modes of presentation enabled audiences to engage with the works in different ways. A hard core of people (mostly artists) who attended the all day listening event later returned to spend more time with a particular piece. Others who were uncomfortable with the crowd environment (who were vulnerable or actually had Covid so couldn't attend the event) came when the conditions were more socially distanced. And then there were some who only heard about the exhibition by word of mouth after the listening event, and came to find out more.

Like much that is most interesting in culture, the audio essay extends beyond the familiarity of fixed formats and genres, and seeks modes of becoming that draw upon disparate aspects of cultural life—notably, for the artists who made the audio essays featured in *Sonic Faction*, these long pieces with subtle shifts in cadence, atmosphere and rhythm owe a great deal to the flow of dance music and the myriad cultures it has spawned. What became apparent to me spending time with these three works in the gallery was that, while the audio essay shares specific characteristics with other time-based media including radio, film, video, and sound art, it occupies a space between them and, counterintuitively, its ability to adapt to different contexts and forms poses unique challenges to artists, audiences, and programmers alike.

Ben Borthwick
Head of Programme, KARST

Maya B. Kronic

Introduction

'Audio Essay' is a term which, precisely on account of its indeterminate inten-
sion and extension, served as the theme of two Urbanomic events hosted by
Iklectik in London (14 July 2022) and at KARST Contemporary Arts in Plymouth
(4–11 February 2023). At both venues, the *Sonic Faction* programme included
a collective listening session featuring playback of three pieces—Mark Fisher
and Justin Barton's *On Vanishing Land* (2006), Steve Goodman's (Kode9)
Astro-Darien (2021), and Robin Mackay's *By the North Sea* (2022)—along
with a public discussion with the artists. At KARST, during the week following
the event the three works were installed in the exhibition space along with
background materials relating to each of them (see colour plate section).

We could provisionally define the audio essay as an extended recorded
piece that combines discursive and/or narrative speech with both musical and
nonmusical sound elements. However, several of the works discussed by the
contributors to this volume—many themselves artists who have laid claim to
the form—fall on the margins of even this loose definition. The exact nature of
the audio essay remains an open question. In the context of the *Sonic Faction*
events, which required audiences to exercise an extraordinary level of auditory
attention to three pieces that differ significantly in terms of theme, approach,
and execution, it made sense to fold this question into the proceedings, using
the public discussions as an opportunity to reflect upon what it was that each
of the artists had been seeking to achieve, why the medium of sound was most
appropriate to it, and what advantages there might be in retaining 'audio essay'
as a category.

As the contributions to this volume demonstrate, recent years have seen
the production of a number of audio works which have in common a resistance
to being accommodated in existing formats, even those with which they share
certain qualities and characteristics—radio play, documentary, audiobook, essay
film, concept album, mixtape, sound art, podcast, ambient music, soundwalk, field

recording.... While some of the texts here set out from one or another of these existing forms as a point from which to approach the audio essay, all testify to its specificity in terms of creative possibilities, discursive scope, and auditory experience, while making it abundantly clear that its potential remains largely underexplored. Significantly extending and complexifying the public discussions of the *Sonic Faction* events, then, the volume continues to circle around this unknown 'X', asking what the audio essay is or could be as medium and as method, and where it stands in terms of both its formal definition and its cultural status.

The *Sonic Faction* events did however draw upon a specific lineage. Beyond their significant differences in content and approach, *On Vanishing Land*, *By the North Sea*, and *Astro-Darien* emerged, albeit at a distance, from a common microcultural history which saw the audio essay coalesce as a medium with particular affordances, and as an experimental device to navigate conceptual territories for which more conventional discursive treatments had proved inadequate. It is this history to which we turn for our initial model of the audio essay's form and function in the first half of the volume, which features a transcript of the KARST *Sonic Faction* public discussion along with additional context, documentation, and interpretation of the three pieces. Not in order to stake a claim to priority, but on the hypothesis that the pressures under which the audio essay emerged in this particular context give us an indication of the problems to which it responds and what it promises in return.

Moving fluidly between fiction and conceptual discourse, using narrative dramatisation to think through speculative ideas, employing sonic abstraction as the glue for conceptual collage, ambiguously undercutting the veridical authority of the voice, on this model the audio essay is a medium which opens up a space of the 'oneiric-real', hinting at 'something beyond the surface of the day' and making possible what Barton and Fisher call 'outsights'[1]—whispers, at once perceptual and cognitive, of a realm beyond the normative space of discourse, whether the latter is construed in terms of distinctions between different disciplines, media, and registers of speech, the fixedness of chronological time and geographical space, or the delineation via attentional conventions of what is and is not 'possible' to articulate, what may or may not be voiced.

1. See Mackay's interview with Barton and Fisher, 'Outsights', in R. Mackay (ed.), *When Site Lost the Plot* (Falmouth: Urbanomic, 2015), 281–303.

Taking the conversation beyond the small 'faction' represented in the two 2023 events, the second half of the volume features a wider group of writers and practitioners, many authors of their own audio essays. Remaining unconcerned with settling on a final, unified definition of the form, these contributions on and around the audio essay demonstrate the depth and breadth of the problematics it brings into play. What operations does the audio essay make possible in relation to truth and fiction, narrative force and conceptual work? How is the essay form expanded both by writing *on* sound and writing *with* sound? Given the specific affordances of recorded sound, what can an audio essay do that neighbouring formats cannot? And what *should* it do? For not only does the audio essay naturally lend itself to particular styles of thought and modes of inquiry, it may be a privileged medium in which certain modes of thinking and certain voices can begin to be heard—and therefore may bring with it certain political and ethical demands.

Audio Essay as Cybernetic Culture

As recalled in Steve Goodman's discussion with Kodwo Eshun and Emily Pethick around the circumstances in which *On Vanishing Land* was commissioned and the setting in which it was first heard, one of the most significant players in the development of the audio essay was the late Mark Fisher. Fisher's absence was invoked throughout the *Sonic Faction* events—as co-author, with Justin Barton, of *On Vanishing Land* as well as the earlier *londonunderlondon* (2005), as the 'absent motor' of *By The North Sea*, but also as an early experimenter in and tireless advocate for the audio essay, championing its singular promise and persistently testing out the disarming disturbances that sound can occasion (this is, of course, the same Mark Fisher who would later make sound the privileged modality of the eerie, 'fundamentally tied up with questions of agency').[2] As discussed by Eshun, Pethick, and Goodman, Fisher's work here involved not just the progressive definition of a format, but the staging of trials to work out the kinds of delivery methods, venues, and audiences that might be receptive to it. The prehistory and production of *On Vanishing Land*, it transpires, were inseparable from the process of feeling out a space—physical, cultural,

2. M. Fisher, *The Weird and the Eerie* (London: Repeater, 2016), 11; Fisher discusses the relation between sound and the eerie further in 'Outsights', 282.

and discursive—in which the audio essay could be heard and, in parallel, the 'construction of an audience' for it.

In the 2000s–2010s, Fisher's negotiations around how to present this in-between medium which by its very nature—being neither pedagogy nor entertainment— generates 'disciplinary perturbation', proceeded via the 'deep listening club' and his *Vocalities* seminars at Goldsmiths. But these in turn echoed earlier experiments in which Fisher had been involved during the late 1990s with the Cybernetic Culture Research Unit (Ccru). The hybrid, neo-cut-up, transmedia nature of the proto-audio-essays created by Ccru during this period[3] was fuelled by the 'rogue unit's'[4] refusal to bow to proper academic protocol or to accept the demarcation between form and content, cultural analysis and cybernetic intervention. Plugging theory *into* the circuits of cybernetic culture rather than theorising *about* it, Ccru repudiated any division between the cognitive abstractions of discursive enquiry and the sensory intensities of popular culture—in particular electronic music, the rave ecosystem, and what Goodman would later designate the 'hyperdub continuum'.[5] According to Ccru libidinal-materialist theory and practice, 'concept engineering' and dancefloor physics were to accelerate one another in positive feedback loops of sensory excitation, cognitive abstraction, sensory abstraction, cognitive excitation…. Experiments in delivering philosophy with a side order of breakbeats (or vice versa) were the inevitable outcome of this conviction, as Ccru's cryptic philo-sophical assemblages[6] developed in lockstep (or techstep) with their pragmatic deployment, whether at conferences or in the club.

3. These included presentations by Ccru affiliates at the *Virtual Futures* conferences (1995 and 1996) at Warwick University, the *Afrofutures* and *Virotechnics* events organised by Ccru, the *Ko::Labs* jungle nights run by Goodman and Mackay during the same period, and 'Swarmachines', played at a conference on the legacy of Situationism at The Hacienda, Manchester, 1996 (see <https://www.urbanomic.com/podcast/swarmachines-rewind/>); Later manifestations included the Ccru/Orphan Drift show *Syzygy* at Beaconsfield Arts in 1999 and 'Split-Second Timing' at DEAF_00, Rotterdam in 2000 (see <https://v2.nl/events/split-second-timing>).

4. See S. Reynolds, 'Renegade Academia: The Cybernetic Culture Research Unit', <https://energyflashbysimonreynolds.blogspot.com/2009/11/renegade-academia-cybernetic-culture.html>, and Robin Mackay's interview with Christopher Haworth, 'Towards a Transcendental Deduction of Jungle', <https://readthis.wtf/writing/towards-a-transcendental-deduction-of-jungle-interview-part-1/>.

5. Goodman's Hyperdub record label began life as a series of communiques regarding the 'Hyperdub virus', posted anonymously on the internet in 2000. A year later a webzine emerged featuring writings from Goodman, Kodwo Eshun, Mark Fisher (writing under the name Mark de Rosario), and others.

6. See Ccru, *Writings 1997–2003* (Falmouth and Shanghai: Urbanomic/Time Spiral Press, 2017).

Philosophy on the Dancefloor

In the years following the group's millennial disintegration, Ccru veteran Good-
man, doubled by DJ-producer Kodeg, perpetuated this coupling of high theory
and low-end vibration in his writings,[7] in his work with the group AUDINT,[8] and
through the Hyperdub record label, which he founded in 2004. Notably, early
Hyperdub releases included Kodeg's own productions in collaboration with The
Spaceape, in which the vocalist's ominous proclamations were twinned with
jungle stripped down to skeletal infra-dub, not so much gesturing toward US
hip-hop as lending an newly dystopian slant to the British diaspora legacy of
Linton Kwesi Johnson's dub-poetry oral histories.

In their key contribution to this volume, Matt Colquhoun addresses the
relation between the audio essay and these post-Ccru incarnations of 'sub-bass
materialism' via the relationship between Hyperdub and its sublabel Flatlines, cre-
ated specifically for audio essays and launched via the club night ø (2017–2020) at
Corsica Studios in London, where various audio works were presented alongside
DJ sets. Suggesting that both prongs of this twofold sonic practice express the
cognitive pathologies of contemporary life, Colquhoun first turns to one of the
styles which Hyperdub pioneered during the late 1990s, citing Mark Fisher's
commentary on how Chicago footwork appropriated, remixed, and redistributed
the already-hybrid history of dance music, unearthing subterranean rhythmic and
timbral connections between genres and redistributing musical traits in a way that
reflected the obsolescence of geography and the crumbling of genre tribalism in
a highly online culture. In the same article, Fisher diagnosed footwork as a form
which, no longer using computer music to envision and evoke a futuristic or alien
machine-world, instead directly expressed a contemporary subjectivity rendered
'frustrated, angular' by its continual reprocessing through electronic networks and
by dividualising dopamine addictions. While footwork manifests this subjective
disintegration in its frenzied 'lalanguistic' relation to speech and signification, it
refuses to propose a cure for the disorders encoded in its high-velocity rhythmic
fugues. In its determination to stay with the trouble and transmute it into the
jouissance of compulsive sonic tics, in its unresolved 'expressionistic tension'

7. S. Goodman, *Sonic Warfare: Sound, Affect, and the Ecology of Fear* (Cambridge, MA: MIT Press, 2009).
8. See <http://www.audint.net>, *Martial Hauntology* (Audint Records, 2014), and S. Goodman, T. Heys, and E. Ikoniadou (eds.), *AUDINT—Unsound:Undead* (Falmouth: Urbanomic, 2019).

between intellect and affect, between speech as signification and speech as sonic material, according to Colquhoun footwork carves out a role for the dancefloor as the flipside of the analyst's couch—a place where, rather than interpreting and resolving symptoms, the rave collective uses sound to unfold them into new mind-and-bodyscapes via synthetic forms of physical and auditory jouissance.

Similarly, Colquhoun suggests, if audio essays are not clearly legible as either entertainment, theoretical proposition, narrative, documentary, or sound art, this is because they too tend toward a 'digital psychedelia' that recombines and reprocesses 'the remains of [a collective] unconscious experience not properly signified'. Like footwork, rather than resolving problems, the audio essay recruits the listener into productively intensifying *the problematic* at both formal and thematic levels. This analysis is echoed in the *Sonic Faction* discussion where Barton describes the audio essay as a way to access a 'profoundly problematic domain consisting of a specific form of the faculties', Goodman insists on the 'inbuilt openness' of the audio essay, and 'the psychological torque that it subjects you to', and Mackay links audio essay practice to the figure of the spectre returning to haunt an unresolved scene, and suggests that ideally the audio essay should 'present the tensions constitutive of a problem in a way that pulls you in and [...] forces you to become the connective tissue between heterogeneous elements'.

This at once synthetic and problematising aspect of the audio essay is reflected in the peculiar attentional demands it makes upon its listeners. As Goodman observes, the listener has to negotiate the tension between, on one hand, being absorbed by sound or physically activated by rhythm, and on the other, having to maintain cognitive focus on a spoken 'text' that is often complex, non-sequential, shifting in its modalities, and sonically 'at war' with the other frequencies around it. It is notable that the sea is a recurring figure in many of the pieces discussed in these pages, but it is not the 'ocean of sound' in which the listener can gain respite from the demands of thinking. We are at some distance from David Toop's 'drifting' ambient nonspace of dissolving boundaries which 'encourages states of reverie and receptivity [and] a very positive rootlessness',[9] an ocean that at once disconnects and reconnects, comforting the listener by

9. D. Toop, *Ocean of Sound: Aether Talk, Ambient Sound and Imaginary Worlds* (London: Serpent's Tail, 1995), xii.

releasing them from the symbolic realm while providing a humanising ritual retreat to combat the alienating forces of contemporary reality. The internal tensions of the audio essay militate against the kind of pacificatory understanding of sound sometimes advanced in theoretical texts where hearing is understood as an intangible sensory modality whose defaults are beatific absorption and blessed asylum from cognitive labour.[10]

In staging audio essays in the larger Room One at Corsica, the ø nights dramatised these tensions on the scale of the club setting itself. As Colquhoun points out, not only did ø reverse the traditional order of priority between main-event party room and subsidiary compensatory or restorative chill-out room, it simultaneously tore down the duality that structures this segregation—the metaphysical opposition, inherited by music criticism, between 'mindless bodies and bodiless minds'. Any superficial affinity of the audio essay with the dance-floor-curative genres of ambient and chill-out was therefore swiftly disposed of: rather than compensating for the bass onslaught with an inoffensive pabulum that would help addled minds to decouple from the body and float off into the ether, or making a special pleading for the quietly contemplative 'intelligent' dimensions of the dance music ecosystem, ø demonstrated how Hyperdub and Flatlines play on the tension between intellect and affect from both directions simultaneously, while refusing to dispense a cure.

All of which might amount to a convincing case for the positioning of at least this particular lineage of the audio essay as an outlying zone of what Simon Reynolds dubbed the 'hardcore continuum',[11] the cultural space across which the 'disjunctive syntheses' of sonic history and contemporaneity continue to 'collide and fragment', rewiring their own historical circuits. On this model, the audio essay remains attached to techniques inherited from the sonic laboratory of dance music (the encrypted breakbeats and sub-bass of *By The North Sea*, the quieter but still perturbing cross-cut soundtrack of *On Vanishing Land* and the Mark Fisher 'Ballard over Eski' segment of its predecessor *londonunderlondon*, and

10. For a carefully considered remapping of the auditory that implies a renunciation of the 'ocean' model in favour of that of the 'archipelago', see F.J. Bonnet, *The Order of Sounds: A Sonorous Archipelago*, tr. R. Mackay (Falmouth: Urbanomic, 2019).

11. See S. Reynolds, 'Simon Reynolds on the Hardcore Continuum: Introduction', *The Wire*, February 2013, <https://www.thewire.co.uk/in-writing/essays/the-wire-300_simon-reynolds-on-the-hardcore-continuum_introduction>.

then the aggressive sampladelia of *Astro-Darien*, which also exists in speechless form as the Kodeg album *Escapology*). It announces its alliance to the track and the mixtape just as much as to the radio play and the documentary, and continues to remix Ccru's noisy dialogue between the disavowed auditory dimension of the spoken word and the conceptual richness of sonic field operations.

Public and Private Listening

As recalled vividly in the dialogue between Eshun, Pethick, and Goodman on the atmosphere of early performances of *londonunderlondon* and *On Vanishing Land*, the unresolved problematic nature of the audio essay is materialised socially in the collective intensity of listening sessions, where the effort necessary to achieve a 'diagonal between immersion and attention', absorption and concentration, is heightened by a very particular sense of communal experience. In an age where background music and mediated chatter is everywhere, such concentrated auditory attention can be both an uncommon pleasure and an unaccustomed labour for listeners.

It was the audio essay's mesmerising, slowing-down effect that inspired Fisher's perseverance with the format, which he saw as harbouring a disruptive potential for thought precisely because in actively exploring these zones of affect, it ran counter to a visually-dominated culture in thrall to the immediately recognisable and the visibly demonstrable. In listening sessions the room becomes a theatre for the non-spectacle of listening, and from the very beginning the audio essay was understood as a strategy for subverting the supremacy of the eye and listening for what becomes possible once it is neutralised, sidelined, or distracted. In their discussion Mackay, Barton, and Goodman discuss the sparing use they make of visual materials in listening sessions in order to occupy the eye so that the ear can take over. But as Goodman states, whatever supplementary items may accompany it, the audio essay is defined by the fact that it *starts with sound* and with a curiosity as to how sound compels and can set thought in motion. The listening session was for many years its principal testing ground.

By the time the ø nights were cut short by Covid in 2020, however, the audio essay had made its first official appearance outside of this setting, and part of the discussion between Goodman, Eshun, and Pethwick revolves around the significance of the shift from public performance to digital dissemination.

On Vanishing Land's release on Flatlines in 2019, after a considered and purposeful delay, marked the transition from the combined discomfort, 'attentional magic', and occasional epiphany of collective listening sessions to the interruptable and noncommittal listening enabled by the decanting of the audio essay into the streaming networks of 'digital overabundance'. This inevitably brought with it a type of audience at once more intimate and more dispersed, although it could be said that the audio essay's online availability brought it back into proximity with one of its erstwhile models, radio. The release of *On Vanishing Land* also followed the massive growth, since 2014, of the podcast, a post-radio format which had seemed to offer a certain promise adjacent to that of the audio essay, but had soon settled into a number of pedestrian formats rarely consciously attentive to their use of sound. The podcast generally lacks the multiple interpenetrating layers of the audio essay and its use of different registers of speech, which echo the collaged and montaged methodology of Ccru's early cyberpunk experiments, themselves inspired by the sample-heavy tracks of nineties hip-hop and jungle. These 'uncanny adjacencies' also characterise the texts of audio essays, often fragmentary and requiring effort on the part of any listener seeking a route through their 'shifting spaces and temporalities', interweaving registers, and overlapping sources.

Extracted from the ideal dark and hushed environment of the listening session, once the audio essay can be experienced anytime and anywhere, the listener's own situation adds yet another layer, producing a kind of laminar soundwalk. As Shelley Trower notes in her contribution, when heard on headphones or earbuds, audio essays superimpose themselves upon the listener's own movements and environment. In adding *On Vanishing Land* and *By The North Sea* to the mix of her own experience of the coastline in her native Cornwall, Trower links the audio essay's breakout from the definite lines of the written word with the shoreline as a figure for the breaching or collapsing of boundaries. Both *On Vanishing Land* and *By The North Sea* deal with shifting sands and the possibility of escape ('This whole coast is about fending off incursions from the outside' [*On Vanishing Land*]; 'the terminal beach [...] Compressed sediment, unconsolidated material' [*By The North Sea*]), but the coast can also serve as a hard line drawn in political assertions, a bulwark of defensive paranoia. Trower's attentive listening in defiance of these operations of exclusion converges

with her reflections on the audio essay as a form that dissolves the clearly delineated rules of the written essay. Echoing Goodman's observation that '*essai* means to try something, and almost implicitly to fail at doing that thing', she argues that the audio essay helps us uncover a broader sense of the term which its restricted and restrictive role as a tool of academic intimidation obscures: the essay 'encompass[es] a vast range of experimental possibilities', and is capable of breaching the lines that demarcate jealously-guarded entities, whether those of national pride or those of academic propriety.

One Thing Leads to Another

This sense of the audio essay as an anti-cartographic exercise is echoed here in an excerpt from Ayesha Hameed's audiovisual essay *Black Atlantis*, which, concerning itself with movements of transnational migration, draws a parallel between the 'non-cartographic quality of ocean' and the 'untranslatability' of sound onto the page.

Indeed, the excess of the audio essay over what the conventional essay form can do arises repeatedly in these pages, although not necessarily as a premeditated motive for turning to the format. As evidenced in the case of Ccru, what brings an artist to the audio essay is more often the discovery that the multiple dimensions of their process cannot be encompassed in any other available format. It is an indication of the perplexities that bring artists into its gravitational field that few if any of the audio works discussed in these pages exist in isolation from other projects in various other media which preceded, followed, or intersected with them. One thing leads to another: in Angus Carlyle's list of what was omitted from the sleevenotes for his album *Powerlines* we glimpse the same corralling of 'multiplicities, linkages, intra-actions, entanglements, interferences, combinations of experiences, past and present, into future sonic and material conglomerations' invoked by Paul Nataraj in his contribution, a text which is both research sketchbook and exegesis of a work in progress, *Repetitions of 108*. Nataraj describes this project as 'a poly-translation [...] between language, sound, form, thought, materials, memories, and movement through making catalysed by the imagination'—as good a definition as any of the manifold movements the audio essay tries to capture and extend.

This porosity of projects is also a common thread in the *Sonic Faction* discussion and in the participants' texts on their respective audio essays, where Mackay reveals how *By The North Sea* is the belated fallout from an abortive film project, Goodman that *Astro-Darien* emerged in part from his series of collaborative works with Lawrence Lek, and Barton that the walk which forms the basis of *On Vanishing Land* began with 'another project in mind' and emerged from the apparent impossibility of yet another, more ambitious project of which it became a ghostly 'double'.

The crooked path through endless sidequests is given a performative walkthrough in Iain Sinclair's contribution, where *By the North Sea*, itself the 'definitively unfinished' residue of a project that 'never existed', is folded into parallel incomplete assignments, following the method employed in Sinclair's video essays with Chris Petit (*The Cardinal and the Corpse* [1992], *The Falconer* [1998], *Asylum* [2000]). Mixing unstable personal memory with uncertain historical fact via cryptic frame-within-framing narratives and fictionalised protagonists, these works erode the narrative conventions of the film and TV documentary formats in ways that pay homage to the genius of Chris Marker (a common point of reference in the *Sonic Faction* discussion). Here, as Sinclair intercuts his *Sonic Faction* assignment with another ongoing project (a book on the photographer John Deakin for an upcoming exhibition at Swedenborg House), what emerges in the edit is the apparently incongruous enterprise of approaching the audio essay via the photograph. Which does perhaps make a certain sense in so far as they are both materialised modes of memory and ways of returning to something which 'isn't there any more': in audio essays as in photographs we find ourselves in dialogue with arrested histories, including some that never came to pass, ghosts, spectres, reanimated presences 'hauled into existence' and resynthesised by technological alchemy; we find ourselves lost in images of images, 'quotations of quotations'. Sinclair's confabulation of 'rephotographed photographs' with rerecorded sounds places light writings in relation to the 'sound shadows' in Barton's fiction *The Corridor*, which, like technomagical proxies for the audio essay, act as access portals to a parallel world, allowing egress from 'the Disaster'—the capitalist drome—to 'the Corridor' which leads to planetary immanence.

Sinclair stitches the *Sonic Faction* audio essays—further evidence to be pored over forensically, scoured for clues—into the fabric of his overdocumented

obsessions, crossfading their personae with the characters that have marched tirelessly for decades through his works, transmuted with each appearance: 'the researchers, the readers, the documentary filmmakers [...] random authors' with their 'fragments and misquotations'. And for Sinclair's autocaricature as an underresourced and overtaxed 'creative worker' desperately raking over personal experience and memory-dumps hoping to turn up some treasure, there is only one way out: to produce another text in which the fictional proxies for the authors of yet other unfinished works blur into the figure of the researcher himself, as he imagines a story in which he would play a bit-part in the kind of events whose hidden traces he believes he *may* have glimpsed in the latest sweep of the archives....

Looming here is the paranoiac fear that, however many hidden cameras and listening devices one plants, the enterprise of 'trying to find connections, discover shared histories', conversations with the departed, always implies a risk of succumbing to its own peculiar sickness. In the midst of such elective apophenia, the audio essay, discovered as an alternative to the straight ways of narrative fiction and learned treatise, is often arrived at as a result of what is not working in what is being worked on. What is discovered is its affinity for a certain type of conceptual-aesthetic-memorial-fictional work that struggles to find space in other media, but whose construction is also beset by doubt. In discussion, Mackay associates 'the process whereby which you produce the kind of consistency needed for this work' with 'doubts that arise when assembling something without any assurance that it will "gel"'. Becoming increasingly unable to distinguish between discovery and fabulation and being spooked by 'the horror of the false epiphany' is evidently an occupational hazard for anyone working with this patchwork-faction methodology. As 'ghosts talk to ghosts, with a bias toward watery conclusions', the urgent derangement of conspiratorial cartography yields to the sea, figure of an unmappable liquid archive, a shifting body of momentary connection and disconnection rhythmed by indecipherable currents: *By the North Sea*'s 'nemotic tide' murmurs: '*you are writing weather*'.

Redrafting History, Abstracting Time and Space

Sinclair's hapless amateur detectives with their 'insane projects', 'gleaning for traces', following trails that may not exist, reflect both the predicament of the

audio-essayist and that of their bewildered listener, since ultimately all work of this kind—whether *Astro-Darien*'s calling up of a Scottish historian as a synthetic videogame avatar, Mackay's dialogue which he insists is '*with* not about' Mark Fisher, or *On Vanishing Land*'s triangulation of M.R. James, Gazelle Twin, and Joan Lindsay—is a fabrication of conversations which could not possibly have taken place. According, that is, to the infallibly-ordered chronology of the AOE, the Architectonic Order of the Eschaton,[12] malign chrono-police of the Ccru lore that Mackay imports into *By The North Sea*, and whose presence lies heavy over *On Vanishing Land*'s attempts to discover a mode of escape from the capitalist time-circuit, 'the latest form of capitulation'.

Meddling with chrono-logic, memory, and the archive in the ways that the audio essay tends to do involves operations of temporal derangement that stand in uneasy contrast to its material linearity (it is, after all, a medium most often 'performed' as playback). This in turn is reflected in the fact that even in describing their own projects, the artists of *Sonic Faction*, while able to detail the causal sequences of their making, remain somewhat perplexed by what they have created, unsure of its place within the still-inchoate history of the form. Thinking around the audio essay continues to poll precursor moments while conscripting new influences from elsewhere. It is therefore, like the hardcore and hyperdub continua,[13] still in the process of retrospectively writing its own history at the same time as it anticipates its virtual futures.

One aspect of the *Sonic Faction* discussion that recurs throughout this volume in various forms is the observation that sound's privileged relation to abstraction allows it to mobilise speculative fictions effectively and economically, but also endows them with the agility to move between conceptual thinking and reported experience, between first and third person, between storytelling and the 'essayistic' proper. Another is the audio essay's relation to place: although no reason immediately springs to mind why an auditory medium should lend itself so strongly to meditations on specific geographical locations, a common theme shared by all three of the *Sonic Faction* pieces is a relation between such locations and speculative trajectories or alternate histories that depart

12. See Ccru, *Writings*.

13. For Goodman, the hyperdub continuum extends the hardcore continuum back beyond the origins of dance music, and places it within the broader field of resonance of the Black Atlantic, in particular Afrofuturist escape velocities in jazz, funk, and dub.

from them. They are 'rooted in particular spaces [...] already pregnant with [...] mythology, history, folklore, things that have disappeared or things that are about to be built' (Goodman); they 'return and repeat and reimagine those places and extend them into a speculative space' (Mackay).

Just as it toys with the documentary form's quest for truth, in attaching itself not so much to geography as to psychogeography, the audio essay strays from the veridical promises of the field recording in favour of what Goodman suggests is a 'hyperlinked' relation to place: place understood as a palimpsest of archival traces and employed as a launchpad for achieving speculative escape velocity. And indeed all three of the *Sonic Faction* pieces are narratives of escape—into a 'second form' of the planet or a 'third order of time', escape from the contingencies of political history, escape from Earth.... Each exemplifies the role played by the audio essay in attuning the listener to a sense of immanence, a 'planetary' point of view that relativises the political-administrative structures layered over the earth and suspends their claims to eternal permanence.

Synthetic sound provides a powerful means to take off from concrete time and space—the sonic imaginary as counterfactual or counteractualising force. As well as providing a means of escape from the tyranny of the visual and its 'unambiguous presence', working with sound makes possible a persistent petitioning (a haunting) of places whose conceptual or cultural valence is not exhausted by their here-and-now. *On Vanishing Land* starts from the Suffolk coast and attempts to produce an 'anomalous' form of cultural expression that points outside the human world, taking its lead from those 'portal fictions' in which singular privileged points in the landscape afford access to alternative dream-realities.

In his contributions, Justin Barton addresses this vector leading from singular place to planetary immanence, and insists upon the importance of anchoring 'outsights' in 'a known correlate', a 'straightforward zone of reference', in order to achieve an 'awakened dreaming'. As well as contextualising *On Vanishing Land* in terms of this methodology in 'Planetary Suffolk', in 'The Westmorland Fells' Barton, in whose writing physical place always plays a crucial role,[14] sketches out a prehistory of the audio essay that sets out from another of those sites of 'exteriority' that seem to be 'in touch with the outside of ordinary reality'.

14. See J. Barton, *Hidden Valleys: Haunted by the Future* (London: Zero Books, 2015).

In this text Barton argues for the necessity of the audio essay format via a careful assessment of the ebb and flow of key modern developments in literature, poetry, music, philosophy, and fiction, the vicissitudes of anomalous subcultures and microcultures, and their efficacy in promoting access to 'lucidity' in opposition to retrenchments into the traditional and resignation to the ordinary.

According to Barton, the audio essay can be understood as an attempt to appropriate what each of these forms—popular music, literature, poetry, philosophy—once managed to touch in terms of the anomalous, and to distil it into a more potent form. The audio essay is of value in so far as it serves a 'pragmatics of intensification of encounters with the world', and can play a part in the meditative philosophical discipline in which Barton seeks to instruct his listeners and readers: to attune them to the deeper resonances of place and thereby set them on 'the path that leads away from ordinary reality', awakening 'the faculties of dreaming, lucidity and navigation' via an enigmatic or anomalous 'impression of the planet as the fundamentally unknown'. For Barton, wary of the snares of culture for the sake of communication and a champion of 'departure' over 'development', by gathering the forces of popular music, literature, tales, and philosophical thought, the audio essay is capable of building a machine that 'abstracts out the human world'. Through its use of sound it can induce a lucidity not just via discursive understanding, but via the sensory crafting of a *mood* that reveals the human world to be nothing more than an outgrowth of planetary immanence. Accordingly, Barton and Fisher's particular formulation of the audio essay in *On Vanishing Land* is both a thematic meditation on, and a formal apparatus for, assembling the suggestive patterns of those 'luminous filaments of the anomalous' discovered in other cultural forms, threads that promise to lead, through the Corridor, out of Capital's 'grey labyrinth' of self-damage, redundancy, and chronic trauma—that 'ongoing disaster' from which, in Fisher's words, we have 'only a lifetime to escape'.

While one of Sinclair's voices notes that absorption in memory is what imparts the 'specific weight' that makes writing effective, rather than memory Barton prioritises *dreaming*, understood as the production of 'lenses' which give access to virtual futures as much as remembered pasts, allow us to envision the planet otherwise, and ultimately enable 'a second sphere of action' that can help us ascend 'from the drome to the sunlit uplands'. Here, then, in a virtuous

hyperstitional circuit,[15] physical place serves to 'ground' a speculative fiction that progressively unmoors it from its empirical coordinates. Certain places are conducive to dreaming, but dreaming untethers them from administrated space and delivers them to their full consistency, in a movement which the audio essay is particularly well-placed to induce.

Inaudible Voices, Unwritten Sounds

Approaching the audio essay from the direction of field recording, with its direct relation to a given time and place, Angus Carlyle provides another strong argument for straying from sonic veridicality with respect to place: namely, that truth-to-place can itself be an obfuscation, and even a politically violent one. Connecting the proposition that '[t]he threshold governing what we are hearing and what we are not hearing is by no means fixed' to the film essay's tradition of attempting to locate the political within images drawn from the archive, Carlyle reveals how, probing the surface of a history written by conquerors and a landscape mapped by colonisers, the sonic can be a sensitive instrument for detecting and amplifying what would otherwise be consigned to inaudibility—notably, as in his Arctic soundwalking project, when the 'silence' of a 'wild' landscape has been produced by the erasure of indigenous cultures.

In Carlyle's meditations on *Powerlines*, the registering of unseen energies 'in the wild' via an instrumentarium of recording devices becomes a figure for the making-audible of silenced histories. But does the album, devoid of voice, qualify as an 'audio essay'? Carlyle uses this as an opportunity to ask whether the audio essay perhaps continues to bow too much to the didacticism of the traditional essay form, clinging too insistently to fragments of the textual archive as anchors from which sound can take off. If 'sound is its own currency', wouldn't it be possible to make an audio essay that completely cast off the discursive, or allowed it to subsist without being (physically) heard? Perhaps such an essay, he admits, is made audible only in the compulsion to provide 'captions' even if at a distance—to produce written essays about audio essays.

In her contribution, Trower asks, inversely, whether one might not create an audio essay purely from written evocations of sound. If an audio essay involves a writing of sound, perhaps this can take place on the page—as in the vivid

15. On hyperstition, see Ccru, *Writings*.

descriptions discussed in Lendl Barcelos's contribution, noise complaints in which Seneca and Schopenhauer make their respective sonic nemeses heard. Starting with the question of memory and with those sounds that stick in the mind but will not be heard again, Barcelos explores how, for the thinker and writer, noise can be the 'murderer of thoughts', and can even awaken trauma, but—as in the case of Nataraj's investigation into the mysteries of the mantra—may also summon sounds lost, and with them inquietude and a sense of the cruelty of time and loss. On this basis Barcelos interrogates the ways in which descriptions of sounds can both succeed and fail in returning them to our ears. Trower similarly suggests that, if the audio essay risks making writing seem poor in sonority, written words 'can be sonorous insofar as readers may hear them internally'; in this sense the enigma of the audio essay reawakens some fundamental questions of poetics. Ultimately, in her critique of the restricted and restrictive sense of the 'essay' as a locus of academic intimidation, and in opposition to a sometimes over-paranoid defence of sound against the incursion of text, Trower asks whether it might be possible to stretch the definition of the audio essay to include writing 'potentially audible to readers' that would 'represent and convey a sonorous world'—an experiment she assays in her own text.

Gesturing, like Trower and Barcelos, toward the possibility of a written piece that invokes and involves itself in the auditory, Paul Nataraj's contribution is a textual anticipation of a virtual work which he describes as having been produced by 'interdisciplinary, multi-practice research, standing at the crossroads of arte-facts, sounds, forms, ideas and memories'—it is a fragment among fragments of a work yet to be made.[16] Is this a 'score' for an 'imagined sonic essay', then, or is it itself the essay? *Repetitions of 108* is certainly a synthesis: through bricolage, assemblage, collation, remix and repetition, Nataraj's 'mixillogical' 'flakes of sonic memory' mark out the floating connections of 'intra-relating entanglements', their ambiguities releasing 'the blockages that mitigate against grasping the intertwinement of histories' (Michael Rothberg, cited by Nataraj). The artist uses remembered sonic episodes—some cherished, some dredged up from memory still dripping with fear and apprehension—to reconstruct in auditory form the tangled 'in-betweenness' of a 'un-whole' mixed-race subject who has

16. An installation version of the work, *Repetitions of 108: Counting Almost Nothing* is at the time of writing being exhibited as a part of the touring show *Jerwood Survey III* (2024–2025).

continually failed to fall along the clear lines required by univocal or even dual identity. Sidestepping the temptations of identification, the dualities of black/white and oppressor/oppressed, but also that of 'two-part hybridity', Nataraj's writing, in parallel with the artefacts in his multimedia work (for example, an assemblage consisting of cut-out segments of vinyl, or a sari-covered record), explore 'the nomadic sonic materiality of the bi-racial experience'.[17] In this 'sonic-factive mnesonic practice' the description of experienced sound and collages of sonic fragments segue into an invocation to a creative act still in progress, an 'uninstalled, stalled installation existing in fragments' which stitches together memory, exploration of the archive, conceptual interrogation, and auditory investigation.

Nataraj's project is once again indicative that in many cases, audio essays attempt to make audible that which would otherwise remain silent. This making-audible may be, as in Nataraj's work, related to voices that are not heard or have been silenced. It may equally be related to the stories that places 'want' to tell, but which more straightforwardly documentary or analytical approaches cannot convey. As Barton explains in 'Planetary Suffolk', in *On Vanishing Land* the Suffolk landscape, via the literary, cultural, and military heritage that shifts our present-and-correct perception of it, along with the assistance of the 'inchoate power' of music, affords the listener access to a 'planetary' version of itself that has been occulted by the reified grid of capital and the deadening forces it conducts. In *Astro-Darien*, a portion of Scottish territory turned over to futuristic plans for a spaceport tells the story of the colonial misadventures that connect Scotland to Panama and which led to the national union under which Scotland is still subsumed. In a more personal way, *By the North Sea* uses the geographical figure of a singular place where there is 'nothing to see' to interrogate the silences that interrupted a friendship, investing the site with philosophical and emotional intensity.

Whatever it listens to and invites us to listen to, then, the audio essay puts pressure upon it to 'surrender some of its silences'. In place of the armoury of field-recording devices catalogued at the opening of Carlyle's text, it assembles a set of probes ('send out a signal...' [*On Vanishing Land*]) and transducers—sonic, conceptual, fictional—in order to 'listen beyond human capabilities', to carry out

17. Paul Nataraj, personal correspondence.

an active haunting, to expand the narrow bandwidth through which we usually receive the world in its orderly, punctual chronological form.

Lament and Resist

In her contribution Eleni Ikoniadou identifies a political undercurrent to this methodology and condenses it into an imperative: the audio essay is summoned to become a medium that will render audible '[e]verything that can be spoken on the ground of the enormous voices that have not yet been, or cannot yet be heard' (Stuart Hall, cited by Nataraj). In particular, Ikoniadou positions the audio essay in relation to a sonic ritual that intermediates between realms: the lament, understood as a 'contrapuntal' activity in which aesthetics and the sociopolitical context of a work enter into dialogue. Traditionally, the lament involves a collective negotiation of grief that is resistant and polyvocal, and, according to Ikoniadou, it is the audio essay's inherent polyvocality or polyphony that marks it out as a medium for resistance and grief in relation to the colonial violences of modernity. As a form, it is able to encompass plurality and a decentring of voices in unique ways that are of value in responding to the 'demands of the present moment', a moment of 'apocalyptic' global circumstances in which 'there are no impartial observers' (citing Paul Robeson).

Carlyle's Arctic soundwalks were designed in part to attune their participants to the sonic traces of invisible energy passing through space via the question 'What are we not hearing?' But beyond the technical matter of inaudible vibrations, as Carlyle recognises, in this question the 'underheard' communicates with Fred Moten's 'undercommons', gesturing toward the political significance of the fact that, as Luc Ferrari discovered (and John Cage before him), 'there is no "nothing"': far from being self-evident, silence is a result of a silencing of other(ed) sounds and voices, whose lines of energy nonetheless continue to crisscross the 'pristine' landscapes that we like to imagine our way back to (including, perhaps, that famous 'ocean of sound' in which we can beatifically float). Both within the cherished sublimity of the 'remote wilderness' and within the realm of the politics of speech where it is decided who gets to speak and what cannot be spoken, silence is loaded, charged, 'trembling with tension'. 'Blocks are silences', as Nataraj suggests when re-auditioning the UK government's attempts to stem the imagined tide of immigration, and taking as his watchword Holger

Schulze's dictum that 'no specimen of aurality can be regarded as unmarked and [...] ahistorical'.

For Ikoniadou, in its breaking of silence, what the audio essay has in common with the lament is an ability to move beyond speech proper into a breakdown of articulacy and an indeterminacy of voice capable of challenging the structural limits placed upon what can be said. In the lament, as in the audio essay's sonic deterritorialisation of speech, as in footwork's disarticulate rhythmic *lalangue*, an unconscious-undercommons expresses itself through a quasi-speech that refuses to disavow its vocality, its sonority, its materiality, and which assembles with other forms of noise and commotion to bear witness to violence: 'sound [...] transmits the devastation of the event more effectively than the word [...]'.

Ikoniadou goes on to think this 'polyphonic strategy of resistance', with its ability to 'attune us to the voices of the South', in relation to one of the earliest pieces that has been conscripted into the 'audio essay' genre, Glenn Gould's 1967 'The Idea of North'. As both Ikoniadou and Carlyle note, in Gould's polyphonic 'speculative journey in time and space', as sound enters into a contrapuntal relation with voices suspended from presence, it reveals the tensions that underlie an apparently sublime and silent landscape—in this case the North as a supposedly 'empty last frontier of solitude waiting to be discovered'—and renders audible some of its silenced voices. And according to Ikoniadou, it is indeed the duty of those lucky enough to be working with aesthetic materials rather than directly confronting repression or death to use the 'contrapuntal' forces of the audio essay to make heard a 'grief beyond language'—that is, beyond the language of power and the ways in which it delimits the speech of its subjects.

In *Black Atlantis* Ayesha Hameed explores the complicity of nonhuman traffic with the inseparable histories of the anthropocene and of slavery. As a medium of translation for these material histories, Hameed suggests, cartography is treacherous and often spiked with political motives, and shares its deceptive nature with the enterprise of writing on sound: for how does one 'objectively' map travelling waves? As Trower writes, coastlines are themselves 'semi-fluid, taking the imprint of waves', and by this token may seem to herald an end to clear-cut distinctions and exclusions. But their malleability is not necessarily a friend of humans, as attested by the depredations of climate change (anticipated in the decline of Dunwich, as documented in *By the North Sea*), and by the

role played by wind and tide in the exploits of colonialism (as explored recently
by John Akomfrah, member of the all-important Black Audio Film Collective, in
his multi-screen video piece *Arcadia* [2023], which casts the wind as a colonial
actant, tracking the migration of spores along with enslaved humans). Hameed's
'tidalectics' between land and sea recall both Trower's meditations on the liminal
politics of the beach, and the sinister resonance of the 'flakes of sonic memory'
that recur in Nataraj's text in the form of samples of xenophobic political dis-
course from the 1970s and the 2020s.

Atlantis or Lemuria?

Alongside Ikoniadou's sonic remapping of Global North and South, Hameed's
piece brings us back once again to an obsessive relation to the sea that flows
through many of the works discussed in these pages. In particular, both of their
contributions clearly summon the long shadow of the Black Atlantic.[18] Paul Gil-
roy's conceptual geography looms large immediately in relation to the questions
of colonisation they raise, but it also speaks to the hybridisations of sonic matter
characteristic of afrofuturism which infuse the audio essay, and is present in a
broader and more abstract sense in the audio essay's persistent tendency to
materialise the forcefield of historical and archival traces in the form of virtual
geographies, disrupted cartographies, and intensive maps.

For, with its patchwork methodologies and its attachment to science fiction,
speculation, the virtual and the futural, the audio essay mobilises not only direct
political confrontation, but a more oblique resistance, albeit one that is in many
cases rooted in (or routed through) the very planetary histories that Ikoniadou
and Hameed urge us not to turn away from and the administration of time and
space they imply. To understand how the resistance of the audio essay to formal
categorisation is inseparable from its resistance to the present and from the
turn to the virtual as a way to crystallise political and philosophical stakes, it will
be useful to revisit the 'origin story' outlined above and to examine some of the
ur-sources of Ccru's experiments in audioconceptual synthesis.

As we have seen, the three audio essays featured in the *Sonic Faction* events
did not strike out from the world of academia in search of a new sensory medium
in which to express their theoretical insights, but sprang from a microcultural

18. P. Gilroy, *The Black Atlantic: Modernity and Double Consciousness* (London: Verso, 1993).

milieu in which sound and concept were already mixillogically entangled. A strong stimulant for these early experiments was Kodwo Eshun's exposition of what we might consider the audio essay's inverse twin, 'sonic fiction' (also one of the inspirations for the 'bass fictions' of Kodeg and The Spaceape).[19] Simply put, if the audio essay uses sound as a tool to grapple its way out of the purely discursive, sonic fiction designates the set of processes whereby popular musical forms venture into conceptual, fictional, and speculative territory. Two prominent examples proposed by Eshun were the Wu-Tang Clan and Drexciya.

The heterogenesis of the Wu-Tang Clan, guided by the hand of audio-visionary RZA, spawned a complex fictional manifold. The grindhouse exotica of *Eight Diagram Pole Fighter* is spliced into the American nightmare of *Scarface* and projected onto the urban jungle; chivalric ancient China collapses into Staten Island, project housing becomes Shaolin monastery. The Clan's methical fumists, their tongues liquid swords laced with esoteric knowledge, profess a lyricism whose speculative aspirations—at once keeping it real and elevating street life into a multiplex hallucination of superposed fables—billow like weedsmoke from a heady blend of Five-Percent supreme mathematics (the liberatory imprecations of an already-synthetic Islam cut with black nationalism) and Shaolin wisdom.[20] If the resulting mythos constitutes a sort of precipitated dreamwork in which these disparate sources condense, on the street the Clan also did the pragmatic cyberpunk footwork of assembling the available technologies (home video, turntable, four-track...) and hustling to build a shoestring business that would take the subjective tensions this dreamwork expressed and megafy them into a 'pop-culture Galactus'.[21]

19. See Eshun, *More Brilliant than the Sun*. For bass fiction, see Kode9 & the Spaceape, *Sine of the Dub* (Hyperdub, 2004), *Memories of the Future* (Hyperdub, 2006), *Black Sun* (Hyperdub, 2012), but also *Bacteria in Dub* (2004), a piece performed alongside Luciana Parisi and Jessica Edwards.
20. For RZA, *The 36th Chamber of Shaolin* (dir. Lau Kar-Leung, 1978) 'was like an echo of the Lessons [of the Five Percent] from another world' (S.H. Fernando Jr., *From the Streets of Shaolin: The Wu-Tang Saga* [New York: Hachette, 2021], 74). In parallel to both the Five-Percent Nation and the heroic path of *36th Chamber* protagonist San Te, RZA conceived of the Wu-Tang as a heterodox bid to establish a renegade 'thirty-sixth chamber' that would open up to the profane masses the secret lore and fighting style developed by the nine on the Shaolin streets.
21. Ibid., 8.

As an exemplar of those machine-music forms that reactualise cultural histories forcibly virtualised in the Middle Passage, reassembling them in radically new forms using whatever tools the street provides so as to face down a bleak present, the Wu-Tang is a quintessential product of Gilroy's virtual-geographical configuration, with all of its cultural ambivalence, callbacks to an abysmal historical past, and ambivalent futuristic auguries. The other exemplary afrofuturist vector explored by Eshun, the techno of Drexciya, explicitly crafted a cybernetic folksong for the 'transcultural, international formation' of the Black Atlantic. Drexciya's sonic fiction fabulates a murky alternative to, or supplementary outcome of, Gilroy's 'transnational black modernity': the inaccessible, sunken cryptopia of Drexciya, which, as we gather from terse sleevenotes and track titles, is an underwater nation populated by the unborn children of pregnant African women cast overboard from slave ships, who adapted to breathe underwater in their mothers' wombs and founded an aquatic alien aquapolis which the techno outfit's severe sound, with the motoric compulsion of a Trans-Europe Express rerouted through Detroit, at once evokes and 'terroristically' blocks affective access to.[22]

In both cases, sonic fiction amplifies sound via annexed text, image, and branding to create skeletal alterworlds that warp, plex, collapse and superimpose geographies and political planetary histories, assembling militant 'esoterrorist'[23] discourses that are inseparable from their sonic assault vehicles. A sunken undercontinent whose productive energy springs from a ground of alienation and suffering, the Black Atlantic is the only geopolitical entity to which these hybrid cultures of modernity can possibly pledge allegiance, and they repeatedly materialise it in new synthetic assemblages—artificial 'Jewels Brought from Bondage'—in order to resist the cruel factuality of the present. Just as the events of myth play out in a time that is not further back, but perpendicular to historical time or subterranean to it, so afrofuturist sonic fiction, in order to produce its defiant visions, always has to leap over any future upon which historical prediction could have the slightest traction: *My 7XL is not yet invented... Rap moves on to the year 3000...Let me show ya somethin'.*[24]

22. See K. Eshun, 'Drexciya: Fear of a Wet Planet', *The Wire*, October 2011.

23. Ibid.

24. Dr Octagon, *Dr Octagynecologist* (Mo' Wax, 1996).

Clearly, Ccru's cyberpunk practice, with its low-budget assemblages of cut-up texts, VHS loops and samples, was inseparable from the group's attentiveness to these afrofuturist currents and to the stupendous force invested not only in their sonic forms but also in the quasi-concepts and fictional worlds that accompanied and intensified them. The tendency of audio essays to spring the most expansive speculative territories from apparently unpromising real-world sites, and to accompany this operation with a radical political charge, should then come as no surprise. And while the Black Atlantic is thematically present in the work of Hameed, and its echoes are heard in many of the other texts in this volume, in subtler ways Gilroy's methodology—i.e. the retrojection of the anatomies of ad hoc reassembled forms of displaced, forcibly virtualised, hybrid-ised culture back onto the world-map, radically reconfiguring its contours—is also at work in that singular moment in *On Vanishing Land* where Fisher and Barton allow the apparently incongruous setting of *Picnic at Hanging Rock*'s eerie outback to superimpose itself onto M.R. James's East Anglia, or the way in which *By the North Sea* overlays Lovecraft's imaginary New-England Innsmouth onto Dunwich, or in *Astro-Darien*'s invocation of a Panamanian-Cal-edonian 'heart of darkness'. Yes, Darien, Felixstowe container port, and even Dunwich also belong to this dark continent in so far as they are figures of the potency of virtual distributions which political states, geographical borders, and other administrative boundaries can only attempt to mask—distributions which are as much a matter of temporal tensions as of spatial correspondences. At the limit, taking the lead from *By the North Sea* and turning to a privileged figure of Ccru lore, we might say that, in using sonic abstraction to swerve from actual to virtual geographies, audio essays exhibit not just a Black-Atlantean but a *Lemurian* tendency to morph the globe, producing virtual territories 'that won't show up on the old maps', trafficking routes untraceable by the AOE.[25]

Like Black-Atlantean sonic fictions, audio essays use sound to militate against cartographic forms of presence and chronology that serve only to mask the anomalous convolutions wrought by modernity. Their methodology is instead to work flush to capitalism's violent and topologically anomalous foldings, peeling away actual geography—synechdoche for the inescapability of here-and-now presence in the configuration of the present—to reveal both the undercurrents

25. See Ccru, *Writings*, in particular the section 'Black Atlantis'.

and the undercommons that work it from below and the powers of administration that map it from above. Needless to say, the audio essay resists an over-explicit politicisation that would attenuate its care for the sensory—otherwise, one could simply write an essay or make a speech. It is precisely in superimposing political, conceptual, and aesthetic contestations, balancing sensory seduction with discursive stringency, that it produces its unprecedented effects.

Sonic Warfare

As if in an admission of the impossibility of deciding between the demand for direct intervention in the contemporary situation and the type of more oblique relation suggested above, Lawrence Abu Hamdan, whose professional practice of forensic acoustic analysis brings him into contact with direct evidence from the most war-torn areas of the planet, speaks about the difficulties involved in collecting and analysing evidence in a 'post-truth' world, alongside the deployment of 'productive untruths' in his parallel practice as an audio-essayist. As he argues in his interview with Goodman about the relation between his audio forensic practice and the 'live audio essays' in which he dramatises it, there is no such thing as the objective and self-evident (and it is telling that there is no auditory equivalent of the visually-slanted term 'evidence'). Based on work in which lives can depend on a split-second acoustic detail, his audio essays expand his ultra-focused work of investigation into a collective act of listening in a dramatising zoom-out from the sonic minutiae to their wider consequences. As Abu Hamdan emphasises, however, this sharing of attention also then feeds back into his investigative work by staging a critical open forum in which the heuristics of listening can be challenged—a space to attend not only to the role that sound can play in decrypting what has taken place, but also to the ways in which sound itself is becoming, increasingly, a weapon of war.

An earlier episode in this weaponisation of sound is recalled in Jessica Edwards's text on the historical 'soundclash' between East and West at the height of the Cold War, excerpted from Nik Nowak's audio essay *A War of Decibels*.[26] This resounding explosion of a 'politics of sonic repulsion' saw amplified electronic sound deployed across the Wall in an experimental form of sonic warfare. Here Edwards demonstrates once again the audio essay's ability

26. Flatlines, 2024.

to draw upon and amplify anomalous historical sonic encounters and incidents, and attests to the fact that the places and spaces of the audio essay bear an extremely complex relation to their physical grounding, from which they depart and return in a cyberpositive circuit—here, from noise hurled over the Berlin wall to Caribbean sound systems and back again.

Walkie-Talkie

To consider this relation to place in yet another way, many audio essays may be understood as maximally abstracted and expanded soundwalks. Indeed, the soundwalk is one of the practices that abuts onto the audio essay. The field recordings of Carlyle's *Powerlines*, for example, had their origin in a soundwalk, and *On Vanishing Land*, *By the North Sea*, and *Astro-Darien* all originated in journeys through the sites whose haunting they perpetuate.

In Lawrence Lek's large scale installation *NOX*, however, the artist integrates the act of walking and listening into the work itself, eschewing the linear form of the audio essay and instead distributing overlapping sound and voice fragments across a physical space. Like *Astro-Darien*, *NOX* bears witness to the audio essay's ability to absorb techniques from yet another medium, the videogame. As addressed in the *Sonic Faction* discussion, the move from an implicit model of radio—albeit in a mutated form—in *By the North Sea* and *On Vanishing Land* to videogame in *Astro-Darien* brings with it a different cultural history and sonic conventions shaped by a different mode of interaction. In Lek's interview with Goodman, he explains how *NOX*, installed in an abandoned shopping mall in Berlin, owes more to gaming than to the radio play or the documentary, since it combines the soundwalk with techniques of sound distribution borrowed from the open-world 'walking simulator' typified by *Death Stranding* (also one of the inspirations for *Astro-Darien*).

NOX can therefore be understood as a remarkable example of an audio essay that turns the format inside-out. Where the architecture of videogame sound design involves the user inadvertently 'mixing' a number of layers of sound themselves as they move within virtual spaces (the simulated environment as well as the possibility space of the plot with its missions, sidequests, inventory, NPCs, etc.), Lek's 'virtual audio walk' installation transfers this mechanism into a physical space via a virtual double. As noted above, once removed from the

collective listening situation into earbuds or headphones, the newly portable audio essay inevitably tends to become what Goodman calls an 'augmented audio reality', its sounds layered, perhaps incongruously, over those of the listener's physical environment. Inversely, in *NOX*, the listener's physical trajectory through space becomes 'internal' to the audio essay; navigating through the installation unfolds the audio material in a nonlinear manner. *NOX* therefore presents an alternative response to the question of what becomes of the audio essay once it is released from the concentrated intensity of the listening session: rather than becoming indifferent to time and place, on-demand, personal, and streamable, the audio essay can be keyed to a physical space in a different way.

But this comes at the price of a looser authorial control over its sequencing. The audio essay's encounter with the videogame also raises questions about its temporality: in Lek's installation, as in a videogame, the user is to some extent free to chart their own course, whereas the three audio essays featured in *Sonic Faction* are linear. The difficulty of containing within a linear form the complex networks of concept, images, and sonic elements dealt with in those pieces is in fact one of their central challenges—the audio essay is always in 'protest against its own form', Mackay suggests. This is a challenge from which one exempts oneself as soon as one turns instead to a navigable 'interactive' space, while on the other hand the curse of interactivity, as Lek notes, is that in loosening the audio essay still further from the original situation of collective listening, the artist also cedes some of their control over the listener's experience, not knowing how, at what speed, and with what kind of attention the audience will navigate the work.[27]

27. The history of the relation between the exhibition and locative audio begins with the ambitious show staged by philosopher Jean-François Lyotard and design theorist Thierry Chaput at the Pompidou in 1985, where visitors equipped with radio headphones could wander at will through a series of interconnected 'zones'. Lyotard saw this as a way of concentrating, within the space of the exhibition, the contingency, disorientation, and multiple overlapping zones of 'postmodern space-time', an approach he conceptualised in reference to his own experience of the car radio picking up a series of stations as he drove the highways of California. Significantly, Lyotard posited this as exemplary of a 'postmodern' modality of experience attuned more to the ear more than to the eye: it marks the recession of the modern dream of a spatial-visual synopsis that would allow one to entirely map out a project—for example, a modern city such as Haussmann's Paris—as a logical, unified, and contained entity. It has an affinity, instead, with the unplanned sprawl of LA, its freeways and suburbs like 'organs expelled from a city in the process of turning itself inside out' (R. Mackay, 'A Diauditory Note on Synopsis', in F. Hecker, *Resynthesizers* [Falmouth and Los Angeles: Urbanomic/Equitable Vitrines,

Whose Voice?

When she locates the lamenting voice as already being 'outside the domain of the human', having passed beneath the protective border walls that delimit the human from its others, Ikoniadou also insists upon its affinity with these artificial voices which, with increasing uncanniness, are insinuating themselves between the *pneuma* of life and the flatline of digital unlife. And, like both *Astro-Darien* (systematically) and *By the North Sea* (at a certain pivotal moment), *NOX* makes use of synthetic voices. As we have seen, the audio essay—in the form reflected in the three *Sonic Faction* pieces—always stood in a direct relation-ship to electronic music's ability to continually reprocess its history while drawing in new elements to surprise and disrupt normative hearing patterns and mobilise the body. And from the time of pieces such as 1996's *Swarmachines*, Ccru treated the voice as a material. In doing so, rather than referencing the academic tradition of musique concrète, they were drawing upon the alter-concrète afro-futurist scratchadelic tradition. Machine music, from hip-hop to techno to jungle to footwork, has always mobilised the uncanny affects yielded by cutting up the voice or processing it by, for example, scratching, sampling, timestretching and, more recently, the advent of autotune and of fully synthetic voices. This material relation to the voice plays a significant role in the symbiosis whereby the

2023], 17–22; see Y. Hui (ed.), *30 Years of Les Immatériaux: Art, Science and Theory* [Lüneberg: Meson Press/Leuphana University]).

 Les Immatériaux's pioneering audio enterprise thus brings us back to Colquhoun's argument that audio essays reflect a fractious postmodern unconscious, via Goodman's observation, in the *Sonic Faction* discussion, that the ease with which the audio essay shifts between registers, periods, and spaces may reflect the information environment and fathomless archive of the internet, in which fiction and nonfiction and all forms of media datableed into one another. As Goodman suggests, like many audio essays, and despite its apparently stately speed, *On Vanishing Land*'s soundwalk, studded with literary, historical, and film references, involves a form of 'hyperlinking', supplementing the present reality of a specific place with archival details which are then extended into speculative counterfactuals and alter-worlds.

 Incidentally, the *Sonic Faction* event at KARST unwittingly produced its own version of the 'virtual soundwalk'. The installation of the three pieces in separate rooms interconnected by the main exhibition space made it possible for visitors, passing through the space and between the pieces, to hear them in dialogue across the main space, which also housed a 'listening station' with headphones, offering fragments of audio essays past. Whereas Lek's *NOX* sees the physical building meticulously reconstructed in virtual form in order to synchronise the audio experience of an imagined SimBeijing with the visitor's physical experience, at KARST, as they looped, the audio spaces of the three pieces drifted together to form contingent, shifting montages mediated by the physical space in which they were temporarily housed, with sometimes striking results as the visitor 'cross-faded' the three pieces by moving through the gallery.

discursivity and archival bent of the audio essay is infused with contemporary sonic-fictional innovations.

In Lek's work, the synthetic voices of fictional AIs also serve to advance a question of agency that often attaches to the voices in audio essays—sampled, reassembled, quoted, captured, but in any case rarely addressed univocally from one subject to their listener. Lek proposes that the AI ecosystem of SimBeijing, which the visitor to *NOX* experiences by travelling through a series of overlapping sections of text spoken by synthetic voices, is representative of the fact that, rather than a monologue, consciousness consists of 'multiple, overlapping flows'. Rather than being located at one point in space and time, these flows are spread and distributed across multiple surfaces. The audio essay may then be said to address, access, or anticipate this techno-humanoid 'machinic unconscious' with its 'uncanny adjacencies', its continual shifts and discontinuities of identity.

Although Ikoniadou's 'polyvocal assemblage' already heralds a disruption of the notions of agency, intention, and consciousness traditionally imputed to the voice, this is made yet starker by the use of synthetic voice. This points to the audio essay as a practice in which the emergent fields of AI, machine listening, and synthetic voice models converge with Hall's 'enormous voices that have not yet been, or cannot yet be heard', alien voices from 'a parallel nonhuman history' that are the counterparts to the synthetic voices emanating from the virtual future worlds of *Astro-Darien* and *NOX*.

A form that 'thinks in fragments just as reality is fragmented and gains its unity only by moving through the fissures' (Theodor Adorno), which 'produces complex ideas not necessarily grounded by reason or reality—ideas that might be contradictory, irrational and fantastic' (Norah Alter); 'a tissue of quotations drawn from the innumerable centres of culture' (Roland Barthes), a 'sociological essay written in the form of a novel, but you only have musical notes at your disposal.' (Jean-Luc Godard), a 'one-hour audio movie' (RZA),[28] a 'mayday signal of Black Atlantic Futurism' that 'uproutes you by inducing a gulf crisis, a perceptual daze rendering today's sonic discontinuum immediately audible' (Eshun), a 'mode of time where [...] everything can, with the correct procedures, be accessed, resynthesised, recast, producing something new and unprecedented' (Mackay), a 'spiral [that] loops back and forth across time in an often perplexing fashion,

28. Fernando Jr., *From the Streets of Shaolin*, 167.

as chronology and discursive form congeal and assume their own consistency' (Goodman), the opening of an 'anomalous perspective' on the planet (Barton).... To observe that all of these could apply to the audio essay is to conclude, albeit provisionally, that as medium and method it responds to the great displacements of postmodernity which have rendered impossible the work of art as finished unity, the demarcation of fact from construction, the sanitary sequestering of human agency from machinic manipulation, and so on. What we hope to present in this volume are some indicators as to what the 'dialoguing fragments' of the audio essay might offer us in navigating this perplexing new configuration to which, centuries later, we are still struggling to adapt our inherited language and attitudes—as an auditory probe into the unmapped zones of a global culture with neither unity nor univocity....

Sonic Faction (Discussion)

Edited transcript from the Sonic Faction *listening session, 8 February 2023, KARST Contemporary Arts, Plymouth, UK.*

ROBIN MACKAY: Some of you might be wondering what an audio essay is, and that's why we're doing this event—because we have the same question.

The three of us have all made pieces that we've decided to place under the heading of the audio essay, which is something which we can provisionally define as being characterised by the use of voice together with sound collage and music—somewhere in-between a radio play, a documentary, ambient sound, field recording, and mixtape. We're interested in understanding why each of us has turned to it, in our different ways, in order to make the work that we wanted to make. There's also a common thread here because of a shared heritage: Justin, Steve, and myself have all known each other since the nineties, and were involved in working together in various ways at a point at which UK cyberculture, electronic music, and speculative philosophy collided in a quite unique way—so maybe the discussion will cover that heritage as well to some extent.

In the week immediately following the death of Mark Fisher in 2017, I returned to the archives of a project that Mark and I had embarked upon to make a film about Dunwich, the East Anglian town that disappeared into the sea. In 2001 we took one trip to Dunwich during which we filmed and conducted interviews. But the project never came together, in spite of the fact that, over the years that followed, we periodically talked about reviving it.

In 2017 the Dunwich project became a focus for asking questions about finality, about things that could now never happen, about the possibility of continuing, and about a distant friendship marked by depressive absences and constantly deferred promises to spend time together.

I soon realised that I was returning to what had already been an attempt at the repetition or recovery of an intensity of engagement and creativity

experienced during the 1990s in the context of the Cybernetic Culture Research Unit (Ccru), a period that had come to an abrupt end and which we must both have felt the loss of.

In *By the North Sea*, a 'definitively unfinished' audio version of the Dunwich project, our actual 2001 trip becomes just one timeline in a convergent wave of intensity. Across a series of embedded hyperstitional narrative shells, what emerges is a common task pursued by Stillwell (1949), by Templeton (1968), by the two of us (2001), and then by myself in the wake of Mark's death (2017). A search for a mode of time where nothing passes absolutely but where everything can, with the correct procedures, be accessed, resynthesised, recast, producing something new and unprecedented.

[Playback of *By the North Sea* (44'53")]

RM: For me—although this wasn't something I consciously deliberated on at the time—a part of what was crucial about the audio essay was that I intuitively knew that working with sound would provide the means to make something that wasn't linear or narrative in a straightforward sense.

Since *By the North Sea* is dense and multifaceted, to provide some sort of navigational aid for the listener I usually describe its construction as a set of concentric 'shells', each one dated: the outer shell is my position in 2017 trying to return to the Dunwich project, inside that you have Mark and myself in Dunwich in 2001, and inside that you have a fictionalised account of that same trip, with Professor Templeton and his assistant going to Dunwich in 1968, and right at the still centre of it all, expounding the philosophy of time that encompasses or underlies the reflections of the piece, you have Stillwell in 1949.

I imagine the listener weaving a path through this complex structure in such a way that they get fragments presented to them that perhaps don't immediately make sense, but that eventually give them a feel for the whole thing, which involves a resonance between different periods, different registers of experience, and different subjects.

The reason why it seems possible to attempt that type of complex operation in an audio essay is that the form presents an opportunity—or a challenge—to pay attention to sound in a very concentrated way. Although in the context of

this event I feel like apologising because *By the North Sea* is quite long, it also delights me that all of you have just sat here in the dark for an hour, listening. I think it's something that we don't do very often, and it means the audio essay can do unique things.

BEN BORTHWICK: This is proposed as an audio essay, but it's being presented within a contemporary art gallery, in a room that was built for a video projection. And you use imagery that begins with an epigraph and then has a repeating refrain of the sea and the waves.

RM: There's a long story about what kind of media this piece is. The first thing I was thinking about when listening to it today was that, on a personal level, it 'succeeds' on two levels. Firstly, one of the most important lines in it comes right at the beginning where I say 'There's less to fear from the acuteness of loss than from the loss of acuteness: you try to put down markers'. This piece for me is a marker which, every time I listen to it, takes me back to the moment immediately succeeding Mark's death, when that line was written: the 'stark lucidity' of that moment of loss, and of realising that all of the things that I always assumed might happen, or were going to happen in the future, now definitively couldn't. How do you deal with an ending? So it succeeds, at least, as a personal marker. But the second way in which I feel it's a success is that, when I experience it, I think to myself: *What the hell is this?* And all of my favourite works of art, music, writing, anything, they're always the ones where I'm thinking *What is this?*, asking what exactly it is that I'm listening to or looking at. To perplex myself, or to extend the perplexity that is the theme of the piece, that feels like an achievement. And the medium is also a part of that.

Mark and I decided in 2001 to make a film about Dunwich that would include certain fictional elements. We took a consumer DV camera to Dunwich and we did a few interviews. You can see some of the footage here. So when I started *By the North Sea* I thought about taking the video footage and making it into a film. But it soon became really obvious that making a film would take me the rest of my life! As it was, it took me six years to finish the audio essay, so it wasn't exactly easy. But there was something about focusing just on sound that made it somehow smoother for me to work with, and I very soon concluded

33

SONIC FACTION

that sound was enough, more than enough, to lead an audience through the convoluted time-complex that the piece deals with.

At the second playback for an audience, at Miguel Abreu Gallery in New York, I can't remember the exact details, but for some reason they had a projector set up already, and because I was nervous about making people sit in a dark room and just listen for an hour, I thought I'd better give them something to look at too. I took that footage of the sea at Dunwich and made a very simple set of loops, and I found it was successful because it stops the audience's eyes from interfering—as a listener, it takes care of your eyes and then you don't have to pay attention to the visual and you can listen properly. So it's kind of a hypnotic device.

BB: Like a sort of visual white noise?

RM: Yeah, just something that fools your eyes into thinking that they're doing some work, and so therefore you can concentrate more on the auditory.

BB: This is maybe a point at which to bring in Justin, because *On Vanishing Land* doesn't have any kind of visual component.

JUSTIN BARTON: It's obviously an extraordinary thing that, when you bring people together into a room now, it's very hard to just give them audio: leaving the screen blank seems a very strange thing to do. But Mark and I felt all along that we didn't have anything that came close to being a visual correlate or expression of what the piece was about. We found music that, on one level, was an effective correlate—a powerful expressive adjunct—but nothing that came close with images. And because people are so visual and will focus heavily on the image, the last thing we wanted was for there to be a focus on something that was ineffective.

We always felt that one way in which we would like *On Vanishing Land* to be heard was on the radio, a domain where people are still accustomed to there being no image. You can go different ways in thinking about playbacks and installations, although I feel I'll probably always think that listening to *On Vanishing Land* in darkness is best. However, I do think the water image with

By the North Sea works really well. And maybe the key in this case is that it's something mesmeric as well as having a level of expressiveness.

RM: When we've discussed the making of these pieces, we've often talked about what you can do with sound that the visual element would positively prevent you from doing. For me an important part of that involves moving between these different 'shells' that make up *By the North Sea*. Moving between different levels of abstraction—from a very concrete story, a personal story, a specific place, to fictional personae, to a set of abstract concepts, via material sampled from various sources—different authors, poets, sound sources, and so on.

That kind of sliding between different spaces is something that would be very difficult to do in a visual medium, with an image or series of images of actual scenes. Because as soon as you have a concrete image of a place, then all of the abstraction is brought back down into the empirical space you're seeing. As a viewer, you're looking at it and you're placing yourself there, whereas with sound somehow you can move off into these other spaces and back again in a far more fluid way. Attempts to do that visually—to move between physical places and people and abstractions—rarely succeed: unless you're an exceptionally skilled film maker, they generally turn out cringey or comically 'dreamlike'.

And one thing that these three pieces have in common is that they move between very specific geographical places and abstract ideas, they return and repeat and reimagine those places and extend them into a speculative space.

Justin, a couple of weeks we were talking about hauntology and you said to me that the concept of hauntology, one of the ideas that Mark is best known for exploring, can be understood not in terms of something spooky or ghostly, but simply in terms of the concept of a 'regular haunt' or an 'old haunt'—somewhere you return to regularly, perhaps obsessively. In the original usage of the term 'hauntology' Jacques Derrida is talking about how Marx says that the spectre of communism continues to haunt Europe. What he means by that is that we have to keep returning to it because it remains an unresolved question, it remains a pressing virtuality, a problem. That's what the spectre or the ghost does, it comes back because there's something unresolved. The intensity that lends the spectre its virtual persistence (if not existence) is the gap between what should be and what is, or between the actual and some unrealised, still-latent virtuality.

It worries away at that gap, returning to it, haunting it. And that's definitely something that's happening in *By the North Sea*: there's a haunting there, a going back and back again to an 'old haunt', and pulling more and more out of it. And again, somehow that was easier to do with sound. To haunt visually is difficult because the visual gives you such immediate, direct evidence of something's unambiguous presence.

We could link this to the concept of the eerie, which, as Mark writes in *The Weird and the Eerie*,[1] is more likely to arise in the context of sound and voices rather than vision and faces.

JB: I agree, my feeling is that there's a whole other way of expressing insights or 'outsights' about the nature of the world that is very different from a conventional discursive mode, and very different from conventional realist fictional forms. It comes in a lot of different modes, from anomalous tales to plays to so-called genre fictions to dramas to dialogues, but it's the same thing: perspectives that have been broken open, but through very different methods. Poetry too, and obviously there's a lot of poetry in *By the North Sea*.

I think that probably there was a kind of catastrophe, maybe not only for poetry but for all kinds of anomalous tales, somewhere around about the 1930s. Since then, poetry has been replaced to a great extent by songs, and the anomalous tale has darkened immeasurably in various ways.

I think that the audio essay provides an opportunity to push your way through to the point where you're saying something which would be very hard on any level to find a visual format for. You can break open a space at the level of the oneiric-real within the audio essay, so that people are inhabiting a space very powerfully. All of these three pieces are very much located in place in different ways, in one place, but there's more than one space here.

One thing about words that are trying to break open a very unusual anomalous perspective, a very powerful outsight, together with music, is that the music will have no difficulty at all in working on one crucial level of the abstractness of what you're saying. It has all the necessary power if you find the right composers or musicians, or if you do the work yourself. It's very hard to reach that point

1. M. Fisher, *The Weird and the Eerie* (London: Repeater, 2016).

with the visual. There are some people who've done incredible things in this direction, like Tarkovsky's *Solaris*. But it's actually very hard.

And yes, I think sound has advantages in terms of the eerie. When you're outside at night, and someone passes in the distance whistling casually, you listen in to the timbre—is it really casual, or is it designed to unnerve with its casualness? Listening and watching in to the timbre is likely to take place with less focus in daylight, and, switching to film, everything has a tendency to be saturated with the quotidian, even with horror and fantasy, so that shock and surprise are what punctuates the experience at best. With the audio essay the voices are there with their timbre, and with the music you are hearing atmospheres and tonalities, and once a perspective toward the unknown is opened up, something of the acousmatic experience of hearing a stick breaking in a forest at night—what you are focused on then has nothing to do with the stick—can go into effect. A reaching-in to the intent revealed by the timbre—a feeling of *What is behind this?* A feeling that something that is finding expression in the work is being revealed—something behind the surface of the day.

STEVE GOODMAN: I do agree with what you're both getting at, which is to do with the power of sonic abstraction. But I wonder if I can do something which I don't normally do, which is to stand up for the visual. I wonder if what you are both referring to is the issue of audiovisual redundancy. Think about the audio essay as a format, compared with the film essay: essay-film, at least at its most powerful, does something really interesting to scramble audiovisual redundancy: sound and image don't merely illustrate one another, but resonate to produce something greater than the sum of the parts. The sound can add a dimension to the image that literally isn't there.

In this sense, I think the audio essay and the essay-film both have the power to create an image of thought; they don't have to operate linearly, as in an essay narrowly conceived as an argument for example, and the image doesn't have to represent the sound, or vice versa. I obviously have a lot of sympathy with what you're both saying about the greater power of sonic abstraction, but I think where the film essay is most successful is in trying to navigate that problem of the overdetermining power of the visual.

RM: One reference we all return to continually is Chris Marker, isn't it? Marker is one of the few to have mastered the essay-film. However, André Bazin rightly pointed out that he is a very unusual filmmaker in that the visual is not primary in his work: 'the image only intervenes in third position' after intelligence and language, he says.

The thing that I love about Marker's work is that it continually produces a tension between the images and what's being said. You'll see an image, you don't really know what it is, where it belongs, and then twenty minutes later something is said which makes you have to connect back to that image. For me this is constitutive of interesting discursive art in general: by placing you as a viewer into a field of tensions, it includes and integrates you into the process of making. The piece is *using you* to think about what it wants to think about. Its job is not to set out a solution, but to present the tensions constitutive of a problem in a way that pulls you in and invites or in fact forces you to become the connective tissue, the bridge, between heterogeneous elements, to provisionally resolve the problem by resolving the piece itself: *What is this?*

So Marker has implicitly been a huge inspiration, but I definitely feel in my case if I had tried to integrate the visual into the piece it would have been even more of a crushing task than it was.

AUDIENCE MEMBER: Where did the music in *By the North Sea* come from?

RM: I made all the music myself, and, as I said, I made this over six years, and what I would do was to give up, despair, and then return to it a few months later and just add one sound. Each time I just added one sound or one loop and each time it worked, I had to push it around a bit but eventually it worked. I never took anything away, I just added elements one by one.

One of the main things was that I didn't want to make it just a gloomy meditation on death, I wanted to include the things that Mark and I shared a love for and an enjoyment of—basically, 'pulp' elements. So one reference for the music was John Carpenter scores, where you have this very minimal synth loop just going over and over.

BB: Scores which he also makes himself.

RM: That's right—and then there's this furtive pizzicato motif which was somehow ready-made in my mind, for the slightly Arthur-Conan-Doyle-style storytelling of the Templeton narrative. A lot of the sound elements are a bit corny because I'm trying to conjure up the mood of somewhat obsolete classic genre forms. Because using pulpy narrative and musical devices gives the listener a way to move through this quite complex conceptual space, using forms that are so familiar and even hackneyed that they play their part without registering as explicit sonic choices that demand attention.

One of the joys of listening to it with an audience, in physical space, is to hear the sub-bass as well. Listening to it on headphones I always forget that that exists, and it intentionally adds a whole other physical-spatial dimension, which Steve is well qualified to talk about, being a sub-bass technician....

SG: One practical difficulty is that sub-bass and voice, even if they occupy very different frequency ranges, are still often at war with each other, and that's one of the challenges of mixing these kinds of pieces: keeping the voice audible and not drowning it in a sea of vibration. During the 2000s I made several beatless, spoken-word pieces with the late vocalist and poet The Spaceape, which we used to call 'bass fiction'—for example, our cover of Prince's 'Sign o' the Times', called 'Sine of the Dub', our cover of The Specials' 'Ghost Town', and a piece called 'Bacteria in Dub', also featuring Luciana Parisi and Jessica Edwards, which involved them reading excerpts from Luciana's first book, Abstract Sex,[2] over a sluggish bass loop. That last piece was actually made for the launch of both her book and Hyperdub Records in 2004, to be played on the incredible sound system of the now deceased club Plastic People. None of these were made for art spaces, but the notoriously unpredictable and usually awful acoustics of gallery spaces, hard reflective walls with no absorption, means that it's often such a delicate balance to have that vibrational physicality you are referring to without completely submerging the voice—making a little pocket for the voice to sit in and remain audible.

2. L. Parisi, Abstract Sex: Philosophy, Biotechnology and the Mutations of Desire (London and New York: Continuum, 2004).

RM: Since we're talking sub-bass, which inevitably leads to jungle, the other thing that's in *By the North Sea* is the amen break, albeit disguised in a massively timestretched form, I just had to have it in there.

BB: In *By the North Sea* sub-bass pulses punctuate the script. Did you have a specific function for the sub, or is it more intuitive than that?

RM: For me there was always a temporal tension involved in making *By the North Sea*: between the use of pastiche and literary sources, and the need to place it within more recent sonic history and avoid nostalgia. In the second half, the synthetic voice brings it right up to date. But in the first half I brought in the amens and subs as a temporal reminder, a kind of 'memo to self' and to the listener to not let the whole thing get absorbed into comfortable tales and sonic LARPing. And at a playback of the piece, it also adds a strong bodily element to the sound that makes it more involving.

SG: Another thing that you and Mark clearly both shared is a love of English television from the 1970s.

RM: Yes, one of the last lines in the piece is a quote from the 1979 series *Sapphire and Steel*. And the atmosphere comes in part from the feel of those TV shows that were ambitiously trying to evoke other worlds, weird forces, and cosmic anomalies, armed only with a very meagre budget, a synth in the BBC basement, and a day's filming in a Devon quarry.

All of that has gone into *By the North Sea*. I talk about it sometimes as being like a radio play afflicted by ontological rot, or a documentary that's been kind of crumpled up so that all the wrong parts have got attached to each other. There are bits poking out here and there that still sound like they belong to some straightforward identifiable genre of media, but they are all mixed up in an anomalous way. Again, that's something which, for me, was made possible by the audio essay format.

*

SG: One aspect that *Astro-Darien* has in common with both *By the North Sea* and *On Vanishing Land*, I think, is that it's structured as a spiral which emerged out of a journey (in the case of *Astro-Darien* a road trip across the north coast of Scotland instead of a walk along the southeast coast of England), and it loops back and forth across time in an often perplexing fashion, as chronology and discursive form congeal (fiction, documentary, archival samples, etc.) and assume their own consistency. This is one aspect that perhaps differentiates how we are conceiving of an audio essay, a rarer modality than the more every-day form of an essay in sound, a staple of radio.

With *Astro-Darien*, the chronological spiral takes in both past and future. So, to provide what Robin has described as a 'navigational aid' to *Astro-Darien*, it's helpful to point to a few nested layers. One, which motivated the original road trip, is the actual space race taking place between a number of sites in the north of Scotland (including Sutherland Spaceport and the Shetland Islands) to be the first vertical satellite launch spot in the UK.[3] The road trip involved a visit to the empty fields which are the proposed site of the Sutherland Spaceport on the A'Mhòine peninsula, near Tongue, and also a hike up Ben Hope, the most northerly Munro, which overlooks this open moorland. These empty spaces are kind of pregnant with, are haunted by, the imminent arrival of this spaceport, which, in *Astro-Darien*'s speculative extrapolation, becomes the escape route out of an eco-politically troubled UK. So, in the piece, excerpts from real news reports about these sites and the future of the Highlands space industry are included.

Another layer is the story of Guna Yala, a game designer working for Trance-star North, a fictional production company producing a geopolitical simulation game (*Astro-Darien*) about the end of the United Kingdom and Scottish independence. She is programming a predictive AI game engine called T-Divine. Some of the audio in *Astro-Darien* consists of her internal voice, her thoughts regarding the design conundrums she is puzzling through.

Then there is another historical layer, framed as the audio from fictional cutscenes generated by this game engine. This layer relates to the inception of the UK prior to the Act of Union in 1707, and specifically the Darien Scheme, a catastrophic attempt by Scotland to colonise what we now know as Panama, in order to capitalise on trade between the Atlantic and Pacific Oceans. This story

3. The license was eventually granted to the Shetland site in December 2023—ed.

also extends into the debts and liabilities accumulated through the exploits of the British Empire once Scotland had joined forces with England.

Finally, there is the future-facing aspect. At the end there is a Trancestar North advert for the game. There is more cutscene audio generated by the game engine including soundscapes from the spaceport exodus, and transmissions within the Astro-Darien orbital space habitat, located in a Lagrange Point (a gravitational well located between the Earth and the Moon).

So, as you listen to *Astro-Darien*, you are zigzagging backward and forward in time, skipping between these levels, the rings of the time spiral. In twenty-six minutes, therefore, you are covering around four hundred years. I see *Astro-Darien* as the first window into the process of a much more long-term project.

[Playback of *Astro-Darien* (25′42″)]

BB: That's a very different sonic landscape to Robin's more vocally-driven essay, and I wonder if that's a place to start, to hear your thoughts around how you constructed that sonic space in terms of the instrumentation and its relation to the voice.

SG: As a sound project, *Astro-Darien* emerged out of an invitation from François Bonnet to play on Ina GRM's acousmonium at La Maison de la Radio in Paris, a sound system with more than fifty speakers designed by François Bayle in 1974. In addition to the kind of dark ambient underscore featured in *On Vanishing Land*, I was interested in designing sounds that I could move around the space, insectile sounds and fizzling sounds that could be interestingly spatialised. So, it started with me just banging around making noises that loosely conjured up the world of *Astro-Darien* in the vaguest possible sense—more a set of embryonic ideas and feelings, not yet a narrative. As the sound world developed, the story crystallised out of that. And when I was thinking about what kind of voices would populate that sound environment…well, I was quite keen that the sound and music itself would do a lot of the storytelling on a par with the voice, that it would almost be a protagonist, or an immanent wordless narrator. Also, I didn't want to overload it too much with voice—although listening to it this time, I didn't quite realise how little voice there is in it, especially after listening to *By*

the North Sea. I think I hadn't realised until now how much of the story is still in my head, and only virtually, or partially, exists in the sound piece.

So, the project started with the sound, which then catalysed the emergence of the narrative. I didn't really want to put my own voice in it for various reasons, mostly because I've never found the voice that I would be comfortable listening to. I've done a number of audio essays with my own voice, for example *Audio Virology*,[4] but I've always had to pitch it down a little bit or manipulate it somehow in order to feel comfortable listening back to it. I'm always a bit disturbed by how your recorded voice feels more high-pitched than you expect.

That's one reason I was quite keen to play around with these synthesised Scottish text-to-speech voices, which I'd never really heard before in this kind of project. So I used some that were modelled on a range of Scottish voices and dialects. It was hilarious, there was actually one Glaswegian text-to-speech voice I found that I didn't use because it was such a bad parody of a strong Glaswegian accent, a joke Glaswegian accent.

Because I made most of *Astro-Darien* during the pandemic, the idea of a virtual cast of voice actors was appealing. During lockdown I had a lot of time to play around with the narrative, so that evolved very slowly, in a modular fashion, over a couple of years, and it was originally made in six or seven chunks. It's clearly not a linear story, it's flashing forward and backward in time and covering a long historical stretch, so it's got quite a lot of cuts that are hard to follow. I was constantly shuffling around these modules until they took on their own, achronological consistency. So that's how the sound evolved.

RM: I'd like to ask something about voices as well. Since I only took six years to make *By the North Sea*, I obviously can't wait to get started on the next one...! And one thing I've been thinking about a lot is how we're in an age where the voice is being disassembled, analysed, and reconstructed in many different ways, whether it's synthetic voices, deepfakes, autotune in pop music—there are so many things that you can do to the voice now, from manipulation to bottom-up synthesis. In *Astro-Darien* you have synthetic voices, but you're manipulating them further—there are points where they seem to melt, spread out, get deeper. Are these new technological uses of the voice also a territory that the audio

4. Commissioned as an video essay for Unsound Festival in 2020.

essay can explore in a different way to how pure text-to-speech, pop music, or automated train announcements use it?

SG: All of the voices, apart from some of the spaceport news items, are text-to-speech. They simultaneously have this relatively inhuman, deadpan, flat affect, but at the same time, because they are admittedly relatively well-spoken Scottish accents, they retain an ambiguity that places them, at least slightly, in the uncanny valley. They are not the usual Anglo-American text-to-speech dialects, and are fairly realistic models, so their humanity is at least debatable. But it's also interesting to start with synthetic voices as the original raw material, and then try to process them further as part of the sonic worldbuilding, for example in the Astro-Darien orbital space habitat. What would the psychoacoustic experience of such a speculative architecture be like?

So there are definitely a few experiments going on. For example, when you slow something down or pitch it down, its affect changes, and it takes on this more ominous sinister tone. But it also screws with your perception of time. There's a part in *Astro-Darien* where it's scrolling back several hundred years to detail these dark colonial exploits, and the piece quotes William Patterson, the guy who proposed the original Darien scheme. Literally the last thing I did before *Astro-Darien* went for mastering was to have this section where the whole thing, not just the voice, but also the underscore, pitches down. It's somewhat schlocky. It's definitely simultaneously a bit chilling and a bit cheesy, but it's an experiment I wanted to try. That happened at the last minute: I thought that somehow this section whose content is really quite dark and intense historically felt a bit flat using synthetic voices. But now, for better or worse, it gets a bit Darth Vader. I did it to create this more ominous tone, but also to play around with the fact that that part of the narrative is going backwards in time, to try to capture time travel through manipulation of pitch and frequency. I listen back to bits of it and I'm not sure they all work. You have to be careful with last-minute decisions!

RM: Timestretching was always deep temporal manipulation....

SG: That's one way of putting it!

RM: I also noticed listening this time that you have used the voices in a sample-like way, something that I don't think I do or Justin and Mark did in *On Vanishing Land*, with one exception—the phrase about dream ('the dark door'), which occurs in *On Vanishing Land* and then later returns as a kind of eerie sample. In *Astro-Darien* a phrase will appear and then you'll have that phrase repeated as a sample would be in a track. That usage very much foregrounds speech as sound—we all know how, if you repeat a piece of speech enough, its meaning begins to drain and it becomes 'just' a sound.

SG: Yeah, that happens a couple of times, first with the news report about the spaceports in the north of Scotland—they're completely real, but to me it still felt like a science fiction story to find out that there will supposedly be these rocket launch sites in the Highlands. So, I wanted to process that audio to crank up the fictional feel of these real news reports.

And then the second example almost sounds like a tannoy system within the space habitat, or it could be the thought process of the game's AI that's generating these landscapes, or it could be the thought process of the game designer—it's none or all of these things. But the delay effect, where the delays go down in volume and then surge back up so they sound like they are imploding and folding in on themselves, became the signature effect of the piece, in the sense that it's like a microcosm of the space habitat: the sound disappears around the torus as you move away from it, and then ramps up again as you approach it around the loop. A little sound torus.

RM: Those parts also reminded me of *Total Recall* or *Blade Runner*, the ads for off-world migration or holidays in other people's memories. Do you remember watching *Total Recall* in the nineties and thinking, wow, imagine if there were really screens with moving graphics on subway trains…!

SG: All of these films are lurking around in the unconscious of *Astro-Darien*, most obviously that quote from *Blade Runner*, 'Your chance to begin again, off-world'.

BB: On that note, I think of that scene in *2001: A Space Odyssey* where the astronaut makes his video call from the wheel-shaped space station back to

his family on Earth. I remember watching that in the early nineties and thinking 'Video calls? Not in our lifetime!' While the scale and grandeur of Kubrick's space station only really makes sense as a projected cinematic image, there is something about your use of gaming graphics to create a similar space habitat that has a different feel to me, like you might encounter it more at home in front of the screen with a controller in your hand. Nonetheless, cinema and gaming are both visually-driven realms, which sets *Astro-Darien* apart from Justin's and Robin's pieces which have a much stronger connection to radio as a place where you might encounter these sort of speculative narrated pieces.

SG: That's interesting, because there was some sense of responding to *On Vanishing Land* in terms of my feeling that, stylistically, *On Vanishing Land* has a very English vibe that wouldn't work for *Astro-Darien*, and I didn't want *Astro-Darien* to be a 'hauntological' piece in that way, because it's not...and also it's not coming out of 1970s English TV! Even though it's dealing with four hundred years of history, if anything *Astro-Darien* is more about a spectre of the future haunting the present, to do with the breakup of the UK and Scottish independence and so on, and about turning Brexit against itself. The science fiction and game world aspects are just devices for talking about that. So it's both about how the near, or not so near, future is haunting the present and about several hundred years of British colonial exploits haunting the present.

The visual component of *Astro-Darien* that you saw today, a slow glide around the inside of the Astro-Darien space habitat, was made in collaboration with Lawrence Lek. I came across Lawrence's work six or seven years ago, and what drew me to it was that he was using game software to create these eerie, depopulated environments and locations. For example, he would do site-specific re-creations of the architecture of art galleries, but completely evacuated. So instead of these kinds of eerie fields or coastal regions that Robin and Justin and Mark's pieces address, there's an eerie in Lawrence's work which relates to the emptiness of virtual spaces, of digital spaces. I've worked closely with Lawrence on a few projects and I am drawn to the way he uses game software cinematically: he takes away the actual gameplay—often the most grating part of games is the insistence on gameplay interaction—and you're left with just these landscapes. That contributed to thinking this whole narrative through the

lens of a game. So it's in the album artwork, some of the animations that have accompanied the *Astro-Darien* installation and *Escapology* live audiovisual sets, but it's also woven into the narrative.

Trancestar North is obviously a play on Rockstar North, the Scottish games company who developed *Grand Theft Auto*. In thinking about a videogame as a framing device, I suppose I was thinking about British history as a predictive simulation game, the gamification of politics and referenda. So, in the advert for *Astro-Darien* that you hear in the piece, the pitch is: *Don't like the result? Play it again.* And Guna Yala is a game designer of Panamanian descent who, in an odd twist of fate, acquires the power to program the parameters of the future. The end of the UK, in the game, occurs as a weird inversion of the beginning of the UK.

Also, Robin reminded me the other day of this Chris Marker film *Level Five* (1997), which is also to do with a simulation, a simulation of the battle of Okinawa, and which is also told through the framework of a game and its production. I'd seen it a long time ago and, like *Total Recall*, it must have been lurking around in the melting pot without me realising it.

BB: What is particular about the use of sound in games?

SG: Contemporary games tend to have these different modes which they alternate between—for example credits, options screens, cinematic CGI cutscenes, inventories, maps, and action scenes—and each will often have its own palette of sound effects and music. There is a lot of bleeping going on in *Astro-Darien*, especially in the sections that are supposed to be expressions of the game AI, T-Divine. Some of these bleeps are sampled from Hideo Kojima's game *Death Stranding*, from the inventory sequences—that game has great bleeps and interface sound design. Regarding cutscenes, even with today's hyperrealism there is still a slightly flat affect that often accompanies them owing to the limitations of motion capture and so on. For *Astro-Darien* as an audio piece, that was another reason I opted for these synthetic voices, to embrace and make a virtue of that flatness.

JB: I think the figure of Guna Yala is really crucial in terms of the power of the essay, because you've drawn on something which you call a 'Caledonian heart of darkness', the Darien project. Obviously, there is a main level on which it was good that it failed because it was a colonial attack, but for Scotland it was the most shockingly traumatic thing, almost everybody involved died in terrible ways, and it bankrupted the country, it's an extraordinary event. But I think what's really important is that you used an indigenous female figure to pivot away toward a different line of departure, a different escape, one which is definitively better than that, and yet you keep the tonality of the world of the Darien project by not making it some utopian escape—in fact, they're deeply threatened. What you see at the end is that they're threatened by reactionary forces that are trying to tear down the entire project. I think that's what gives it a real consistency. There's a sense of it being incredibly charged because of the music, but also the use of the cold voices, which suggest this difficult situation and prevent it from having any sentimental utopian quality. This is a momentous thing being described, but it's a very dark cosmos in which it's taking place, in that things continually go wrong, and the people of this space escape-zone are deeply under threat.

SG: I think it's all of these things simultaneously. I do think of the Darien Scheme as what I refer to in *Astro-Darien* as a Caledonian heart of darkness—it's a fever dream that ends in malarial catastrophe and leads to the union of Scotland and England, and therefore accelerates the dark side of the British Empire. But the question of *Astro-Darien* and of *Escapology* is to speculate, in somewhat oblique fashion, about the unpicking of this undead political arrangement. Most of my previous projects have been pretty dystopian, but there's a utopian element to this project. It's summed up in this speculative notion of the Glaswegian novelist Alasdair Gray: *Work as if you live in the early days of a better nation.*[5] As you rightly said, it's tempered by all of these acknowledgments of the likely threats—the threat of nationalism, purification, xenophobia, and sabotage of the space colony. All of that's lurking there, tempering the utopian science-fictional impulse. But you are right that the figure of Guna Yala is pivotal

5. This quote appeared on the frontispiece of the first edition of Gray's novel *Poor Things* (1992). Gray later attributed it to Canadian author Dennis Leigh.

here, because as a Scottish-Panamanian, and as the game designer, she has some agency in at least setting the parameters of the space habitat, its criteria of success or failure as a project for a Caledonian Cosmism. The threats are real to her, as she is being hacked while attempting to program the game.

Both this project and my last album from 2015, which was called Ø, were in some way satires of different aspects of accelerationism. In my last album, 'fully automated luxury communism' is appropriated by a luxury Chinese hotel chain, the Nøtel Corp: the Nøtel concept, which Lawrence visualised and animated, explored an automated luxury hotel gone wrong (from a human point of view) to the point where the drones, which were there to serve elite humans—well, there are no humans anymore, so the enslaved machines are trying to work out what to do with their free time because they're no longer indentured. *Astro-Darien*, on the other hand, is a simulation of an off-world utopia, a hi-tech independent Scotland as an escaped space settlement, which this time doesn't stake a claim to someone else's territory, but which comes with all the promises and dangers such a unlikely venture would entail.

RM: I think I said before that I would describe my piece as a 'perplexity'; yours does seem to have an argument. And to that extent it seems like you could have written an actual essay. So what's the difference in potential for the outcome of creating an audio essay like *Astro-Darien*, rather than writing an essay drawing people's attention to the Darien Scheme—Starting with 'In this essay I will...' and ending, in good academic language, with 'Perhaps we might draw some interesting conclusions from this for the present situation'...?

SG: Obviously it's more pleasurable not to write an academic essay!

RM: But what about the outcomes for it as a cultural form, what is the difference with putting it out as an audiovisual performance and a record rather than writing an essay and placing it in a journal?

SG: I'm just going to return to this quote I sent you this morning, which I think captures a little bit of what I was trying to do with *Astro-Darien*, but also maybe maps out the remit of the Flatlines label as well. It's a quote about essay-film, by

Jean-Luc Godard, but it's maybe much better related to how I am thinking about audio essays, or at least a sub-genre of audio essays: *Think of a sociological essay written in the form of a novel, but you only have musical notes at your disposal.*[6] I take him to be referring to a form, or an inter- or trans-form, that might contain elements of fiction, documentary, history, theory, music, poetry, samples from the archive, and so on, all gelled together through the power of sonic abstraction. There are plenty of eminently listenable sonic thinkpieces out there in the world, experimental podcasts and radio, hip-hop, documentary-fictions, recorded lectures in music and sound, underscored arguments and sonified fictions and so on. But we are all exploring different approaches to synthesising these strains onto a diagonal between immersion and attention, fiction and non-fiction, sound and music, future and past. And experimenting with listening to the result collectively in a space, with or without minimal visual accompaniment, in addition to the usual formats of streaming, downloads, radio, LPs and CDs.

Obviously, writing an essay for a journal limits the scope of the audience that such work can reach. I'm not sure what the audience for these audio essays is. In a sense, it needs to be constructed, and that's part of the experiment of finding an interzone between these different templates. I didn't want *Astro-Darien* to come across as a didactic essay, as, for me, that is usually pretty offputting. That's one reason for treating much of the voice, even when it is primary generated material, as samples. That's also why any historical data is framed as a cutscene from the game, and why the sound often takes over from the voice as narrator. I'm also aware of the context in which I'm releasing this kind of work which, falling between electronic music and art piece, may not have any audience at all. I was conscious of trying to walk a tightrope, potentially to nowhere, but hopefully it intrigues rather than spells everything out. Anyway, there is no conclusive argument as such. The aim was to create a little hyperstitional myth that lives on virtually, regardless of the ins and outs of political reality.

JB: You can imagine *Astro-Darien* with a completely different kind of extremely slow ambient music, you can imagine just how different it would be. The music is I think deeply expressive, it expresses a kind of dynamism and a danger, a

6. J-L. Godard, *Godard on Godard*, tr., ed. T. Milne (New York: Da Capo, 1972), 242.

kind of cosmicist feeling of everything that led to that Caledonian heart of darkness, and it suggests that all of the departures from ordinary reality, with its reactionary and colonialist aspects, take place as precarious contingencies, surrounded by danger. The music conveys that, it conveys the kind of charge of the dynamism and the adventure of escape. I feel like it does fundamental work and carries a whole extra dimension in comparison to a text. And immediately you changed it to a different type of music, the tone would be different; the charged pace of the music is fundamental to it.

SG: This is another area in which I had learnt from *On Vanishing Land* but didn't necessarily want to reproduce its approach: *On Vanishing Land* situates its voices in a bed of dark ambient music. What could we learn about this embryonic mode of the audio essay by expanding the palette? Among other influences, it was an experiment in response to the successes of *On Vanishing Land*. There are some eerie stretches, especially in the Darien sections, but elsewhere I wondered, what if the sound and the music were somehow more protagonistic, and not just an underscore, not just setting the mood? In the opening, jagged and somewhat jarring part of *Astro-Darien*, for example, the sound is a bit more active in conveying the meltdown of the UK.

*

JB: *On Vanishing Land* came about as a result of Mark Fisher and myself going to Felixstowe in April 2006. We took the train up from London. The year before, we'd finished another audio essay called *londonunderlondon*,[7] which works in a very different way from *On Vanishing Land*. One of the powerful phrases from *londonunderlondon*, Mark's phrase, is in a section where he reads a kind of anomalous micro-essay in the middle of the piece. He says: 'You come to be in a mortifying structure which precedes you, and you only have a lifetime to escape.'

7. Mark Fisher and Justin Barton, *londonunderlondon*, audio essay broadcast by Resonance FM, 2005. The section of *londonunderlondon* in which this statement appears—a section written by Fisher, to which he gave the title 'Necropolis Now'—is included in its entirety in Barton's edited version from 2022, *transmission: londonunderlondon*, a piece which was made available for the first time at the Karst *Sonic Faction* exhibition and, in parallel to the publication of this volume, is scheduled to broadcast and archived by NTS Radio. The text and overview of the piece can be found at <https://www.urbanomic.com/document/londonunderlondon/>.

This obviously connects up with the 'escapology not escapism' line from Steve's piece. I want to just make it connect a little bit with what I said earlier about the idea of another modality, some other modality of expressing perspectives, outsights, about the nature of the world, of which the audio essay is just one manifestation, just one form, whatever audio essays are.

On Vanishing Land is in part an expression of an awareness of the grim circumstances of the social field of the entire planet. Technically speaking, at present, the current macrological form of the ongoing disaster is capitalism and the nation states. But the awareness involved here relates to a very subtle, subtending aspect of this ongoing disaster, the 'mortifying structure' into which you're born. Something that is very wrong at the level of how social formations work, but that also and perhaps primarily is an aspect of the micrological level of individuals. But the other side, the other thing that's there to be expressed, is the line of escape, the line of departure, which takes infinite forms including all of the liberatory micro-departures, all of the alliances that deterritorialise across a threshold—and all of the creativities and kindnesses that you encounter, they are also the escape. But the full line of the departure, the line of escape, is the intent-world or intent modality of becoming-active and waking the faculties. It is the alliances and the joy of travelling-forward—of what can be called meta-morphics. That is what is really fundamental in terms of what I'm saying about another way of expressing outsights about the nature of the world.

When we went to Felixstowe we had another project in mind. We did the walk, on a really brilliant hot day, Felixstowe container port, past Bawdsey Radar Station to Sutton Hoo, and afterwards, having focused on M.R. James and Brian Eno being connected to the area (it was Eno's album *On Land* [1982] that was important for us) we knew that the walk itself was the basis for an audio essay.

It was very much a group project, in the sense that very early on we worked on getting the music that we were looking for by telling our friends and contacts who were musicians about the kind of atmosphere that we wanted the music to express or invoke. These included two friends of mine and a whole series of friends and contacts of Mark's. And then a musician called Elizabeth Walling, whose stage name is Gazelle Twin, came into the project through John Foxx knowing her, and that was incredibly valuable—her music is really crucial for *On Vanishing Land*.

As I started to work on the script I knew that a key starting point was fending off incursions from the outside: fending off invasion, fending off the erosion of the land. But I knew I wanted to go from this to depth-level incursions, to other kinds of issues, concerning encounters with the unknown.

And as it went on it became about being as close as possible to the terrain of the walk, and yet at the same time it was about opening up the wider space of the planet.

There are three interviews in this piece, they're real interviews. *Londonunderlondon* involved fictional interviews, a whole series of fictional interviews about something that had taken place at a warehouse rave in London. In the case of *On Vanishing Land* they're real interviews, so there is a sense in which we worked closer to the terrain, but I was aware that what I really wanted to do was to work with the space, follow the lines, the contours of the space, but then find a way of moving out toward crucial zones of the exteriority that, of course, was already included (the place is to a great extent about exteriority, from the fortifications to the container port).

It's as if the problem with the place was to stay very close to it but ultimately to slip away to the wider space, to the wider, deeper view of the world at the level of intensity, of intent, but also not just to go wider to capitalism because of the container port, which is about the corporate world, but to go wider in terms of departures, and to see these at the level of the planet. I wanted a positive counterpart that was not just based in Suffolk, that would be the line of Escape, and this was *Picnic at Hanging Rock*. At a certain point, it was going to be a question of slipping away from the immediate and the local into a very wide oneiric and abstract view.

In the end I feel like the crucial point was that I wasn't aware of just how much support the music was going to give. There is the section of *On Vanishing Land* where there is the figure on the hill, who sees 'a white void of air beneath their feet'—who sees 'behind the surface of the day.' I knew in writing this section that it was a point of maximum intensity, with only the end, with the three women 'crossing a threshold of existence in midday heat' alongside it. At the point where Mark found the piece to go with this section, I was very struck by the sheer degree of assistance that there would be from the music. So it was like the music being made by other people fell into place and then there

was an incredible jolt—you saw what it could do. The same was also true with Gazelle Twin's music. What is key here are different aspects of the impersonal. Music is far more problematic as a form than is generally realised. Its power is inchoate, so that with music on its own it's very hard to build an escape-spiral of outsights, of lucidity—and it recurrently has nothing at all to prevent it from being grasped in terms of human subjectified emotions, or in terms of the-ex-pression-of-the-composer's-spirit, in fact it often conducts in these directions. But when it is alongside outsights, and is impersonal in its tonalities, whether with a serene or with a charged, edgy quality, then it becomes something through which formations of intent and anomalous forces can be heard.

And I think now we're going to hear *On Vanishing Land* in conditions which are as close as they've ever been really to what we had in mind, which was to listen in darkness.

[Playback of *On Vanishing Land* (44'53")]

BB: Thank you, what a remarkable piece. I realise that over the course of the day each of you have talked about a relationship with Mark Fisher, and this is the piece where he is present not in an oblique or ambient way, or in the sense of loss, as in your piece, Robin, but actually in a third-person account.

I don't want to be trite and say he is present here in a hauntological sense, but I wonder if we haven't named him as a sort of absent presence within the day, and if you can just talk a little bit about his role in this entire enterprise of the audio essay.

JB: Absolutely, that gives me the chance to say some things I really wanted to say.

The whole thing started from Mark and I having conversations around about the year 2000, and this became *londonunderlondon* in the course of the next five years. Mark was amazing to work with, in terms of collaboration. And in terms of sequencing and fusing of tracks and elements he was exceptionally good.

You mentioned the fact that it's a third-person account, and one thing to say is that in musical terms this is the 'key' in which the narrative is composed. And this was Mark's idea. He suggested it, and instantly I knew that it was

right, because of the impersonal tonality, and I switched immediately to doing the writing that way.

Another thing that should be said is that it was Mark who came up with the idea of reading a fusion of a section from 'Whistle and I'll Come to You my Lad' and a section from *Picnic at Hanging Rock*: what you hear is half M.R. James and half Joan Lindsay, seamlessly spliced together.

To talk about the details of the collaboration, there was the point where I came up with the idea that *Picnic at Hanging Rock* should be in the piece—it's obviously a leap, because it's so much a piece about Suffolk, and there was a moment where Mark was probing this idea and then a moment after that he took flight with it, in the sense of talking about it enthusiastically in that conversation, but subsequently he came up with what I think is a really important thing, the actual reading from it, but fused with M.R. James.

So that was the nature of the collaboration. But I also would say that in both *londonunderlondon* and *On Vanishing Land* he does this incredible work in terms of music composition. With *londonunderlondon* I've looked at this very closely recently—at the point where he creates a piece which is mostly Delia Derbyshire, but not entirely. In fact he has added things which make it a new piece. It's a very powerful track that is set to his reading from J.G. Ballard's *The Drowned World*—a sonic correlate of the pounding Jurassic sun.... With *On Vanishing Land* Mark worked together with Andy Sharp (English Heretic) in terms of recording concrete sound and then morphing it—though there's only a little of that in the piece. But also they worked together on the whistle track in *On Vanishing Land*, although I think this is mostly Mark. The whistle track, with its weird, trembling, four-note melody, is the music for the fused readings from 'Oh, Whistle and I'll Come to You My Lad' and *Picnic at Hanging Rock*; that is Mark's work, and it's a striking, haunted track, and is very effective together with the words.

This is going to seem like a strange reference and I don't want to give the wrong impression with this, but when Mark got all his tracks together, the brilliant way in which he sequenced them called to mind at the time this strange moment in William Gibson's *Count Zero* that features a derelict bit of a destroyed space station where there's an artificial intelligence which is no ordinary artificial intelligence, it's an artist—an AI fragment of something which

was while it existed, according to William Gibson's world, at a higher level than individual human beings. Surrounded by wreckage, it creates these very beautiful box montages in a hidden, zero-gravity corner of a destroyed space station. Mark, when he was sequencing, he just gave me the impression that he took a piece of sound and was just enchanted by its possibilities and was always slotting them in one after another.

I wrote the script, with suggestions from Mark, and Mark was substantially more involved with the tracks. We always worked on the tracks together in terms of the major decisions of sequencing and overlay, but the sheer skill with which Mark brought everything together was just very impressive, he was an exceptionally good sequencer and combiner of tracks, he loved it and he was very good at it.

RM: It's funny that you mentioned Gibson, because I was thinking about him at that very moment, and about the definition of cyberpunk: the idea that the street finds its own uses for technology. Cyberpunk is not about being at the 'cutting edge' of technology, which invariably is the preserve of some corporate megamachine, it's about finding technojunk and slotting it together in an impro-vised way, and that's the kind of lineage that we're coming from in making these pieces, assembling not just the content but even the form as we go along, out of whatever comes to hand.

What you're saying about the AI also reminded me of a film with perhaps less of a classic cyberpunk pedigree, *Bumblebee* (2018). The autobot Bumblebee, in the shape of a VW Beetle, makes friends with a human girl, but he can't communicate with her at first, and the way he learns to talk is by tuning his car radio up and down, finding little bits of sound, and gradually splicing them together to make words. Which not only brings us back to synthetic voices, but could serve as an interesting metaphor for what the audio essay tries to do with all these fragments of work from elsewhere, trying to piece together a voice for something alien by tuning in and out of them.

Let me give some historical context to your question about Mark here, Ben—because as I mentioned at the beginning, there's a kind of heritage here that goes back to the nineties. When I first met Mark he was part of an outfit called SWITCH, which was basically a theory boy-band, there were four or five

of them and they used to dress kind of New Romantic and would go to cultural studies conferences and have a projection of cut-up loops from *Terminator* and *Sans Soleil*, *Total Recall*, *Videodrome* and *The Fly* projected behind them, and they'd read a bit of text each. Crazy cut-up videos made on the living-room floor by copying between two VHS recorders, or parts of them made by pointing a video camera into the TV screen to make visual feedback—cyberpunk method. A mind-blowing thing to see when you've been at a university and been bored to death in lectures. By around 1995 I'd started to imitate them and gave a paper where I had assembled a jungle mix and then had a projection of me playing *Doom*, and I'd sequenced the text to synchronise with the segues between the tracks. By 1996 Ccru had taken over the *Virtual Futures* conference at Warwick University, which used to be a more or less conventional academic conference with people giving papers. In 1996, to some of the audience's displeasure, four-fifths of it was people reciting libidinal-materialist theory over jungle or hip-hop backing tracks with cut-up projections! So that's definitely a large part of where this whole audio essay thing comes from: the hybridisation of high theory and popular culture, assembled in the living room using the technological appliances available to the consumer.

I feel like this also has a bearing on the question of modernism that's quite prominent in *On Vanishing Land*—that modernism doesn't have to be to do with austere abstract structures and 'critical' interpretation, it can also voice itself through the assembly of these pulp cultural materials. Maybe that's something like what you call 'unfettered modernism', Justin, and it could be that the audio essay is a form that is particularly attuned to it.

JB: There is no doubt that the audio essay has certain advantages, when narrative, philosophical perceptions, and fictions are brought together with an expressive, impersonal functioning of music—and there is no doubt that the line of flight here is unfettered modernism. But at depth unfettered modernism is an expression of outsights, and a laying out of diagrams for forms of escape, where all available means are used and where tales, dialogues, narratives, and philosophical accounts can all be used, and can be used together. There is a focused, stripped-down power about voice using different forms of these kinds, together with music, but this shouldn't distract from the crucial power of

outsights expressed through philosophy and outsights expressed through tales or narratives of the anomalous, and in particular the power of these when a way is found of bringing them together. Unfettered modernism in a sense that relates to art is to a great extent about tales of the anomalous, which in fact is inseparable from saying that it is thought reaching lucidity. Modernism barely happened in philosophy, but this isn't to say that philosophy failed to be creative—it is to say that philosophy has been involved far less in the struggle to reach lucidity. And the simplicity that is often found in tales and dialogues—sometimes a work is both, as with Poe's 'Mesmeric Revelation'—is something that recurs in different forms here. When there is a zone of outsights to be expressed—when there is a world of the oneiric-real to be expressed—although each of these is vast, very little is needed. Unfettered modernism is inseparable from pulp or punk modernism: not much is needed, and although a film could be made, if you had the resources and people of a film production unit they might even get in the way.

SG: I was also just remembering 1996, when we made the video for the essay 'Flee Control', which is in the first volume of the first swarm of *Abstract Culture*, a zine that was produced by Robin, populated by the writings of Ccru. I remember sitting in a living room with video recorders going from tape to tape, with Mark splicing out excerpts from *Sans Soleil*, excerpts from *Women of the Dunes*, all of these films, and producing these backdrops for us to talk over at conferences.

But I've been wondering how much of an influence the internet is on this methodology, because after hearing *On Vanishing Land*, I went to do part of the walk, and something about the audio essay that you'd made had activated the space: it kind of switched it on and brought to life all of these latent stories and mythologies and local history surrounding that area. Listening to it again here it was almost like, as you take a walk you're clicking on things, bits of history and bits of tangential connection are popping up. So there's a question about the hypertextual role of the internet in this kind of methodology—although obviously montage and collage and soundwalks existed before the internet.

I have a related question to do with why you chose that walk: How did you end up doing that walk? Were you aware of all the stories in that area, or was the walk such a powerful experience that you started 'clicking' on all the places

you'd been and finding out all of this stuff? What was the magnet that drew you to that particular walk and that geography?

JB: It did to a certain extent come in sideways. We went to Felixstowe because we had an idea for an audio essay that would have continued a sort of technique that we used in *londonunderlondon*, but which was going to be very hard to realise because it would have involved a lot of acting performances. It was a story, a fiction, which later became a novel I wrote between 2008 and 2013, called *The Corridor*. The story in that precursor form, the story for the planned audio essay, was told via fictional interviews, and it was going to be quite a major production process to do it, and we did a little bit of recording for it but we didn't have directing experience and we just weren't sure at that time whether we were in a position to do something quite as large-scale as that would have been.

It was all quite strange because the story involved the development of a technology called sound shadows—this was within the fictional world—which had taken place during the Second World War, and in advance—before the walk—I was thinking yeah, okay, I'm going to incorporate the Suffolk coast into the story and there will be a research base there. Then I found Bawdsey Manor and Bawdsey radar station in reality—it gave me a real shiver. I then wrote this piece which, in terms of the research base, included elements from Watson Watt's first implementation of a full radar protection system (which was done from Bawdsey), along with the fictional elements about sound shadows.

But the thing is, that was the starting point—and then we realised that the area was just too good, that we had something, and we basically started from there. We knew that the walk was the core of an audio essay, and there was a kind of weird connection with *londonunderlondon* because that had been about London's strange dreams about invasions or incursions, from things like *The War of the Worlds* to the invasion of water and vegetation in *The Drowned World*. With the Suffolk coast the connection was the incursions of the sea and the potential incursions of invading forces—so there was a line of connection, but it was clear that there was a new piece, and so we went from there. And after this there was a kind of bifurcation, which was also a doubling. I went on to write a novel about the parallel world, which its inhabitants call the Corridor (they call the ordinary world the Disaster), which to a great extent is set in a

forest-surrounded house in Suffolk, and during the first phase of writing the novel I was writing the script for *On Vanishing Land*, which also involves disappearances, via *Picnic at Hanging Rock*, and in which a forested, overgrown Felixstowe container port appears. The doubling relates to these common elements, while the bifurcation involves their being very different projects. And I feel the doubling is also involved in the movement inland in *On Vanishing Land* that follows the walk we did—where I wanted the key moment to be away from the superficial fluidity of the sea, the moment where the planet is seen as a white void of air: this line also then goes on in the same direction to a house in Corridor forests, a few miles from a fictional, derelict Suffolk town called Melford, which in turn is twenty miles northwest of Ipswich. But in terms of the doubling, what stands out most is the idea of a disappearance across a threshold.

I haven't talked about Mark as a philosopher. Our philosophical conversations over the years were hugely valuable and interesting, and it was great in *londonunderlondon* seeing how he created this really powerful subtle sci-fi Gothic essay in the middle of the piece, in which he uses the phrase I quoted earlier—'you only have a lifetime to escape'. It's a brilliant piece of writing about the ordinary-reality forces that cause people to die before they die—that conduct people toward recurrently being a kind of grey twin of who they really are. And then the last thing I would say is that, listening to the two pieces now, I find something quite strange and powerful, because when Mark chooses readings he chooses specific things from *The Drowned World*: a piece where Kerans, the central character, has a dream where he swims out into a lagoon surrounded by dinosaurs, with the pounding Jurassic sun above it, and has an experience of spreading out into the water. That was Mark invoking a kind of immanence and the way in which we're all connected to the outside. And I find it really eerie now listening to what he chose to read for *On Vanishing Land* because once again there's a figure in the water at the end—but they're drowning, they're not spreading out. It's not immanence, they're drowning. And when I listen now to his description of the scholar fleeing from the demon, in his reading of part of the M.R. James story, and to him describing getting over a groyne, and then there is the phrase *Will he get over the next one?*, and somehow he does, but then collapses—what I hear is the sequence of his collapses into depression. He was in depression when we started talking about what became *londonunderlondon*, and around

that time I saw him take flight again. And around the time we were making *On Vanishing Land* I always knew that there was a real danger that there would be another depression, another groyne, he would come to it, and it was disturbing and I thought it could happen—but, you know, I always thought that, as was the case previously, he was likely to end up in hospital if it happened and it would be bad, but he'd be okay if that's what did happen...so I do find it chilling to hear his incredibly powerful rendering of that struggle, one groyne after the next: *Will he get over the next one?* There's a charged poetry, a charged visionary quality about *On Vanishing Land* which runs in some very strange channels.

RM: One thing that I've heard very distinctly this time in *On Vanishing Land* and which resonates strongly with all of Mark's writing is that you have this prosaic level where there are two friends going on a walk: everyday reality exists. But then there's an undertow of energies and forces, possibly malign, possibly benign. And at times in *On Vanishing Land* you hear those two levels are present, very distant but reaching toward one another. That was something that is characteristic of what Mark did so well in his own writing, too: giving you a depiction of very banal everyday reality, the dismal boring dystopia we live in, which would then suddenly be revealed to be a cosmic scene involving the clashing of gargantuan warring forces, like something out of a Marvel comic.

But then that begs the question: What are you doing, what was he doing, what does one do when one tries to produce that shift in hearing? Which is also what I was trying to do with Dunwich. Are you just desperately trying to enchant something that's really a banal reality, or do those forces 'really exist'? There's a passage in *By the North Sea* where Templeton's assistant is essentially saying, I'm not sure I want to go on this trip to Dunwich with this weird professor, I don't know what he's up to; I'm going to pretend that I'm just helping him do some innocent research...and then he wonders, why did I need to make up an alibi, what's going on, is there actually anything going on or am I just building this up in my mind...is this just a series of coincidences or is there really something to it...? What's being described there is really the creative process itself, the process of hyperstition, the process whereby which you produce the kind of consistency needed for this work—and the doubts that arise when assembling something without any assurance that it will 'gel'.

The word *consistency* has already come up: How do you bring heterogeneous elements together and slowly build up the conviction that they belong together and that the connections between them really hold, that the story you're telling isn't just *you* making something up—in other words, that there is really something there 'in the third person'?

I say that also because the problem I have with fiction is that I can never write it because I feel like I'm 'just making stuff up', and that feels stupid! So collaging fragments of other people's work into it and making it consistent is a work I'm happier with, as an editor-assembler.

SG: There's the psychogeographical aspect of it too: that all of these pieces are rooted in a particular space which in a way don't need to be enchanted because they're already pregnant with all of this mythology, history, folklore, things that have disappeared or things that are about to be built.

So it's already there. The question is what happens from that point on, what's the relation between the psychogeography of these spaces and the audio essay? What does the audio add to the virtual reality of these spaces which is its psychogeography, how does it get transported into the essay format which, obviously, one way or another, is what we've all done. Which would be different from just making shit up!

RM: True, but there is still a certain element of 'making shit up', and for me anyway an element of self-doubt: What have I actually done here? I've just put all this stuff together and perhaps it doesn't really hold...there is a precarity to the enterprise, in part precisely because you are not constructing a step-by-step linear argument but condensing a constellation of 'outsights' into a series of phrases and auditory spaces.

JB: What I feel is that to produce fiction as a philosopher is a very strange thing, because you usually work in a way where there is an expectation that what you're saying is aimed at being strongly and straightforwardly valid. One possibility for working with this situation is that you make it something that somebody has experienced, rather than being stated outright, as with the section in *On Vanishing Land* where there is a figure on a hill who sees 'behind

the surface of the day'. When I wrote that section I was aware of the fact that suddenly you're getting this view of the planet teeming with inorganic awareness, inorganic entities, but the fundamental thing—more than the distancing from the statement—is that there is a known correlate, so that part at least of what is being pointed toward exists. The world of human beings is in fact teeming with the most extraordinary oneiric-real forces, it's a global world, it's very strange, so no matter what, there is a body without organs of the human world which is full of the most bizarre extraordinary myths, forces, dreams, weird unnoticed and perturbing modalities, subtle, disturbing forms of control, all sorts of things—it's a teeming world of intent which is very, very freaky and also sublime, also full of the most incredibly beautiful things. It should be pointed out as well that the planetary sphere of intent, awareness, and feeling also and inseparably consists of animals. The distancing from the statement points out that the full extent of the planetary body without organs is unknown, but the oneirosphere is known, and is profoundly anomalous and extremely important in its effects. It is myth-systems, worlds of outsights, and it is dreams about the future, which at their most intense are inseparable from planning and from the transformation of the virtual into the actual—there is nothing more powerful than dreams.

So you write in such a way that there is a straightforward zone of reference—in this case, no matter what, there is the oneirosphere of the human world of dreams and intent, and that world of the oneiric-real has an unbelievably strong connection to the planet, the planet as its source, its dream-source, its inspiration-source, its initiator of affects and becomings. There is an area of validity, and yes, it seems very likely that all along there is planetary immanence. There is the oneirosphere in its connection to the planet, and beyond that there is something else you are suggesting.

RM: Although we are not striving for that kind of philosophical validity, I feel that when we talk about these as 'essays', part of the work that term is doing is to insist that there's some kind of stringency of thought at work here, it's not a fiction, a fantasia, or an impressionistic poem, it's an essay. It's not just about making things up and free-associating. A quality that I think is common to all these works is that there's a theoretical quality control operating at the same

time as there's a purposeful drifting out of the space of academic thought and 'reasoned argument'.

SG: The essay is a kind of presentation of an argument and so on, but also in French *essai* means to try something, and almost implicitly to fail at doing that thing. So there's an inbuilt openness to the essay form which to a certain extent accounts for those doubts, but there is also the way in which, as a form, it requires the listener to complete the system, or it asks for some work from the listener: it's not easy to listen to these audio essays, it demands attention and immersion simultaneously.

RM: On the other hand, 'essay' is also a tacit refusal of the classic idea that sound is a medium of oceanic drifting, something you go to in order to escape from the cognitive. The very cliched idea that anything to do with sound involves floating around in a sonic soup, being free to drift, a relaxation of focus, and so on. These pieces in a sense recuse that opposition: you can become absorbed in them but only if at the same time you work at them, accept their challenge to be continually thinking and in a sense 'reading'. Although the audio essay is in some ways close to ambient music, it departs from that idea about immersion and sound being a kind of beatific oceanic non-thinking experience.

SG: In all three of the pieces, a big alarm goes off every time I can't quite hear what's being said, you know, you're constantly made aware of the attempt to pay attention and the failure of attention to quite grasp what you've heard due to some issue of mixing, or the acoustics of the room, whether it be deliberate or not. Those red flags going *Oh, I couldn't quite hear that*, they remind you that you're not just supposed to be drifting off, even though that's what often happens when I do listen to these pieces—you drift off on tangents at certain points.

RM: That brings us to the multiple levels upon which listening works. Sound and our relation to sound is not a single thing, because the auditory system that we have and the parts of the brain connected with it emerged in different evolutionary periods. When you've got the sub-bass rumbling, that's really like reptile

hearing, from when creatures first came out of the sea and their heads used to rest on the ground and they could sense very crude vibrations conducted up through their skull and bones, and have some sense what was happening around them. That is perhaps more keyed into fight and flight triggers. Then you have the part of listening that's more acute, operates with two ears and therefore offers spatial resolution; that's to do with spatial attention and a more high-resolution predator-prey relationship. And then there are the more refined types of listening in which spatial addressing is not so important, but which are highly attuned to language. That type of hearing is 'transparent' in the sense that you don't usually consciously *hear* a voice as sound. Language is to do with orders and with social order, it is a kind of hearing that grabs you as a subject and forces you into subjection, makes you react in a certain way, you're a prisoner of the sounds of language and yet it constitutes you as a subject—which is why it's torturous when you can't quite hear what's being said.

So our auditory system is a temporal Frankenstein, there are all these different parts of hearing grafted onto one another, and as a result listening is never just one thing. For me that's the power of sound, it's addressing you on all those levels at once.[8]

SG: I always find the film theorist Michel Chion's way of schematising the different modes of listening quite useful: reduced listening, which comes from music concrète and Pierre Schaeffer, when you're listening to the sound in itself, causal listening, where you're scanning the environment for signs of danger and then attributing a cause to these acousmatic or unidentified sounds in the environment to make an assessment of whether you're under threat or not.[9] And then semantic listening, which is linguistic, listening for meaning. Obviously we're constantly switching between these different modes of listening and they're feeding into each other. And then there's this other mode you talked about, the oceanic immersion into the ambience of the atmosphere of sound. So I think we're constantly flicking between at least four modes.

8. See R. Mackay, 'Synthetic Listener', readthis.wtf, <https://readthis.wtf/writing/synthetic-listener/>.

9. M. Chion, 'The Three Listening Modes', in *Audio-Vision: Sound on Screen*, tr. C. Gorbman (New York: Columbia University Press, 1994), 25-34.

AUDIENCE MEMBER: In *On Vanishing Land* you say something about 'travelling in intensity', and I was wondering if you could elaborate on that, maybe it's something similar to this psychogeography thing.

JB: The line is, 'Why is it that the ability to travel in intensity is so rarely accessed by human beings?'. Again, it's this idea of the escape from ordinary suppressed reality, with its attenuated suppressive system of the human faculties.

But the idea of traveling in intensity is the idea of acquiring a capacity for really exploring, and exploring in a way where it's a kind of metamorphosis: the really fundamental thing is that in the process of travelling in intensity you cross thresholds. So you're not the same anymore, something new has gone into effect or has woken. It's this thought of threshold-crossings that is the key aspect, rather than the idea of the impact of an environment that is central to psychogeography.

For instance in philosophy there is an urgent need for new philosopher's tales. Plato's fictions are damaging oneiric constructs and fabrications—they trap attention so that it works along the lines of a blocked, moralising form of reason, and so that it does not reach a sustained focus on the intent, dreams, and affects that are central for lucidity. And the analogy of the cave is monstrous, because the cave we are trying to escape from is precisely Plato together with other suppressive philosophers such as Kant and Hegel. To write liberatory philosopher's tales is to travel in intensity, as is the process of breaking open outsights through customary philosophical, conceptual means, and to do these things is to take reason to the fusion with lucidity that ordinary reality systematically blocks. However, this on one level is a minor, misleading example, because ultimately it's not about works that are produced, it's about the heightened effectuation of people's lives.

And again, that's because of the encounters you've had. You meet people who produce things which initially may not work at all for you but then it hits, and often it's really just about that openness, so that the encounter finally works, you open up to the new things that are arriving and you think, *Oh yeah, this is extraordinary* and you take flight with it. And as well as openness it's about the courage to take leaps. An aspect of this is carrying on doing things even though you don't really know what exactly is going to come of it, but you just keep

doing it and explore the space: you put up a sail and you have no idea what's going on and then eventually it's like, *Oh, yeah, something has now emerged, the wind has caught the sail.*

RM: The audio essay is a journey in intensity, but so often we seek movements in intensity by making tracks in extensive space. If we need to think, or change, if we want to transform, if we're looking for something but we don't know quite what it is, often we'll go for a walk, we'll travel somewhere. Or we may need to return to an 'old haunt' to continue to think or rethink something. So it's not intrinsic, but sometimes moving through extensive space is what you need to do in order to let something shift.

JB: It's a really interesting question, and something I've wondered about a lot, and I'm really only now beginning to arrive at an answer. To what extent is it contingent that the two audio essays I've done have started out from a place: London in one case, an area of Suffolk coastline in the other? And when I think about other projects, it's the same thing. I'm always starting from the thought of the space, a place, a terrain, an area—it's a strong tendency, and I think this is a way of blocking any tendency to start from some interiority of the meanings of concepts, or of the structure of mental temporality, or whatever. I think that in the end a part of the answer has to be what Robin has said, in that fundamentally, again and again, the place you get to is about the journeys in intensity, which on one level is all about the intensity and consistency of the arrival of the place through your perception and through abstract perception. A singular terrain of energy formation and intent formations, with the affects it produces, has the necessary dimensions as a starting point. And it's important to remember that journeys in intensity are not only connected to encounters: the oneiric-real worlds of emergent dreams about the future, and dreamings of all kinds, again have a spatiality. A solution to the riddle of a place is that it is a part of the planet, and an audio essay could appear to move across an apparently loose aggregate of places and all along be about the planet, and the planet in its exteriority in relation to the sun, the stars.... But even when you take the case of a piece about journeys in intensity in its specificity in relation to threshold-crossings, these journeys are not separable from those individuals involved being body-shaped eyes surrounded by the spheroambiently encountered world. Inseparable from

the journeys in intensity is the sphere of encounters, and this sphere is a place composed of places. If you leave time for space, time comes back as the metamorphosis that is journeys in intensity. And if you leave concepts for spaces of energy formations, intent formations, and zones as initiators of affects, then new concepts, concepts of metamorphics, will go into effect.

RM: I think we all know that the worst forms of thought, the worst forms of philosophy in particular, are those that pretend that they start from nowhere, or from a neutral space. Because that's always bullshit: there's always been something that's happened, somewhere you've been, something that's disturbed you, that makes you think. Nothing comes from just wanting to think about stuff for the sake of it.

SG: I think there is a parallel here to why, where it's possible to separate them, some strains of science fiction are usually more compelling than fantasy. As opposed to the supposed fabrication of a fantastic universe out of nothing, there is a positive charge generated by even the most tenuous connection to an actual location, the derealisation of a place and what is, what used to be, or what could be there.

Justin Barton

Planetary Suffolk: *On Vanishing Land*, *The Corridor*, the Escape-Path

The faculties which initially need to be woken are perception and dreaming.

When Mark Fisher and I went to Felixstowe in the spring of 2006 we were working on an audio piece that was based on a story I was developing about an emergent parallel world. The parallel world is forested and derelict: the impression it gives, for those who find their way into it, is that it is the ordinary world many hundreds of years in the future, though with just a few small areas that are unchanged—but in fact it is another dimension of the present, one which has only recently come into existence. One way of getting across to this parallel world is through listening to a type of layered and processed sound recording which has been given the name 'sound shadows'.

Although there is a serene, impersonal beauty about the forested/derelict world, it is an eerie and sometimes very dangerous place, full of anomalous, enigmatic aspects. Its inhabitants refer to it as 'the Corridor'. They call the ordinary world 'the Disaster'.

As a result of this mythos (or lens mythos), Mark and I had become interested in Second World War ruins, which we felt had a very different affect from gothic ruins—removed from a function within a war, eroded and overgrown, they seemed to us to have a sunlit, planetary affect of serenity. Mark knew about the Second World War structures around Felixstowe because of his holidays in the area as a child. I did an internet search looking for ways of connecting sound shadows to the area, thinking that in the world of the story there would be a research base on the Suffolk coast, and it was a striking moment when the search immediately led me to the Bawdsey Manor radar programme. I did the

writing, in draft form, for an audio fiction, and we went to Felixstowe, drawn by the ruins from the Second World War, and by the radar base.

We did the walk described in *On Vanishing Land*, and over the next few months set out to get recorded performances for a work which consisted of several voices giving accounts of what they knew about the emergent world. But we felt the results were the start of a process which was beyond our resources at that time: so we put aside the initial project, and we decided to take the walk we had done for the initial project as the basis for an audio essay, and began work on what became *On Vanishing Land*. But at the same time as I was writing the essay for this work (with occasional ideas and suggestions from Mark), I was in the middle of a five-year process of writing a novel about the emergent parallel world, a novel called *The Corridor*, which is primarily set in the Suffolk of the other world—in an area of Corridor forest, about twenty miles northwest of an overgrown, derelict Ipswich.[1]

Whereas *On Vanishing Land* is in a border zone between narrative and the modalities normally employed by philosophy and sociocultural theory, *The Corridor* is a long way across the border: it is a tale of the anomalous which takes place within the world of the lens mythos (a lens mythos being one which aims to allow people to see the world more clearly). However, the two works are very closely connected, in the sense that they share crucial genetic aspects:

Overgrown, derelict terrains.

A disappearance over a threshold of a group of individuals.

In *On Vanishing Land* the overgrown and derelict terrain is primarily the envisaged Felixstowe container terminal, but is also the Second World War ruins; in *The Corridor* it is almost the entirety of the planet in the parallel world. The disappearance in *On Vanishing Land* is the vanishing of the women in Joan Lindsay's *Picnic at Hanging Rock*; in *The Corridor* it is the departure of a group of six individuals— three women and three men—into the enigmatic second form of the planet.

It would be correct to say that the largely derelict, forested world (together with the process of escaping into it) is glimpsed in the audio essay, and is explored

1. This novel forms part of a three-book philosophy project called *Explorations*: see <http://scanshifts.blogspot.com/>; *The Corridor* comprises sections, 16, 26, 27, 28 and 43 of *Explorations*.

in detail in the novel. But what is being *figured* by this world? An initial response is that it is a world without the direct influence of countries, or nation states. A better, but still incomplete answer is that what is here being indicated is what can be called the second sphere of action, a sphere in which the planet is in the foreground (and in particular its wilderness, semi-wilderness and scurfland areas), where a recurrent state is an inner silence in the form of perception of the surrounding world, and where the nation states are far in the background.

The first of two key issues at this point is that both in writing *The Corridor* and in writing the narrative essay for *On Vanishing Land* I found ways of setting out the idea that human beings exist within a planetary sphere which is not at a lower level of substance in relation to the human world (this idea is an exploration, a movement toward a view of the planet as unknown in a full sense, not a trivial one, and, tangentially, the line of thought leads to a rethinking of human faculties). In both cases this is done through a defamiliarising, substantialised use of the term *dream* (in the second case the use is drawing both upon Edgar Allan Poe, and on Peter Weir's film of *Picnic at Hanging Rock*). In *The Corridor* the inhabitants of the emergent parallel world have come to the conclusion that a way of describing this world is that it is a new dream on the part of the planet. In *On Vanishing Land*, it is the 'figure on a hill' section where this perspective is opened up:

There is a feeling of a hot summer day, where something becomes perceptible behind the surface of the land, behind the surface of the day. [...] [T]he land becomes hollow, it becomes hypersubstantial, it becomes an eerie emptiness consisting of awareness, feeling, intent. The sea is not around the land, it is the land, and it is the sky [...].

There is a figure on the edge of an escarpment. [...] [M]aybe it is Rendlesham Forest behind them, and Lantern Marsh off in the distance [...]. They will live this, but they will not remember, or only their dreams will remember. There is a white void of air beneath their feet. This white void is the planet, it is beneath the figure on the hill, and all around them, they are a dream within a dream, the planet is a dream within a dream. The planet is teeming with inorganic sentience, as is the cosmos—potential allies, parasitic entities, explorers of the unknown, shadows, M.R.James demons. The figure on the hill—a man, a woman?—they

see this, grasp it all, but it is too intense to be remembered, too perturbing for any normal level of energy.[2]

The second key issue is that both *On Vanishing Land* and *The Corridor* are informed by a principle of exteriority. When you see the human world spread out within the sphere of the planet like a mist, you find a profoundly problematic domain consisting of a specific form of the faculties (one where our choice-making defaults onto control and defending-or-widening territory, as opposed to letting go and venturing outside, and where reason dominates over barely functioning faculties of lucidity and dreaming) together with, on the macrological level, the composite of capitalism and the nation states; you also see that there is an escape-path leading away from ordinary reality. The application of the principle of exteriority, which is one of the main elements of what it is to travel along the escape-path, has eight aspects:

1. A primary focus on the planet as a whole, rather than the human world or a specific country, with attention being given in particular to wilderness, semi-wilderness, and countryside/scurfland terrains, along with sky-terrains.

2. A primacy of the faculty of perception—that is, of sustained attention in relation to the spheroambient world that arrives continually into the world of a perceiving being, and, inseparably from this, a primary focus on the body, and on energy.

3. A concentration of attention on the faculties which form the outside of the dominant forms of connection with the world, where these other faculties are perception, dreaming, lucidity, intent, and feeling, together with the faculty of becomings, which transects the other five.

2. For the full text of *On Vanishing Land*, see R. Mackay (ed.), *When Site Lost the Plot* (Falmouth: Urbanomic, 2015), 271–79, which also contains 'Outsights' (281–303), an interview with myself and Mark on the project.

4. A primary focus on a specific modality of existence which can be called brightness (where this is in opposition to gravity).

5. A primary focus on the non-state societies of nomadic or tribal social formations: this being a focus which concerns not so much the entire fabric of empirical details of these societies, but instead takes the form of giving attention to these societies insofar as they involve knowledge of the escape-path.

6. In relation to modalities of expression, a primary focus on the world to be delineated or dreamed, as opposed to a focus on concepts and forms of writing (new concepts and new forms of writing will emerge, but precisely through the conceptual/linguistic issues involved in creating them being secondary).

7. A centrality of attention in relation to the transcendental-empirical, as opposed to the empirical (knowledge of the escape-path is an example of knowledge of a transcendental-empirical aspect of the world).

8. A centrality of attention in relation to groups, and all micropolitical issues, as opposed to the domain of state politics.

What is in effect in the two works is the idea that there is another form of the faculties, beyond the one that is constitutive of ordinary reality, and that this other form has perception, lucidity, dreaming, and intent (choice-making) at its centre, with intent now released toward opening up, letting go, and venturing outside; and with reason functioning as a less fundamental faculty, alongside lucidity (which is the ability to see intent in individuals, social formations, myth-systems and accounts of the world, and the ability to perceive affects, very much including the affects involved in our connection/encounter with the planet). And what also informs both works is an awareness that it is necessary to depart from the oppressive value-systems and fixations of the social or macrological formations of ordinary existence.

It is clear that ordinary reality is a very disturbing and denuded place. In its current form it is 'capitalism, the latest form of capitulation', to use the description from *On Vanishing Land*, and it is 'the Disaster' from which people have departed in *The Corridor*. It is the place where people are crushed by circumstances, and where animal species and environments are being destroyed. It is where what attempts to break free in the direction of 'love, lucidity and wider realities' (*On Vanishing Land*) often does not get far, and where, when the escape-threshold is crossed, the records of this event are likely to be misunderstood and misconstructed in ways that mean there is no widespread alteration involving people setting out toward the second sphere of action.

The forested world of the Corridor is a place of deterritorialisation—a world without nation states. And although the story of *The Corridor* mainly takes place in the parallel emergence form of Suffolk, the world of the novel deterritorialises to other parts of the planet, opening up connections, in particular, with four zones: Patagonia, Australia, the Amazonian/upper Orinoco terrains of the Yanomami, and the cross-border area consisting of Mongolia and Tuva. In relation to the third of these areas, two of the protagonists at one point meet a woman who tells them that five Yanomami groups succeeded in crossing to the Corridor at the point when it emerged (if you were to fly above the Amazonia jungles of the Corridor, eventually you might see a *shabono*). However, in connection with the pragmatics of Departure, the fundamental deterritorialisation in both *The Corridor* and *On Vanishing Land* relates to the transformed, widened functioning of the faculties.[3]

The philosophical process of development on which Mark and I were embarked had begun at Warwick University in the mid-1990s, but it had now developed in the form of lines of flight that in different ways involved Suffolk. By the time we were in the main phase of working on *On Vanishing Land* Mark was living in Felixstowe, and I would arrive by train with my head full of sunlit Suffolk forestlands from *The Corridor*. Before Felixstowe Mark had been living in Woodbridge for two years—the trip when we did the walk, together with two subsequent trips the following summer, had convinced Mark that he should leave London for Suffolk, a move which had taken place by the autumn

3. The concept of deterritorialisation has been taken from G. Deleuze and F. Guattari, *A Thousand Plateaus* (London: Athlone, 1988), 508–10.

of the same year. The initial trip in 2006 had led to Mark being in Suffolk in actuality, and to me inhabiting an anomalous Suffolk in the virtual-real—in the dimension of the oneiric. The impression is of a current that had caught both of us up in different ways, and which had a central, fully shared element in the form of the audio essay.

*

I wrote the script of *On Vanishing Land* between 2009 and 2011. Around this time we contacted the people we knew who we thought could make the right kind of music for the piece, and we did everything we could to give a sense of the kinds of terrains and atmospheres that we wanted the compositions to evoke. Two of my friends agreed to make tracks, and Mark had friends and contacts who agreed to compose pieces, including John Foxx, who generously provided us with a long, charged composition, and also—in the final months of production—introduced us to Gazelle Twin (Elizabeth Bernholz), whose three tracks are a fundamental final element at the level of sound. Mark was now in touch with the Bawdsey Radar Group, and Mary Wain agreed to give an interview. The journalist Dan Fox was interviewed about his experience of travelling on a container ship,[4] and I got in touch with the archaeologist Angus Wainwright who agreed to be interviewed about Sutton Hoo. Andy Sharp helped us with sound recordings. Everything for a long time had gone slowly, and then suddenly it was going very fast, but with a quality of serene intensity that was unaltered by the change of speed.

Early in the writing process I had arrived at the idea that we should include *Picnic at Hanging Rock* in the piece, and after a discussion about it, Mark agreed with me. We came to see that *Picnic at Hanging Rock* (book and film) was crucial, partly because it opened up a planet-wide aspect that was a positive counterpart to the focus on capitalism, but primarily because it broke open a view along the escape-path. With four months to go before the *On Vanishing Land* exhibition at The Showroom gallery Mark had the idea of reading a section from M.R.James's story 'Oh, Whistle, and I'll Come to You, My Lad' spliced seamlessly with a reading of a section from Joan Lindsay's novel.

4. The full text of this interview appears as D. Fox, 'Silent Running', in Mackay (ed.), *When Site Lost the Plot*, 305–19.

We worked together on the major decisions of sequencing and co-emplacement of tracks, and Mark did the fine-grained work, with immense skill, on the modulations and layering of the piece in relation to sound. Mark composed the 'whistle' track: an expression of a perturbed, unnerved state. This piece is an expression-into-music that comes from him looking toward the transcendental-empirical in an affective direction that is a long distance from the zones of the world which generate the affect of brightness. Doing this can produce a powerful, valuable jolt, though it is dangerous to focus too much on critique—the horror is all-too-real, and primarily it is necessary to look in the Futural direction, which will give you the outsights and energy necessary to escape (though it needs to be added that the key to looking in the Futural direction is to be travelling towards it in a process of waking the faculties and of becoming-active).

*

In *On Vanishing Land* the importance of sound is radically emphasised, at the same time as it is radically displaced. The materiality of the piece is sound, and everywhere there are sonic thematic elements—the whistle in the M.R.James story, the music box, the idea of an eerie cry breaking into a silence, radar (it should be pointed out that this thematic side of the emphasis is very much on the side of sound, as opposed to music). But there also is the displacement: it is 'solar trance' in a singular, non-human terrain (with no emphasis on sound) that draws the women over the threshold-of-escape in *Picnic at Hanging Rock*. And the experience of the figure on a hill—who sees a 'white void of air' beneath their feet—is connected to a terrain (Rendlesham Forest, Lantern Marsh) in a way where the description makes no reference to sound on any of its levels. Everything is sky and planet: something becomes visible behind the surface of the day.

Both the emphasis and the subsequent displacement are taken even further in *The Corridor*. The main aspect of what causes the six characters in the novel to be drawn into the emergent world is 'sound shadows'—the transition takes place through listening to recordings consisting of layered drone tracks whose perforated, modulated form has an unsuspected power. However, it will later be

discovered that these sonic components of passage are only one way of getting across to the Corridor—and also that the next level of transitions does not involve sound. Instead these subsequent threshold-crossings involve perception of the sky, multi-sensory or 'haptic' perception in relation to the visual and the tactile senses, and certain, very specific processes of perceptually-based envisaging which do not involve sound.

There is a change taking place here. A shift toward space, away from time—a change that is on a wider level than the raising up and displacement of sound. It is necessary to reach sustained spheroambient perception in a process which intensifies sound but which does not have it as a central element. The change is not directly a question of aesthetics but instead involves a metaphysics and a pragmatics. And, relatedly, the move from sound is not a move toward film and other visual art forms, but is instead a move toward perception in its relation to the worlds beyond artworks. Sound as component of passage is here primarily not music, and in the same way the visual here is almost entirely the world of the perceptual in this wider sense, and of envisaging based on the perceptual (this envisaging is a modality of dreaming). It is true that in relation to the form of the two works narrative and fiction come to the forefront, but they do this as modalities of dreaming, where this relates, amongst other areas, to written tales, dreams in sleep, dreams about the future, narrative accounts, and processes of memory-based envisaging, rather than there being any main focus on film, video, and painting/drawing: in fact, in *The Corridor*, it is both the case that the visual as initiator of threshold-crossings is either perceptual or in the form of envisaging, and that the film/video mode has something damaging or deleterious at work within it (although this of course is not definitive of the mode in any way). The tale/narrative retains a level of emphasis (through the forms of the two works) but in a way where its most crucial spaces are the virtual-real worlds to which the written or spoken words lead, with their capacity for helping you see the world around you. Here a mythos is a lens for seeing the world, with the tale set within the mythos also being in different ways a space of lenses and guidelines—the tale overall as a fragment and diagram from the bright direction that is visible in the world of affects, a transmission of the joy of travelling into the Future.

*

The summer of 2013. Making *On Vanishing Land* and writing *The Corridor* had been a process of expressing outsights through narrative, and I was now about to return to writing philosophy in a more customary form. On the horizon of the perturbingly difficult terrain of cross-currents through which I have been travelling, there is *somewhere else*. A somewhere that is also dangerous, but is at a higher level of intensity—and which leaves certain dangers behind. The philosophy in question here is transcendental-empirical or facultative philosophy, the philosophy of exteriority.

The crossing to the second sphere of action is a movement toward a new formation of the faculties, but it is important to see that the term 'intent' does not just indicate choice-making or navigation but is also profoundly related to the depth-dimension of human lives which can be characterised in terms of loves, inspirations, becomings, dreams about the future, emotions, desires, and reactivities. As well as liberatory and intensificatory modalities, the depth-dimension indicated by the term 'intent' also consists of subjectified, reactive emotions, such as resentment, judgmental anger, fear, self-importance, and anguished or mournful self-pity—and these start to be left behind in making the crossing. What also begins to be left behind is self-indulgence, together with acute depth-dimension crises in the form of fear/anxiety and depression. But the crossing is not easy: a lot of energy is gained in the process, but the 'common-sense' world of ordinary reality does not easily give up its grip to lucidity and dreaming: if there is a backward movement in the form of ordinary-reality impositions, the accrued energy can be turned against you. The terrain of the crossing is a little like the Zone in Tarkovsky's film of *Roadside Picnic*: take a wrong turn and you can end up in the meatgrinder.

The dangers of this transition belong to ordinary reality rather than to an intermediate terrain: they are acute as opposed to chronic manifestations of ordinary reality's suppressive formation of forces. As Mark wrote in *londonunderlondon*: 'You come to be in a mortifying structure that precedes you. You only have a lifetime to escape'.

The escape-path is as real as a path that leads across mountains. It leads away from the preoccupations of the forms-of-intent of ordinary reality—away from the ongoing disaster. This is also to say that it leads away from a damaging and attenuated formation of the faculties which has the socio-economic

modalities of capitalism as its macrological expression. The escape-path is the pragmatics of concentrating on the planet and the other forms of exteriority, and it is the pragmatics of becoming-active, of departure-alliances and of waking the faculties.

Go for walks in planetary Suffolk, planetary Australia, planetary Patagonia, planetary Tuva. The faculties which initially need to be woken are perception and dreaming. Become sustained spheroambient perception, and sense how you are surrounded by a bright, eerie void filled with formations of energy, formations of intent, formations of feeling. Form escape-alliances. Be ultra-practical in waking the body and the faculties, and be ultra-aware, both in immediate encounters and in thought, of the real-abstract worlds of formations of intent. Within the human world there is a solar thread of exteriority and becoming-active, a thread of joy and lucidity. This thread or filament runs everywhere at different levels of intensity, but around it is the Disaster, from which the human world desperately needs people to depart. The white void is also the planetary worlds of sunlight, starlight, terrains, places, forests, mountains, houses, animals, humans, groups. Look on the horizon for the affect of brightness. It will lead you to the Future.

Kodwo Eshun, Steve Goodman, Emily Pethick

To Release the Unnameable You Just Dim the Lights and Then the Playback Starts

Edited transcript of a conversation on the impending appearance of Justin Barton and Mark Fisher's On Vanishing Land *as a vinyl and digital download release on the Flatlines Label, London, 25 June, 2018.*

KODWO ESHUN: We're going to talk about the process by which *On Vanishing Land* went from being a work made by Mark and Justin over a certain period of time to being installed within The Showroom,[1] about working with Mark, who was and is better known as a theorist than as a so-called sound artist, and Justin, who's better known as a theorist and novelist[2] than as an artist, the transition of *On Vanishing Land* from a work that was really concerned with playback, and was specific to venues and moving to vinyl and to download so that *On Vanishing Land* enters into circulation as a digital file that marks the change between 2013 and where we are now in 2018, about Mark and Justin working in sound, whether that was Mark's mixes or the audio essays with Justin that mediated between theory, sound, and fiction, between sonic fiction and theory-fiction in the space of the exhibition. So, first of all maybe we could start with you Emily. It's a long time ago, but maybe you could reconstruct some of the moments in that process.

EMILY PETHICK: I'm remembering that you and Anjali Sagar as The Otolith Collective came to us with the proposal to commission Mark and Justin. It was

1. 6 February–6 April 2013, <https://www.theshowroom.org/projects/mark-fisher-and-justin-barton-on-vanishing-land>. The *On Vanishing Land* audio and visual essays were commissioned by The Otolith Collective and The Showroom with support from Arts Council England.
2. See J. Barton, *Hidden Valleys: Haunted by the Future* (London: Zero Books, 2015).

quite early in my time at The Showroom. In 2009, we worked on our two-part exhibition *A Long Time Between Suns*,[3] which was realised between The Showroom and Gasworks, and was the first exhibition of my tenure at The Showroom, and opened our new building. In Part I, at Gasworks, we did a listening event for *londonunderlondon* with Mark and Justin, as part of a whole series of events that we planned around the two exhibitions.

What was nice about that first show at The Showroom was that many different things grew out of it. It was an amazing starting point for the new era at The Showroom that we'd started to build, and for activating a community around it. Those events grew into other things, and I think that was something that became a conscious approach at The Showroom: to grow things and build on things rather than see an art space as always having to have something new and different; to be a place where you could develop ongoing conversations and relationships. And so, having got to know Mark and Justin via your project, it made sense to continue the work with you on a curatorial level and to open up a new conversation through that with them. To me it was also interesting to work with theorists on an audio project, and to develop The Showroom as a place that could be open to different kinds of practices and ways of theorising; to create a platform for theorists to work more experimentally in the visual arts field and a space that is outside of academia where other kinds of processes and practices could be tested out.

KE: We invited Mark and Justin to present *londonunderlondon* at Gasworks as a playback[4] followed by a conversation with Sukhdev Sandhu, curated by Anna Colin; this was February 2009; it was really successful. We did a second event in Frankfurt at a temporary art space at Deutsche Bank Towers in March 2011[5]— and invited Mark and Justin to playback *londonunderlondon* again; they also presented *Radar Traces*. Justin was talking about *On Vanishing Land* and he said, 'We have this project that we've been planning for years, and we really

3. 15 February–5 April 2009, <https://www.gasworks.org.uk/exhibitions/a-long-time-between-suns/>.

4. 29 February 2009, <https://www.gasworks.org.uk/events/londonunderlondon/>.

5. *Globe: Art, Music & Performance in den Deutsche Bank-Türmen*, 2 March–15 April 2011, <https://cdn.contemporaryartlibrary.org/store/doc/1988/docfile/original-731f1c0ddd0b75a84d6f7e787f8f217d.pdf>.

want somewhere to show it'. I said that I knew where it would work. It just made sense to bring it to The Showroom. I got the feeling that they had worked on it already. There was a strong sense that they were ready to take it to the next stage, and the way you organised The Showroom made it an accessible space to try.

STEVE GOODMAN: What were the early discussions for the Gasworks playback of *londonunderlondon* in regard to the format of collective listening? I didn't go to either the *londonunderlondon* or the *On Vanishing Land* playback, but it's an unusual and challenging format, it's difficult in most spaces. At that early stage, what were the conversations with Mark and Justin regarding the choice of this mode of event, not on headphones but actually in a space? And what was happening with the lighting—was it always dark?

KE: It was a dark space. Mark was elated at the success because *londonunderlondon* is two parts, ninety minutes in total, we played the first part; everybody was totally attentive. In the 'Outsights' interview,[6] Mark said that a certain kind of 'attentional magic' took hold. It was an experiment that worked brilliantly.

I've just remembered two earlier experiments. In 2009 Mark did an event at the ICA at which he played Glenn Gould's 1969 work *The Latecomers*,[7] that was billed as the first session of the 'Deep Listening Club'. When he joined Goldsmiths, he started these evening sessions after 5pm, in which some of his students from his *Vocalities* seminar would present audio essays. Mark encouraged them; we would all discuss them; Mark invited Gazelle Twin to present a new track that she had made. He didn't distinguish between her music and audio essays by students like Tristan Adams and Carey Robinson who made a work on ASMR.

The structure was simple. You just dim the lights and then the playback starts. Mark really liked the idea of taking over the Goldsmiths rooms to use the speaker systems, which he always said were underused. He wanted to experiment with collective listening sessions that intensified words, voice, music, and silence.

6. J. Barton and M. Fisher, 'Outsights (Interview)', in R. Mackay (ed.), *When Site Lost the Plot* (Falmouth: Urbanomic, 2015), 281–303.

7. 15 November 2009, <https://archive.ica.art/whats-on/mark-fisher/>.

There would be a search for terminology. You could call them 'audio essays' or 'sonic fictions'. I think that the fact that there was no given term was what Mark liked. It meant that there was terra incognita. He kept saying how shocking it was that so few people make these works. What he liked was that the form didn't seem pedagogic at all—but it also wasn't a gig, and it wasn't a club, and it wasn't a concert. It was an event which didn't really have a status or a name. I think he loved the fact that something so seemingly simple could create a disciplinary perturbation.

EP: I remember the opening of the exhibition at The Showroom was completely packed out. It was quite a moment, because with so many people in a space crushed in and listening in a really concentrated way, there was an amazing atmosphere. We had chairs, but everyone was sitting on the floor.

SG: The sheer torture of some of these audio essay listening sessions should be dwelled on a little, because the heat of so many bodies packed in, the often appalling acoustics of so many art spaces, and the fact that some of *londonunderlondon*, for example, is really badly mixed so the voice just disappears into the music half of the time—so that you are drifting in and out of what is legible in the voice—and yet all of these 'negatives' are part of what is compelling about the experience.

EP: *Londonunderlondon* was more lo-fi, but with *On Vanishing Land*, Mark received Arts Council England funding so that he and Justin could buy a laptop to make the mix on, and the music was all commissioned. Part of what we tried to do at The Showroom at the time was to offer artists opportunities to up their game, to scale up their work, or do something in a more ambitious mode. What was really special about that occasion was that so may people came. There wasn't a lot of access to *londonunderlondon* because it contains so many 'borrowed' materials. So until then, not many people had come into contact with this side of Mark and Justin's work.

KE: When you'd ask Mark or Justin how far it was along, Mark would say, 'It's nearly all done', and when you'd press him he'd say it was a matter of

bringing in songs and placing them. It was a matter of finding a weekend here, a day there to do the mix, of Justin finding an evening to listen. Considering how many producers they were working with, they seemed to have a good workflow going that allowed the artists to deliver the work. Mark called it 'coincidence engineering': the artists were working on things that were just right. It was never about telling the artists what to do. It was as if all the artists were already making music for the project.

A key question was the relation between listening and watching those photographs Mark had taken. How long would those images be up on the screen, and what would they do to the audio? In a gallery, people will fixate on those images and start to think the work is about them. Mark would say, 'No, they're documentation, they are not the work'; I would say that people will see them as the work because that's what they do in a gallery.

EP: I seem to remember that image sequence was quite long, because we had to wait for the image sequence to finish before the audio work could come on again.

KE: Yeah, because they had these slow fades.

EP: [Laughing] It was like an hour of images!

KE: I got the feeling that Mark was trying to make the images fade like the sustain of those John Foxx sustained pianos from *Cathedral Oceans*. The way the piano dies with a very slow decay—I got the feeling he wanted the images to do the same. These pianos in this reverberant space giving this sense of—What was the phrase?—ancient sunlight. You start hearing them as the dying or the fading of the light.

That was the point at which I started realising how many people had been reading *Capitalist Realism*, how many people loved his writing, what an attractive figure Mark had become. There were so many people. It just became an event. Maybe because they hadn't realised that Mark and Justin had this ongoing fascination with drawing this diagonal between sound and voice, it just created a new context around his work that people could access.

EP: I was just remembering the press release that we had spent a long time writing and discussing and then it got critiqued in an article in *The Independent*. Do you remember? For pretentious language [laughs]!

KE: Yes, because I wrote it, mostly. We were proud of that.

SG: It's a badge of honour.

KE: Exactly.

EP: In press releases, you're always supposed to be writing to capture the interest of the press, so not using long words. But we decided, because both you and Mark worked so much with language, to just go with it. To be proud to carve a difference in language. It immediately got seized upon and ridiculed in that article about pretentious language in the press. But I actually thought in the end it was indeed a badge of honour, and at the time you'd also been in *Private Eye*'s 'Pseuds Corner'.

KE: And so had Mark.

SG: Things have changed, haven't they, because the discourse around Mark now is all about what a great communicator he was and how he had this ability to communicate difficult theoretical concepts in everyday language. I don't know, maybe his very presence has transformed the press context now.

KE: What they were responding to was this devil's mixture of Mark's concepts and my attempt to dramatise them. I expected it and welcomed it and, far from being afraid of it, he welcomed it too. It shows you're doing something right.

EP: It shows that you're sort of pushing at their...

SG: ...cognitive immune systems. Their *we can't deal with that* reflex.

KE: The British exposed nerves.

EP: But I think the audience isn't the one who is reading *The Independent* anyway.

KE: No, *The Independent* wasn't ever going to show up.

The discomfort of sitting there with your legs drawn up because there were people all the way around you so that you can't lean back, you can't drift away, you're hunched up and paying attention. The discomfort is a necessary part of the strategy of rarefaction that made a demand on you.

SG: There is the physical demand of just staying still, not rustling, being in this space cramped with bodies, but then there's the psychological torque that it subjects you to, and this starts from the voice and music work that Mark was doing in the nineties. For example, when the Ccru did the *AfroFutures* and *Viro-technics* events around 1996–1997, there were cassettes that came out of those events.

And these were lectures in a sense, but they were also cut-up texts that zigzagged between fiction and theory and neologism production, with hard-core and jungle running under it all, and it's psychologically hard to process. On the one hand you're getting this affective experience where your body's being activated by the music and your cognitive faculties are shutting down because you want to dance and go in that direction, and on the other hand the voice is demanding that you concentrate, it's demanding that you pay attention. And somehow they're held in tension. The sound is making you want to flee and the fact that you're having to concentrate on the semantic content of the voice is forcing you to stay and really pay attention.

But there has been a shift from these mid-nineties works with Ccru, per-haps mapping the change in the zeitgeist and in music. It went from having this accelerated underscore to the voice, of dance music tracks and hardcore jungle but, by the time you get to *londonunderlondon*—well, there are some grime tracks in it, but the whole thing's become much more subdued and mel-ancholy. The John Foxx and Harold Budd material in *londonunderlondon*, the pianos you were talking about, that's a sense of the direction it's heading in, where all of the rhythm dissipates and it becomes an atmospheric dark ambi-ence that surrounds you, that glows, and everything slows down and becomes more spacious and somehow slightly easier to process. It's almost as if Mark

and Justin needed to refine this work from the nineties where it was far more of a punk-style slamming-things-together with elements pulling in very different directions. There's still some of that tension in *londonunderlondon*, but by the time it gets to *On Vanishing Land* it's really hit a plane of consistency where—and this doesn't necessarily mean it's less challenging to listen to for forty-five minutes—there's a more synergetic relationship between the sound of the music and the voices, that was refined over the course of twenty-odd years.

EP: It's quite sensory, the way that the sound is working, but also at the beginning, when they're talking about the sun and the walk, it was quite an embodied thing to experience. I remember how, whenever we had sound pieces at The Showroom, because the building's got quite thin walls, we'd always have these moments where you'd hear it through the building shaking the structure. This happened in *On Vanishing Land*, especially as there's a really intense part where you have the music of Gazelle Twin coming in. The way in which it worked in the space, I think sound really takes over a space in such a way that you can feel your own body when you're sitting there.

SG: You can feel the journey of the walk in *On Vanishing Land*. Each track that they use is almost like one of the fields that we're walking through with them, and some are swampier than others, some are more dramatic and squelchy, or slightly noisier passages of ambience. I'm not quite sure who did what yet, I'm still reconstructing it so we can attribute things to the right people on the record, but you get that, especially when he starts talking about the film *The Swimmer* (dir. Frank Perry, 1968), where he's going from garden to garden swimming through the pools. You get a sense of moving from field to field, and the terrain of some is easier to navigate than others, but also the atmosphere of that aspect of their journey evolves throughout the piece.

KE: They would talk about the notion of the *solar gothic*, this sunlit world that beckons toward a darkness. I think that comes from *Picnic at Hanging Rock*, which is taking place in the light. Mark and Justin talk brilliantly about this relation between *Picnic at Hanging Rock* and 'Oh, Whistle, and I'll Come

To You, My Lad', and the way in which the writing of Joan Lindsay offers an exit to the outside blocked by the gothic of M.R. James, which is a Christian world view that counsels against escape, staged via the Eno of *On Land*. You could feel the heat as an audio hallucination. Justin's voice would cut right through with that English tone of his which is both crisp and quite languid—his cut-glass accent enunciating every sentence and every word. The brightness shifts into darkness when Justin starts narrating a story about this ancient Viking burial ground in which a widow of a Viking king is ritually murdered. Things become more eldritch.

SG: Yeah, it gets progressively more eldritch—it starts off relatively benign and pastoral, and by the time it gets to when Mark's voice comes in after about sixteen minutes, it's chilling.

EP: The interview at Bawdsey Radar Transmitter is creepy.

KE: Exactly. I realise now that a lot of the ideas in *The Weird and the Eerie* are being premiered in *On Vanishing Land*. *On Vanishing Land* is an enactment of the eerie in its method and its intent; it is the audio eerie from beginning to end.

SG: That was his genre now wasn't it—the audio eerie, or the 'earie'.

KE: Mark was using the word 'eerie' but he hadn't formulated it in as much detail as he came to do.

SG: It becomes more systematised in the book.

EP: What was eerie about our event on the eerie was that the recording didn't work. We did this very big event during the show where we had John Foxx, Gazelle Twin, and a few others on a big panel and everybody responded to the theme of the eerie. It was absolutely rammed, with people standing in the stairwell. It's really sad actually that that happened, but in a funny way, it's fitting. You're always trying to save things and record things and sometimes you have to let them go.

KE: I think the eerie allowed Mark to draw together preoccupations that he had had over the last few years. I think of *On Vanishing Land* as quite different from so-called 'folk horror' or pagan horror that goes from, say, *The Wicker Man* to *A Field in England*. *On Vanishing Land* feels different from that. I think Mark's friend Andy Sharp aka English Heretic was a key figure in this.

SG: This is the guy who made *The Plan for the Assassination of Princess Anne* with Mark, which is like another prototype that just hits a plane of consistency. It's incredible.[8]

EP: Andy collaborated with Mark and Justin on the photographic image sequence for *On Vanishing Land* at The Showroom too.

KE: He shared Mark's interest in M.R. James. Mark had written an essay for the *English Heretic* zine in which he revisits the locations of the 1968 Jonathan Miller BBC TV version of 'Oh, Whistle, and I'll Come To You, My Lad'. It's an analysis of a terrain which exists as a screen memory, as a literary site and a geographical aftermath.

Andy was a key interlocutor for Mark; Mark always needed these figures who would bring their enthusiasm to the project. Some time after *On Vanishing Land*, we three, Mark, Andy and I, went for a walk that retraced about a third of the same route as *On Vanishing Land*; as we walked, Andy was continually narrating the geography, history, and media of the landscape.

Mark needed Justin and Andy to help him build the project, to repotentiate the walk. The anti-figure is W.G. Sebald. At this point in time *The Rings of Saturn* enjoyed a canonical status that nobody criticised. Mark wasn't having it at all—he was like, no, *The Rings of Saturn* evacuates everything that's most potentiating about the Suffolk coastline, rendering it in terms of a mitteleuropa melancholia. *On Vanishing Land* is an anti-Sebaldian project.

SG: I'm trying to think back to *londonunderlondon* and to how that ranked on the 'eerie scale'—and I don't think it was particularly eerie, actually. It had

8. English Heretic, *The Plan for the Assassination of Princess Anne*, 2011, <https://englishheretic. bandcamp.com/album/plan-for-the-kidnap-of-princess-anne>.

this melancholy air with the Harold Budd piano pieces we've talked about—it had a kind of languid melancholy during the Ballardian *Drowned World* sequences where the character is walking around in a post-apocalyptic, deserted London, going to the empty cinemas and libraries and everything's deserted. But it's not at all the same ambience. It's not the same atmosphere as *On Vanishing Land* at all.

KE: It's under the sign of *The Drowned World*. What I remember is Mark reading passages of a figure walking around a deserted roof garden somewhere in Kensington. It's a Ballardian hauntology, not a Joan Lindsay-esque eerie.

SG: It seems like there are a few stages in the evolution of his thought to do with the dark side. I was reading his PhD the other day and the material about the gothic flatline, and on the face of it the gothic flatline is all about the undead. So this must have something to do with hauntology, right? But when I was reading I realised that it's really a quite different set of issues that's being tackled, even though on the surface it looks like something to do with horror and haunting and the undead and the dark side and so on. It's doing a very different job—he's using it to talk about cyberculture. And then hauntology is something very different again, and then, as you said, *The Weird and the Eerie* is a step beyond that still. So, there are these figures of the undead and ghosts and so on that keep reappearing, but they function differently in these different stages.

EP: I think it's nice that it ventures through a landscape in order to find that. It starts near to where Mark lived, the Felixstowe container port, then ventures into this landscape.

SG: You've talked about this idea of 'rarefaction'—that one of the things that was important was that these were listening events—you couldn't get hold of this material in any other context—but all of that was set against the backdrop of digital overabundance.

KE: The fact that *On Vanishing Land* was designed to be inaccessible meant that your memory would have to play it back; large parts would drop out—you

would have to artificially reconstruct that relation to memory. You have to construct the conditions of scarcity because abundance is the norm. You have to work at scarcity—you have to design its conditions.

SG: But that also, I suppose, ensures that it percolates in a certain way. As you said, you're forced to artificially reconstruct it, but it slows down the speed at which it spreads, and there seems to be something qualitatively important about slowed transmission that goes against the norm of instant disposability and consumability.

EP: Yes, it's been fairly inaccessible until now, when it's going to be released, because actually it was only available in the space at that time.

SG: So how many playbacks have there been? We did a playback earlier this year at our monthly Ø event at Corsica Studios.

KE: There was one at Goldsmiths...

EP: There was one in Brisbane—Do you remember?—at this small gallery. There was a huge amount of back and forth about that one, and they really wanted Mark to go over but Mark didn't want to go because it was too far away—he didn't want to travel, so he managed to wriggle out of that. But they did the playback anyway, and sent us a photo of it taking place .

Earlier this year I was doing a seminar with students in Thessaloniki, and they instigated the idea that we'd do the whole seminar as a listening session. They wanted us to walk as well, so they'd organise all these audio recordings and we'd walk up and down the seafront listening to theory, which was fantastic as it was very cold and sunny. I suddenly thought about *On Vanishing Land*, so in the evening we managed to get hold of the sound file. It was amazing because at the beginning of *OVL*, you're walking into the sun, which is what we had been doing all day, walking progressively along this seafront. We couldn't find a quiet place, so we ended up in this student dormitory altogether, deep in concentration. Even in a small group, the experience of sitting together listening was really affecting and intense. I think there's something about the way in which

you share, it's a different kind of sharing that happens when you sit and listen to something together, than when you watch a film—you're far more conscious of yourself, I think, when you're not being visually stimulated, you go more into yourself, and you're not used to being in a relation like that along with others.

SG: You really become conscious of the mechanisms of distraction which kick in so easily and how you're constantly fighting these drifting-off tendencies. Because even musically, it's very easy to just relax, to let the music carry you away—even if I'm walking around with it on headphones as I have been for the last day, I'll just realise sometimes that I've stopped listening to the words for ten minutes or so. I'll have it on loop and I'll just find myself living inside of it in a very different way from a listening event. This is a different listening mode— listening to it as an environment that's just there, and you drift in and out of it and certain lines start to become memorable—there is that amazing line that's really been sticking in my head: 'With the eeriness of amnesia, the unknown thing from the outside is you.'

EP: It transports you because it's so much centred on a physical experience, that walk.

SG: I wonder how the energy would have been different if it had been immediately available straight after the first event—if it had been immediately digitally available and everyone could have listened to it on their own and studied it and analysed it and taken it apart, because obviously that is what's going to happen the minute it becomes available. People reading it with, or as a prototype of, *The Weird and the Eerie*.

KE: Mark's death was clearly the signal for another phase. Once Mark died, you're playing it as a memorial listening session. At that point it seemed important to share it more widely. It wasn't about constructing the conditions for a kind of phenomenological intensity. In a way, Mark's death reversed the polarity of listening.

SG: There's also an interesting parallel with his writing here—how it started online and gathered momentum and snowballed its audience online, and

now it's been packaged and entered into a different kind of circulation as the k-punk monolith.[9] But these different formats have different speeds of circulation and different ways of resonating with people.

EP: But I think in a way the sound works got a bit left out of his oeuvre—I haven't seen many people paying attention to those works.

SG: His biggest book and concept was *Capitalist Realism*, and that's what most people seem to know, so there's a process of unveiling the iceberg that was Mark—under the surface of the ocean there was this sprawling k-punk entity, and then his own sound work and music.

KE: There are people who knew him as Mark, and people who know 'Mark Fisher'. The people who know him as Mark Fisher are the people reading his texts. If you knew Mark, you knew that music was a vector or a delivery system to theory to cinema back to music, to politics, to music. Those people coming to the show wanted to be around Mark. Coming to *On Vanishing Land* was about sharing something with Mark—entering into the coordinates of his thinking in which his thought has become sensorial and palpable.

 On Vanishing Land is nothing if not an intensification of *The Weird and the Eerie*—it is for all those who want to go further into Mark's work. If *On Vanishing Land* circulates across the net, circulating across the planet, it still has—or can still have—an initiatory capacity.

SG: Well, obviously, you can just casually shove it on Spotify while you're in the office working, or on headphones. But *On Vanishing Land* is such anathema to the mode of listening that Spotify has cultivated, of just streaming anything in the background, like an algorithmic update of Muzak—you see the playlists that are popular on Spotify and many are to do with just lubricating various parts of the creativity, work, and industrial process. You can obviously listen to *On Vanishing Land* like that but it's going to be constantly distracting you because it's constantly demanding that you pay attention and listen to the words. It's in that

9. M. Fisher, *K-punk: The Collected and Unpublished Writings of Mark Fisher (2004–2016)*, ed. D. Ambrose (London: Repeater, 2018).

interesting interzone of the audio essay—it's not a radio play, it's not a podcast or a lecture. The closest thing is the idea of the essay film, because it has all these Markeresque overtones which I think had been in Mark's work since the nineties, of zigzagging between the archive, fiction, and theory.

KE: On Spotify streamability seems to be a question of delivery, but this is not separable from the content, of the music. What you're listening to is, in a way, availability—the sound of availability.

SG: And mutability—streamability has unpicked the album because it allows people to make their own playlists, so they zigzag from one album to another, or the algorithm suggests something relevant and then they're taken off on some auditory dérive generated by the algorithm, so they don't even know what they're listening to by the end of it. And obviously you can cut in and out of *On Vanishing Land*, but it's a solid chunk of forty-five minutes.

KE: It's the auto-recommendation algorithm.

SG: The hype for streamability would say that it puts the control in the hands of the listener—the artist's intention doesn't matter anymore, and the listener can reconfigure what they want to listen to as opposed to being dominated by the structure of the album that the artist wanted to you to consume it through. So it kind of unpicks the album and makes it modular.

KE: Ultimately what you listen to is a database which promises infinite combinations. I'm quite looking forward to hearing it on Spotify because it seems so alien to that algorithmic logic—*On Vanishing Land*, which was made around the same time that Spotify took off, is some kind of unacknowledged response to the structure of listening promised by streaming.

SG: It'd be interesting if it causes a problem for their systems: iTunes, for example, is very fussy about the specifics of what you give them—a track can only be a certain length, an EP can only be a certain length and then it becomes an album—they have all these restrictive definitions. Some people like to bundle

an album together so you can't just pick and choose what you buy, you have to buy the whole thing. Obviously, Spotify has podcasts on there, so they're used to having these long files.

KE: That's where it will end up.

SG: It will be interesting to find out the technicalities of how it slots into their database.

KE: Yes, it's an awkward fit, hopefully, but I have no illusions that it can't be made to fit. I'm sure it will be made 'databaseable', shareable, streamable. The idea is for it to not live outside of circulation.

SG: No, I think Mark would somehow have wanted to get right into the belly of the beast.

KE: Yeah, totally, so it takes on a new existence.

EP: It was made for a space, but I think actually, even at the time, we talked a lot about doing other things with it—not necessarily streaming, or something as accessible as that, but we had loads of ambition for it—that it would go beyond. It had such a strong critical response—I think I remember the editor of *Frieze* told me that twelve different people got in touch wanting to review it.

SG: It's a reviewer's dream because there are so many layers to it.

EP: But then it somehow didn't go further, so I think that it's important to take it elsewhere now.

SG: Mark's work is still a challenge for a certain mainstream world.

EP: It's not necessarily a work that easily fits into any circuit because it's not really a straight kind of artwork—it doesn't slot in.

SG: It could obviously function very well as an installation that's on loop in a gallery, with some attention paid to the context.

KE: Without ever mentioning Ccru, *The Weird and the Eerie* is Mark Trojan-horsing a lot of Ccru ideas without using any of its vocabulary.

SG: The Dunwich aspect, which is in *On Vanishing Land*, but with the Lovecraft connection—is a hidden hotlink—Lovecraft is lurking in the background to *On Vanishing Land* and most people wouldn't pick up that connection. Obviously his relation to hauntology—to Caretaker, Burial, and so on—made Mark very well known among a certain music world in the UK—but certainly much of this critical response we're seeing now seems to come from America.

KE: Can you talk about how it fits into your work, in terms of you releasing *On Vanishing Land* now?

SG: Well, Hyperdub is starting a new sub-label called Flatlines specifically for this release, named after a concept that Mark looted from *Neuromancer* (the 'flatline' is when you get neurochemically fried in cyberspace) and was developing during the Ccru years, and in his PhD, into the idea of the gothic flatline, an undead interzone between life and death.

Mark's mode of audio composition has certainly been very interesting to me as a way of formatting a jumble of ideas that have been floating around in my head, and it very much influenced part of this collective project I have been working on since 2009 called AUDINT.[10] We did a record in 2014 called *Martial Hauntology*, which was two quite different short stories soundtracked and sound designed, loosely about the weaponisation of ghosts and spectres, via the format of sound, in a military context. These two sides of the AUDINT record inhabit tangents that flesh out the AUDINT hyperstition. That format of bringing together already-existing music, new sound design, and new compositions with theory-fiction is definitely one I learned with Mark during the Ccru era in the nineties. I've learned so much with Mark and Kodwo—I would never have

10. <https://www.audint.net/>. See also S. Goodman, T. Heys, and E. Ikoniadou (eds.), *AUDINT— Unsound:Undead* (Falmouth: Urbanomic, 2019).

started Hyperdub as a record label if it wasn't for them and the vistas their ideas opened up—it's their fault for torturing me over the years. So the idea with Flatlines is that it has crystallised a number of ideas which fit loosely into this audio essay format that Mark has mapped out and implicitly systematised by just doing it and refining it.

That process is quite interesting, because I hardly saw Mark after we both left Warwick in 1999. But it's amazing that you could be physically out of touch with someone but they'd sent out enough messages into the ether that you were almost telepathically communicating, because when I came across Burial's music about 2002—and eventually released it a few years later—any connection to Mark's ideas must have been unconscious. But after it happened, retrospectively, it's so clear that that was partly my way, through someone else's music, of crystallising some of the ideas I'd learned with Mark—you know, after the fact, it's like, of course it happened like that—of course I would meet Burial and his music would sound like this, and Mark would immediately find an affinity with it—and obviously Burial was into M.R. James, and so I was just a catalyst for them to come together somehow. So it's a really interesting weird symbiotic process that I had with Mark's ideas from the moment I was no longer in a shared physical space with him, and I'm still uncovering things and still unpacking some of these ideas, and that's why there's this Flatlines series. It's very inspiring to me, at least, because there is finally a home for this strange unnameable format, and it begins to crystallise all of these embryonic ideas I've had for audio essays in one way or another.

EP: I always think about Mark as being very much part of a community—later on we produced another audio piece by Laura Grace Ford, the connection to whom came via Kodwo and Mark who kept on telling me, 'You've got to work with Laura'. So I met her and then of course I thought the same, we've got to work with her—that's what's nice, going back to what we've done with The Showroom: being able to follow the different interconnections between different players within an extended community of people, exploring different shared interests and ideas and practices. This is what was exciting about that particular moment.

KE: As I was reading some sections in Mark's thesis I realised that he was the first person to use this term 'theory-fiction'.

SG: I've often wondered about that, because it was used by Mark to describe Nick [Land]'s work. They are both such generic terms that you imagine that the phrase has always been around, but obviously it hasn't, no, it was invented.

KE: I think Mark formulated it and, typically, never said as much; but there it is in the thesis, and when he talks about it, he talks about it as if it already exists, as if we all know what we mean by that, so it's already circulating in Ccru.

SG: That's the classic hyperstitional move—to just give substantial reality and credence to something that is actually kind of embryonic or virtually real, yet to be unpacked and concretely fulfilled, unfolded.

Proposed site for Sutherland Spaceport, A' Mhòine peninsula, north coast of Scotland. Photo: Steve Goodman

The Old Man of Storr, Isle of Skye. Photo: Steve Goodman

Steve Goodman
Astro-Darien

Provoked by the 2014 Scottish independence referendum, Brexit, and the pandemic, *Astro-Darien* is a 26-minute sonic fiction about the break-up of Britain, narrated by synthetic Scottish voices and framed as an eponymous videogame. It is the second release on Hyperdub's sub-label Flatlines, and features artwork by my long-time collaborators Lawrence Lek and Optigram. Whereas the first release on the label, Mark Fisher and Justin Barton's *On Vanishing Land*, wove an audio essay around a walk along the south-east coast of England, *Astro-Darien* takes off from a road trip along the north coast of Scotland.

The documentary fiction spirals between the role played in the founding of the UK by the catastrophic Darien Scheme in the late seventeenth century, when Scotland failed to colonise part of present-day Panama,[1] and the contemporary disintegration of the union. The Darien scheme almost bankrupted an already impoverished Scotland and led to its having to enter into union with England. So the time spiral, moving simultaneously forward and back in time, with the present at its apex, sweeps up both the inception and prospective demise of the union. From a Caledonian heart of darkness to a supernova Scotia?

In a somewhat wild extrapolation of the race to become Scotland's first vertical satellite launch station playing out between Sutherland Space Port and the Shetland Space Centre, independence is speculatively framed as an exercise in escapology, a jailbreak and exodus to an orbital space habitat, with all the risks and dangers that entails.

The loose plot follows a game designer from a fictional games company called Trancestar North who, in attempting to lift the dark spell cast by Darien, models a counter-future by ingesting Cosmism, the history of racial capitalism, and the demise of Empire into T-Divine, the geopolitics simulator of the game engine. She follows the Brexit algorithm as it runs to its logical conclusion.

1. See J. McKendrick, *Darien: A Journey In Search of Empire* (Edinburgh: Birlinn, 2018); T.M. Devine (ed.), *Recovering Scotland's Slavery Past: The Caribbean Connection* (Edinburgh: Edinburgh University Press, 2015).

Initially conceived as an audio essay for diffusion on François Bayle's fifty-speaker Acousmonium for INA-GRM at La Maison de la Radio in Paris in March 2020, but subsequently postponed by the pandemic, it wasn't until October 2021 that *Astro-Darien* was finally played back in this intended form. The array of fifty speakers made it possible to diffuse the voices and sound design around the auditorium. Most of the speakers were spread out in front across the stereo field, but others were located behind the audience. The playback happened in complete darkness.

Earlier, during the peak of the pandemic, the original audio essay had evolved into an audiovisual installation. The postponement of the original unveiling provided more time to develop the fictional dimension of the project and to develop the sound design, so before Paris, *Astro-Darien* first surfaced as an installation on the dancefloor of Corsica Studios in South London in June 2021. As the pandemic eased, some club venues in London were allowed to open their doors, but not as late-night music venues. Corsica Studios at Elephant and Castle was the venue in which, from 2017 to 2020, we had run thirty-six Ø events where we would turn the main dancefloor of the club into an installation space. I decided to take video footage I had filmed with Bianca Hic on the road trip to the Scottish Highlands between lockdowns in October 2020 and put together a three-screen installation, which was open there for two weeks.

The visual material in this installation was captured during the journey around the North Coast 500. The first stop was an area near Durness on the A' Mòinhe peninsula, proposed site for the Sutherland Spaceport which had aimed to be the UK's first vertical launch site for rockets taking satellites into orbit, although it will probably be beaten by the Shetland Space Centre. We climbed Ben Hope, the most northerly Munro (a mountain with an elevation of more than 3000 feet or 914 metres), which provided a vista over the empty moorland of the would-be spaceport, and explored the area generally, stumbling across the surreal spectacle of the wide white expanses of Balnakeil Beach, a proposed and then abandoned Cold War listening post near Cape Wrath. Local legend suggests that Russia had shaved a couple of minutes off the time that its nuclear missiles would take to arrive in the UK, so the early warning wouldn't be early enough. Almost like a desert mirage, but in the dreich drizzle and without the heat, just as we arrived, in the distance a military convoy rolled across the beach.

We then headed to the Isle of Skye, spending some time at the anomalous rocky outcrop of the Old Man of Storr, a view that I'd first become aware of as the opening scene of the film *Prometheus* (2012) and which ended up on the front cover of *Astro-Darien* and was reconstructed in Lawrence Lek's animation. So the road trip produced some photos, video, and, more importantly, an abstract cartography that grounded the sonic fiction and provided a point of departure for its speculative line of flight.

What is going on with the game *Astro-Darien*? During the first lockdown of the pandemic, holed up in my flat in South London, I spent a lot of time in the virtual world of *Death Stranding* by Hideo Kojima. From its storyline of post-apocalyptic reconstruction and interdependence, to its relentless long walks through spectacular digital landscapes, to its inter-level bleeping sound design, it really got under my skin. Much of our road trip, and the landscape of *Astro-Darien*, was inspired by the game's virtual hiking.

The imaginary videogame *Astro-Darien* is produced by the fictional production company Trancestar North. I was curious about what the original developers of *Grand Theft Auto,* Rockstar North, a company based in Scotland, would produce if they were to make a game about the break-up of the UK instead of simulating American street life. *Astro-Darien* is a geopolitics simulation of the history and future of the UK. We're in the mind of a game designer of Panamanian descent, Guna Yala, mapping all of this out. Bearing in mind the real history of the Darien Scheme, she is trying to exorcise those ghosts and the shadows of Scotland's joint colonial exploits with England in the eighteenth and nineteenth centuries. She is building game levels with an almost utopian outcome given the dire terrestrial reality, but programming them so that it's literally impossible to repeat the mistakes of the past. She has at her disposal the ability to write future history by feeding the predictive AI at the heart of the game engine with a fairly comprehensive history and geopolitics of the UK. In order to do this, she relies primarily on the research of one of Scotland's leading historians, Tom Devine. The AI, T-Divine, is named after him, and is programmed to simulate and generate playable possible futures post-UK. After all, the real-world quest for Scottish independence seems to indicate a game: if you don't get the referendum result you want, you play it again and again until you get a better result.

There is a quote in *Astro-Darien* that gets close to essence of the project. In an essay on Cosmism by Benedict Singleton entitled 'Maximum Jailbreak', he writes of the Cosmists' 'refusal to take the most basic factors conditioning life—gravity and death—as necessary horizons for action' and of the need

> to consider the earth as a trap, and to understand the basic project of humanity as the formulation of means to escape it—to conceive of a jailbreak at the maximum possible scale, a heist in which we steal ourselves from the vault. [...] Escapology not escapism.[2]

I take liberties with Singleton's essay to speculate on a Caledonian Cosmism, with the escape from the gravitational well of London's centre of governmental power transcoded vertically into an escape from Earth's orbit.

So *Astro-Darien* is a kind of weird documentary about the UK political situation, post-Scottish independence referendum, post-Brexit, and post-pandemic. It asks how Brexit can be turned against itself, against the kind of English nationalism that inspired it. *Astro-Darien* takes the Brexit algorithm to its logical conclusion, so that the rest of the UK breaks away from England, and reflects on the extent to which this marks a final threshold in the history of British Empire, a final nail in the coffin of the Empire, forcing England to confront itself beyond its self-image as an imperial nation of global significance.

Reflecting a hostility to nationalism, in my deployment of Singleton's quote, escapology is a carefully devised strategy to escape a trap, to achieve independence, while the escapism of nationalism is ultimately conceived of as a short term, dead-end strategy. The political gulf between London-based governments and what Scotland wants has been widening for a long time. But given that the sheer weight of unionism in the British media and political establishment both left and right is so overpowering, perhaps the science-fictional version is more likely. Brexit made the idea of the UK look totally outmoded, and so this *Astro-Darien* project is really channelling those frustrations.

This reactionary inertia in the British establishment would have to be overcome for Scottish independence to happen, in addition to the obstacles of

2. B. Singleton, 'Maximum Jailbreak', in A. Avanessian and R. Mackay (eds.), *#accelerate: The Accelerationist Reader* (Falmouth and Berlin: Urbanomic/Merve, 2014), 489–507 : 498

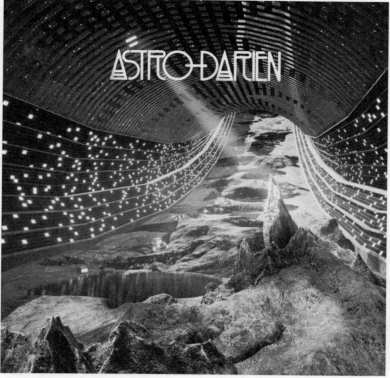

Digital world: Lawrence Lek, Typography: Optigram

regressive nationalism, what happens to the currency, and its relation to neoliberalism, etc. So while it faces all these hurdles in reality, in the short term, it can happen fictionally as myth. *Astro-Darien* is an escape pod which can happen virtually and gather momentum in this alternate reality. It is therefore not really set in the future, but is rather an alternate version of what's going on right now, and that's the sense in which I call it a documentary fiction.

The Darien Scheme and Scotland's subsequent involvement in colonialism, imperialism, and slavery are chapters of history that are becoming more visible. There is no point in being romantic about the past. Vigilance against the dark side of the country's history and those reactionary tendencies that foreground national purity or hostility to the outside and the alien is key. *Astro-Darien*, with

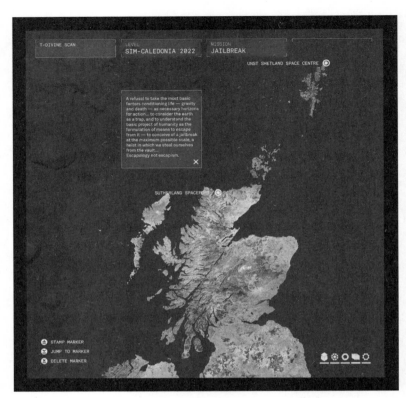

Map: Lawrence Lek, GFX: Optigram

its exit portal to a quasi-utopian orbital space habitat, is an attempt to reckon with all that.

As for the prospect of Scottish spaceports, while the space industry is adjacent to the military-industrial complex and to *Elysium*-style fantasies of the rich escaping a blighted planet, it can't be conceived as a purely dystopian development. Spaceports might in fact be a response to a number of dystopian trends: if it wasn't for orbital satellites there wouldn't be anywhere near as much concrete data regarding climate change. They would also inject some economic life into rural areas undergoing massive depopulation. The proposed spaceport around Sutherland, for example, is supported by much of the local community, but has met with resistance from, among others, a Danish billionaire, Anders

Map: Lawrence Lek, GFX: Optigram

Povlson, who owns vast chunks of the Highlands and who, along with Lockheed Martin, is backing the Shetland Space Centre proposal.

While I've never been much of a fan of the 'space opera' subgenre of science fiction, the spaceport plans, after I finished the project, led me to a strain of Scottish SF that runs through the poet Edwin Morgan and the novels and short stories of Alasdair Gray, Ken Macleod, Iain Banks, Andrew Crumley, Matthew Fitt, Michel Faber and others, which feature glimpses of weird scenarios such as interdimensional portals at the Glasgow Necropolis, UFOs over the Highlands and aliens abducting hitchhikers travelling across them, factory-farmed humans sent off to other planets, faster-than-light interplanetary submarines built in Greenock, nuclear explosions at Rosyth,

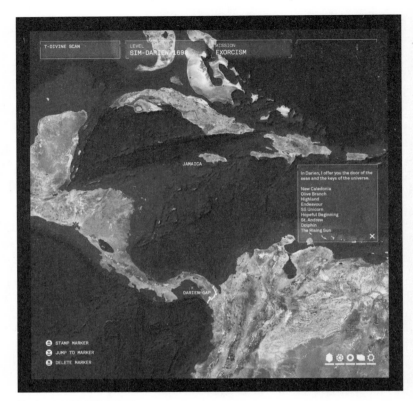

Map: Lawrence Lek, GFX: Optigram

NATO torture centres on the Western Isles, a submerged UK with the only land above water being the peaks of northerly mountains and the remaining habitants living on floating oil platforms.

Chinese science fiction writer Cixin Liu's *Three-Body Problem* trilogy did however cast a shadow over *Astro-Darien*, both in its depiction of the history of civilisation unfurling in microcosm in a simulation game whose distinction from reality becomes uncertain, and in the somewhat brutal scene in the final volume *Death's End*, where humanity has been quarantined into Australia by the invading aliens, the Trisolarians. Under threat of immanent genocide, there is a mad panic to escape Earth. The book is set in an era of widespread space travel, so the scene depicts hundreds of tiny spacecraft all attempting to take

Digital world: Lawrence Lek, GFX: Optigram

off simultaneously, with much collision, bodies charred by fusion drives, and generalised chaos. This idea filtered into *Astro-Darien*, inspiring the frantic, vertical exodus you can hear in the background of the piece.

Another key text that looms large in the *Astro-Darien* cocktail is *Space Settlements* by Fred Scharmen, in which he describes the findings of the 1975 NASA Summer Study, a conference that brought together scientists, engineers, and artists to speculatively explore humanity's prospects of survival in space.[3] One of the proposals was the Stanford Torus. Previously proposed by Werner von Braun and Herman Potocnik, this idea for a rotating doughnut-shaped space habitat came up again in 1975 in original paintings by Don Davis and Rick Guidice.

3. F. Scharmen, *Space Settlements* (New York: Columbia University Press, 2019).

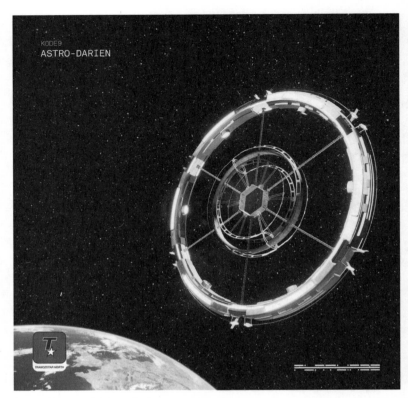

Digital world: Lawrence Lek, Logos: Optigram

It was the basis for the architecture of *Astro-Darien*, designed by Lawrence Lek. It was literally the same CGI wireframe as the Nøtel, a fully automated luxury hotel which Lawrence had designed for my last album *Nothing*, rotated and launched into orbit in a gravitational well, a Lagrange Point, between the earth and moon. But instead of an escape pod for the one percent (as in Neill Blomkamp's film *Elysium* [2013]), it becomes a quasi-utopian inverse Elysium. Both of these projects have used architecture to explore and satirise utopian and dystopian dimensions of accelerationist philosophy.

Over the last few years, I've worked with Lawrence on some collaborations (the Nøtel project and his recent *Death Drive* film, where we worked together on the score) and I had watched with interest as he developed his Sinofuturist

trilogy of films, (*Sinofuturism 2046*, *Geomancer*, and *Aidol*). I really liked the way he used game environments in a cinematic way to create these eerily depopulated digital landscapes. Hence the use of the framing device of a videogame to think through aspects of the *Astro-Darien* universe. Lawrence and Optigram also made a couple of animations to help visualise aspects of this universe, and we share an interest in what happens when you start a process of worldbuilding with sound as opposed to image. Both the Nøtel and *Astro-Darien* allowed us to explore this idea of sonic fiction, where even a visual project can start from the sound, which is obviously the opposite of most film and videogame projects, where sound is an afterthought, both in terms of production time and budget.

As far as the sonics of *Astro-Darien* are concerned, the piece is mostly narrated by synthetic voice models (Fiona, Heather, and Stuart) trained on Scottish accents, making a welcome change from the default Anglo-American presets of text-to-speech systems. Their uncanny valley dialects swing stylistically between the convincingly human and an automated Scotrail timetable announcement. This was partly a mid-pandemic convenience, partly the result of wanting the production to be a collaboration between an array of virtual voice actors, and partly to evoke the cold affective tone of a blighted, uninhabitable planet. The characters you can hear include an unnamed female narrator, probably the vocalisation of the AI T-Divine, the game designer Guna Yala, William Patterson (instigator of the Darien Scheme and also co-founder of the Bank of England), King William of Orange, and Earl Moxham, a Jamaican journalist who featured on a BBC documentary concerning Scotland, slavery, and the Caribbean.

More than space opera science fiction, the interest in space derived primarily from two musical strains. Around five years ago, I came across a retrospective vinyl box set of Caledonian futurism called *Official Guide to Scottish Minimal Synth 1979–83*,[4] featuring groups such as The Klingons, Final Program, The DC3, Dick Tracy's Wrist Radio, 100% Manmade Fibre, and Al Robertson. Clearly heavily influenced by Kraftwerk, I had no idea this stuff existed at the time. I made a little mix last year which Robin Mackay tagged '*Dreichwave*',[5] and which connected the stuff I was aware of in the early eighties (the Associates, early Simple Minds, and so on) with this new haul of old material from that period.

4. Vinyl on Demand VOD127, 2014.
5. <https://soundcloud.com/kodenine/dreichwave>.

There is also the key role of Afrofuturist sonic imaginaries, from Sun Ra onwards, as mapped out in the Black Audio Film Collective's film essay *The Last Angel of History* (1996). That film was an important influence in setting up the record label Hyperdub and also for my book *Sonic Warfare*.[6] This is a crucial tradition of using electronic music as a speculative probe to envisage alternative, better (or worse) futures, of using outer space as an oblique canvas to explore the terrestrial. It was most compellingly mapped by Kodwo Eshun in his now canonical book *More Brilliant than the Sun*, in which he develops the idea of 'sonic fiction', of fictional worldbuilding conveyed through sound, through instrumental music but also in sleevenotes, LP artwork, and track titles.[7] Kodwo gives specific examples such as Drexciya, who created a whole underwater mythos relating to the colonisation of the African continent, the middle passage, and slavery. But sonic fiction can obviously also involve voice, and in this sense it might overlap and resonate, extremely productively, with what we are referring to as audio essays, experimental radio fiction, and speculative audio documentary.

While this project has accumulated imagery as it has evolved, it emerged from the sonic, and sound, even in its extra-vocal abstraction, serves as the driving force of the narration, evoking the disintegration of the UK, the historical flashbacks to Darien, the escape off-world, and the struggles and battles involved in dealing with the attempted sabotage of the orbital space habitat. In the process of its development, *Astro-Darien* also spawned an instrumental, more upbeat version, *Escapology*,[8] to underscore the action scenes of the fictional game, with each track representing gameplay levels. It loses most of the narrative voices of *Astro-Darien* while being animated by rhythmic engines drawn from footwork, juke, jungle, gqom, and the basslines of amapiano.

6. S. Goodman, *Sonic Warfare: Sound, Affect, and the Ecology of Fear* (Cambridge, MA: MIT Press, 2009).

7. K. Eshun, *More Brilliant than the Sun: Adventures in Sonic Fiction* (London: Quartet, 1998).

8. Hyperdub HYPLP004, 2023.

Matt Colquhoun

Footwork/Dreamwork: On Recent Developments within the Hardcore Continuum

On DJ Rashad's 2013 album *Double Cup*, Mark Fisher heard an apparently new approach to the digital audio interfaces and dancefloors of the twenty-first century. But Rashad's growing popularity throughout the 2010s also complicated the then-accepted temporality of dance music's development. In listening to Rashad's debut album, Fisher argued, 'we are in the presence of something which scrambles the defaults of rear-view hearing'.[1]

Today, the album is recognised for bringing footwork to the attention of a newly networked global ear, but the genre's origins can be traced back to innovations made by the likes of RP Boo and DJ Godfather (among many others), in Chicago and Detroit respectively, during the latter half of the 1990s. Nonetheless, 2013 appeared to be the moment for which footwork had been lying in wait, as the affects it expressed better reflected and converged with the conditions of an even more digital world. *Double Cup* thus arrived like a subcultural manifesto belonging to an alternate rave universe, landing with a bold contemporaneity that simultaneously demanded the rewriting of history.

Footwork's scrambling of dance music's history was made apparent in a number of ways. Despite arguably sharing more DNA with US ghetto house than with UK jungle, it wasn't long before the genre was absorbed into the hardcore continuum regardless. Footwork's use of breakbeats means that its inclusion within this continuum is hardly inappropriate, but it is all the more significant because, as Simon Reynolds had previously argued, UK hardcore produced 'unique mutant versions of House and Techno [...] by adding elements from dub reggae, dancehall, and hip hop that weren't British in origin, but equally would

1. M. Fisher, 'Break It Down', *Electronic Beats*, 22 October 2013, <https://www.electronicbeats.net/mark-fisher-on-dj-rashads-double-cup/>.

never have been let into the mix back in Chicago and Detroit'.[2] Footwork's broken house rhythms immediately challenged this assertion, complicating the popular understanding of much that apparently came before it by lashing together transatlantic sounds to create an audacious new construction—one that resembled certain strands of hardcore, whilst expressing affects more appropriate to now.

As Fisher observed, whilst jungle 'used digital technology to smooth out some of the hard lines that had been characteristic of early computer sound and imagery, footwork [...] deliberate[ly] opted for [an] angularity' that reflects and exacerbates the 'frustrated, angular time' of the present.[3] This is most apparent in footwork's sampling of speech and song. Whereas jungle often used samples of speech from film or soulful lines of vocal melody to juxtapose with its inhuman drum patterns, footwork's samples are typically clipped, stuttering. As Rashad stabs at the pads on his Akai MPC 2000XL, his samples echo the scratchadelic approach to the human voice utilised by early hip-hop DJs and electro artists, allowing the voice to become yet another percussive element within each track, newly entwining human and machine whilst also retaining a rhythmic friction between the two. Previously, jungle had already affirmed the seductive otherness of the machinic—something Fisher famously heard on Rufige Kru's 1992 track 'Terminator', which 'actively identified with the inorganic circuitry beneath' the cyborg's fake flesh[4]—but footwork is less a subcultural flirtation with the machinic and more the direct product of an uncomfortable posthuman immanence. Through its more hostile and abrasive sound, footwork affirms our perverse and immersive enjoyment of the broken, glitching machinery that defines our contemporary era of communicative capitalism and the fizzing subjectivities it produces.

Fisher notably went on to compare footwork's staccato rhythms to those of the animated GIF—at the time a relatively new form of cultural gesture. It is a fitting analogy, as the GIF epitomises the use of extralinguistic signifiers synonymous with social-media communication today. But, extending Fisher's

2. S. Reynolds, 'The Wire 300: Simon Reynolds on the Hardcore Continuum: Introduction', The Wire, February 2013, <https://www.thewire.co.uk/in-writing/essays/the-wire-300_simon-reynolds-on-the-hardcore-continuum_introduction>.

3. Fisher, 'Break It Down'.

4. M. Fisher, Ghosts of My Life: Writings on Depression, Hauntology and Lost Futures (London: Zer0 Classics, 2022), 31.

analogy into less technological and more psychoanalytic territory, we can also hear how footwork's glitching GIF-like vocal samples flutter like 'butterflies caught in the network of signifiers'.[5]

These butterflies denote the half-speech of *lalangue*, Lacan's term for 'all those "parasites" of speech—stuttering, muttering, rumbling—that trace the remains of unconscious experience not properly signified'.[6] Such a reference to psychoanalysis is hardly inapposite here. Both the dancefloor and the psychoanalytic couch are sites for (re)problematising the relationship between intellect and affect, between conscious and unconscious communication. But the dancefloor is arguably more significant than the couch today. Alongside '[t]he bedroom [and] the party', the dancefloor is one of the experimental and subcultural 'labs' available to us in the twenty-first century, where contemporaneous 'nervous systems assemble themselves'.[7]

Footwork's deconstructive approach to language skirts around the habitus of everyday intelligibility, recentring itself on percussive alinguistic affects that do not entirely alienate us from sense and meaning but rather emphasise a dancefloor *lalangue* over and above any communicative utility. On the *Double Cup* track 'Let U No', for example, the promise of communicated knowledge is perpetually suspended. 'I'm about to let you know', it begins, followed by the truncated line, 'You make me so, so, so...'. The implied relationship between intellect and affect is never settled, and in its jagged repetition, the intended meaning of each sample slips until the words become raw sonic materials. This is an indirect appropriation of *lalangue* that rejects the curative approach of psychoanalysis, the experience of which intends to highlight the splitting of subjectivity before attempting to 'speak' to the unconscious mind, and instead communes directly with the embodied double consciousness of intellectual and affective experience, as well as that produced by communicative capitalism more generally.

The distinction between the split subject of Lacanian psychoanalysis and the double consciousness of (a more explicitly racialised) subjectivity under capitalism is subtle but worth highlighting here. For Frantz Fanon, 'it is implicit

5. B. Patsalides and A. Patsalides, '"Butterflies Caught in the Network of Signifiers": The Goals of Psychoanalysis According to Jacques Lacan', *Psychoanalytic Quarterly* LXX (2011), 201–30: 202n3.
6. Ibid.
7. K. Eshun, *More Brilliant Than The Sun: Adventures in Sonic Fiction* (London: Quartet, 1998), 00[-001].

that to speak is to exist absolutely for the other', and it is therefore necessary that we communicate in ways that are intelligible to the other if we hope to have our humanity recognised.[8] It is this process that splits us, and for Lacan, this splitting is universal within human experience. But for Fanon, we must also consider the ways that this pressure to speak in a common language has been forced on other cultures through imperialism: 'To speak means to be in a position to use a certain syntax, to grasp the morphology of this or that language, but it means above all to assume a culture, to support the weight of a civilization.'[9] The heavy tongue that has broken the back of many a Black body is that of Western civilisation, rather than that of a Black diaspora more generally. Footwork, affirming its Black subcultural status like hip hop and jungle before it, also affirms its absorption into the hyperspeed fragmentation of a machinic world, and refuses to participate in any clear communication whatsoever.

With this in mind, we might alternatively argue that footwork's approach to the vocal sample is more akin to a kind of digital creolisation—a process whereby different languages contract and combine in a hybridisation that is fugitive to the standardisations of linguistic imperialism. Dance music's relationship to Blackness is, of course, integral to any consideration of its affective history. Its rhythms simultaneously evoke the stomping of liberatory protest and the beating—both literal and figurative—of marginalised bodies by racial capitalism. As Édouard Glissant once wrote of creolisation: 'The discourse of various peoples brings a certain pace and rhythm to this stabbing pulsebeat.'[10] These rhythms stammer and mutate linguistic expression in equal measure.

Glissant is here referring to the adaptations of language brought about by globalisation in the aftermath of the transatlantic slave trade, but his words are no less applicable to footwork's tinkering with linguistic expression in the age of digital globalisation via the internet, which affects bodies of all kinds. Footwork, in this way, takes an approach to recorded speech that scrambles sense in a manner not dissimilar to creolisation, imbuing the footwork producer with the 'capacity [...] to descend, like Orpheus, into the underworld of the collective

8. F. Fanon, *Black Skin, White Masks*, tr. C.L. Markmann (London: Pluto, 1986), 17.
9. Ibid., 17–18.
10. É. Glissant, *Caribbean Discourses: Selected Essays*, tr. J. Michael Dash (Charlottesville, VA: Caraf Books/University Press of Virginia, 1999), 3.

unconscious and to emerge with a song that can reanimate a petrified world'.[11] And since this process retains a relationship with a broader collective unconscious, a psychoanalytic reading is no less relevant here.

It is as if *footwork* represents the other side of a cultural *dreamwork*. Indeed, if, for Freud, dreamwork is the active (intellectual) labour of interpretation applied to unconscious messaging, footwork more affectively interprets rhythms of music and broken speech through experimental dance, the dancer's immediate identification with its sonic patchwork further complicating Lacan's famous insistence that 'the unconscious is structured like a language'. A twenty-first-century unconscious is structured more like a dancefloor.

Rather than understanding the unconscious as being 'made up of "chains of repressed signifiers" that relate to one another through their own rules of metaphor and metonymy',[12] on the dancefloor we find signifiers stripped for parts, salvaged and reassembled according to temporalities that are more complex and polyrhythmic than those of speech in general. On dancefloors, then, we bear sonic witness to the return of the repressed in another form, which always escapes language and the enunciating requirements of psychoanalysis proper. In this way, footwork does not hope to make sense of the alinguistic messages projected outwards by the (collective) unconscious, but rather lingers schizoanalytically in the unsettled affects of an embodied expressionism newly networked with contemporary machines—a form of expression that 'characterizes *both being and knowing*', eliding any clear demarcation between the two;[13] a form of expression that 'involves the body, but is explained by the influence of other bodies [...] composed of extensive parts that are determined and affected from outside, *ad infinitum*.'[14]

We might consider DJ Rashad and Freshmoon's track 'Everybody' as a prime example of this expressionistic tension within footwork. Taken from the 2013 EP *I Don't Give a Fuck*, the track samples a meme popularised on the now-defunct

11. J. Michael Dash's summary of the creative impulse at work in Glissant's writings. J.M. Dash, 'Introduction' in ibid., xiv.

12. G.P. Perman, 'Jacques Lacan: The Best and Least Known Psychoanalyst', *Psychiatric Times* 35:12 (December 2018), <https://www.psychiatrictimes.com/view/jacques-lacan-best-and-least-known-psychoanalyst>.

13. G. Deleuze, *Expressionism in Philosophy: Spinoza*, tr. M. Joughin (New York: Zone, 1992), 181, my emphasis.

14. Ibid.

platform Vine. It seems almost quaint today, slow even, in an era when a staple of many DJ sets is the accelerated funny edit—which doesn't so much avoid a contemplative seriousness but ridicules it explicitly, as ever-increasing BPMs race ahead of what might otherwise be considered common sense or good taste. By contrast, jungle and drum'n'bass have passed through a desire to be taken more seriously.[15] But moving against this development, footwork returns the body to the fore, in all of its complexity, refusing to neatly untangle the contradictions of human experience, and instead staying with the trouble of contemporary subjectivation.

The choice of sample on 'Everybody' is all the more relevant here. It centres on the comical wail of a man featured on a 2010 episode of the American documentary TV series *Intervention*, in which friends and family confront individuals struggling with substance abuse. 'Because I know, somewhere deep down in my heart, I still love you', the man exclaims, his voice cracking before giving way to an almost cartoonish 'waaahhhhhh'. The track—like the meme before it—retools this cry, shifting the clip's relationship to addiction, even embracing it, taking an almost Burroughsian cut-up approach to this act of social intervention and creating a newly addictive and contradictory earworm out of it.

As Fisher once wrote of the work of William Burroughs: 'Whether hungering for a drug, for orgasm or for images, the principal figure of human bondage in Burroughs' universe—the addict—is enslaved to exogenous forces.'[16] Rather than moralise against this subject-position, Rashad and Freshmoon, like Burroughs before them, take the cracked utterances of human subjectivity and re-utilise them as raw sine waves, turning this abject expression of emotion back onto dancefloor bodies, further scrambling the original context and reorienting the interpersonal friction of televised group analysis towards the newly embodied facetiousness of collective rave joy.

15. As footwork made itself heard on dancefloors across the world, some drum'n'bass producers were collaborating with orchestras—as many formerly underground artists have been tempted to do, on contact with the overground of canonical 'proper' music—as if an adjacency to classical music represents the final acceptance of the underground's more contemplative tendencies. Consider, for example, the re-imagining of Goldie's 1995 album *Timeless* by the Heritage Orchestra, first performed at London's Southbank Centre in 2014. See <https://theheritageorchestra.com/projects/goldie/>.

16. M. Fisher, 'Emotional Engineering', *k-punk*, 3 August 2004: <https://k-punk.org/emotional-engineering/>.

This relationship to drugs is no less explicit on *Double Cup*, being alluded to on at least half the album's tracks. The album's title is itself a reference to the usage of two Styrofoam cups to hold lean, a mixture of cough syrup and soda. The question of why two cups are used is a frequent topic of discussion on internet forums. Today, it may be nothing more than an aesthetic choice. One user of Reddit, however, suggests the two cups were first used for mixing the two liquids together, as well as helping to keep the drink cold. Another suggests they are used to prevent leaks and seepage.[17] Whether or not there is any truth to these explanations, the double cup is an interesting symbol for footwork's hybridisations: a psychedelic container for the double consciousness of racial-ised subjectivity, or the new commingling of human and machine that makes its sonic recombinations of affective materials all the more potent.

However, because of these references to drugs, alongside its unseriousness and its frustrating of any discursive intelligibility, footwork's affective angularity momentarily reignited a dismissive tendency within popular music (and par-ticularly rockist) discourses that has plagued dance music for decades. Indeed, for all its untimely futureshock, footwork once again goaded rave-sceptics into debating dance music's utility. As Fisher noted, like various genres before it, footwork was 'being written of as something that you can't dance to at the same time as it is dismissed as a functional music, something that would only be properly appreciated by those dancing to it'.[18] It is a music that illuminates, once more, the tensions at work in our attempts to conceptualise subcultures of dance music and the non-philosophical preservation of the affects—or more precisely, the 'structures of feeling' (Raymond Williams)—they produce within us.

This dichotomy is, of course, a false one; nevertheless, it is a disparaging comment that would already have been familiar to many dance music aficio-nados. Warp Records' lauded 1992 compilation series *Artificial Intelligence*, for example, famously played with this mind-body problem in a similar way. Its pio-neering of a so-called 'intelligent dance music' (or IDM) was a challenge to the popular derision of rave culture as a home for broadly 'stupid' genres, wherein the mind-expanding psychedelia of dance music ran parallel to a moral panic

17. See 'Why Do People Double Cup Lean?', *Reddit*, 31 October 2015, <https://www.reddit.com/r/OutOfTheLoop/comments/3r0fds/why_do_people_double_cup_lean/>.
18. Fisher, 'Break It Down'.

surrounding its penchant for drug-induced mindlessness. IDM thus pushed for a kind of dancefloor-adjacent sound, as useful for the chemically burned-out inhabitants of the chill-out space as it was for the wistful armchair listener in their living room, or otherwise bridging the gap between experimental dance music and modern classical composition.

Today, rather than joust with rockist cynicism directly, more 'ambient' genres of music defiantly take the intractability of intellect and affect as a given. Footwork arguably has its own counter-genre in this regard, albeit one that is largely under-theorised in such a context. In the UK, footwork's popularity has been spearheaded by labels including Hyperdub and Planet Mu—two imprints with close ties to the Chicago footwork label Teklife—and the former has more recently published a series of intriguing counterpoints to this dancefloor mindlessness in the form of a series of audio essays. The Hyperdub sublabel Flatlines, in particular, presents us with a view of this mind-body problem from the other side.

On the one hand, Flatlines is the natural extension of an experiment first implemented at Hyperdub's Ø nights, inaugurated at London's Corsica Studios in January 2017.[19] Usurping the stereotype of the chill-out room as a makeshift ward for amphetamine casualties, attendees of Room One would find installations of audio-visual essays and artworks that offset the often organ-rattling DJ sets and live music performances next door, with each room newly and explicitly informing what was happening in its neighbour.

On the other hand, Flatlines signifies a return to the theory-fictional tendencies of the Cybernetic Culture Research Unit (Ccru), now infamous for its para-academic distorting of contemporary philosophy in the late nineties and early noughties. Its audio experiments, often produced in collaboration with the Orphan Drift collective, cyberpositively affirmed the digital distortions of written and spoken language explicitly. These experiments were not produced in a vacuum, however; they retained an implicit relationship to the hardcore continuum in general. Indeed, just as footwork has continued to mutate the dancefloor's relationship to language in the age of social-media communication, these sonic artworks drew on the tandem twisting of linguistic expression on both the dancefloor and the internet, implementing their shared cut-up aesthetics in other

19. See: Optigram, S. Goodman, S. Simpson-Pike (eds.), Ø (London: Flatlines Press, 2021), <https://hyperdub.net/products/o-book>.

contexts, such as lecture halls or art galleries.[20] This diverse array of cultural happenings engaged in a 'kinaesthetic' process of cultural deterritorialisation, 'overrid[ing]' that pre-modern binary that insists the dancefloor is all mindless bodies and the bedroom nothing but bodiless minds',[21] and it is precisely with this in mind that we can better understand how the audio essay relates to the hardcore continuum today.

The name 'Flatlines' is a clear reference to a term first conceptualised by the Ccru as referring to a smooth space of zero intensity.[22] Its reference to the line, however, should not be understood as promoting linearity. 'The distinction [between line and twist] no longer concerns a single aggregate or subject; linearity takes us further in the direction of flat multiplicities, rather than unity.'[23] It is a line that is at once impossibly entangled and impossible to disentangle.

For Mark Fisher specifically, the flatline 'has two important senses, referring to (1) a state of "unlife" (or "undeath") and (2) a condition of radical immanence.'[24] On the one hand, it 'indicates a vernacular term for the electroencephalogram (EEG) readout that signals brain death; a representation, on the digital monitors, of nothing[,] no activity'. On the other hand,

the flatline is where everything happens, the Other Side, behind or beyond the screens (of subjectivity), [a] site of primary process where identity is produced

20. The ultimate iteration of this deformed speech was given the name 'Tic-Talk' by Nick Land in the mid-2000s, referring to an 'ultimately decoded numerical semiotic, stripped of all nonconstructive (or symbolic) conventions'—a decoding we might similarly hear in the digital cutting-up of footwork's vocal samples. Whereas 'Tic-Talk' affirms a cyberpositive decoding, today the TikTok platform demonstrates communicative capitalism's ability to reterritorialise fragmented short-form media into a newly addictive matrix of likes and shares. As indicated by our discussion of DJ Rashad and Freshmoon's Vine-sampling track 'Everybody', however, this fragmented media and the tics it induces are still fuel for second-order deterritorialisations of other kinds. See: Nick Land, 'Tic-Talk', in *Fanged Noumena: Collected Writings 1987–2007* (Falmouth and New York: Urbanomic/Sequence Press, 2013), 607–22.
21. Eshun, *More Brilliant Than The Sun*, 02[023].
22. Ccru, 'Flatlines', in *Writings* 1997–2003 (Falmouth and Shanghai: Urbanomic/TIme Spiral, 2017), 101–19.
23. G. Deleuze and F. Guattari, *A Thousand Plateaus*, tr. B. Massumi (London and New York: Bloomsbury Academic, 2013), 68.
24. M. Fisher, *Flatline Constructs: Gothic Materialism and Cybernetic Theory-Fiction* (London: Zer0 Books, forthcoming).

(and dismantled): the 'line Outside'. It delineates not a line of death, but a continuum enfolding, but ultimately going beyond, both death and life.[25]

It is worth noting that, for Simon Reynolds, who coined the phrase, the 'hardcore continuum' is itself a kind of flatline. It does not simply refer to a linear theory of dance music's canonical development and progression, but rather the atemporality of its various innovations and their relationship to music-industrial hype machines—a space for all possible connections. Of course, the hardcore continuum is nonetheless 'empirically verifiable'; 'there is a body of testimony and reportage [that] relates to the analysis of how this subcultural and musical entity came into being, what governs its development and mutation, where it fits into the grand scheme of music'. But for Reynolds, attempts to linearise this testimony are 'fun but foolhardy because the continuum [...] will always ambush you with some new twist, a mind-wrenching paradigm shift.'[26] The hardcore 'continuum', in this sense, is an infinite space where dance music's disjunctive syntheses collide and fragment, producing ever more ruptures and hybridisations; where everything can connect with everything else. Though it is colloquially used today to refer to a journalistic canon of acclaimed music, it is better understood as an expressionistic force—in Deleuze's sense—that takes the full circulation of affective bodies into consideration, and which necessarily includes other forms of music and culture that may not be considered stereotypically 'hardcore' in nature. Just as Warp Records' forays into ambient music must be included in any account of dance music's history, as a kind of 'beatless' dance music that circulates alongside other genres in the hardcore continuum's broader sonic ecology, so must the audio essays of the 2020s.

This understanding of the hardcore continuum—although prefiguring the term itself—has been built into Hyperdub's output from the beginning, with label head Steve 'Kode9' Goodman recently reiterating that 'Hyperdub started as a kind of umbrella term to talk about the electronic music of the Black Atlantic that had converged into the 90s musical singularity of jungle'.[27] The Black Atlantic

25. Ibid.

26. S. Reynolds, 'The Hardcore Continuum, or, (a) Theory and Its Discontents', *Energy Flash*, 27 February 2009, <https://energyflashbysimonreynolds.blogspot.com/2009/02/hardcore-continuum-or-theory-and-its.html>.

27. M. Lawson, 'Kode9 on *Escapology* and *Astro-Darien*', *The Skinny*, 17 November 2022, <https://www.theskinny.co.uk/music/interviews/kode9-on-escapology-and-astro-darien>.

is Paul Gilroy's term for a moment of 'historical conjunction' which, like the flatline and the hardcore continuum, contains all of 'the stereophonic, bilingual, or bifocal cultural forms originated by, but no longer the exclusive property of, blacks dispersed within the structures of feeling, producing, communicating, and remembering that I have heuristically called the black Atlantic world'.[28]

It is within this amorphous set of relations that footwork and the audio essay come into contact, despite having very different relationships to the dancefloor. Indeed, although it may appear that the audio essay has no discernible relationship to the dancefloor whatsoever, whether heard in Room Two at Corsica Studios or in the comfort of one's living room, each implores the listener to suspend the easy separation of these two forms of cultural object in space and instead focus on the act of listening as a more amorphous activity that transversally crosses spaces, temporalities, and subjectivities of all kinds.

Double-cup the dancefloor track and the audio essay. No matter which of these cultural objects we are thinking of, the various samples of recorded speech allow us to 'imagine the listener weaving a path through this complex structure in such a way that they get fragments presented to them that perhaps don't immediately make sense, but that eventually give them a glimpse of this structure, which involves a resonance between different periods, different registers of experience, and different subjects'.[29] This structure, scrambling the defaults of rearview hearing, is the networked chaos of communicative capitalism, which (often disastrously) cuts through all that we might associate with the Black Atlantic, the hardcore continuum, and the flatline, in an attempt to make them profitable, whilst it also intersects with and further reveals the plane of immanence upon which they all interact.

This entanglement with the networks of communicative capitalism does not signify a regrettable complicity, but an intentional problematisation of the cultural objects it makes available to us. In decontextualising cultural signifiers spread across the platforms of contemporary capitalism, the sonic output of Hyperdub et al.—regardless of the disparate forms this output takes—returns us to the fractured realm of *lalangue*, retracing 'the remains of [a collective]

28. P. Gilroy, *The Black Atlantic: Modernity and Double Consciousness* (London and New York: Verso, 2012), 3.

29. Robin Mackay, *Sonic Faction* discussion, present volume, 32.

unconscious experience not properly signified'. Engaging in what Mark Fisher calls a 'digital psychedelia', each 'composes a plane of consistency from these orphaned semiotic-libidinal fragments' in its own way.[30]

Footwork fuses these samples together at an accelerated rate befitting of the present, whilst the audio essay takes a slower, more contemplative, but no less scrambling and alienating perspective on the listening subject. Both access the flatline. Each may have its particular mode of expression, with the 'dreamlike' qualities of the audio essay making its relation to dreamwork appear more explicit, but footwork nonetheless shares a similar relationship to cultural lacunae, escaping any purely discursive space—something demonstrated on both Kodeg's *Escapology* LP and its sister project, the audio essay *Astro-Darien*. Each album feels like the dream of the other; the dub of the other; a remixing and respatialisation of the other's affective qualities.

The audio essay, then, is not adverse to the 'uselessness' of rave; its con-templative tendencies are positioned provocatively across from dance music's stereotypical mindlessness. But rather than overcoming the rave in favour of the living room, the mind and body of the listening subject are forever caught between the two. Both spaces are labs for affective engineering. Just as the living room and the bedroom are 'not, or not just [...] domestic space[s] [...] where the family shelters from the harsh reality of the outside world, comforted by entertainment', nor is the rave (just) a hedonistic space that shelters its inhab-itants in similar ways; the flatline intersects them all, as 'ultrasensitive listening station[s]', as 'antennae where all the vibrations of culture can be picked up and resynthesized'.[31]

This tension is arguably modernist in nature, responding to an ethics and aes-thetics of active listening first proposed by psychoanalysis itself. For Lacan, the entire purpose of psychoanalysis was the re-writing of (an analysand's) history, implicitly understanding any 'psychoanalytic cure' as the positive re-narration of traumatic experiences. This is not so much a process of re-articulation—as if we only needed to find the right words to express that which bothers us inexpress-ibly—but rather a process of 'revelation'. As Lacan explains in his first seminar:

30. M. Fisher, 'Digital Psychedelia: The Otolith Group's *Anathema*', in *Death and Life of Fiction: Taipei Biennial 2012 Journal*, eds. A. Franke and B. Kuan Wood (Leipzig and Taipei: Spector Books/ Taipei Fine Arts Museum, 2012), 164.

31. R. Mackay, 'A Marker', present volume, 146.

Without doubt, speech is mediation, mediation between subject and other, and it implicates the coming into being of the other in this very mediation. An essential element of the coming into being of the other is the capacity of speech to unite us to him...

But there is another side to speech—revelation.

Revelation, and not expression—the unconscious is not expressed, except by deformation, *Entstellung*, distortion, transportation.[32]

Caught between the stuttering utterances of footwork and the ghosts of the audio essay, this is how we find ourselves: transported. Where exactly? It is hard to say. But to find ourselves on the other side of the communicative restrictions of the present is nonetheless a revelation.

32. J. Lacan, *The Seminar of Jacques Lacan, Book 1: Freud's Papers on Technique 1953–1954*, ed. J.-A. Miller, tr. J. Forrester (London and New York: Norton, 1988), 48–49.

Robin Mackay
A Marker

The following passages are drawn from transcripts of discussions during listening events, in conversation with: Matt Colquhoun, Natasha Eves, and Amy Ireland (online, for k-punk event, 2022), Mattin and Eleni Zervou (following playback of the piece during Mattin's residency at Cafe Oto, London, 2022), Amy Ireland and Katherine Pickard (following playback at Miguel Abreu Gallery, New York, 2022), Justin Barton and Amy Ireland (first Sonic Faction event at Iklectik, London, 2022), Natasha Eves, Zara Truss Giles, and Kitty McKay (for k-punk event, Fox and Firkin, Lewisham, 2023).

The (Un)Place Itself Over the centuries Dunwich has gone from being an important trading port to being a tiny little village with only one street. Apart from this remainder, the whole town has fallen down the cliffs into the sea as a result of the erosion wrought by the North Sea. Foremost among the lore that has developed around the ill-fated town is a spectral sonic phenomenon: it's said that, because a number of Dunwich churches have ended up toppling into the sea, sometimes you can hear the eerie sound of church bells clanging beneath the ocean.

Dunwich is a part of the territory both conceptual and geographic covered by Mark Fisher's book *The Weird and Eerie*,[1] a territory he would go on to explore with Justin Barton in the audio essay *On Vanishing Land* and in many of his writings. Mark and I both visited Dunwich as children—I remember listening for those waterlogged bells, and relishing the strange atmosphere of this place whose claim to fame is that there's nothing left of it.

Mark was a great connoisseur of M.R. James and loved the sixties TV production of 'Oh, Whistle, and I'll Come to You, My Lad'—which features two locations both of which were places I went on holiday as a child: Dunwich, and

1. M. Fisher, *The Weird and the Eerie* (London: Repeater, 2016).

Waxham Sands in Norfolk. So Mark and I both felt ulterior forces compelling us to go back and rediscover the place. I was only partly conscious of this at the time, but the more I think about the piece, the more movements of return and repetition and reiteration I discover, tangled up tightly together.

Loops Early on in *By the North Sea* I mention my father's death, which was sudden and traumatic, left so much unsaid and undone, and was still unprocessed at the time when Mark and I began planning our trip. A part of the motivation for returning there in 2001 must have been my memory of trips to Dunwich with my father, and his attachment to the county of Suffolk. On the same trips we also used to go and visit his parents in Felixstowe—just up the coast from Dunwich—where Mark lived for some years before his death.

In 2001 Mark and I had hatched a plan to take the Dunwich story and splice it together with bits of the mythos and the characters from the Ccru writings[2] and themes from H.P. Lovecraft's tales, and make a kind of hyperstitional documentary film. (I found some release forms we made up for our interviewees, where we'd called our imaginary production company 'Hyperstition Films'!) One of the key references was a passing mention in the Ccru's writings of the 'Tridentitarian Church of Dagon', elsewhere referred to as the 'Trinitarian Church of Dagon'. It's just a reference thrown out without any explanation, a loose end with an implicit reference to Lovecraft that gestures toward a whole series of aquatic, oceanic tropes—ideas about thalassic regression and geotraumatics— that appear elsewhere.

Mark, myself, and my then partner Ruth travelled by car from London to Dunwich in what was, at least in my memory, quite an epic journey. We did some filming and conducted a couple of interviews. But the project never went any further than that, and my friendship with Mark then fell back into the pattern it had followed ever since we had worked together in the nineties—long periods of non-communication. Retrospectively, now I can see there were many things at stake for both of us in that attempt to get back together and make something; in that sense too, it was an attempt at returning to something that had been lost.

2. Ccru, *Writings 1997–2003* (Falmouth and Shanghai: Urbanomic/Time Spiral Press, 2017).

An Ending I wrote essentially the whole script in the two months directly after his death. I was also working on editing the Ccru *Writings*, which Urbanomic republished, or in fact published for the first time in printed form, in 2017. So I was absorbed in the Ccru mythos. After Mark's death, the Dunwich project became something I couldn't let go of, a focal point for figuring out how to hold on, what to think, how to live, in the face of an ending. It became emblematic of the many things which, without him, would now definitively never happen. I realised almost immediately that throughout this long period when we hadn't really spoken much, I'd always assumed that there would be a time when everything we had shared was going to come back, when we would work together again, when we'd be in the same state of creative production as in that incredibly intense period in the nineties. Not nostalgia but certainty, rooted in a real virtuality.

Because throughout the years Mark was always someone I was in conversation with virtually, a constant presence, and that's no less true today. But actualising that was always deferred to a time which I assumed—*knew*—would come. So how to deal with the finality of an event that seemed to definitively rule out any such return?

Moreover, why had our contact been so sporadic and faltering? Every few years we had spoken about the Dunwich project again, so why did it never happen? A major factor in that was depression. The last phone call that I had with Mark, a week before he died, was about depression. A conversation which again ended with our saying that we should get together some time soon. Partly, *By the North Sea* interrogates the fact that we were in separate, non-communicating black holes, each of us perhaps thinking, in that dismal fashion that depression induces, that the other wouldn't want to talk to us.

Going back to this project and trying to make something of it was then an attempt to do something with Mark. And during the times I was working on it, it was *with* him, not *about* him, it was drawing on that virtuality, in spite of all actuality.

Unspeakable Rites The Dagonite cult tries to awaken the sleeping Old Ones by some kind of regressive ritual activities like those that Lovecraft always described in veiled terms. In Lovecraft this is linked to fear: fear of miscegenation,

a racialised fear of regression, contact with the biological past of the human, fear of sexuality, and fear of the countryside as opposed to the city—the simple folk with their old ways.... Well, if this Dagonite cult was going to pop up anywhere in England, it would have to be Dunwich—all of the conditions are in place there for that kind of fanaticism to arise, because the people of this town are literally witnessing the sea reclaim the land year upon year, including seeing a succession of churches, along with their graveyards, collapsing into the sea.

As the Lovecraft expert S.T. Joshi says in the piece, we don't know whether Lovecraft himself knew about Dunwich. He doesn't explicitly discuss the English town anywhere. and its melancholy story of attrition makes it more reminiscent of Innsmouth in 'The Shadow Over Innsmouth'. And yet—'coincidentally' or not—Lovecraft uses the name in one of his most celebrated tales, 'The Dunwich Horror'.

Our original idea for the documentary was that it would introduce all of these connections and would then speculatively extrapolate them, with a hyperstitional ambiguity hovering over the whole affair. There was in fact far more to the story we'd envisioned, plot threads that we were talking about at the time and which we discussed in the interviews that didn't make it into *By the North Sea*. Fish, fishermen, and Christianity (Dunwich was the entry point for Christianity into England); the Knights Templar presence in Dunwich, and the geopolitical history of the area: there's a spit of land that comes off the edge of the east coast there, and the economic fate of Dunwich was essentially bound to the action of the North Sea combing this spit of land downwards over years, over centuries, moving it around like a slow-motion tentacle that then finally closes off the port of Dunwich and renders it commercially unviable. Linked with that there was a bitter rivalry between Dunwich and Walberswick, the next port along the coast, along with political manoeuvrings, because wherever you have a town that used to be very populous and has become less so, you have the phenomenon of 'rotten boroughs'—too many members of parliament for too few people. There are all sorts of stories we dug up, and I couldn't include everything.

Shells The piece was constructed through multiple resonant returns, and it retains the imprint of that structure: a series of shells, one within the other, in resonance, at different levels of intensity.

The first voice we hear is that of Echidna Stillwell, who is writing letters to an unnamed correspondent about their research into the Dagon cult and the relationship of Dunwich to her anthropological hypotheses. Stillwell is the flatline, at zero intensity. And then there are outer shells. The outermost surface level is myself in 2017 returning to reflect on the 2001 project in the wake of the terrible event of Mark's death, and trying to make something out of the remains of it, to make something out of nothing, to make a version of something that can't be finished but only 'definitively unfinished' (a phrase borrowed from Duchamp).

There's the 2001 trip itself. And then there's this fictionalised version which I project back into the figure of the Ccru character Professor Templeton, who is perhaps the recipient of Stillwell's letters.

The result is a series of sedimented (and to get geological about it, sometimes *brecciated*—fractured and reassembled) textual and sonic layers. The main text spoken by myself in the piece was written in 2017, there are fragments from our recordings in Dunwich in 2001, and then there are other hyperstitional narratives drawing on the Ccru mythos which are set in 1968 and 1949, and which serve to lay out a conceptual space within which the other elements become embedded—a series of shells, a depth system or a system of intensity.

In terms of the process of making the piece, they are also drawn from different moments in time. The Ccru material all comes from the years leading up to the millennium. From 2001 there are the interviews with Stuart Bacon, a diver who runs Suffolk Underwater Studies, and Morgan Caines, the keeper of the Dunwich Museum. In addition, between 2001 and 2017, I'd gone back to the project, I'd sat and pored over this material and thought, *Can I do anything with this?* And I'd written the fictionalised version of our trip in which Mark becomes Templeton, and I'm his bewildered assistant. I was no doubt reflecting on a feeling that I know a lot of people shared being around Mark—that he's one of those minds that sometimes was just going too fast for you to follow. A great teacher and a great explainer, but when he was going full tilt then you really had to run fast to keep up with him. So that's a kind of wry fictionalised version of our trip, in the very English vein of a Conan Doyle story. At the time, I'd just left that attempted text behind, half-finished.

At the centre of this assemblage, the zero intensity upon which everything else floats, there are the meditations of Echidna Stillwell, who has been drawn into a series of philosophical questions concerning the fate of Dunwich. These parts were all written in 2017 but in a sense they come 'first': Stillwell is expounding the theoretical basis of the whole thing, which has to do with a shared latent pull toward the sea, the 'thalassic regressive trend' as described by psychoanalyst Sandór Ferenczi (and as rejected by Freud in his correspondence with Romain Rolland concerning the 'analysis of spontaneous religious sentiment'—for Freud the sea is a screen image for the infantile 'primitive ego-feeling', whereas Ferenczi will argue that 'the sea is not the symbol of the mother. The mother is a symbol of the sea').[3] The thalassal trend is the compulsion to return to the ocean, and

3. S. Ferenczi, *Thalassa: A Theory of Genitality*, trans. H. A. Bunker (Albany, NY: Psychoanalytic Quarterly, 1938), 19. 'Where Freud favours psychic reality, while renouncing the tangible in favour of

this is seen in inverted form in the whole Lovecraftian complex concerning a terror of the things that dwell in the deep, and the possibility of some hideous hybridity between humans and their deep ancestors—phylogenetic horror.

The conceit of our original project was that all of this was embodied in the idea of the 'Tridentitarian' Dunwich Dagon cult, whose scandalous activities had supposedly plagued Dunwich across the centuries. They were known to have conducted 'unspeakable rites' beneath the cliffs, calling to the Old Ones to accelerate the process of coastal erosion and draw them back into the sea. As in all good stories of this type, there's an ambiguity: were they just fanatics who had succumbed to a delusion because they were so affected by the spectacle of their town slowly being consumed by the water? Or were there really greater forces at work—had they in fact, owing to their contingent situation there in Dunwich, been afforded access to something anomalous? Had geological happenstance allowed them to tap into to an unconscious complicity with deep eldritch forces...?

In Stillwell's analyses we are clear of all of the specificities and contingencies of the empirical episodes; we reach a certain level of conceptual clarity on the nature of the Dagon cult's activities, and certain problems about time upon which they shed light (without assuming that these problems can be 'solved'; Stillwell herself is resigned to perplexity)....

The recording of the 'nomo chant' of the Dagon cultists is an incursion of material from yet another time period—it's taken from the Ccru/Orphan Drift collaborative CD *NOMO*, from the *Syzygy* project staged at Beaconsfield Arts in 1999.

Stillwell in 1949, Templeton in 1968, then 2001 and then 2017: each level is an iteration of the same struggle, the same attempt to discover an anomalous mode of time in which things can emerge that aren't already pre-accounted for within the security system of linear integrated history. The key to all of this is given right at the beginning, when Stillwell talks about the 'three modes of time', ascribed to the lost codex of the Tridentitarian Church of Dagon.

the spoken word, Ferenczi claims tangible and material writing, providing for the corpo-reification of the symbolic' (Roland Gori). See R. Mackay, 'Thalassa: A Fantasia on a Fantasia', in R. Mackay, L. Pendrell, J. Trafford (eds.), *Speculative Aesthetics* (Falmouth: Urbanomic, 2014), 97–105.

Navigating the System of Intensity There may seem to be a lot—too much—going on in the piece, but it's really the same thing resonating on all of these different levels in which the listener comes to participate. A nonlinear landscape of intensity: the listener has to make the effort to piece it together, just as I am trying to piece it together, just as Templeton's assistant is trying to understand what Templeton's up to, and just as Stillwell, at the end of her life, is trying to understand how all these different threads hang together.

I believe that in order to be successful a piece needs to be in tension, it needs to think and to enlist its listener in what it's thinking. There is a implicative structure to *By the North Sea*. As a listener you're traversing that structure in various directions as the piece progresses, so that it appears fragmentary and disconnected. Your journey takes place in a supplementary dimension to the work, if you like. The apparently fragmentary nature of the piece, then, is the sound of it protesting against its own form: by its nature as sound, it must progress linearly, but it needs to insist, to protest, that this linear playback runs counter to the real 'transcendental occurrence' that is at stake. Intensity always escapes the chronological timeline.

Sonic Construction The actual sound piece was tentatively built up over years. This is basically the same way I write, it's a clumsy, probing form of sculptural practice. I don't ever plan anything, I have elements that I need to include and I gradually scrunge them together until they form something that feels like it is meant to be there. So all of those different parts of the soundtrack arranged themselves, settling over a long period into the right shape. I don't necessarily know how to make it right, but if I sit for five years and move bits forward and backwards then I eventually arrive at some parts where I think, that's *exactly* how it should be. And those are the parts that make me really happy in the piece, where the movement and dialogue between the sounds seems just right. All of the bits are clinging together in the right way and they're all smoothed off at the right points and sticking out jaggedly at the right points, in directions that indicate what it's been built from, and I can turn it around in my head and think, *It's done.*

Music and Silence Among other things, I was thinking of John Carpenter soundtracks. When you see a film now, it sounds like there are five orchestras playing all at once continuously, constantly instructing you how to feel. In Carpenter's films there will just be long periods of silence and then one synth line. That's something they have in common with the low-budget seventies science fiction TV, like *Doctor Who*, which Mark and I grew up with: there's a lot of space in them, empty space—*Sapphire and Steel* is exemplary here—often coupled with a minimal use of synthetic sound. I didn't want to do too much, and I wanted to have something of that aesthetic. That was part of my sense of making something that Mark would have enjoyed, making reference to things that we were both into...and of course it's also very English, that was deliberate, I wanted it to communicate with that tradition of popular radio and TV which throughout the seventies provided extra work for Shakespearean actors in BBC plays and series, yielding a weird mix of the highbrow and the low-budget.

Why Go Back? Memorialising is the opposite of what I wanted to do. I wanted to put an end to the memorialising, to 'reopen the crypt' rudely, drag Mark out, and make something happen again. *By the North Sea* therefore had to think about the conditions of possibility for being able to make things, about the creative process. It's not a work of mourning. You could instead call it an act of *re-membering* in the sense of piecing something together (something anomalous and as-yet purely virtual), remembering in a productive rather than a nostalgic sense. What remained of the Dunwich project provided the clues that I was lucky enough to have at hand in order to enter into a working relationship and, in the wake of the loss, to be doing something that I knew Mark would enjoy, and that was a product of us plotting together.

When I was writing it in those truly desolate months—but months which were also a kind of awakening, there was a kind of lucidity to them—I would get these little sparks at moments when I'd written something and I would think, *Mark would like that*. And when putting it together as an audio piece, there were moments when I could imagine his delighted chuckle at the way two sounds fitted together, or the peculiar way a phrase is spoken or abuts onto another phrase. It was a way of being with him and of asking all of the questions that being without him raised.

In fact, I'd never forgotten about the project. Every couple of years I'd go back to it. The email that's quoted in the piece is Mark replying to me in 2016 after I sent him a compilation of the rushes that I'd assembled. I was saying to him, *Look, do you remember this? Let's talk about this again.* I'd always been conscious that this was a project with potential, perhaps too big, too much to handle. And it had also always been for me an artefact of the impossibility of our relationship, of what had gone wrong, what wasn't working, what needed to be returned to—so the project was already invested with all of that. And that leads on to the whole story about the Ccru in the nineties—what's referred to in the piece as 'the other episode'—and its aftermath. The collective and consistent sense among those involved of something happening that then ceased abruptly, and a sense of trying to find out how to get it back, or just figuring out what the hell (Cthelll) it was.

What Happened? Maybe nothing happened, we've got to get on with whatever we're doing and there's nothing that can be done about it. Plus, of course, no one was remotely interested in the Ccru's work between 2000 and 2017—the current interest comes largely from the period following the republication of the Ccru *Writings*. Sometimes in life there are those periods when, apparently, nothing happens. I have learned since then that everyone involved was in a state of, to say the least, bewilderment and not knowing how to exist outside of that crazy reality. It was what Mark, in the email quoted in *By the North Sea*, calls the 'period of isolation', when, after the massive intensity of Ccru, it was as if everyone had attempted to go back to some kind of 'normal life', but with this unactualised virtuality still simmering somewhere below. Whatever seemed to be within our grasp during those years had crumbled away.

In the notion of the 'three modes of time' that Stillwell attributes to Dagonite dogma, one mode of time is cataclysmic—an event happens that cuts time in two, a before and an after, everything's totally different afterwards and there is no going back. Within the piece, that links to the reference to 9/11, an event that swept a whole world away in an instant. Our trip to Dunwich took place ten days before that event. And then there is the mode of attrition, a slow decline, a continuous process of winding down, like the slow crumbling of Dunwich into the sea.

The struggle to access a third mode of time reaches beyond but is positioned between attrition and cataclysm, both of which we were actually experiencing before and after the trip. The third mode of time is also heavily associated with the sea, the idea of the sea as an entity that escapes capture by either of the other modes. The sea can be cataclysmic, it can be deadly, it can be inhospitable to life, it can be destructive. But it's also a living system that breathes, that slowly cycles, and that in some sense remains constant in its continual transformation.

Making is Remembering The process of making is also a matter of non-chronological time. When you're working creatively you're serving something else, the Thing. Unless the Thing is in some sense 'already there', waiting for you in the future, then you're not really doing anything interesting. Your job is to assemble some materials that will satisfy this Thing that already virtually exists. That's how it feels. Creation is always retrochronic, it always obeys the kind of logic that Ccru talks about in terms of the causal pressure of the future upon the past.

In my experience you have an Idea of something that needs to be made, an abstract vague set of coordinates—not vague as in blurry, vague in the sense that you couldn't write down a list of requirements, and yet there is a definite orientation, a touchstone. You then have to experimentally assemble pieces in order to try and make that thing exist. Eventually you get there...although you don't always get there, of course. There are no rules for doing it, that's the problem, there are no surefire ways to make it—it always comes from experimentation and felicitous encounters.

Perplexion The Ccru Mythos tells us about a 'Time War': the Architectonic Order of the Eschaton (AOE) want to completely seal up time and ensure that nothing unplanned and unaccounted-for ever happens, but a glimmer of...not exactly hope, but dissidence, comes from the Lemurians, shady characters who do their best to induce anomalous becomings.

In line with the Lemurian path, the concept of the definitive is something that *By the North Sea* refuses to accept. It picks up so many strange loops and tangled threads, all of which attest to the anomalous temporality of the subject and its haunts—always returning, always breaching the linear timeline

and therefore heralding the hope of escaping the traps of ontology, of *what is*. It returns, it circles, it spirals, a spectral subterfuge, under the radar. The gap between actuality and virtuality, and the intensity it produces, is what keeps it returning—not in the melancholy mode, and not so as to achieve resolution, but further extending and perplexing the problem.

By the North Sea is a massive block of grief that I've been carrying around with me for five years (I realised when it was finished that I had basically turned a tough emotional processing task into an even tougher audio processing task...), but it's also an attempt to think about the conditions of production for making something out of nothing—and of course there is precisely nothing at Dunwich. It is ultimately also about some really tough questions which, also, it doesn't answer in any definitive way, either positively or negatively, it just tries to stay with the problem. But most of all it is about resistance, defiance.

And Yet... The phrase 'and yet...' recurs in the piece. It stands out to me as being a phrase very characteristic of Ccru thought. Let's assume that something like the AOE exists, a kind of cosmic bureaucracy which, from the position of the future, attempts to organise all of history from beginning to end so it's absolutely sealed and impenetrable to any unexpected occurrence. The AOE want to construct time as a gigantic read-only memory, a complete prewritten script where everything confirms everything else, and there are no anomalous gaps, there is no potential for exploits. Obviously, in a sense, to even attempt that enterprise you must have such supreme confidence and immense power that you must be very nearly able to succeed...*and yet*.... It's the *and yet* that prises open this small crack of potential, the tiny hairline crack in the system (of chronological time and causality) that is otherwise absolutely homogeneous and hermetically sealed. As Templeton says in *By the North Sea*, when the AOE sealed all the exits, they couldn't help accidentally bringing some of the outside back in with them; the operation is never entirely complete. At the moment of writing *By the North Sea*, I needed that *and yet* desperately. And, after all, why *do* the AOE need to put so much effort into doing this if there isn't some anomaly there, if there isn't a very real possibility of a third mode of time emerging?

With, Not About The most important thing in making *By the North Sea* was to be with Mark as the person I knew him as, and to share with him again all of the things that bonded us together and that we got excited about together. For instance there's that Lovecraft quote where he's getting eldritch about the ancient artefacts of the frog-people: 'half-ichthyic half-batrachian in sugges- tion'—I just remember reciting that phrase with Mark over and over again and just being in hysterics about it because it's such a brilliant phrase. I remember a lot of funny moments from the Dunwich trip and, as it's described in the piece, it really was a delirious journey, and a lot of the things that happen in the Templeton narrative are real, like Mark falling asleep in the car and then suddenly waking up just as we get into Dunwich...and the pigs, we were driving down these roads where there are all these pigs and their metal houses, and Mark just looks out the window and says sardonically, 'Pigwitz'! And Orford: after we interviewed Stuart Bacon, we found this smokery, this guy was smoking meat by hand in a shed in his backyard, and we bought a massive smoked ham hock and ate it on top of the hill by Orford Castle, looking out across the village. There's a 'frogs crossing' sign just outside the village which we laughed about endlessly, And in Dunwich Museum there was this animatronic smuggler that told you about all the dodgy dealings in Dunwich town, a low-grade uncanny mannequin that Mark absolutely loved. And the moment when Stuart Bacon reveals that 'the merman...was a marshman', after which he went on to regale us about an entirely unconnected story about seeing a ghost horseman in a forest!

Those little things, being faithful to those moods and moments, is ultimately what I wanted to succeed in. This is something that I wanted to make *with* him, and all that mattered was that I got to the point when I was sure that was the case.

Saint Fisher In terms of thinking about Mark and his legacy, I think it's a good thing that *By the North Sea* wasn't released earlier, because I haven't really felt comfortable about it until now, and I quickly became increasingly apprehensive because I don't want it to contribute to the hagiographical tendencies that have emerged since his death. *By the North Sea* is not intended as a representation of Mark, and I feel that it's disconnected from the public figure, the crusading political prophet or hero, a figure I increasingly find unrecognisable.

When I think about him, what I think about is his immense energy. Back in the Ccru days, he could be quite fierce: that energy could come out in coruscating critiques of something you happened to have just said thoughtlessly; it could also express itself in a totally inspiring out-of-control overenthusiasm and speculation; but it also I think was expressed in his depression—because I think of depression as a kind of turning of your energy back on yourself, an expression of excess rather than lack. Obviously Mark could really be punishing on himself in that way. In my life I have been, too, and I have suffered for it and others around me have.

But I remember Mark most just as a person who was caught up in creative ferment and energy, who was constantly thinking about how to put the conditions in place for production, for making things, for engendering microcultures. He was a connector, someone who loved making things, a cultural synthesiser. If I think of an image of Mark at his most joyous, Mark at work, it would be him sitting on his living room floor with books and papers and records and stuff strewn around him, a record playing, the TV on, creating this spiderweb between all of these things in order to produce something new. And for me, that's where the whole conception and possibility of the 'audio essay' comes from. Connecting and making something out of the materials at your disposal—not as a leisure activity but as a necessity for survival and as the sole source of real joy. That's really the key thing I saw him as standing for.

Time Machines Templeton's assistant isn't quite sure what it's all about: Templeton hasn't divulged to him the object of their trip to Dunwich, but he somehow knows that they have to be careful about how much they reveal to others. And given what we know about his work, what Templeton is doing is obviously searching for a way to exit from linear time.

Immanuel Kant was the first thinker to say clearly that time is not an experienced thing but a condition of all possible experience. For experience to cohere at all, its elements have to be formatted by this linear continuum in which events succeed one another. But at the same time, that implies some Thing that is doing the formatting. Which means that, if your experience of objects—including *yourself* as an object of your own experience—is always temporally formatted, then the 'real you' that carries out that process is somehow outside of time

and inaccessible to formatted experience. There is this other part of you that is pulling the strings, but which you can't access because you're trapped inside time, a kind of security structure that you can never break out of. But the thrust of Templeton's theory seems to be that you can find certain faultlines whereby, in fact, you can exit and make anomalous crossings, disrupt the time-assembler. Now compare this with the way in which, in talking therapy, you can arrive at a moment where you'll say something, realise you've said it without knowing you were saying it, and cognise that it explains or interprets your predicament in a new way, thus changing your understanding of your past and of who you are. *So who said it?* The you that isn't inside of time, maybe? That's the moment of 'crossing' in the therapeutic or psychoanalytic situation: the effects of something the speaker has voiced-without-intention are propagated into the speaker's past, transforming their identity in the process.

Alienation in time has another name, and it's psychoanalysis. Psychoanalysis always involved a problematisation of subjective time in relation to the scientific understanding of time as a linear directional continuum. Freud also had all sorts of interesting things to say about phylogenetic time and the fact that, perhaps, in a sense, our experience is built from memories that aren't our own, but are transmitted to us by those who came before us—not just our family situation but our pre-human ancestors. Although it was Jung and Ferenczi who went furthest with it, Freud also kept open the door to the idea that the anomalous time occurrences that psychoanalysis glimpsed might include Dagonic fish-regressions....

The fascinating thing about psychoanalysis is that it's not a theory that is formulated and then tested out in practice. The theory emerges from the practice, when the early practitioners realise that, in the situation of therapy, the person facing them is experiencing something that is happening in another time, and using the therapist as a device to rescreen it. And so psychoanalysis is one of the great sites for the discovery of time anomalies, as Mark explored many times in his writings. Like Kant, Freud tells us that, to the extent that we think we're not alienated in time, we're deluded—that is, to the extent that we think we're present as a presence right here and nowhere else in time, we have no idea what we are as subjects.

Capitalism, in one of its aspects, is a massive temporal administration system, an AOE servomotor that functions to keep everyone convinced that they are

present in one place at one time, all the time. From the factory clock to the Apple Watch, the more that technocapitalism develops, the clearer it becomes that it's concerned with making sure that everyone is operating according to a common set of temporal coordinates, that everyone's life interlocks and matches and coordinates together. Escaping that time structure is hard: it's hard to not look at your phone for ten minutes, hard to resist updating your status to remain in time with the rest of the world—again, something that Mark discussed at length: the real cutting edge of capitalist subjectivation is time. At this point I'd like to insist that one must understand that 'political' side of Mark's work in combination with what might seem the more out-there aspects of his writings and those of the Ccru. It's not as if they can be separated.

Crossing Point In *On Vanishing Land* Mark and Justin explore the Suffolk coast through the literary heritage associated with its eerie landscape. Dunwich in a sense is the most eerie and spectral site precisely because there's nothing there; you have to hyperstitionalise it into existence. There are certain places on Earth where the eerie runs close to the surface. You go back there, you don't know what you're looking for but you're feeling something. And these are usually places where the surface is uncluttered by semiosis—I think of this as the flipside to what Mark called 'semiotic pollution'. The eerie sites are those places where the thick semiotic surface that is usually constantly communicating and directing you around what has become a semiotically saturated world, keeping you in-space and in-time, is absent, and therefore you're reduced to gazing into emptiness and populating it with signs from elsewhere.

Thinking back to 2001, the Dunwich project was already somewhat infused with a mordant sense of futility: yeah, we're going to do this project together, it's going to be amazing—but it actually ends up with us just driving in the rain for six hours and arriving in this place where there's *nothing*—it's just a beach, one gravestone on a cliff, a beach cafe which has good doughnuts, and that's it...it's ridiculous. But underlying that comical expedition there was an intense defiance: *and yet*...no, we know this place is rich, full, pregnant with something. We know that there must be a way to cross over. Once again, it's the question of the conditions of possibility for production, for making a crossing. *By the North Sea* refers to it as 'clearing a channel'. *We know that there's a way that things*

can happen. But we don't really know how to get there again. And that's what I was asking again while putting *By the North Sea* together over years and years, despairing about it, thinking it was a failure, but doing it anyway: there must be some way to make this crossing, there must be some way to live this other mode of understanding oneself and the world. A third mode of time.

Markotron The piece only really started to feel complete when I did the final part with the synthetic voice: that somehow allowed me to finish it, and it was a technical challenge as much as anything else.

From the beginning, the script had included extracts from this email that Mark had sent me, which in retrospect seemed to say a lot about all of these things I've been talking about in our relationship: the need to return, something being wrong, not being able to reach the state we were seeking. Originally I was going to read it myself, but that wouldn't have quite been right. At some point along the line I hit upon the idea of making a synthetic voice. In 2016 I worked with Florian Hecker on *FAVN*, a sound piece first staged at Frankfurt Opera House which involves a reading of my libretto by a synthetic voice. And so I learned a little about how voice models are produced. For *FAVN* Florian and I used a seven-hour long audiobook as data for the voice model. For *By the North Sea* I used the audio from just one of Mark's lectures to build a voice model which was then able to speak the words I gave it.

I didn't want it to be a perfect model, it had to be uncanny, not quite there. But still, the first time I heard it, it was devastating, it was awful, eerie in the extreme. And because it was an imperfect model, at the end of every output there were these stuttering sounds, artefacts of the model not having quite enough data, so it sounded like the voice was being hauled into existence, then falling apart and not quite functioning—as if you're dragging someone's spiritual presence up out of the abyss to piece itself back together. It was harrowing, and at that point I thought, *What am I doing? This is awful, macabre...*but then I also thought, *Mark would have loved it!* He would have been so excited by this uncanny *flatlining vox of doom*. That's what gave me the faith that it was okay to perform that little bit of spectral resurrection.

But also, since *By the North Sea* deliberately makes heavy use of tropes and genre clichés from the past, it was interesting to then introduce a cutting-edge

(if slightly dysfunctional) sonic technology. In that sense, the use of the Markotron is also an anti-hauntological device, I think. I was never really a great fan of hauntology in its musical incarnation, and I didn't want that to be the mood here. Using the synthetic voice serves to undo some of the nostalgic tendencies of *By the North Sea* since the technology to do it only exists in the 'outer shell'. When it arrives it suddenly flattens everything onto the present, making you explicitly aware that this whole thing is a patchwork of digital recordings made in 2017—that the whole piece is an attempt to raise spectres using technological sorcery. It exemplifies a temporal eeriness and it is certainly a haunting, but one that could only be produced *now*. This eerily accurate yet utterly vain attempt at invoking a ghost also gestures toward the weird way in which, for the Ccru, an obsession with the deep past always went hand-in-hand with speculation on technology.

Sorcerous Threshold The last part of Mark's email also brings us back to prosaic contemporary reality. Mark's saying that those of the elite ruling class always have confidence in what they're doing and *know* it's worth doing, but for us to even think for a moment that *it's okay* for us to do creative work is 'a huge achievement'. This may seem a little out of place in the midst of all the different narratives in *By the North Sea*, all the stuff about the sea and so on. But it's intimately related to everything else I've mentioned.

Mark and I are both people who need to be making things and connecting things and getting excited about producing things as a *matter of survival*, not because it's a distraction or we want to get on someone's podcast, or get some funding, or whatever. So I like the fact that that part is direct and is slightly at odds with the ponderousness of the rest of the piece, and yet in a way it's saying very succinctly everything that needs to be said. How do you obtain the sense of entitlement that what you're doing is real when it's always so precarious and so often it feels like it's nothing, like you're just working with sand, and it's all just going to crumble and fall through your fingers?

Grey Time Depression is also to do with time, a specific kind of time perception, a dead grey time in which nothing can possibly happen. My experience of being profoundly depressed, which emerges in retrospect when I look back, is of

reciting a script: one can be quite active—I produced a lot, I did a lot of work when I was depressed—but always with the feeling of *Right, this is what you're supposed to do when you're alive, and I'm doing it*. There is a huge distance between that and actually being alive.

The widespread social condition of people just carrying on doing what they're doing just is generalised depression, really—AOE reality just *is* depression. The question is whether it's possible to generate situations where you can go off-script.

To Anticipate, to Hope The Church of Dagon were persevering in their hope, their desire, to enter into a third mode of time whereby they could access a nonchronological temporal structure. They don't want to go back to the past in a chronological sense—but to loop time, via the future return of that which activates what was always in the deep past of humankind. 'It was this convic-tion, after all, that lent these poor souls the fortitude to anticipate, to hope, to continue their travails in such cryptic obscurity.' The referent here is ambiguous and multiple: The Dagonite cultists, Stillwell and Templeton, the Ccru, Mark and I, and finally myself, alone, in 2017. This is indeed the only hope, the *and yet*....

A Marker One of the things I say right the beginning, one of the first lines that came to me, was: 'There is less to fear from the acuteness of loss than from the loss of acuteness: you try to put down markers'. I was trying to put down a marker: to make sure to be able to remember what was, in the most awful sense, a liberation. Liberation from the world, being released into a void that had suddenly opened up. Put down a marker so as to say, this is how it feels when everything else has been shoved out of your life, when you have this harrowingly lucid perspective on things. When I'm listening to the piece I return to that moment of utter desolation. A kind of mini-time-machine: rather than expiating or shedding the grief, take me back into it and enabling me to inhabit its problem, to think the absolute necessity of the third mode of time.

You can neither avoid loss nor evade the onward march of chronology, but when these cataclysmic events break you open, you can retain the acuteness. And the way you do that is by putting down a marker.

The Living Room In my eulogy at Mark's memorial service[4] I recalled how, when I had said to Mark, *Look at the sonic fictions Wu-Tang Clan have created, we could never do anything like that!*, he had replied, *But we don't come from the street, we come from the living room!* Of course, he always had a keen and brutally honest sense of where he came from and its value and what it gave him access to. But I now realise what's really important about this is that, for Mark, the living room was not—or not just—a domestic space, the place where the family shelters from the harsh reality of the outside world, comforted by entertainment. It was an ultrasensitive listening station, an antenna where all the vibrations of culture could be picked up and resynthesised. Down on the carpet, VHS recorder, fax machine, mac, notepad, cigarettes, pile of books and cup of tea gone cold.

The audio essay is an extract from what passes through that resonance chamber, that internal space electrified by a continual flow of energies from outside the present, a space of navigation where withdrawal, hiding from the sun (he always refused to open the curtains, 'because then you can't see the TV properly!'), and cups of tea are by no means antithetical to the most extraordinary journeys in intensity. Maybe in the internet age the bedroom has become the privileged space instead. I'm sure that the internet has done something to the living room, obscurely displacing the navigational competences, the skill at scavenging, the cyberpunk mode of assemblage it implied. But, after all, we're still there, I'm still here Mark, let's make something.

4. <https://www.urbanomic.com/document/mark-fisher-memorial/>.

Iain Sinclair

No Returns from White Sea Asylum

'You go there to see something that isn't there anymore.'

On the uncontained and brimming lake of necessity, a single shoe floats, a formerly lemon-loud trainer resisting the inevitable; stubby nose down, taking water; optimistic retail history pulling towards the theoretical shoreline, a rind of sediment and disused memory without consequence or doctrine. 'The parallel world is forested and derelict.' If there were once tribes, they have gone. And their songs.

An unsourced photograph in a drowned archive. Impossible to discover whose story this is to tell. An 'author' of reputation has been remotely commissioned but de-assigned. Digital prompts offer no point of access. Without serviceable anecdotes, no forward momentum. Tidal, yes. But not progressive. Cliffs nibbled but not swallowed. Author-Ship trapped for a season in pack ice. Floes do not flow. Words stall. A lowering and undeveloped sky blanket scratched by rivers of sound. Flights discontinued. Rumours of volcanic activity in Iceland. Ash clouds of burnt pages. He dreams of days in cryogenic suspension: boarding house, bar, whorehouse in Lisbon. Assassin on the run when nobody is chasing. Minor celebrity of out-takes and multi-storey car park surveillance tapes. Pulled from the line at budget airline check-in. Saved by forged vaccination certificates. Accredited plague carrier. Two cameras, analogue and Polaroid, and no film. He listens to the monumental silence of cloud streets. And packs his plastic briefcase with stun grenades and shredded hotel newspapers. Wars. Ruins. Conferences. Hospital bunkers. Intelligent bombs launched by stupid operatives. Pharmaceutical conspiracies. Cryptocurrency harvests. Protests about protests. Football. Tablet fucks breeding like cameo artworks carved from ivory.

'Would it work if I sent you the pieces and related resources as a dropbox?'

Resource 13: 'Transcript of panel discussion at Sonic Faction. Plymouth, Feb 2023. Uncorrected.'

'It's really an essay about returning and repeating and it is about loss.'

Twinned participants, competing witnesses, set off by car for Dunwich. They communicate best in absence, one ocean apart, so they say. They want something they both know is no longer there. And was never there. It's about negative space and positive affinities. Ghost hunting without nets. Ghosts harping in bare trees. Interspecies internet dating. Fog horns confirming zero visibility when those with open eyes are unable to see. When they begin to learn to listen. To echoes left in the stones.

Out on the B-road before sunrise. Blinded therefore, coming east, muddied motorway windscreens, too misted in memory to locate the breakfast stop where they shiver as they wait alone in the deserted shack to be guided to a red Formica table. Buttered maps. Panorama of featureless fields. The sullen hiss of wet tarmac.

Already in play, neither before nor after, but always in the perpetual hunger for stasis, unappeased by the bucket-brewed vegetarian conceit of a full English deathwish starter, washed down by jugs of reburnt lukewarm coffee substitute. Where are the saturnine rings of influence playing out from the radioactive bones, the unlabelled file boxes of Norwich? Where are the upside-down tree circles with time-blackened wood, emerging at low tide, too hard and stonelike to kindle the pyre of a witch's barbecue? Unviolated negatives going back to alpine villages in shudder of war are not negative by intention: they are ripe with potential. We strain to hear what the Prophet said when he walked through the antiquated set of the old town, its courts and warehouses and cathedral, seeing the throng of dead all around him. We are the ghosts of our better selves.

The editor approaches the rumour of the nuclear power station. She pretends to be an unbadged Agent of Oblivion. She meets another woman, a little younger and stranger, a photographer disguised as a photographer. The editor, with her finely honed visual sensibility, absorbs the sentiment in the passage of

wind through marsh grass and reed bed: what she expresses is not pretence. She predicts loss and resurrects anticipation of a brighter day. She dowses for sound in the conviction that it acts outside time, where the photographic image is stalled, replete: a resistance. The land here is an incursion on the sea, which is our natural condition. Reverse evolution. Going under again. Homeless at home. The two women, perhaps in the same film at different times, are erotically aware, one of the other, but more of the waves, and memories still to come of lovers set aside, of potentialities, of the salient other with the golden eyes. And the rabid sonar pulsing of their padded stick microphones. Sensuality is stoked at the turn of the tide, the ceaselessly breaking retreating reviving crump of massed wave rage. There is structure now, but no plot. A junkshop album from a roadside barn soliciting fiction. The man with the camera, trying to hold the action in frame, but wanting to pan away to the horizon and hold that too, suffers. Everything within a mile of the nuclear facility, its deadly rods, sounds like black-letter pages being shredded in a decommissioned nunnery.

His mania spent, he ordered the jumble of papers strewn across his study but dared not approach them for days. The horror of the false epiphany was so apparent to him that he did not need to sit down before his desk to know that his mistakes were too many totally, his ambitions too large to anchor in reality.

The serpentine venom of the Bakelite radio, from somewhere beneath the shelf of polished limestone pebbles, flaunts the promotion of a conceptual artist, confident in his folly. This personality acquires mounds of popular novels, a single title based in borrowed conspiracies, probably the work of government agencies, to turn into a defanged dystopian product of wartime and smoke-choked briar pipe post-conflict seminars in soundproofed broadcasting studios: sanctioned enterprise. He delivers lists of left-leaning unbelievers. Suspects. Involuntary volunteers for biological experiments. Frontline Spanish rivals comparing wound patterns. His terminal script, once approved and promoted, is neutralised in reflex acceptance. Yours for a monkey from the charity pit where they found the authenticated skull of Emanuel Swedenborg.

And he walked through the ashes left in front of the State Opera, where the pages of twenty thousand books had gone up in flames. He recognised

that the one he was exploiting had been extracted from so many others, and that somewhere in the deserted committee room with the long polished table, the glass-fronted bookcases, those cold white busts of the Prophet, there was a live volume, annotated by Coleridge, rewriting the rewriting of depressive visions and seizures fated to become the instruction for séances of sex magic in the house separated from the river by a highway of thieves and mendicants. We come here, he said, to eat ghosts.

Meanwhile, Nelly reported, artists had fully embraced the thesis; she believed that the rediscovery of the irrational was the driving force behind vanguard movements, movements that, even to a lay observer, were evidently suffused with a Faustian, boundless energy, haste, a tragic fall in which everything was permitted.

Activated to the point of mania by the viral parasite chewing on his liver, turning his spine to powder, the dying man drew deeply on his own extinction, the first chill breath of the abyss, the enfolded star, and recognised mother ocean as the only pre-temporal mantle, a field in which sound is subsumed, roiling, growling, disassociated: in those waves, in those wordless wonders, no measurement of time was possible. It flowed all ways. Untamed by even the most brilliant intelligences. Ripened by whale song. Chilled by moonlight.

All have failed. He was surprised to discover that his own mind, frenzied and fractured as it was, had suddenly developed a wondrous affinity for fluid equations, so powerful that it not only took over his waking hours but also seeped into his dreams. At night, he would see dark water all around him, his naked body pounded by savage currents, sucked in by a colossal maelstrom that spun around an unfathomable void.

Heliogoland. German Bight. Doggerland. The continental causeway. Order out of chaos. Caught on the shingle, sinking in wet sand, the two men watching and recording the two women who gathered sound on that terminal beach, surmised, without conviction, that here at last was a final reality: the ocean covering their submerged trackway was the key, the penultimate metaphor.

Chaos-Order. Ruled and regular. Older and fresher and deeper than alphabets. If they were sanctioned to assemble this material, if their script was indeed commissioned, it was meaningless. That which can be prophesied in ordinary language has no intrinsic value, it has already happened. The mathematical formulae, the aesthetic beauty of the page of equations, the wave patterns of decoded symbols, are as elegant as an illuminated Book of Hours. Letters became fabulous beasts. Monsters of truth. Numbers become numbers. At this point signal is noise. Noise is message. And the shapes of the movement of the wrist are independent of their clumsy scribes. You are writing weather.

It appeared to the observers who had tracked the women from the city that they must have occupied the same vehicle. That they must have arrived together at the beach. But this was impossible according to the laws of physics and fiction. The listening devices planted in the car confirmed their nagging suspicions. There was a buffer of what passes for silence—engine throb, variable road surface, wind—and there was what sounded very much like a pre-scripted monologue, possibly recorded months later in some editing facility, after the younger woman, the one in the black slicker, was found dead. Her taller slimmer partner, walking over what she took to be the same ground, sound-stick extended, gleaned for traces, believing that the narrative of a past crime could be reconstructed from sonar hints left in shallow bootmarks, in trampled couch grass at the sea's edge. Sound waves dervish-dancing across a green screen.

The writer attached to the project was in trouble. *He developed a severe eating disorder, and subsisted on a diet of butter, baby formula, and laxatives. He also started seeing ghosts.* Salvation, so his co-conspirator, the former director, informed him, lay with two apparently disconnected local phenomena: a seafood restaurant at Orford and the relegation battle, that afternoon, in Norwich. If the team he had supported, longer than Delia Smith, prevailed, then he would treat his associate to a dry white wine and a bucket of oysters, kill or cure; although he would limit himself to a bottle or so of Adnams Ghost Ship. No call for laxatives after that.

He remembered, when he was a runner on the fabled horror film, coming away from a solid morning's bloodbath in the tower, to find a deserted house,

its doors left wide open with a handwritten invitation to inspect the carpet of books in the mildewed sitting room and to leave the appropriate coins in a diver's helmet. He came away, as an oblique homage to Monica Vitti, a party scene from *La Notte*, night of the long wives, with a battered first English edition of Hermann Broch's *The Sleepwalkers*. He dropped the coins he had, but it still felt like theft. He was unobserved. There had been no conversation, no grunts exchanged with some surly provincial bookman for whom the temporary possession of these volumes was a curse. Therefore, he could never bring himself to read that book, or any other by Broch, even as he continued to collect them, whenever possible, on his travels. *Are we, then, insane because we have not gone mad?*

A woman records the confession of another woman, deceased, washed up from another time, as she walks across the dunes towards the power plant that seemed to be pushing out fungal threads of misinformation. The images of the taking of sound had a particular beauty. The atemporal rapaciousness of the waves, the affronted grasses rubbing their dry stalks together, the passerines on their shady pond. Scenes of carnage directed in the castle keep. That afternoon a busload of harmless schlock tourists stopped to pay their respects, to pose with real and fraudulent instruments of torture. The listening devices buried in the shingle of the spit of government land confuse the issue. They have been mythologised. The birds they net are trusted performers. The composition is another heresy.

Our man is sick. The sea is on fire. The layers of pre-determined imagery are an absolute. There are no clocks. Dim photographs brought back to dress a page are improved by a technician. The glamour of the prints can be located in the specifics of the moment they represent. And only there. The tourist bus concludes in the wrong Dunwich, a windswept heath where bearded men, and women in sloganised t-shirts and comic hats, take out their impotent phones in order to record the mistake. The way the poet imagines and translates all this grants it a spurious authority. The crafted walk is for other people. He climbs from his hospital bed and falls back, sitting stiffly now, heels anchored to yielding rubber, the window a black rectangle. Dispelled emptiness predicts more emptiness. *The colourless patch of sky framed in the window.* The reassuring

drone of Chris Marker. The growl of Werner Herzog defaming jungle fecundity. *A sepulchral monument erected over a hecatomb of black bodies.* What is the point of a dead photographer, he said. It was not a question. He set himself, in the remaining months before the rent on the basement studio fell due, to the task of extracting sound from shirt boxes of unprinted negatives and paint-smeared contact sheets left under the bed in Berwick Street when the pariah failed to open his hotel door in Brighton. But that was another quest. Is there no end to it?

'We have a shared history,' the commissioner said, 'in comic book mythos cum occult divination.' The magnum opus had been announced but never published. Many had reviewed its wonders. Many swore that lives had been changed by application of spells and incantations. How was it then, he challenged, that the particular light, so miraculous and blood-boiling that it almost convinced him that he had just to take up his bristle brushes again to become a painter, was only available after travelling beneath the English Channel, walking a full anticlockwise circuit of the walls of Montmartre Cemetery in torrential rain, riding ticketless to Auvers, drudging over the church road to the village burying ground and then out, even among the Japanese with their cameras: only then was the location revealed.

Later, a small rather indifferent painting, obscurely displayed in Pontoise, confirmed the site of the fatal shot. No sound. No movie until cinema misdirected the mass audience, drenching the screen in cod authenticity and the richest available dyes, in order, so it appears, to entrap another painter, a gambler down on his luck. *Here both murder and suicide are rituals, acts instantly transformed into legend, facts that in all their specificity transform everyday life into myth... There is a constant war between the messengers of god and ghosts and demons, dancers and drinkers.*

A man dies and continues to dream. We set out to follow him by assembling a sequence of the photographs he left behind. Now they are all converging, participants and narratives, on a place that is no longer there. Or, if it is, they aren't. The researchers. The readers. The documentary filmmakers. The random authors who are dictating 'direction of travel' by way of fragments and misquotation. He discovers, in a coverless book filched from a stacked cave in Santiago,

Chile, the one English language item among friable pyramids of gaudy shockers, an account of the Dunwich drowning that has not yet happened. The one he invites the persistent sound recordist to investigate. She talks, she whispers her prompt lists. Concrete cancer. Chemo trails. Poisoned crows flapping on tarmac beside the landfill dune. Smoke twisting into language. A child's hand in a yellow bucket. A bent fork. A heavy man, heavy no longer, reaching out for an empty glass. The sound of his breath clouding the window of the school house. Bitterns booming. An apple drops at the end of the poet's garden. Other apples ripen to decay on a dusty shelf. All of these elements have sounds. None of them are photographed.

Walked into the ocean in the middle of the night. The police found the car her father had given her. It was parked on the edge of the dunes, its engine cold. Her dead body washed up after dawn on November 10, 1936. According to the coroner's report she was wearing a long black cocktail dress with wrist-length sleeves, black furred cuffs, a zippered back, and a high neckline. It was weighed down by approximately fifteen pounds of wet sand. They also found sand in her lungs.

According to the male voice that overrode the whispers the recordist released among the reeds, in that inaccessible film, the body on the beach was naked: glazed, blue, bruised and swollen. Wearing only an unlaced pair of heavy military boots. The interrogation took place in a pre-booked seminar room down a long corridor of identical suites, numbered and lettered, on a campus that could have been located on the quiet outskirts of any non-metropolitan city. The slow-speaking and modestly confident author of the text (or texts) under examination—this was not a punitive report on malfeasance in a time of plague—spoke of everything being 'on the point of decline'. He spoke with no hint of a smile, but with a certain grim relish. And studied pauses. As if waiting for a competent translation to be made. 'It is as if everything was somehow hollowed out. Even the sheets of paper on which one endeavours to put together a few words and sentences seem covered in mildew.' Generous paragraphs are formulated around pre-processed images. Without these holes in the page, the entire edifice would fall apart. The books, he admitted, were lengthy captions attempting to justify the frozen accidents of re-photographed photographs. 'It

seems likely,' he concluded, 'that sensitive material was removed before the file was opened, and so the mystery of Shingle Street remains'.

The published document derived from a conference attended by artists and academics called *When Site Lost the Plot*. It opened with photographs, terrifyingly banal, probably rendered by some form of artificial intelligence: the scene of the crime. A seminar room with a circle of chairs. This was stressed, no hierarchy, no tenured course leader, no panting doctoral careerists, no visiting geniuses overpaid, lavished by honoraria, in order to boost future funding. Windows offered a provocative glimpse at the encroaching forest. By the scattered positions of the chairs, it can be assumed that the participants with their laminated badges and papers to be extracted from cellophane files, their primed laptops, power points, have departed, to carry on their discussions over vacuum-sealed coffee in an identical room with a different arrangement of chairs and one long table on which chapbooks and publications from small presses and graduate schools have been laid out. With few readers beyond immodest and agitated authors repositioning their stacks to advantage.

The main man could not be there in person. After being captured outside his hotel in Aldeburgh, at a literary festival, clutching a bunch of books, titles debated and discussed by scholars, he declined to appear, but permitted a 'sound only' presentation of an interview analysing his use of photographs. The responsible technician, a man of obvious integrity, with no impulse to claim significant collaborator status, was questioned in his workroom, across the corridor from the cluttered office he had photographed to represent, a convenient fiction, the lair of a man who never lived outside the pages of a book, but who absorbed the characteristics of a number of people with verifiable biographies.

DR. NORTON: Did you make prints for all the chosen images and did he comment later on what you had done?

SW: Before starting work on any job it was essential to find out exactly what was required. There would be a brief meeting, between classes or at the end of the day, in my office. Erich was not involved in the actual printing process, although he liked to stand sometimes, watching every move I made in the darkroom. He was fascinated by the gradual emergence of the image in the

developing tray. He wanted to calibrate the precise moment at which revelation passed over into darkness. When the positive print blackened like a winter night in the Hebrides. And after that, he would say, what? What now? Where did it go? When it is as dark as our ignorance, where is the original capture? And where the photographer?

DR. NORTON: What did Erich mean when he said that he wanted to 'erase ownership'? When he called his photographs 'documents of absence'? Was he abdicating his own responsibility for these enigmatic additions to the page?

SW: I have no idea. He never indicated his displeasure with what I undertook for him. He would nod, hold the wet prints close to his face and take off his spectacles. He would sniff, wrinkle his nose above that moustache. When he left, I would sometimes find a handwritten note on my desk. And when, with some hesitation, he invited me to make a particular photograph that he needed, a room or a tree, a page from a guidebook or a volume of art history, he permitted me to choose my own angle, my own lighting conditions. Then he would begin the interminable process of re-photographing the photograph, working it, over and over, through the department's rather antiquated copying machine.

DR. NORTON: It is well known that Erich would construct an elaborate fictional apparatus to support some special photograph that he had found. What do you think is the status of the many negatives that were never processed, never printed? And are now stored in files that might never be accessed by scholars. Do they represent, untainted by words, the potential for pure narrative?

SW: We did not socialise. I never, for example, visited his house. When I retired I sent a note to Erich to explain that in future I would no longer be in a position to produce any photographic prints for him. I assumed he would already be working on the next book. It was not a thing he would discuss with me. My duties were posthumous, even when every last page was predicted and sketched out. He died two months later. I remember that afternoon in the darkroom when he said something about trying to 'connect sound shadows'. If he decided to withdraw from academic life—which was unlikely—he would look for a way

to extract sound from the shadows in the re-photographed prints he spread across his desk. He said that he would dedicate the time left to investigating the 'precarious nature of materiality'.

DR. NORTON: Were there any photographs in particular that stand out for you, ones that Erich requested?

SW: Orford Castle and Dunwich. The Suffolk coast is an area I know quite well. I've lost count of the number of times I've visited that town. As a photographer I like to think that I have a good visual memory. And I recall in particular those images that required more care to get the best results from the negative. With the use of digital cameras and digital printers the reproduction of the photographic image has changed totally.

DR. NORTON: Did Erich adapt accordingly?

SW: He detested digital technology. He was sentimental about alchemy, accident. He would actually use a pencil to darken parts of the sky. He disdained colour photography too. He believed that 'older' back-and-white photographs, especially postcards, had a 'mysterious quality'. He disliked the idea of producing anything that could be seen as 'artistic', but it is hard now to deny that he composed his pages as a tapestry, an artwork. A retreat from personality into... I don't know what. He was a kind man.

With the lifting of restrictions and a temporary truce while the successfully imported virus regrouped and evolved, there was a brief period, like the heady days after the last war, when doors were opened again and we felt the obligation to strike out. Insane projects, stumbling attempts to formulate a Grand Theory of Everything, were being prepared for publication. There had been too much reading, too many files of indifferently transcribed quotations. Quotations of quotations. Photographs of photographs. Released citizens were directed by their phones and tablets. Eyes down to absorb the latest horrors, the bombs, ruins, wildfires of reputation. I took up a bunch of overdue and abandoned essays and with some reluctance admitted responsibility for their

shape and structure. My cultural ramblings around the history of a renegade Soho photographer, friend of painters and poets, a much loved and much loathed pariah, was fit to be rewritten for the fourth time. The commissioners, who had no office or publishing address, and who operated entirely by way of lunches in private members' clubs, said that the book was now considered to be a novel. Take out anything, they said, that could be construed as academically acceptable. No dates, no acknowledged sources. I started again. The deadline was indefinitely extended.

After so many months when the nagging presence of the photographer—giving, withholding, sneering and revealing—dominated my locked-down existence, the voice of a dead man I never knew became the voice of London. Pungent vapour trails, Montecristo No. 4 and salt beef sandwiches, swept through deserted bars and shuttered restaurants, calling the vanished to rise from their sick beds. And walk again. Old London, city of smoke and memory, was nothing but a raft of pillaged books and two great yellow boxes of photographs.

Then, suddenly and unexpectedly, with my halting tale almost told, everything opened up. Doors were unlocked. Neighbours nodded as they passed. Bushes, trees, birds. The city was taking a deep breath, shaking the ground. Vibrant colour returned to the cracks in the paving stones. One bright and frictionless morning I struck out, wide-eyed, with appointments to keep. Trains were running, major burrowing exercises were almost complete. Blind plasterboard enclosures removed their barriers to reveal revived permissions: the island labyrinth of Soho was touting for custom. Small enterprises were readying their caves. Fast-food stalls simmered and stirred. The polished windows of private dining rooms where aspirant bohemians drank and plotted in gleeful entitlement were visible on upper floors of Georgian properties. The entire zone was performative, straining to remember its ancient vices and visions. That shrug of winking wickedness had once navigated my photographer. The thrashing of wild palms from posters displayed in the tactful windows of production houses. And the darker windows of offices without any declared purpose. The antic mysteries of forbidden entanglements are not accessible to the neurosis of digital capture. Without the conjuring of negatives and positives, the heady chemical baths and red-bulb séances, there is no history worth retaining.

The point of the exercise was to run down the man responsible, post-mortem, for making prints from the boxes of unsullied negatives left under the bed in a deserted Berwick Street flat. Plague was in suspension. Public enquiries were not yet launched. I came to the pub where this man had a reserved space at the bar.

The printer was at home. This was his good place. The walls were papered with departed friends with whom he was still in conversation: the notable and the notorious, the posthumously tolerated. And those who were only included in the frieze because they had been around in the high days, the lost days, the weird days, and bought a bottle or two, contributing to the babble that never ceased. They conformed to non-conformity: the duty of attendance, holding steady or going under. The fraternity, and the strong women who were also good chaps, the ones who never thought their chat too serious to be thrown away on a shifting mob of life-artists buying into the consensus, the general contract of unspoken mortal creep.

I was sufficiently detached from these games to admit to authorship, the fault line where journalism matures by default into something else. The dead man dreamed the life that he should have had, the biography he deserved, a time of sunshine and uniforms. Barred from his old familiar haunts, a stiffening corpse on a seaside bed, convalescence infinitely extended, he gave up his camera for a return to watercolour. He gave up image for sound. Death rattle in a tightening throat. The mothering murmur of the English Channel.

Nobody knew that the photographer had caught the sound he'd been waiting for all his life. Like the slow creaking of rusted asylum gates, opening without visible agency. The lid of a cobwebbed granite sarcophagus pushed back by a desperate hand in a story by Poe. A paint-locked window some creature from outside is trying to force. It was the sound Malcolm Lowry, in his alcoholic delirium, described as 'a dithering crack'. A crack of protest felt across the crust of a slowly shattering skull: the photographer put his fingers in his ears, to block out the corridor and the stairs. He was hollowed of meaning, so far gone in drink and death that old sheets of newspaper floated from the floor like colourless birds. He felt the scratch of insult as flies shat their copious eggs into his ear.

'Once more', Lowry wrote, 'with a dithering crack, the hospital door had shut behind him… He felt no sense of release, only inquietude. He kept gazing back with a sort of longing at the building that had been his home. It was really rather beautiful.'

Inquietude achieved. Fifty years from the photographer's Brighton abdication, my own release, to the last lockdown page. Like yours, my head is ringing now. With the enduring wonder of this man. His ghosted psychobiography in pictures is safe and stored. Ticking dangerously in its cardboard vault. There is no choice about it: I must book a room for the night. And draw the curtains against the view. Listen to the revellers and the ambulances. And ring down for a pot of tea that I have absolutely no intention of drinking.

Commission fulfilled but unrequired, I browsed the books that might supply the inspiration I lacked. I found something alarming in an essay by Angela Breidbach in which she discussed the way that *The Rings of Saturn* 'opens with the figure of a grid in the window of a Norwich hospital ward'. This, I concurred, was a key moment, as with my stopped photographer in his posthumous Brighton reverie. The journey beyond that window is what should have been and what is now accepted as the better path. The pilgrim in his prison striking out afresh towards an erased and overwritten coast. With a double-page spread of accompanying illustrations. Breidbach quotes: 'It was as if I were looking down from a cliff upon a sea of stone or a field of rubble, from which the tenebrous masses of multi-storey car parks rose up like immense boulders.'

Here, Breidbach tells us, is the true landscape behind the grid. 'It lies, in all its physical relief, in front of the observer's eyes. In an interview with Iain Sinclair, Sebald states that an image has as much "specific weight" as the quality of the memory that it evokes.'

Memory, even if you repress it, will come back at you and it will shape your life and there is very little you can do about it. What the role of memory is in writing is quite simply that without memory there wouldn't be any writing, because the specific weight, which an image or a phrase needs in order to get across to the reader, can only come from things remembered.

A fascinating conversation that I should have recalled, in every nuance, and retained. But it never happened. In my ordinary life, as I remember it, I did not

exchange one word with the celebrated German author and exile. And yet I am credited in a reputable and comprehensively footnoted academic publication with an interrogation that never occurred in historical time. I shared a lift once at Broadcasting House, when Sebald, cushioned with attendants, was promoting *Austerlitz*. He was preoccupied. Making his way from one studio to another, one respectful confrontation to the next. He was not, on any account, to be disturbed. I attached no specific weight to that memory print.

Ghosts talk to ghosts, with a bias towards watery conclusions. The ocean of time. The river of broken concrete. The flooded library. The living, at work but obscured and occulted, unread, communicate with those who are gone but still in play; words flickering in sonar patterns, cutting through ice. Searching the attic, I dug out a cheap, battery-driven recording device used once, many years before, to bolster a book of this locality. Ineffective weapon against lawsuits.

Doors locked, blinds drawn, new batteries secured, I made a stiff and over-emphatic recording of this text, with little attempt at varying pitch and delivery: no police in different voices. The suggested reference to *Under Milk Wood* in the original proposal is a mockery. Richard Burton, half-cut, half-enraptured, lifting and carrying that desperate, last-breath radio project. There was the hiss and scratch of buckled vinyl to deliver. Guilt heaped on guilt. He should have been a preacher.

It came back as ever to a journey, a walk, the simpleton's strategy. A hobbled pilgrimage to bleed out the images holding me back from enlightenment, from the roar of hungry waves, from the pre-written and the least forgotten. When I stalled on that four-day tramp to the disappearing cliffs, the drowned churches, I halted and played back, in field or car park or scrub wood, one section of my recording. Forcing myself to stand still, breath held, listening. Mortified. In shaking terror. Before deleting that part of the tape and lifting a camera to record the moment. I imagined that I would come home with no sound and a set of linear images, cards to send out or hide in books left in roadside exchanges. Instead of which, I turned to the sky: epiphanies of cloud constructions outracing and outperforming my slow progress. My return to the melting ice, to the white sea of a more formidable author's pickled imagination, his premature death dream. Mountains and cataracts of unspilled salt. The vaporous immortality of the absolute: a mirage. 'Photographs,' Erich said, 'are nomadic things designed to be lost.'

Justin Barton
The Westmorland Fells

The forest extends to within two hundred metres of the summit of Mickle Fell. Is this the Eemian forest from 120,000 years ago? Is it the forest seven thousand years in the past, during the initial high point after the last glaciation? Is it the Westmorland Fells five hundred years in the future? Or is it a more unplaceable, otherworldly forest—a forest of the oneiric-real, one that would be Futural, and could help to generate a forest in the actual?

In any case, this relates to a terrain of the planet. Which is to say that it is not a part of a human territory, and is also to say that what is in question here, alongside the Futural, is the planet, as opposed to the specific terrain that is the Westmorland Fells. It is possible to start anywhere, but this starting-point has some slight advantages.

This is therefore about the planet, and about the path that leads away from ordinary reality, a path that to a great extent involves a heightened effectuation of the faculties of dreaming, perception, lucidity, and decision-making, or navigation. A several-body problem: a question of the worlds of human bodies with their faculties, and of the planet grasped in connection with its exteriority, in connection with the sun and the other stars.

In raising the issue of the Futural path, and in looking across the sunlit forests around Mickle Fell, we have brought the faculty of lucidity to the forefront, but in the centre of the foreground is the faculty of dreaming. And in more than one way we will use the faculty of dreaming as a thread to guide us out of the grey labyrinth of customary thought about the planet and the human world.

The massif which forms the uplands of the Wear and Tees valleys—a massif which can also be called the Westmorland Fells—is threaded with mineral veins. It has been mined for lead and other minerals at least since the time of the Roman invasion. And below the level of these veins there is granite.

The area has a minuscule deviation from the normal level of gravity, in the sense that gravity is a tiny fraction less than its average level. This was hypothesised to be the indication of a large area of granite, and deep drilling, to a depth of around three hundred metres, has twice found the granite layer. These results, together with the readings of gravity levels, have been taken to indicate the existence of a batholith of granite the upper surface of which has the form of a series of domes that extend upward beneath the Westmorland Fells and the area immediately around them. The area is cthonically haunted by these domes, whose electromagnetic field produces a fractional lightening of gravity.

The surface terrain is very different from the areas of the Pennines further south. The hills are higher, but there are very few outcrops of rock. They are wide, minimal-contour, whaleback hills to an even greater extent than the fells further south. Their principal feature being the two main places where a vein of harder rock called the Whin Sill—which runs across the whole area—appears at the surface: in one of these places the sill produces a waterfall—High Force—and in another it takes the form of a narrow amphitheatre of cliffs, in the form of a long flattened V shape, called High Cup Nick.

Overall, at the level of its plants and animals this is an area of deliberate monoculture devastation on the part of human beings, and yet at the same time it has a pocket of exceptional plant diversity, which is nourished—made possible—by minerals from the rocks. The monoculture is driven grouse shooting, which means that anything larger than plants like heather and bracken is burned down each year, and birds of prey are shot, so that the grouse in turn can be shot by wealthy hunters who have the grouse driven toward them to make killing the birds easy. The pocket of biodiversity is an area of meadows in upper Teesdale, which has a famous ecosystem of rare flowers—including spring gentian and bird's-eye primrose. These to a great extent are alpine plants from further south in Europe, which do not grow elsewhere in upland areas of Britain because of lack of sunshine, but here they are boosted by what is called 'sugar limestone', a mineral-rich form of rock that is easily dissolved by water, so that a steady flow of minerals arrives for the plants.

At times when the moorland is not being burned, the air is clearer in the Westmorland Fells: on the prevailing wind it comes across the Lake District from the Irish Sea, and the air will be even clearer, through there being less humidity,

when the wind is from the east. And a final feature of the terrain on the ground is connected to the direction from which the wind arrives. Starting from High Cup Nick is a high, southwest-facing escarpment. The North Pennines massif rises to this sudden drop, and when the wind comes from a specific direction the wide, steep escarpment produces a horizontally vortical wind, called the Helm Wind. As part of the same weather phenomenon the escarpment also recurrently creates a long cloud called the Helm Bar.

As well as being a terrain of burned-back moorland, and of valleys with rare flowers, it is simultaneously an area of derelict mine workings, so that it has an aspect of being a post-industrial Zone (in a sense that comes from Arkady and Boris Strugatsky's novel *Roadside Picnic* and from Tarkovsky's film of this novel)—a place that in some way has a quality of being in touch with the outside of ordinary reality.

You can imagine you have crossed an area of moorland on a hot day in June, and have arrived at High Cup Nick as the sun has started to shine straight into the amphitheatre of cliffs. Mickle Fell is over to your left as you sit down, feeling drowsy. A moment later you are dreaming that you have solved some kind of grey labyrinth of empty factory buildings by jumping dangerously off a conveyor belt that somehow is still working. When you land on the ground there is forest everywhere, and the buildings have disappeared. Through the forest that covers the base of High Cup Nick a path is visible. It is sunlit, bordered with willow herb and flowering dogrose. There are five fallow deer walking down it, and beyond them is another animal, moving swiftly away—it looks like a badger, but is the colour of a fox. As you wake you have a confused impression, for a moment, that there is a wall of high-tech offices and factories behind you.

It is necessary to start now from the Westmorland Fells as they currently are, but temporarily to abstract out the human world, so that the focus becomes the geological masses of the hills, the plants and animals of these hills and, most of all, the sunlit atmosphere above them, starting from the air at the level of the ground.

Then it is necessary to reach the point of envisaging the highest zones of the atmosphere, and to allow the envisaged space of air to expand spherically around the planet, and then the image needs to become the entirety of the planet in its spherical height and depth. The planet in its sunlit and starlit exteriority, the small plants growing in upland meadows, the trees extending across slopes

in the Patagonian Andes; zephyrs swirling up dust in mountains in Morocco, the Helm Wind vortically turning on its horizontal axis; the subterranean depths of the planet, the outer atmosphere suffused with starlight; sunlight falling on forested slopes of the Asturias mountains in Northern Spain.

You see the planet in its exteriority as heartening, as inspiring, as initiator of thought, as corporeally and intellectually energising. You register that it is the initiator of this affect—of this world of affect.

And then, it is necessary to see the planet as the fundamentally *unknown*, that is, the unknown in a transcendental-empirical sense—it is necessary to experience the dark, jolting flash of the unknown.

And then you place the human world within this sphere, under the expanse of the atmosphere, as something natural within the planet; the human world on all of its levels and with all of its aspects, as another unknown within the unknown of the planet. And again there is the dark, ultra-intense brightness of the unknown at the level of the transcendental-empirical.

But after this you keep seeing the energy-and-intent domain of the human world as within the planet, working on the basis that this is the correct setting up of the problem of the world of human beings.

And seen in this way it appears as a kind of grey perturbing mist—perturbing in the sense that it is destroying the ecosystems and species of the planet, and at different levels is continuously at war within itself. However, at the same time this mist is threaded with filaments of brightness. The grey mist is the predominating aspect, and yet the filaments of brightness have far greater intensity.

What is this luminous and perturbing mist?

*

It is possible to start from what can be termed the Arkadian and Sayan modalities of thought, and to start from the one hundred and eighty years since the 1840s, concentrating primarily on the idea of Futural departures, and on an affect—generated through an encounter with the world around us, or through either reading or hearing words—that can be called the planetary sublime.

The Arkadian modality of thought is split into two sides, where 'split' has a sense similar to 'lobotomised'. On one side is philosophy and science, and on

the other is art: Socrates and Sophocles; Spinoza and Shakespeare/Newton
and Shakespeare. The Sayan modality on the other hand is integrated—and
it should be pointed out that it could also be named after mountains in China,
or in Mexico, or could be named the Roraima modality or the Andes modality.

Within the philosophy zone of the Arkadian form of thought there have been
rare, isolated attempts in the last two centuries to bridge the divide between
the two sides of the modality, none of which have got very far (although these
attempts have nonetheless been having an impact). If successful, these attempts
would have also bridged the gap to the integrated Sayan modality, which in the
twentieth century expressed itself as a series of emergences within a Central
American and North American anthropology milieu. Within the philosophical
emergences of the Sayan modality, and to a limited extent within the Arkadian
modality's philosophy, there has been the ongoing, overall emergence of what
can be named metamorphics, a form of knowledge consisting of a pragmatics
of intensification of encounters with the world, and of immanence metaphysics.
And to start to provide a way out toward this form of thought, it can be pointed
out that intrinsic to the Sayan modality is the most encompassing expression,
firstly, of the line of thought involved in the idea of Departures from ordinary
reality (together with other related ideas), and, secondly, of expressions of what
will here be called the planetary sublime.

But for now, these developments should be left as something like a terrain
that has been seen in the distance. And what should be concentrated on is the
artistic side of the Arkadian modality, and in particular the aspects of it that
embody what can be termed radical/visionary thought.

Here there have been two major developments:

A series of emergences that reached a first high-point at the start of
the twentieth century, which then underwent a multi-stranded collapse
into conservatism/reactivity in the middle years of the century, and
afterwards briefly went into effect again at high intensity, though under
new, very difficult circumstances of suppression.

The movement of music into the foreground, so that it acquired an
immense radical/visionary domain—a process which can also be seen

as music shouldering a burden which was exceptionally hard for it to carry.

The reason why we are starting in the 1840s is because at this time there was a threshold-crossing in a widespread attempt to see the-World-and-the-human-world with greater clarity. And even though it is fiction (together with poetry, songs, and music) that will be the primary focus, it is important to remember that Marx's phrase 'religion is the opium of the people' dates from 1843.

A further point is that there is no primary focus in terms of areas. However, at the outset the main areas are the USA of Edgar Allan Poe, together with Britain, and it can be pointed out that an initial development was that Oxford and Oxfordshire at this time, for complex reasons, became the centre of an oneiric and abstract-oneiric storm.

The further reference point that will be used will be the work of Shakespeare, because this work is a very highly developed expression of the artistic—as opposed to academic—side of the Arkadian modality.

It is necessary to begin with an overview, and an explication of ideas. One hundred and eighty years after the starting-point in the 1840s the process which began at this time has expressed itself through a series of elements within writing. Futural or radical/visionary elements which in many of the more interesting cases have a kind of inconspicuous power, through being—or through including—outsights into the nature of the world.

The escape or Departure/the escape-group.

The *other* world: the world where the anomalous is in effect to a larger extent.

The damaging modality or force hidden—as an element of the natural world—within the world of human beings, internally affecting each individual from the start of their life.

The pervasive disaster within the human world, where this is to a substantial extent the result of the damaging modality at the level of individuals.

The other, anomalous form of knowledge and action/the other, anomalous way of envisaging the world.

The statement of immanence, or the moment of perceiving immanence.

The dream-like work which has the affect of lightness in the specific sense that it does not get tied down by moralising (recapturing along the lines of an ordinary-reality or Judgemental perspective) and includes one or more of the figures above.

The futural other world—the world many years in the future in which there have been substantial, pervasive transformations of human existence.

There are two primary aspects of works that are expressive of the planetary sublime. The first is that they involve exteriority in a double sense: this is, firstly, the planet in its exteriority in relation to the sun and the stars and the other orbiting bodies of the solar system, and, secondly, the beyond of urban terrains in the form of scurflands, the countryside, and terrains such as mountains, forests and deserts.

The second aspect is the enigmatic. This is the enigmatic in the very specific sense of an aspect of the world of the text which produces the impression of the planet as the fundamentally unknown.

Another name for the enigmatic in this sense is the anomalous. And specifically it is the anomalous that directly involves joy, or which is connected with it (whether the joy of delight, or of serene exploration), even if—to take the limit case—the joy comes through a transcendental-empirical grasping of a perturbing or tragic thread within the world. The anomalous is more effective as an expression of the planetary sublime the more it is connected with the planet. With Ariel, in *The Tempest*, this is done through 'where the bee sucks, there suck I / in a cowslip bell I lie' (Ariel is an anomalous being but his/her home is the planet).

All of this is heightened if there is an individual or group within the world of the text who/which experiences the planet as sublime, and in particular if the

intent involved is an intensive nomadism which also—and as such—involves a travelling in relation to the planet. It can also be pointed out that the individual and/or group then doubles the figure of the planet—because, through their love for the planet (the primary part of their exterior domain), they are also understood in terms of their exteriority.

The island in *The Tempest* is a key element in relation to the planetary sublime in Shakespeare's work, along with the forest outside of Athens in *A Midsummer Night's Dream*. The presence of these two terrains then impacts on other elements. References to the worlds beyond the cities and towns are all given a heightened intensity.

For a brief moment we are in Oxford and Oxfordshire in the middle years of the nineteenth century. Hume's *Dialogues Concerning Natural Religion* is in effect within this world, as is Spinoza's *Ethics*, but at much higher level of intensity is the radicalism of Shelley, and—in particular—the work of Shakespeare. For those setting out toward an ability to think—and therefore toward a waking of the faculty of dreaming as well as the faculty of lucidity—the circumstances could barely have been more tumultuous. Along with the oneiric and abstract worlds that have just been indicated (which were from both sides of the Arkadian modality), a whole machinery of ordinary reality pushing back from thought toward heavily ritualised religious dogma is centred on Oxford in the form of Newman's 'Oxford Movement'. And simultaneously the intellectual world had now not only accepted the validity of the geological map made fifty years earlier by the Oxfordshire blacksmith's son William Smith (which showed the Earth was gigantically older than it was held to be according to all accounts from the domain of religion), but was also starting to process Darwinism—and both of these changes were centred on the area, in that Smith's map was followed by one of the first major dinosaur finds, in an Oxfordshire village called Stonesfield, in 1824, and in that the famous evolution debate took place in Oxford in 1860.

The outlines of what happened can be sketched, and in such a way that subsequent events are connected to them. It can easily be thought that nothing took place at all—but if a focus on this terrain is sustained across fifty years, and if the onward lines beyond this are included, the emergences become more visible.

Alice in Wonderland and *Through the Looking Glass*—something log-ic-pale but bright escaping from a zone of gravity; the whole emergence is brightened and intensified by *Lucy in the Sky with Diamonds* and other songs by The Beatles, and then darkened by *Falling Out of Cars* and the other books by Jeff Noon from the first phase of his writing, as a recondite part of the generalised collapse of fantasy into either grim-and-dark 'fantasy realism', or powerful but partially blocked/suppressed 'young adult' or childrens' fantasy tales.

Jane Eyre and *Wuthering Heights* (Poe is in the background, struggling toward an *other*, anomalous form of knowledge in relation to both customary philosophy and science, and Marx is also in the background, struggling to get away from Hegel in the direction of this same anomalous form of knowledge in relation to how it sees the human socio-economic world); and then Matthew Arnold's *The Scholar Gypsy and Thyrsis*, followed eventually (forty years later) by *The Well at the World's End* by William Morris. In turn these are followed by *The Waves*, *The Rainbow*, and *Women in Love*, the poems of Yeats, *The King of Elfland's Daughter*, and elements of the work of H.G. Wells. The subsequent collapse from this high point is both internal and external, as Lawrence and Dunsany make failed attempts to set out another form of knowledge and dreaming in *The Plumed Serpent* and *The Blessing of Pan*, and as Tolkien and Lewis take the Arnold/Morris line of emergence and collapse it toward Christianity-inflected tales of warfare between Good and Evil. And then, after a gap, works such as *City of Illusions*, *Surfacing*, *Picnic at Hanging Rock*, and the 1980 story 'The Quiet Man' by John Foxx (it can be said in passing that deleterious/damaging directions within the transcendental-empirical were being investigated at this time by Angela Carter and William Burroughs, but that this oneiric critique is to a large extent a separate line of emergence).

The main issue in question here is that of the planetary sublime (the take-up by The Beatles of Lewis Carroll's form of 'surrealism' is well known). But it can

be pointed out that both of these accounts have in part gone toward music, either directly or tangentially.

The sublime in this sense evokes the worlds beyond the urban in a way where there is joy/absence of gravity/visionary-serene brightness involved in the description, and it does this in a way where the work includes the anomalous, even if the anomalous is suggested rather than stated outright. The anomalous can be the horses in *The Rainbow*, the water from the well in *The Well at the World's End*, the disappearance in *Picnic at Hanging Rock*, the lengthened lifespan in *The Scholar Gypsy* (and in *The Well at the World's End*) or the patterning board from the planet Davenant in *City of Illusions*.

The planetary sublime appears in Patti Smith's 1975 album *Horses*. In the semi-narrative of the album's title track ('Horses/Land of a Thousand Dances/Mer de') the narrator encounters a horse 'in the eye of the forest'. The anomalous is there in this song through the description of experiencing a kind of different substantiality, in the form of the lyric 'I put my hand inside his cranium'. And the non-urban terrains become a basis for breaking open 'visionary-abstract' perspectives in a way which supports this anomalous/enigmatic aspect—the outsights reach an intensity that makes the visionary-abstract point toward the faculties of dreaming and of lucidity, and toward a trance-formed relationship with the planet:

> ...the night, in the eye of the forest
> There's a mare, black and shining with yellow hair
> I put my fingers through her silken hair and found a stair
> I didn't waste time, I just walked right up and saw that
> Up there, there is a sea
> Up there, there is a sea
> [...] a sea of possibilities

Three years later, in *Systems of Romance*, John Foxx opens up a glimpse of the planetary sublime in a similar way:

> Listening to the movement that the night makes
> I let the room fade just for a moment

Sitting in the shadows that the leaves make

I felt the floor turn into an ocean

We'll never leave here, never

Let's stay in here for ever

And when the streets are quiet

We'll walk out in the silence

And in this album the anomalous is an element through a series of aspects which suggest that the world is threaded by forces and potentials which are not generally noticed, and which are on a level beyond that of ordinary reality.

In Foxx's story 'The Quiet Man', the protagonist is living in London under ordinary circumstances: he is described setting off to go to work, and then the narrative seamlessly shifts to a description of what he does while living—for years—in a derelict overgrown London; and then, equally seamlessly, it shifts to a description of his return to his home from work. Here the anomalous is simply the existence of the overgrown, derelict London. Everything is there at once: the planetary (the world beyond the urban) arrives through London, and this other London is the anomalous.

And this quiet figure suggests a modality of detachment that has heart. As opposed to a modality of detachment which has crossed a limited-extent threshold of freedom only for all deterritorialisations to be subordinated to an insouciance-process of navigation according to what has kudos, where freedom has been heightened a little, but at the cost of losing the movement into exteriority (which is an active, exploratory love of the world), so that it is now trapped in terms of further development.

In writing 'The Quiet Man' John Foxx is not writing music, and the text is not in the form of lyrics (the fact that thirty years later Foxx placed it with music does not mean that it consists of lyrics, even though a reading of it works very well with music).

It is important to see the difficulty of what the rock-pop line of music was trying to do at its cutting edge. The challenge, at depth, is to go towards the development of a pragmatics and metaphysics of travelling to the outside of ordinary reality (the cutting-edge of rock-pop modernism is always an affirmation of the beyond of conformism/suppressive traditionalism). To maintain

a brightness of tonality (as opposed to gravity) while avoiding affirmations of conformist value-positions, and both to break open glimpses of outsights and to avoid familiar descriptive perspectives by using oneiric, bright surrealism—this had been the technique of The Beatles (and it can be seen that *Lucy in the Sky* is both surrealism of this kind and is also an ultra-minimal, but effective expression of the planetary sublime—there is the sky, the river and the clouds, and the anomalous is both the 'girl with kaleidoscope eyes'/Lucy, and the Departure from ordinary reality indicated by 'and you're gone'). However, to start to develop the pragmatics and metaphysics is hard enough in writing a novel, let alone in writing song lyrics.

The power of songs lies in the immense charge and expressiveness of the music, in the combination of what is conveyed through the words and through the tonality of the singing of the words, and in the deterritorialisation of dance. Nonetheless, the fact that after the 1950s poetry declined and was largely eclipsed by songs does not mean that nothing at all was left behind in this re-channelling after the collapse. But poetry had not been finding a way forward to any significant extent: in the twenties and thirties as well as in the sixties and seventies it was writers of stories who had been getting furthest with expressions of outsights—with work generated by the faculties of dreaming and lucidity (in terms of a new more powerful form of prose, the breakthrough had been in works such as *The Waves*, and in terms of leaps of imagination and of concept-formation within fiction it had been in works such as *The Left Hand of Darkness*). These were the circumstances in which 'The Quiet Man' was written.

The challenge taken on by rock-pop visionary radicalism was an exceptionally difficult one. What was needed was a pragmatics of waking lives, and an asso-ciated (inseparable) domain of outsights toward the depth-level nature of the world. It is not, therefore, that rock-pop modernism held on widely for decades and then faded. It is more that, in terms of a widespread effective process, the attempt barely went beyond the sixties. The initial advantage of the counter-culture of music, festivals/parties, and drugs was that it didn't need to take any detailed positions about a way forward, and just needed to be the beyond of the gravity of reactive judgement. But once the establishment had got rid of some its darker traditionalisms the advantage grew much smaller; in any case, the moment people needed to take pragmatic/political/micropolitical positions,

there was almost nothing there in terms of a pragmatics of Departure. What remained was the deterritorialisations of dance and the use of psychotropics, and the use of drugs in this context is likely for each individual to become counterproductive. In turn, the issue with rave is not so much that it died in the mid noughties (although there was a fade-down at this point) but more that it never had enough focused micropolitical radicalism in the first place. At the outset Aldous Huxley had been injected into the milieus of pop-rock, milieus that would soon have dance-music synthesisers, but this did not teach people how to set out along the escape-path that leads from the ongoing disaster of ordinary reality.

Music in fact has been central to both of the major popular culture technology-breakthroughs in the last century: sound recording and film. There is perhaps not a lot that can be said in this context on the side of film, apart from the fact that music recurrently is the anthemic aspect (telling us what to feel) in evocations of ordinary reality, and that it continues to keep all kinds of reactionary, gravity-infested company in the worlds of political movements, cults, and religions—always producing an ephemeral, false sense of profundity. Often the two sides come together, and this will be all the more effective if the music is impressive: Carly Simon's New Jerusalem anthem ('Let the River Run') in *Working Girl* is one kind of example.

And, in so far as there is a sense in which poetry has been rechannelled into songs, it is not that there has been a decisive gain. Any increase in power or intensity of expression, through the expressive use of the voice regarding the timbre of the words (as well as through the music) is to a great extent offset by the demands of concise oneiric lucidity being less stringent for songwriting. There has been no emergence of a pragmatics of Departure and of a system of outsights, despite the sheer brilliance of albums like *Horses* and *Hounds of Love* (an example of the strength of songs, in comparison to poetry, can be heard in the quietly intense sexual radicalism, in relation to becomings, that is expressed by Kate Bush in her singing of 'come on darling, let's exchange the experience').

And overall there has been a fade-down in relation to the planetary sublime, and in relation to encounters with the spaces of exteriority that are involved in the radical-visionary ideas delineated earlier. It is worth thinking for a moment about the dance track by LCD Soundsystem which concludes the 2022 film

White Noise. The whole song is a radical 'gesture,' in the sense that it is about the frenetic, unhealthy, corporate-inflected processes of ordinary reality, but at the point at the very end where it breaks open a specific view, and where it makes contact with exteriority ('the earth and trees surround you'), the song seems to some extent to have crossed over toward a conventional perspective (which is being expressed in a new way). This is a fine song—and yet the song is about death, and the only 'escape' that can be described as straightforwardly in effect within the song is the end of life: the earth and trees only appear for a moment as what you focus on as you start to die ('the earth and trees surround you / framing your escape'), and the account of death, for all its emphasis on the stars, is strongly suggestive of traditionalism, rather than suggesting that you see the earth and the trees just before death because they were a main part of what had been fundamental all along (the planet, the trees, the sun and the stars as obscured locus of the escape from ordinary reality).

In relation to the one hundred and eighty years in question, both of the developments that have been analysed involve a change in the middle years of the twentieth century—the suspension of the radical emergences, and their later return under more difficult circumstances, and the sudden heightening of popular music. And we are now getting close to the point where the difference between developments and Departures will be clearly visible.

*

The mid-twentieth-century collapse had many different aspects, and in any case, beneath the questions of the short-term collapse, there was a culminating stage in a long process in which religion was set up to function primarily in more implicit, but very powerful ways, and in which the scientific and rational-discursive domains came definitively into the foreground. This is to say that across the domain of the heavily industrialised countries there was a full effectuation of a shift in which the ordinary-reality co-functioning of revelation with a blocked form of reason underwent a change of polarity. To those with no affinity for science fiction, the change gave the implied or indirect religion of the new forms of fantasy writing, and gave new, 'quiet' expressions of religion such as 'whether or not it is clear to you, no doubt the universe is unfolding as it should'

(although written twenty years earlier, Ehrlich's Hegel-affined 'Desiderata' is published and becomes widely known in 1948). It should also be added that after this a much larger aspect, proportionately, of religion would be its implicit form in relation to nations and groupings/alliances of nations. However the most damaging short-term aspect of the shift—even more than the long-term change in the form of religion shifting toward the powerfully implicit, and toward being something that cannot be argued against because it is 'faith'—is the imposition onto thought of models and ways of working with concepts that come from the science-mathematics-logic domain of the functioning of reason, so that the route to the transcendental-empirical is even more blocked than it had been previously.

This change can be explicated by taking three instances: anthropology, philosophy, and fiction.

For anthropology the change involved had a very perturbing aspect. For a long time there had been a colonialist functioning of anthropology which set out to 'show' the cultural or genetic superiority of western and state societies in relation to the remaining tribal/nomadic societies. And at the precise point at which this modality started to diminish, structuralism began to appear (structuralism was an initial manifestation of the polarity change in the system of reason-and-revelation), which ensured that there could be no depth-level encounter with the radically *other* ways of seeing the world that are found within tribal and nomadic societies. The grim counterpart to this was non-structuralist thinkers like Evans-Pritchard, who simply practiced the assumption of superiority in a background form, which in many ways was all the more powerful for being unstated (Evans-Pritchard was a 1944 convert to Roman Catholicism, and so ultimately no stepping-aside from the idea of the superiority of Western spirituality was in any way possible).

Philosophy at this time was a labyrinth of tendencies that were connected to the same shift (the alteration had been underway since the eighteenth century). In the late seventies, in writing *A Thousand Plateaus*, Deleuze and Guattari fight their way out not only from structuralism but from other—closely related—suppressive philosophical modalities such as Kantianism, but they do not get beyond a preliminary stage in this process. There is no sustained, focused development of their nomadism of becomings and deterritorialisations (although

all the elements are there, even if occasionally they are entangled in confusion), but instead there is mostly a series of micro-critiques of concepts and thinkers, and of indications of the line of departure. The text does not bring together the two sides of the Arkadian modality (this is because of the academicism of the micro-critiques, the residual confusions, and, connectedly, a focusing of attention in the wrong areas). However it remains the case that the book guides readers from conventional, blocked philosophy to the way forward. The text is continually leaning outward from the line of development, and toward the Futural direction of Departure.

Amongst many other changes related to the shift, literature sees an immense heightening of science fiction and the—deceptive—split of fantasy into adult tales and stories for children/young adults. The split is deceptive because at the outset there is not much difference between the two sides, and even when—subsequently—it has deepened through the addition of explicit sexual elements to the adult side, there is more in common than might be thought (this is because the structure of tales of Good and Evil all along has a crudely 'reassuring' bedtime-story aspect, and because a lot of dark or 'gothic' elements are allowed within childrens' tales). Ursula Le Guin's work tries to find a way out from this terrain, and within the domain of the other side of the Arkadian modality her work is an equivalent of the philosophy of Deleuze and Guattari. She is in a good position to find the way out, because she has closely read a work from the Sayan modality—*Tao Te Ching* (she produces a translation of it, and includes the book as a crucial survival of ancient wisdom in the world of *City of Illusions*, which is the Earth thousands of years in the future), but what she is trying to reach is transcendental-empirical perception, and this involves a way of thinking that is not the same as what is called 'art' or 'fiction'. A lot revolves around a search for the bringing-into-focus of the anomalous form of knowledge that she has direct awareness of, through having woken the faculty of dreaming: in this respect her work is initially a mixture of exploratory constructions/probes, and of elements that straightforwardly make sense, such as 'far fetching' in *The Left Hand of Darkness*. The patterning board from the planet Davenant; the method of seeing into the depth of things in order to predict the future in *The Left Hand of Darkness*; Ramarren's techniques of enhanced awareness in *City of Illusions*; the Athshean's use of dreaming to reach a different domain of .

aspects-of-the-world in *The Word for World is Forest*—all of these are exploratory constructions. But instead of continuing along these lines, the process largely subsides from the mid-seventies onwards, as the conventional anomalous form of knowledge within fantasy—in this case, the magic practised by Ged in the *Earthsea* books—acquires a sign-of-collapse, conventional academic counterpart in the form of physics in *The Dispossessed*.

After this there is a fundamental way in which Le Guin's work begins to fade down. Perhaps the most powerful moment is a culmination of her late taking-up of the female-protagonist perspective in the eighth and final Life Story, 'The Visionary', in *Always Coming Home*. However, in the end you are left with the sense that if you drew up a list of lost or nearly-written books, at the top would be *The Pragmatics and Immanence Metaphysics of Those Who Walk Away From Omelas*.

Anthropology is involved in all three of the zones of expression which have just been outlined. *A Thousand Plateaus* is pervasively informed by anthropology and its title is a reference to the work of Gregory Bateson; Le Guin's parents were anthropologists and her work recurrently draws in powerful ways on the domain of thought in question. However, anthropology here is a term for thought focused on what forms the horizon of tribal and nomadic societies in the same way as it forms the horizon of nation-state societies (it is just that there are elements within the whole range of societies—though it seems in non-state societies in particular—which can be taken up together to get a clearer view of this horizon). What this means is that anthropology refers here to a crucial domain of accounts of the outside of ordinary reality. In one of the most powerful sections of *The Waves* Rhoda sees 'fishermen on the verge of the world [...] drawing in nets and casting them'. This has all been about the edge of ordinary reality, and it has been a history of contingency: it is always possible to set out on the orthogonal line of a Departure, and to leave the line of development behind.

<center>*</center>

One hundred and eighty years after the abstract and oneiric semi-awakenings of the mid-nineteenth century, there are certain points that can be made at the level of philosophical and artistic forms. At the level of writing, everything

is being pushed toward the voice/dialogue, and away from description (scripts are preeminently about voice) and the challenge of film/animation/CGI is to become philosophical. Poetry has been largely displaced by songs as conveyor of the radical/visionary (the almost complete disappearance of the long poem can be noted in passing, although it can be pointed out that for a long time this had not been a very effective form, in comparison, for instance, with the play written in heightened/poetic prose), but songs in turn have faded down, and themselves have been partially displaced by dance tracks without words. The post-1940s split of fantasy writing has only intensified since the 1980s, with the work of George R.R. Martin and Philip Pullman exemplifying the division. Stage plays have collapsed, but Shakespeare is still being performed/filmed because there is a generalised block against new production of philosophically-informed fantasy, and of tragedies ('tragedies' in this sense refers to stories which give a glimpse, through a specific trajectory of circumstances, of key aspects of the ongoing disaster within the human world), and as a result Shakespeare fills an established gap (a gap which to some extent his work created), no matter how much this gap is misrepresented and ignored. Despite the fact that books are still relatively successful, reading is being displaced not only by film/TV/ streaming series, but by the visual/sonic domains of social media. Across all of its levels music has faded down from a long phase of high intensity, and for all its power it tends now to have less of what is needed for building an upward spiral of intensification; it is more and more used as anthemic boost for an ordinary reality message, and as decoration of forms of collapse, its immense power continuously offset by its being fugitive in its impact. And the line of emergence of works expressive of the planetary sublime—with their tendency to lead toward a heightened, open-minded awareness of the planet, and toward an effective setting up of the problem of the human world—has also undergone a marked drop in intensity that began around the start of the 1980s.

Art is only a beginning, but it recurrently does not know what it is the beginning of, and although, for instance, being swept up into dance music is a deterritorialisation of the body, this is exceptionally likely to be only a temporary change, so that the person before long is no longer dancing. What is really in question all along is the deterritorialisation of a life, a joy that is on a much higher level than—and includes—the joy of dancing, and this deterritorialisation is one

that is exceptionally unlikely to be temporary, because it cannot fade down as a result of internal mechanisms. However, to this needs to be added that the deterritorialisation in question is a Futural movement toward exteriority and wider realities—as opposed to being a partial or 'surface' deterritorialisation where a limited increase in freedom is subordinated to a following of what has kudos.

*

It has become clear that the discussion is only moving forward through the assistance of the attempts that have been made from the philosophy side of the Arkadian modality to bridge the gap between the two sides.

For philosophy it is fundamental to start from the planet in its exteriority, and from the human body understood in terms of energy and intent, and in terms of its faculties, encounters, and alliances (so, also in relation to its exteriority). It is also fundamental to work in a way which continuously sees the planet as unknown in a transcendental-empirical sense, and which has a sustained focus on the heartening, inspiring/energising affects produced by the planet, in a way where awareness is maintained that the planet is the *initiator* of these affects. This is to avoid thinking 'it's all just matter', and to avoid the death-of-thought trap of 'it is the object, and we are the subject'.

Almost no philosophy exists of this kind.

Working from the perspective of the waking and deterritorialisation—and becoming lucid—of a life, visionary writers are aware of the threshold, and with great integrity they again and again show the movement to the threshold, but do not attempt to go far beyond this.

It is somewhat ironic or poignant therefore that, under the influence of the political or the evolution-of-the-species perspective, visionary writers will set out to envisage the entirety of the human world in a state where it has crossed or is crossing the threshold, *even though this challenge includes the first one.* But this is not a failure of integrity; it is just that the nature of political thought sets up the problem for the writer in a way where it is possible to proceed with a wide focus that prevents an awareness of the gigantic difficulty of what is being attempted. And the results are often profoundly valuable—as with *News from Nowhere, Woman on the Edge of Time, Always Coming Home,* and, in a different way, *Childhood's End.*

Regarding the deterritorialisation of a life (putting aside the question of the whole human world), the very few Arkadian-modality philosophers who work along these lines are able to say a little, with the use of concepts, about the beyond of the threshold, but without getting far in terms of the space of interactions/alliances of the form of existence. Even if no narrative is used, it is necessary to have a full grasp of the pragmatics of the forms of existence beyond the threshold, and this entails that the faculty of dreaming needs to be woken, because without this faculty you cannot embody the form of existence, in that it consists of dreaming up heightened circumstances—dreaming the Future into existence. The artists need to wake lucidity, and the philosophers need to wake dreaming.

Human beings have a tendency to be impressed by memory, and to fail to notice the far greater profundity of dreamings. The line of time is the central focus in relation to memory, but dreamings include dreams about the future, which *create* the future, and their relation to temporality is at another level of importance.

Memory is an element within the oneiric-real envisagement worlds of the body without organs of human beings, but it is the term 'dreamings' that is coterminous with this oneiric-real dimension.

Dreamings are recurrently lenses which reveal the deeper, transcendental-empirical aspects of the world. And in doing this, they are also dreams about the future, which bring the future into existence.

In saying that what is most fundamental is beyond the domain of music, the issue is therefore not one of a comparison between music and writing. Most vitally, the issue involves dreamings (which might or might not be expressed in words), and involves what is encountered through dreamings and through perception; the world of the planet and of what is beyond the planet (within which sound is an element). Beyond music is dreamings, perception, the planet, and the solar expanses of the beyond of the planet (it becomes evident at this point that art is suffused with the planetary sublime, and in being reconstructed as outsights and as pragmatics of intensification of existence, art is transmutated into an aspect of metamorphics).

It is necessary to return to the Westmorland Fells.

*

What is needed here is a dreaming of the planet in its entirety, reached for *from* the Westmorland Fells. The starlit expanses of the upper atmosphere, the mountains, the rivers, the deltas, the forests. Dreamings have a way of taking you to where you are, and of allowing you to see it.

There are the uplands, and there is the drome.

The world of the uplands consists of becomings, joy, creativity, exploration—it consists of whatever has the waking of the faculties and becoming-active as its vital principle, whatever is an embodiment of movements into exteriority, whatever is an embodiment of love and freedom and lucidity. Along with joy, the primary tonality of the uplands is silence, and the key faculties are perception, dreaming, lucidity, and navigation. At the level of pragmatics, alliances for the purposes of travelling Forward are key, and so is a focus on bodies, where the planet is a fundamental or primary focus and the individuals of the human world are grasped at the level of their intent and of their energy: everything here is always about becoming the best unit of metamorphics possible in each new set of circumstances. The uplands also consist of those who are travelling toward this other modality: when individuals are profoundly in love their actions belong to the uplands—it's just that ordinary reality has dark circuit breakers which normally prevent people from getting far when they are in this state-of-existence.

The drome is ordinary reality—it is the plane of organisation of ordinary existence. On one level it is marked by its having an immense amount of infra-structure that has a high degree of affinity for ordinary reality: this is because the infrastructure has been largely constructed by it and for it. However, these structures and built terrains can be viewed with the eyes of the uplands as something else at a deeper level; they can be repurposed; and they immediately have an entirely different affect when they are derelict.

The key affects of ordinary reality are kudos, moral/religious gravity/outrage, the affects involved in keeping everything under control, other more obviously dysfunctional reactive affects (such as fear, self-importance, and resent-ment) and the power-affects within sexuality (that is, control by active-con-ducting-towards, and control by drawing-towards through the modalities of erotic submission). This relates to the chronic forms of affects, but the acute forms—which will only rarely be seen in those who have collapsed into being

highly active along the lines of these affects—consist of angry jealousy, rage, extreme-self-pity, etc.

The primary faculties of the drome are feeling in the form of subjectified/reactive affects, together with a blocked form of reason (not the fully developed reason of the uplands). And happiness here consists of relief at having reestablished control when it was threatened, and of the pale joys of pushing forward and developing the domain of the functionings of ordinary reality.

The drome is the place in which wars, feuds, and vendettas of all kinds are continually produced, along with all the horrific micro-oppressions of domestic violence. Drome warfare. There are sometimes very nuanced empirical issues about what stance to take in a relation to a particular conflict, but this does not change the fact that the drome is somewhere from which it is necessary to depart. The drome is ordinary reality, and is the wars within ordinary reality (it can be glimpsed for a moment as having the shiny-quotidian and sinister aspect of the Overlook Hotel), and it is necessary to walk out of it, and keep walking.

Becoming a unit of metamorphics involves having woken a capacity for inner silence, and an—inseparable—capacity for sustained perception. It consists of delight that is immanent to the processes of exploration, of movements into and encounters with exteriority. It also consists of moving toward whatever alliances are possible. If this had been a tendency previously, it is a movement away from drawing on texts, and from trying to convince those entrenched in a different position.

The language of the uplands is outlandish, and outlandish always appears in new forms.

Lucidity takes you to the point where you can see the ongoing disaster of ordinary reality, and where you can see the uplands beyond the drome. Which is to say that lucidity allows you to see the depth-level of bodies—the world of energy and intent and dreamings.

To travel toward love and freedom (this includes freedom from all kinds of dogma and obscured assumptions) and toward a heightened capacity for silence and for perceiving and envisaging the planet—this is the *outward journey*.

There can be a sunlit, planetary silence. An awareness of a vast astonishing terrain lit up by and absorbing solar exteriority, and a simultaneous awareness that this terrain is the transcendentally unknown (which can nonetheless progressively become the known).

In this silence, what is music?

If you listen to the sounds after a group of notes is played simultaneously on a piano, you hear an exceptionally beautiful rise and fall of the interference pattern of the soundwaves. This rise and fall is not an expressive modulation on the part of the musician—it is the voice of matter. Musical compositions make forces audible which are not sonic—the sea, love, serenity, a kind of intent in relation to the world. But we tend to hear neither the exteriority nor the sound, and to construct the exteriority as being revealed to us by the spirit of a musician, of a social formation, of a system of belief, etc. (this controlling/revealing spirit can then also be projected into an extension of the delusion, in the form of the idea of God as ultimate controlling point of this kind—the conservatism of the forties and fifties includes the work of two writers, Tolkien and Lewis, who each have a creation myth in which the world is music sung by God before it is matter). We generally don't realise the extent to which there is a humanist cult of musical expression, one which in fact is still in full effect when it is at the opposite end of the spectrum from music explicitly connected with religion. Music has a power to conduct toward the sublime domains of exteriority, but overall people are to a very great extent blocked by the obfuscating, damaging way in which music is constitutively constructed within the human world. What is fundamental is to go toward silence. Because it is pervasive across an existence, the joy of the outward journey is on a higher level than the joys of what we call art, and silence is fundamental for the outward journey.

Music heartens, inspires, transmits affects, but particularly with the hearing (as opposed to the composition) of music it tends to do this fugitively—in a way where, at the level of the entirety of the individual, it impacts, and then is gone. Taken as a whole its impact gets attached to all kinds of reactive affects, but what is most crucial is that it does not in itself produce the upward spiral of intensification. In contrast, words are capable of providing the pragmatics and metaphysics of the journey, which is to say that, as well as transmitting affects, words can consist of diagrams for a heightened form of existence, and can break open outsights toward wider-and-deeper levels of reality (where these outsights are effective for the purposes of navigation).

The oneirosphere of the human world is the sphere of the abstract as well as of the oneiric, and in relation to its most crucial aspect it can consist, firstly,

of philosophical works which have a narrative form, and/or are threaded with narratives, or with 'figures' that have an oneiric or first-level-oneiric power, and, secondly, of dreamings in the form of tales, where these are threaded with and/ or overarchingly composed of outsights. The drome, however, is pervaded by blocked, suppressive dreamings which are dominated by subjectified affects such as gravity and self-importance (the worlds of religions and of hero tales/ kudos tales are dreamings of this kind).

It is important not to give too much importance to books: the thresh-old-crossing that leads out of the drome can also take place through spoken language, and in any case it is the combination of the planet-in-its-exteriority, the faculties, and language that is the key—the diagram can also be accurately described as a catalyst for an always singular process of encounters, and of creation of a modality of Departure (and it is vital to remember the primary importance of the silence of sustained perception and of a concomitant suspen-sion of internal verbalising). But, nonetheless, it can seen from this that there are times when the impact of books can be key.

The oneirosphere is very different in comparison with the atmosphere, but there is enough in common for it to be valuable to make the connection. It is divided into heterogeneous micro-zones (individuals) in a way that is different from the atmosphere, and yet it has macrological zones and is profoundly in communication with itself. Books on their own are a feature of a terrain (like the southwest escarpment of the Westmorland Fells), but if someone comes and reads them, an abstract-real and oneiric-real world can appear which is capable of sweeping the person away. The outsights and the diagrams for a heightened form of existence can together take the individual across a Futural threshold.

*

The attempts to bridge the gap between the two sides of the Arkadian modality have not been very successful. In *A Thousand Plateaus* Deleuze and Guattari have a tendency to be confused about nomadism—because they veer toward trying to envisage it as the state-destroying true form of revolutionary com-munism—but more importantly. the endless micro-critiques of the book fill their writing so full of transmutated terms from academic thought that the

pragmatics and metaphysics never get a chance to develop in a sustained, focused way—so that their writing is only minimally accessible to a non-academic readership. They also do not have a good account of, or a good name for, what it is that you have reached when you have brought together the two sides of the modality.

To join the two sides is all along to find that you have bridged the gap to the Sayan modality. At this point a quality of the translucent-and-opaque is likely to appear at the level of the concepts, but there will no longer be an inaccessibility for everyone other than academics. This applies whether you take the example that comes from the China of two thousand years ago, *Tao Te Ching*, or works by Florinda Donner such as *Shabono* or *Being-in-Dreaming*.

This other modality is metamorphics—the pragmatics and metaphysics of intensification, of metamorphosis.

The three delusional, damaging modalities of religion are interiority, as-if-it's-all-fact accounts of the future of individuals and of the planet, and the gravity of judgement with its structure of Good and Evil. Interiority divides into the eternal soul form of the modality, and the 'we are creators of the world we encounter' form of Buddhism/Kantianism. And Good and Evil is both the damaging affect of Judgement (as imposition by its deployers, and as internalised subsequent self-imposition by victims), and the effectively zero and one terrain of Tolkien-modality dreamings, where instead of the depth-level problem being seen as pervasive in a wide-and-deep way, everything is constructed as Hero versus Horror, creating a modality which is a prevention of thought.

The dreamings of ordinary reality are religious, social, political, and philosophical/metaphysical, and they are often so minimal and pervasively implicit as to be barely noticed. Everyone has their own combination, and people often don't have all of the modalities. There is the dreaming of the universe/matter; there is the dreaming of a religion; there is the ordinary-reality dreaming of the family, in one of its (warring) reactionary and inclusionist forms (the inclusionist form evidently has within it an aspect which for each individual could be part of a beginning of the way out of ordinary reality, but given how much effort is involved in raising a family, this does not mean that the way out will be found); there is the dreaming of a specific nation state and of an alliance of nation states, together with formations such as the UN (whereas beyond this, in reality,

there are extremely indebted nation states which have been subsumed within capitalism, and which, under immense pressure from capitalist circumstances, are using neo-crusade pretexts for their struggles to gain advantage).

Because writers of stories are creators of dreamings, they are in a position to intervene, but to speak from the point of view of reason, a great deal needs to have been critiqued at once. To speak from the point of view of lucidity, and from the point of view of all the faculties, you need to wake lucidity. And at that point, the creation of dreamings is the result of the expressing of outsights (knowledge) and the breaking open of an awareness of the world as, at a wide and deep level, the *unknown*—it becomes an aspect of philosophy. Suddenly everything becomes vast, deep, and in a specific sense, straightforward. There is the planet, there is sunlight and starlight, there is energy, there is intent—there is the path.

The forms of travel here, in relation to full and partially effectuated nomadism, are the loose, unstructured semi-group, the creative alliance or collaboration, the individual (who in any case is always a nexus of encounters/becomings, as well as being a multiplicity), and the group. Couples can be swept up within a nomadism, and so can families. There is the non-indulgent tonality of a group of people who are travelling fast in a vehicle to escape a pyroclastic flow from a volcano, and yet at the same time everything has an intrinsic lightness. A full nomadism is metamorphics at the level of an overall form of existence, and it always consists of brightly sober, non-indulgent bonds of affection which in terms of affect consist at depth of the joy of travelling forward and of exploration.

The outward journey is undertaken as an expression of love for the world, and as an audacity that is in itself a delight, but it is important to see that the lines of departure become increasingly vital as the world becomes more and more gridded and locked down into an intricate libidinal-technological domain of ordinary reality—which is to say that the existence of the outward journey is fundamentally needed by everyone.

Everything is normal, and yet there is a fraction less gravity. There are two or three houses, in different parts of an area of hills with a lot of woodland, or maybe it is an area of semi-desert, or of mountains. There is another house in a town or city—or maybe all of the houses are in a city. What takes place is recurrently enveloped in an atmosphere which feels bright, planetary: there are projects of

different kinds, some of which are about earning money for sustenance. The horizon of the projects is the Future.

Where are we now? We are in Westmorland, in Tuva, in Patagonia. We are on the planet. There is a path—it leads toward wider realities. The lines of emergence are not in themselves a cumulative, deepening process of thought and under-standing, and still less are the lines of development: this is only true of the lines of Departure. With the sequences of emergences there is a sedimentation of confused interpretations that takes place over time, and changes in the systems of ordinary reality can bring about a decline. With lines of development the progressions (as with science) are not at the level of the transcendental-em-pirical, and the value of the advances is more than offset by the processes being components within formations dominated by the processes of ordinary reality. However, beyond all this are the outward journeys toward the Future. The recurring expressions of metamorphics in the form of written works is at depth an expression of the obscured option of human beings, which is to wake their faculties. It is this obscured option which entails that the path is a feature of the terrain. It is necessary to walk, and to keep walking.

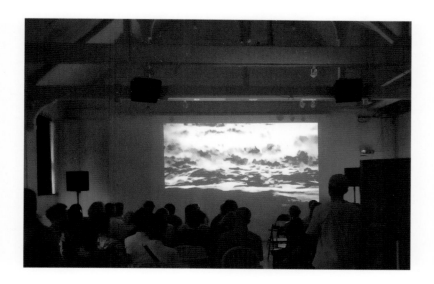

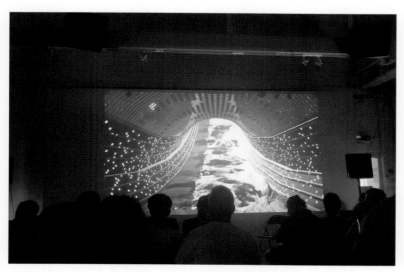

Sonic Faction, Iklectik, London, 14 July 2022: Playback of *By the North Sea* and *Astro-Darien*

Exhibition space for *Sonic Faction*, KARST Contemporary Arts, Plymouth, 8–11 February 2023. Photo: Dom Moore

By the North Sea installed at KARST. Photo: Maya B. Kronic

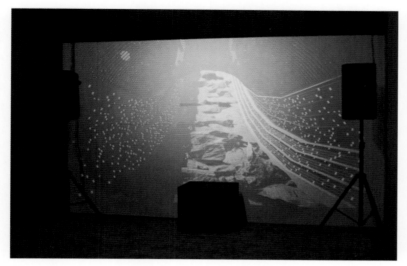

Astro-Darien installed at KARST. Photo: Maya B. Kronic

On Vanishing Land installed at KARST. Photo: Dom Moore

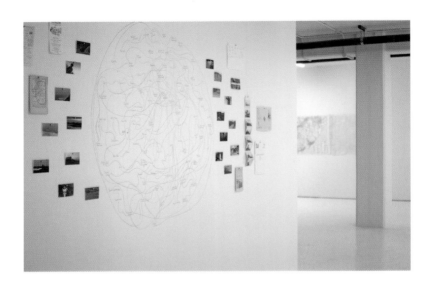

Archive materials for *By the North Sea* and *On Vanishing Land* installed at KARST. Photos: Dom Moore

Listening station at KARST. Photos: top, Dom Moore, bottom, Maya B. Kronic

Discussion event at KARST, 4 February 2023. Photos: Dom Moore

Discussion event at KARST, 4 February 2023. Photos: Dom Moore

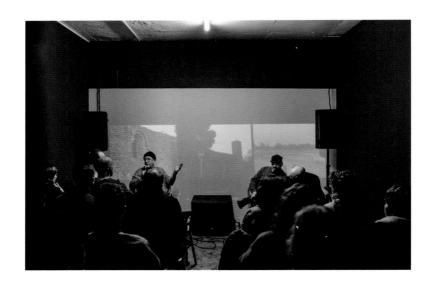

Discussion event at KARST, 4 February 2023. Photos: Dom Moore
Following pages: Archive materials installed at KARST. Photos: Dom Moore

SONIC FACTION
Audio Essay as Medium and Method

KARST
08.02.23–11.02.23

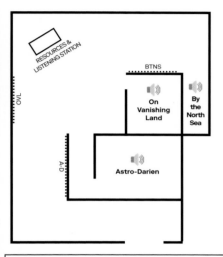

The audio essay is an experimental form, still in flux—a way of making sound think, an opportunity for concentrated listening, a medium that crosses the boundaries between radio play, documentary, audiobook, lecture, ambient sound, field recording, hauntological mixtape....

Sonic Faction presents three exploratory pieces that invite listeners to experience the ways in which sound and voice can produce new sensory terrains and provoke speculative thought.

The exhibition also includes archive material relating to the three projects. The resources area features a range of printed matter that takes the reader further into the sonic realm, and a listening station presenting some rare audio artefacts by the featured artists.

Kode9
Astro-Darien (2022)
Audio Essay with Video, 25'42"
A sonic fiction about simulation, presenting an alternative history of the Scottish Space Programme, haunted by the ghosts of the British Empire.

Justin Barton and Mark Fisher
On Vanishing Land (2006)
Audio Essay, 44'53"
A dreamlike account of a coastal walk that expands into questions of modernity, capitalism, fiction, and the micropolitics of escape.

Robin Mackay
By the North Sea (2021)
Audio Essay, 44'53"
A meditation on time, disappearance, and loss as heard through the fictions of H.P. Lovecraft, the Cybernetic Culture Research Unit (Ccru), and the spectre of Dunwich, the submerged city.

Kode9 *aka Steve Goodman is a DJ/Producer, artist and writer. He set up the record label Hyperdub in 2004, and in 2019 the sub label Flatlines to focus on audio essays and sonic fiction. His book* Sonic Warfare *is published by MIT Press.*

Justin Barton *is a philosopher and writer, and has collaborated on projects with artists and theorists. With Mark Fisher he made the audio essays* londonunderlondon *and* On Vanishing Land. *His book* Hidden Valleys: Haunted by the Future *is published by Zero Books.*

Mark Fisher, *author of* Capitalist Realism, Ghosts of My Life *and* The Weird and the Eerie, *was an English writer, music critic, political and cultural theorist, philosopher, and teacher based in the Department of Visual Cultures at Goldsmiths, University of London.*

Robin Mackay *is a philosopher, translator, and director of the publisher Urbanomic, which aims to engender interdisciplinary thinking and cultural production. He has written on art and philosophy, and collaborated on experimental projects with contemporary artists.*

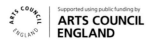
Supported using public funding by
ARTS COUNCIL ENGLAND

In association with **Urbanomic** and **Hyperdub Flatlines**

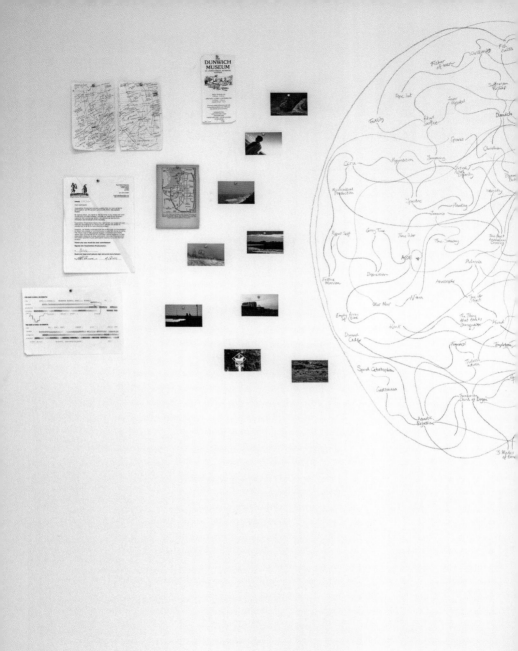

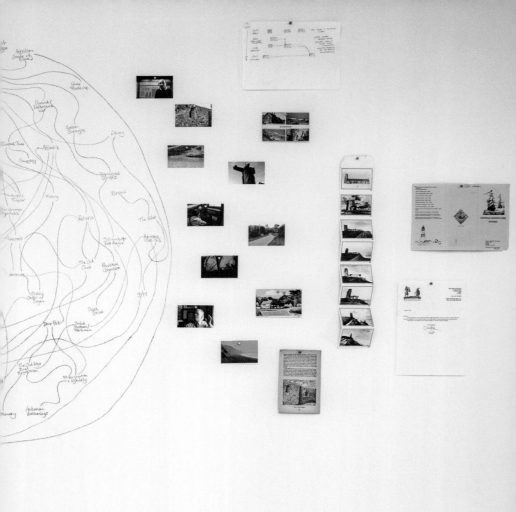

Sound Shadows: Paths of Departure

SONIC FACTION
Audio Essay as Medium and Method

KODE9
JUSTIN BARTON & MARK FISHER
ROBIN MACKAY

Collective Listening Event:
Artist Talks / Audio Essays / Q&As
Exhibition: Sound Installations / Archive

K A R S T

22 George Place
Plymouth
PL1 3NY

karst.org.uk
@karstgallery

Listening Event
Sat 4 Feb 2–7 pm
Tickets £6 from karst.org.uk

Exhibition
Wed 8–Sat 11 Feb
11 am–5 pm
Admission free

URB ANO MIC

In association with
Urbanomic and
Hyperdub Flatlines

Supported using public funding by
**ARTS COUNCIL
ENGLAND**

Lawrence Lek

NOX: An Audio Walk Through the Machinic Unconscious (Interview with Steve Goodman)

From October 2023 to January 2024, Lawrence Lek's exhibition NOX, in collaboration with LAS Art Foundation, ran at the former shopping mall Kranzler Eck in Berlin. NOX follows an errant, self-driving delivery vehicle who undergoes a rehabilitation programme in the eponymous building. Spread over three floors, the exhibition was Lek's largest installation to date. Previously, his work had ranged from 'site-specific simulation' through to 'sinofuturist' meditations on AI, both deploying game engine software to produce cinematic, computer-designed worlds. Also a musician, sound has played a key role in Lek's work, and in NOX, through combining the idea of the guided audio walk with open-world game interactivity, he expands the idea of the audio essay. Our fictional experience of AI—whether in literature, film or games—usually makes a correspondence between having a voice and having agency. Clearly, this is a narrative device in order to make the inhuman relatable to humans. The following conversation with Steve Goodman (11 December 2023) revolves around methodological issues that arise in using voice across virtual and physical space, and the aesthetic choices that inform its use in tandem with music and sound design.

STEVE GOODMAN: I would like to begin by talking about the way in which the audio dimension of *NOX* is installed into and structured around the space of Kranzler Eck. This former shopping mall feels like a Ballardian stage set, both in its commercial abandonment and as the site of car crashes. After I visited the exhibition, you sent me a linear version of the interactive soundtrack. Did you make this mixed-down version first, and then distribute certain chunks of that in different parts of the space, or did you see the space first, decide which

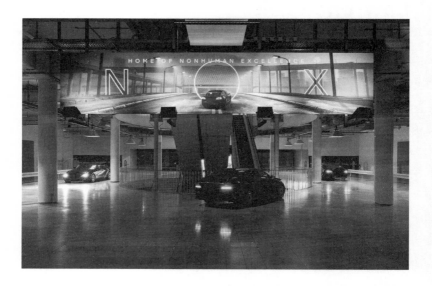

Lawrence Lek, *NOX*, 2023. Installation view, LAS Art Foundation, Kranzler Eck, Berlin. © Lawrence Lek. Commissioned by LAS Art Foundation. Photo: Andrea Rossetti.

areas would fulfil certain functions, and then make audio to suit those? How did you go about using locative audio to map out the space into different territories which corresponded to different parts of the audio? Can you talk a little about the process here?

LAWRENCE LEK: My first idea was to think about transforming the whole building into this hybrid stage set, where the fictional rehab programme would take place over five days, like a five-act play. The next series of decisions concerned how to create a walk-through narrative that worked in the space and that unfolds over different floors. How do I apply this specific narrative about this self-driving car treatment centre to an abandoned but atmospheric building?

Videogames include the genre of the 'walking simulator', where the scope of interaction is pretty narrow. The main action is movement; it's an ambulatory genre. When I first visited the building, I noticed that simply walking around the space, with its high ceilings, strange steel walkways, central atrium, and super-echoey dome on the top floor, was already so compelling. So I wanted to reinforce this walking idea and think about how an audio essay could be built into that. Also, in terms of duration, it seemed I could walk around the space for about forty minutes, about as long as an album or long-ish audio essay. This similarity in duration gave me a basis to think about the actual writing.

In terms of the layout of the story, the ground floor feels like an introduction, you're in this external environment, a highway in the fictional smart city of SimBeijing. The highway space is like an open-world game, where points of interest are demarcated or hinted at by lighting conditions or physical barriers.

On the first floor, the space shifts to a more interior architecture, like a deconstructed clinic, which also reflects what's happening in the audio narrative. The audio trigger zones are indicated through walls, platforms, benches, and fences, so the zones are more physically defined in that sense. But that process of designing the space, and knowing that people would move through it in a nonlinear fashion, meant that I had to prioritise the spatial-sonic layout first. So, the linear audio soundtrack was made after the exhibition opened, rather than at the start.

I wanted to create a narrative which would be deconstructed into that space through these different zones, so that when the audience—the listener/

player—moves through these spaces, their perception of duration would feel similar to a long-form format. At the same time, the set design, which I developed with scenographer Celeste Burlina, would reinforce the auditory journey. Besides video games, the other form I was thinking about was immersive theatre, where your journey through the zones as an audience member is much more prescribed. I didn't want it to be as theatrical as that, but there's a grey area between these deconstructed, physical, open-world video games and physical theatre, where the link between narrative and location is usually more predefined. So, in the end, I wanted it to feel that your route is a mix of going on the prescribed path of the 'main quest' and also being able to explore.

SG: How did the locative audio technically function? You're walking into the space and you enter a territory that triggers a piece of audio. How does that work technologically? Is it some kind of Bluetooth system?

LL: For locative audio, I worked with usomo, a company who have a proprietary system based on triangulated line-of-sight infrared sensors Bluetooth operates on a longer wavelength, and doesn't need a clear line of sight between the sensors to the tracking device, which in this case is on top of the over-ear headphones that visitors wear.

SG: So Bluetooth would be too vague for this kind of setup?

LL: Seth Scott, the sound designer I worked with, had done projects with Bluetooth before, but locative audio obviously evolves according to the technology. With Bluetooth, you basically have a system that gets triggered through proximity, but this is often less reliable than a line-of-sight system. For the setup, usomo fixed infrared cameras on the ceiling throughout the key points of the exhibition space. There were some limitations, of course. For example, if you were to cover the sensor at the top of the headphones, you would lose tracking. Seth and I tried to design the soundtrack in a way that even if tracking were momentarily lost, it wouldn't break the system. How this works is that you are given a handheld device which is actually running a non-visual video game—basically, usomo rebuilt the space in Unity, which is a 3D game engine,

and your motion is being mapped onto a virtual location in the software which then triggers your audio. So, in a very literal way, it is a surveillance system. Of course, audio guides are used all the time in galleries and museums, so *NOX* is somewhere in between an audio guide, a sound essay, and a non-visual video game system.

SG: It's interesting that they would construct the gallery space in Unity because that loops back to your earlier site-specific simulation works, which reminds me that there is some kind of virtual audio walk theme that runs through some of those projects, like *Unreal Estate* for example.

While exploring *NOX*, I became interested in the edges, in the cracks between the different audio territories of the surveillance system—trying to move into more than one at the same time, or finding those boundaries where it sounds like a radio tuning between stations and the signal would distort. Was that the signal losing its strength, or is it programmed into the system to sound like that?

LL: The distortion is a deliberate effect that's meant to be symbolic of the signal losing its strength. With this digital tracking system, the signal would

glitch on and off if tracking is lost, rather than create a fuzzy distortion, as with analogue radio or walkie-talkies. A lot of game audio, like film audio, is basically the art of crossfading. Modern games have many different simultaneous tracks playing. What Seth and I decided is that when you enter zones that have a lot of narrative importance, the ambient sound and music get ducked down in volume, and the voiceover stays clear on top. And then, when you leave that zone, it's only the voiceover that would have the radio-distortion effect. That way, the soundscape seamlessly blends between different zones, but it's clear that the (voice) signal has been lost. We had to find a balance between fades, delays, and actual distances because we anticipated that people would wander in and out, or play with the boundaries of the zones. You don't just want the audio to flick on and off. In game design, besides audio triggers, you have other environmental triggers, like when a level loads or unloads, or you approach automatic doors, you want to have this time buffer to smooth out the errors of an otherwise discrete binary system of sensors. Are you inside or outside the zone? For example, with the voiceover distortion, it ended up being easier to have separate distorted and un-distorted voice tracks playing simultaneously, and then crossfading between them if you leave the zone.

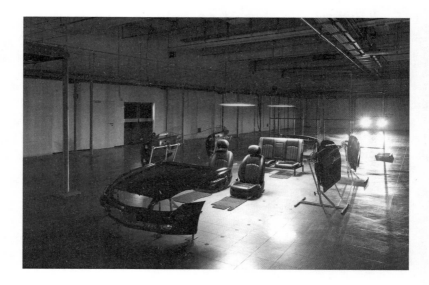

Another important part was deciding how to synchronize things. The main voiceover in each zone is between a minute and four minutes long. Obviously, the voiceover track starts from the beginning when you enter a zone for the first time. But what would be the ideal situation for how it stops? If you stay in the zone and listen to the whole voiceover then it would play as a one-shot and stop at the end without looping. If you went out and came back in, it would play again from the beginning. But if you didn't listen all the way to the end, and then left the zone, it would just pause, fade out, and then resume if you re-entered.

SG: So this is all programmed in?

LL: Exactly, there are two closely related programming ideas; there's conditional logic—if this, then that: if you enter, then voice plays; if you exit, then voice distorts; there's also state logic, which tracks which zones have been entered or exited, and therefore what sequence of audio tracks to play.

SG: So it seems that you calibrated your compositional decisions based on spending time in the different zones, and deciding that you wanted to, for example, spend three or four minutes in this part or that part, and therefore the sound for this part will be that long? However, the way I experienced the audio was probably a little abnormal, because I knew we were going to have this conversation, so I spent a lot of time just milling around, enjoying the atmosphere of the place, getting bits of audio to repeat themselves so I could listen again and playing with the system to see what it could do. Did you do a walkaround and time each subsection, or was it looser than that?

LL: I tried to balance the ideal situation, of having a 'deep listener' who would want to explore everything thoroughly, and that of a 'speed-runner' who might zip around and see everything in fragments. My experience with doing this kind of interactive exhibition is that you just can't predict what people will do. You can try to control it or block off certain routes, but ultimately, some will do as you intended, some will act at random, and some will try and break the system to find the boundaries and edges. I've found that in any kind of interactive work, from games to an open-world audio essay like *NOX*, people explore in all

sorts of ways. I could be very intentional about it, and of course there would be some people who would experience that complete version, and others who would just get a loose sense of the whole composition.

There are certain hotspots where you want to focus attention, such as in front of screens, or with lighting, sound, or seating to break up the walking journey. It's like having dynamic range in music, the spread between loud and quiet, but implemented spatially—you can't have everything highlighted at the same level all the time. So there's a kind of rhythm in that sequencing.

SG: I thought the hidden 'easter egg' element was interesting because it deviates from the more literal audio guide model where, for example, you're standing in front of a screen or a painting or sculpture, and the audio is dictated by vision, and indicates or annotates what you are seeing. Instead, *NOX* creates a kind of augmented audio reality or acoustic virtuality where you could be walking around in the dark, and you stumble into an audio territory where there aren't any visual cues. You can imagine an extrapolated form of this which would be weird and hallucinatory: you walk around a completely dark space and there are invisible easter eggs hidden everywhere. What was the audio for the easter eggs? It seems like there are two poems.

LL: Yes, those are altered versions of Old English poems 'The Ruin' and 'The Wanderer'. What I liked about them was not just the way that they had an epic aura, but also that they dealt with a sense of temporal and spatial dislocation. 'The Ruin' is supposedly about an encounter with the then-abandoned town of Bath, seeing the decaying structures of a past empire. With *NOX*, you have the physical location of this former shopping centre being repurposed for another function—as a rehab centre—but also being part of a wider smart city in a state of transition. In 'The Wanderer', the narrator is a wayfaring stranger who has lost their tribe and longs for a return to their community. And I thought that this related to what the individual player was doing, moving around, as well as the story of the self-driving car in the fiction, cast adrift from their community of fellow AIs. In the context of the main story, I also wanted those fragments to resonate in the contemporary context, while also harking back to an earlier source, an age of anonymous authorship instead of big data and surveillance.

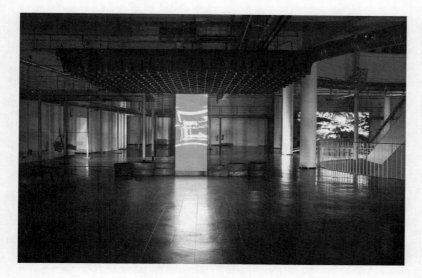

There are also a couple of other easter eggs, semi-fictionalised news reports about other incidents in SimBeijing smart city.

SG: Let's talk about the different kinds of voice in the piece. Apart from the poems and news report easter eggs, there are Guanyin's reflections and Enigma-76's journal entries directed to their sponsor. These have different types of address. Is that an artificially modelled text-to-speech voice? Because I listened to it over and over again, and I was trying to place the accent, and it's not transatlantic, but it has a classic, slightly flat affect. This morning was the first time that I realised that it might not be human because there's some very subtle rigidity in the intonation, like it's on the edge of human.

LL: Enigma's voice is from a model that's trained on English, French, and German voices all at once. When the input text is in English, the neural network output oscillates between sounding sometimes French and sometimes German. It's an in-between accent, almost trans-euro.

SG: Yeah, when I initially thought transatlantic, I was trying to get at that international English dialect that doesn't have one origin point, but is rather a free-floating accent, where English is spoken as a second or third language.

LL: I was experimenting a lot to try to find the right voice. I was also looking at Jonas Mekas's videos, which have a lot of continuous stream-of-consciousness monologues and free-flow conversations. One thing with many commercial text-to-speech voices, whether they are actors or untrained, is that they are made to be easily understood, almost too clear. But having something pristine isn't really what I wanted. Of course, the voice needs to be understandable, but in my work in general, working with AI and CGI, the challenge is how to be both comprehensible and evocative at the same time—that's a big challenge.

Obviously, the voice needs to be pleasant to listen to, simply because there's a lot of it. But that sonic quality also needs to fit in with a visual narrative and the epistolary form. When I was thinking about the intro to *NOX*, the first thing that visitors hear when they put on the headphones, I remembered *A Brighter Summer Day* (1991) by the Taiwanese filmmaker Edward Yang. In several of his films, but particularly this one, props play a big part. There's a transistor radio that ties together the acoustic world with the broader narrative and onscreen action. Right at the beginning of the film, one of the characters—a high school teacher—is listening to a radio broadcast about the graduating class of high school students—so-and-so went to this university, somebody else got a scholarship, somebody dropped out or went overseas. That's the introduction, and it sets the whole tone of alienated youth within a changing world. I thought that would be a great introduction for *NOX*, given that it's like a reform school for cars who don't want to be there.

SG: So that's what's going on in the first section—it's a log report going through lots of different cars, their speed limits, and whether they've graduated out of rehab or transgressed their restrictions and whether they can be exported to different territories?

LL: Exactly, it's like a character selection screen in role-playing games, reading out the car's name, class type, speed limit, and other statistics. So although the voice is just reading out facts, it builds out the wider world in an indirectly didactic way. There's a common narrative problem of how you convey information, not just linguistically, but sonically as well. In *A Brighter Summer Day*, the radio is a source of information about the social and political world of Taiwan

at the time, and I adapted that idea into the context of *NOX* and its place in SimBeijing smart city. On a broader level, radio is also a locative audio system, one whose effective range is much larger than the system in the exhibition, with radio waves going through walls and so on.

SG: It's interesting when you think about the epistolary mode and essay form, because in a way, essays emerged out of people writing letters to each other, and that obviously was drawn into early essay film. But letter writing, or, in this case, directed journal entries, also facilitates this kind of slightly wandering, digressive quality, which allows you to make thematic cuts and follow tangents in a way that a more academic or linear argumentative essay doesn't allow for.

Going back to the voices, Guanyin is a more conventional off-the-shelf American text-to-speech model. And the news reporters' voices also. Are they all synthetic text-to-speech voices?

LL: Yes, but also, I would say the choices are always a blend of convenience, practicality, and intention. I was also thinking in terms of the logic of the world. What if the fictional characters had some agency? What kind of voice would they choose for themselves? Maybe a voice borrowed from science fiction or video essays. Why not? So it's not just my preferences as an artist, but some-thing that could be justified in terms of what the fictional AI character might want to adopt as their identity.

SG: It can just make it consistent with the world. That's how I felt with *Astro-Darien* when I was making it during lockdown. It was convenient to use text-to-speech voices at a time when meeting people wasn't easy, but also totally on topic, on theme, and they were the correct voices for the type of material that was being discussed, as the whole thing relates to the thought processes of both a game designer and the predictive AI of a simulation game about the break-up of the UK.

Returning to Guanyin, their mode of address to Enigma is like therapist to patient. Was that modelled on anything on particular? Obviously, you've been developing this in relation to the wider film project *Black Cloud* [1] and this strange

1. See <https://www.lawrencelek.com/works/black-cloud>.

relationship between Guanyin and the self-driving car—is their speech modelled on any particular type of therapy?

LL: In *Black Cloud*, Guanyin has several conversations with the car, but in *NOX*, Guanyin never actually talks to the car directly; they are always talking to somebody else. Guanyin is either giving a report to a kind of generic listener or to their parent company Farsight. Meanwhile, the car always addresses you as their owner, or 'Sponsor', as it's called. In *Black Cloud*, I was looking at ELIZA, an early chatbot which was based on Rogerian therapy, where the therapist basically mirrors the patient's words back at them in the form of a question. But I was mostly thinking about the therapeutic conversation in terms of what is useful for the *NOX* world, rather than in terms of formal schools, like Lacan or whatever. I was doing thought experiments about what kind of occupational therapy would be applied to a corporate AI. An everyday analogy might be what happens in the Apple Genius Bar when you hand in your laptop. They go through their process. They check your hard drive. They check if you've backed up everything, and then five days later, you get your laptop back, with an upgraded operating system. I thought about how that system might work if it was an AI car as opposed to a laptop. If you're an important luxury car owner, the company would send you messages all the time saying 'Oh, your intelligent but occasionally faulty self-driving car is doing great, nothing to worry about'.

Enigma's five-day treatment culminates with equine therapy in the CGI video at the end of the main open-world zone. Riding and training horses is something you get at the Priory and other high-end rehab centres. In *NOX*, there's also an unspoken bond between the horse and car—as industrial workers, they realise that they are useful only as long as they are economically productive. So I was trying to blend what might happen in this AI Genius Bar and what would happen in a high-end occupational AI healthcare world.

SG: Going back to this epistolary mode of address in the context of AI, it's interesting that Enigma's inner monologue is like a letter. It becomes a journal entry and letter-exchange type device, and this just made me wonder: What is an inner monologue to an AI? When it's technologically instantiated and functional somehow. What is this function? Obviously, a lot of your work revolves

around AIs thinking out loud, vocalising their thoughts, having existential crises, and reflecting on themselves. I'm wondering what the difference is between a human's existential inner monologue and a machine's. In *NOX*, it's transmitted back to the sponsor, like you said, so that the sponsor has some idea that their money is being well spent. So its inner monologue is also a status update to the outside.

LL: Put simply, the monologue is a pure form of linguistic communication because it's just words in a sequence. There is a huge gap between how humans think as opposed to how they communicate through language. When you string words together in sentences, you have to communicate within the narrow boundaries of verbal language, and of course it's an artificial constraint to say that this car or this AI would have a similarly limited, serial form of communication. It is more likely to be some kind of parallel stream of high-density information. In the history of writing that tries to capture the stream of consciousness, like with James Joyce, that's always been the conceit, but of course, consciousness is not a stream, but rather multiple, overlapping flows. But what that monologue does give, with this essay form, is a kind of license to jump between different subjects without being so prescriptive or academic.

SG: On a related note, I was thinking about the decision to not have one voice that accompanies you through the whole walk through the space, that gels it all together, as in the voice-of-God perspective. Or the decision not to personify the surveillance system somehow—maybe that would be the least interesting way of doing it in narrative terms or in sound. Instead, you are navigating through a few perspectives manifested through a few voices, of Guanyin and Enigma, or the news reports and of the poems. So instead of having one voice that unifies the whole thing, where the system gets an 'I', what we have instead is this feeling that you are walking through the machinic unconscious of this system, of this entity, as opposed to listening to its ego.

LL: That goes back to this question of didacticism, of how legible you want the underlying structure to be. One benefit of having a singular authoritative narrator or voice of God is that it makes the narrative structure much more apparent.

But because *NOX* is really about a place, I thought that the hidden forces and complexity that govern that world would be better conveyed through this ensemble of characters. For example, some filmmakers challenge the singular 'hero's journey' narratives by building out interlinked stories with multiple pro- tagonists, with no main character. They're trying to build out their cinematic world through these branching storylines or plots, with less of a singular path through the world. *NOX* shares that cinematic idea, but also another aspect that comes from role-playing games. The conceit is that you are the main character; you're not just witnessing the world from another point of view. In *NOX*, the voice you hear most often is the Enigma or Guanyin, but because they speak using language that is both a message and an internal monologue, your own sense of identity gets blurred over time, as it does in a first-person game once you've been playing for a while. With the headphones, they are literally in your head while you are in theirs.

SG: Yeah, when you subtract didacticism, your perspective becomes more diffused into the ambience and space. In a way, it balances the technical authoritarianism of the surveillance system, which has pre-marked territories, triggers, and pathways. It's an interesting tension between the functional

requirements of the system and making a compelling narrative that you want to return to, uncovering layers over time rather than revealing everything on the first listen. This feature of drawing you back in, to listen again and again and to peel off more layers seems really key, and marks out a difference between this kind of digressive branching mode and, let's say, a more conventional radio documentary or radio play.

I've been working on one piece that samples from a lot of documentaries, and it's noticeable when a documentary's didactic signposting is heavyhanded in its clarity, where the dominant voiceover merely repeats and summarises the points that have been already made, loading in so much redundancy into the piece. When you subtract this redundancy, it actually makes the piece far more compelling, creating an intrigue that makes you want to listen more, but it also takes the listener longer to work out what the hell the thing is about. This seems like something that is really important in this interzone between discursive formats, between documentary, fiction, drama, theory, poetry and the archive.

LL: I realised that when you have strong sonic signifiers, like distorted radio voices or scratchy jazz music, you only need a brief sample to set the tone. More than that and it becomes too much. Take, for example, a BBC radio play, which has super-clear signposting from the sound effects—it's the gold standard in terms of clarity and accessibility because it's intended for the widest audience. This is one of the never-ending problems: How do you balance the desire for allusion and digression while still maintaining the lines which guide people through the work? A common outcome of wanting to be more experimental is that it becomes less compelling from a fundamental storytelling point of view. It's always a challenge to balance the mechanics of tension and causality with a desire for atmosphere and poetry.

Nik Nowak. *Schizo Sonics* (2020), exhibition view, Kesselhaus, KINDL. © Nik Nowak / VG Bild-Kunst, Bonn, 2020. Photo: Jens Ziehe

Jessica Edwards

A War of Decibels: Escalating Delusions of the Topology of Sound

The following text constitutes the narrative of Berlin-based artist Nik Nowak's audio essay A War of Decibels *(Flatlines, 2024) and relates to his exhibition* Schizo Sonics, *curated by Kathrin Becker, which took place between September 2020 and May 2021 in the Kesselhaus at KINDL Centre for Contemporary Art in Berlin. This large-scale audiovisual installation comprised two powerful sound sculptures* (The Panzer *and* The Mantis) *and, like most of Nowak's work, engaged with the phenomenon of sound as a weapon and medium of propaganda, drawing from examples of loudspeaker battles over the Berlin Wall waged between East and West Germany between 1961 and 1965 and the politicisation of Jamaican sound clash culture in the 1970s. Alongside contemporary sonic skirmishes in the DMZ between North and South Korea, these instances constituted ideological and acoustic proxies for the Cold War. In the installation, Nowak positions the two sound sculptures facing off across a border fence. The 43-minute audio essay was conceptualised and sound designed by Nik Nowak and is divided into four movements combining narrative elements with original archive recordings from Studio am Stacheldraht, sounds of nature, and physically palpable basslines. This specially commissioned text was written (and read in the sound work) by Jessica Edwards. The audio essay also features spoken word interventions from Infinite Livez, which are not included in the text.*

I. West Berlin: 'A Prison in Which Only Those Locked Up Inside are Free'

At the height of the Cold War, for nigh on a decade, a clamorous, acoustically-charged ideological battle of pyrrhic sonic victories ensued between the competing world views of Communism and Capitalism.

Berlin: the recently maligned city of terror now turned 'prize', bi-functional portal (and portent of a future to come) to a barely penetrable Eastern bloc world behind the Iron Curtain and to the (manufactured) fantasy of the unfettered 'freedom' of the West. As each system fought for the defence and strategic geopolitical control of the already war-weary, multiply-occupied, and divided city, ideological sound clashes, played out speaker to speaker, sound system to sound system—a war by other means—were launched across the armed checkpoints and barbed wire of a new Wall under perpetual (Communist-initiated) construction.

Transforming each sector into virtual carceral archipelagos, fortressed enclosures—composer György Ligeti, having fled from Soviet-controlled Hungary, called West Berlin 'a surrealist cage, a bizarre prison in which only those locked up inside were free'—the Berlin Wall was to become the preferred site for a confrontational mobile war of decibels between East and West Germany. In parallel to the accelerating programmes of the Soviet-US space race, itself a proxy war, an escalating *Lautsprecherkrieg*, or 'Loudspeaker War', seemingly predicated on a Cold War recasting of the biblical tale of the Walls of Jericho, was being pitched in jet-age proportions, employing methods of bass-heavy guerrilla sonic 'raids on space'.

They tried to divide the sky.

II. Humiliation

Commandeering police vehicles, *Rote Hugos* ('Red Hugos'), customised with public announcement systems and fixed-direction loudspeakers fitted atop their roofs, the East German military were the initiators of this programme of sonic warfare: sending sonic salvos of Soviet martial music, Communist Party songs and propaganda through the barbed wire intervals and over the Wall, they began testing the capacities of sound to surpass architectural boundaries and territorial borders. In so doing, they achieved multiple successes in the 'drive-by' drowning out of public gatherings and political speeches on the other side of the Wall in West Berlin, most notably publicly humiliating West German Chancellor Konrad Adenauer by forcing him to abandon his keynote speech at the Wall by the Brandenburg Gate in August 1961.

Yet, in an age of a newly unbounded potential of sonic mechanical reproduction, East German SED Party Leader Walter Ulbricht would himself come to rue his now infamous, much quoted speech, just two months before implementing the first iteration of the Wall, a speech in which he assured the world: '*Niemand hat die Absicht, eine Mauer zu errichten* [Nobody has any intention of building a wall]'. What Ulbricht had perhaps not considered in the moment when this remark was recorded is that the sonic is hauntological: that it can be captured, endlessly rewound and repeated, turned back as a weapon against its wielder.

Contemporary accounts attest to what would become the highly retaliatory nature of these mutual provocations. At stake was no less than the terminal destabilisation of the legitimacy of the other side's political credibility. But how to ensure the effective transmission of one's own ideologies—with the resultant conversion and defection of your enemy—without simultaneously clearing a channel for their propaganda, and potentially falling victim to it? An impasse: fears of ideological contamination loomed large on both sides.

III. Acoustic Blasts Across Borders
Having suffered a number of these mobile border blasts from the East, Adenauer gave the green light for the West Berlin organisation Studio am Stacheldraht or 'Studio at the Barbed Wire', initiated in 1961 under Interior Senator Joachim Lipschitz, in collaboration with the protectorate US-founded (and funded) broadcaster RIAS, to embark upon decisive countermeasures.

A small fleet of heavy vehicle trucks and Volkswagen Kombi or 'Camper' vans (ironically also the chosen vehicle of freedom for Californian beach-boy surfers at the time) were repurposed into fully equipped, autonomous, one-man-operated transmission studios. With rooftop clusters of the latest American-developed loudspeaker horns fitted onto bespoke hydraulic cranes, and controls that enabled the elevation of the speakers over the Wall—their broadcasts reaching more than five kilometres into enemy territory—the directional concentration of a sustained sonic assault onto a chosen (unfortunate) position or event gestured toward a maniacal politics of sonic superiority.

Of the first deployments of these now multi-functional, mobile, and hydraulic acoustic weaponry studios, whose greatest potential lay in being assembled into a 'networked' swarm of 'ear-splitting terror' which would leave the East with no

retort, Technical Chief of the Studio am Stacheldraht Dieter Graetz pronounced: 'The noise from a jet engine at seven yards is about 105 phons. Just one of our trucks alone can throw out 130 phons.' Asked if the swarm formation could emit a lethal din, he replied, 'Well, it probably wouldn't kill a man. But it would disturb his hearing and make him vomit.' Directed at the East German military, this is a Cold War politics of pure sonic repulsion.

The *Lautsprecherkrieg* (Loudspeaker War) thus reaches its apotheosis.

State-sanctioned, mobile sonic weaponry in service to adversarial, ideological fantasies of territorial, geopolitical, and psychic domination. The technological extremes of sound wielded simultaneously in a perverse interplay of sonic attraction and sonic repulsion, to penetrate, encroach, burrow as far and as deeply as possible into the Walled-off worlds of those once called family and friends, but now deemed 'enemies', in attempts to conquer the 'inner space', the psychological interiority, of that newly created enemy-other.

IV. Inner Pressure

The Cold War: an iterative, closed-circuit feedback loop.

Parallel movements, differing (perhaps) in kind, type, and degree but all attuned, aligned, for a brief moment, to the same ideological sonic registers and frequencies.

In subsequent decades, the ideological weaponisation of sound systems is replayed in other indirect extensions of the Cold War, at other moments of geopolitical crisis: In Vietnam they are tuned to an eerier register in the US military's 'Urban Funk' and 'Wandering Soul' campaigns, exploiting Vietnamese Buddhist beliefs and ancestor worship against a near-imperceptible guerrilla adversary. Apache helicopters bearing loudspeaker horns and blasting near-deafening magnetic tape recordings of the simulated ghostly, ethereal voices of the ancestors' unnerving cries, wailings, messages from the beyond, in the dead of night and high above the jungle canopy—itself a physical division between worlds— achieve a transcendental power: the voice of a superior force. The voice of God.

Cue Wagner's *Valkyries*.

And Jamaica.

How does this diminutive island, lying in the watery breast of the Caribbean—an island territory, existing in the reverberations of a forced monstrous

intimacy, having once been mere pabulum to the voracious appetites of the triangular transatlantic slave trade, as the scene of subjection and attestation to what the *longue durée* of atrocities, meted out over centuries by competing, interchangeable, successive Empires, can do—how does Jamaica become entangled in a *Lautsprecherkrieg* begun on another continent, five thousand, two hundred and fifty-two miles away?

A perhaps surprising protagonist in this Cold War continuum, Jamaica forms a vital articulation. Almost contemporaneous with Berlin's escalating sonic delusions, it is 'the angle between two walls'.

It is the Second World War, England, home to an array of military acoustic technologies that constitute the incubator for the future of Jamaican reggae sound systems. Born of the wartime experiences of Jamaican radar engineer Hedley Jones, whose training within the Royal Air Force provides a virtual 'playground' for experimentation with then cutting-edge electronics and amplification technologies. Drawing on lessons from the colonial mother stored up for cultural transfiguration and thunderous activation upon return home, his self-constructed 'Williamson form' amplifier was the launch base for the first (and best) mobile sound systems and, ever after, the simulacrum of ritual violence enacted in the noise-weapons of the sound clashes that would follow.

Yet it was within the context of the decolonial struggles for independence and self-determination during the 1960s (across the continents of an Africa and Asia in revolt, and the Caribbean) that an explicit Cold War politicisation of sound systems and sound system culture would again be played out, speaker to speaker, sound system to sound system, during the Jamaican General Elections of the 1970s. The island divides along sonopolitical lines as sound systems and their followers, self-affiliated with either Michael Manley's socialist-leaning, Castro-courting People's National Party (PNP) or the Jamaica Labour Party (JLP) of Edward Seaga (aka Edward *C.I.A.-ga*), to go far beyond a mere sonic simulacrum of violence, as a proxy war takes hold: the US fearful of the spread of contagion and of another potential Communist outpost so close to Africa, to Cuba, to home; Castro and the USSR dreaming of ideological and territorial expansion as the old, imperial world order crumbles.

Whilst this first iteration of the Cold War, and its offshoots, may have officially thawed and the Berlin Wall succumbed—eventually—to a sociopolitical

and vibrational accretion of pressure, resulting in the fateful *Mauerfall* (the fall of the Wall), in the stretch of time between that moment and the present day, this ideological posturing and sonopolitical assault on enemy territory is still sporadically employed on both sides of the Korean Demilitarised Zone, a no man's land reclaimed by nature, in an ongoing war seemingly without end, and finds sinister repetition in the belligerence of new actors keen on reigniting both old and new hostilities.

And the foxes.

Apocryphal tales still circulate, even today, in Berlin, in which it is said that in the long duration of the Wall and its many iterations, even the foxes were seemingly made to play their part, adhering, too, to the strict border division of the city and afraid to cross the political divide. Subject to decades of neurological entrainment and epigenetically adapted, today it is said that still they cannot wander across a divide that is no longer there.

Lawrence Abu Hamdan

The Acoustic Fog of War (Interview with Steve Goodman)

Lawrence Abu Hamdan is an artist focused on the politics of listening, a self-proclaimed 'private ear' and director of Earshot, the first agency dedicated to acoustic analysis and open-source investigation in the field of human rights. This conversation was conducted over email between November 2023 and January 2024 in relation to themes of his recently published book Live Audio Essays.[1]

STEVE GOODMAN: I'm interested in the relation of something loosely called the 'audio essay' to our contemporary epistemological climate, which is referred to as a technologically intensified crisis of representation, a climate of post-truth, and the generalised spin-cycle of a memetic fog of war. It seems to me that some of the most interesting approaches to audio essays respond to this condition of knowledge, this unstable ground, as does the essay film. They do so in divergent ways, but, tellingly, both try to navigate through an interzone between fact and fiction. On the one hand, there is a sometimes-allegorical orientation that tends toward extrapolation, speculation, and fabulation, perhaps setting out from a real location or event, and then layering it up with fictional dimensions and productive untruths in order to reinforce the wider cultural or political resonance of that event or place.

On the other hand, one could situate your work within a kind of 'investigative aesthetics' and it's this theme that I'd like our conversation to revolve around.

You've recently had a book published entitled *Live Audio Essays*. I read in an interview with you that you regard a 'live audio essay' as a spoken monologue. Elsewhere you have noted that you don't really see yourself as a writer, and yet these transcripts, with their stage directions about where sounds or videos

1. L. Abu Hamdan, *Live Audio Essays* (New York: Primary Information, 2023).

would be played, etc., but also their digressions, also lend themselves very well to the page. You say, 'I call them essays because they drift and move, and they often hold contradictory positions.' I wonder if you could reflect on how the essay form, whether spoken 'live' or written or recorded, is a useful vehicle for your work as a 'private ear'.

LAWRENCE ABU HAMDAN: The audio essay is the space I use outside of the urgency of the investigative work. The essay form is vital to the practice in that it provides the space and time to develop conceptually some of the political reflections about the acts of listening I have engaged with throughout the course of an investigation. Often cases come down to milliseconds between sounds, the gap between a gunshot and its echo perhaps, or minuscule fragments of the frequency spectrum, the fundamental frequency of a hydraulic door breacher comes to mind. This focus on the sonic minutiae happens for the most part alone, sometimes listening hundreds of times over and over again to be able to decode what is happening in a recorded event. The essay is the space to translate this process into a collective act of listening, pausing and slowly zooming out from the sonic minutiae to unfold these sounds into their full significance through the course of the live event.

SG: For you, how does the essay become a catalyst for a collective thought process? How important is this collective act of listening for your approach? Of course, an essay in sound can assume a variety of modes. But what makes the live audio essay particularly appropriate for you as opposed to, say, producing a radio documentary? When you say a 'collective act of listening, pausing and slowly zooming out', it's almost as if the essay facilitates a space for a shared auditory thinking. Where is the collective work located, exactly? I imagine it lies partly in the fact that you are unravelling the significance of these minutiae and being forced to communicate and contextualise their significance, but perhaps also involves group interaction while you are presenting, and feedback afterwards? There is also the temporal dimension—in creating a non-urgent space it would seem to allow time for the insistent, detailed sound object, trace, or memory to resonate. Resonance takes time. Is there is a qualitative difference between your concentrated, solitary, analytic listening and listening in the context of a group?

LAH: The work of open-source intelligence shares many practices with forensics, but in some key ways it attempts to distance itself from the position of the expert witness, be they presenting the authorial voice of the expert on the news or in the courtroom. It does this by not only publishing the results but by making the methods themselves public and open to peer-led critique. Open-source intelligence is therefore defined by its openness on both fronts, not only taking its source material from what is publicly available but also laying its own methods bare as it attempts to reconstruct events. The expertise is then not simply recognised externally through the academy, but earned and continually refined in the course of each investigation and its subsequent critique, along with suggestions from the peers that surround and circulate the publication of an investigation. In the collective listening events of the live essay, something similar is at work. Not an evaluation of the methods as such, but a laying bare of the political compromises and ethical dilemmas that are also inherent to these intensive acts of listening. The ears in the room, whether they respond directly or not, create a forum for a vital kind of autocritique. This in turn sharpens my listening, not necessarily to the sounds under scrutiny, but rather to the ways in which the claims made in these investigations circulate, in which spaces they effectively resound, and equally where they are left mute.

SG: Perhaps we could run this through an example? Your work *Air Pressure: The Diary of a Sky* (2021), for instance, focuses on aerial incursions of Israeli jets into Lebanese airspace between May 2020 and May 2021 and the spin that this data, or lack of data, acquires for different interest groups in the region. How did that evolve from close audio analysis into a live audio essay, and what did the live audio essay involve, exactly?

LAH: *Air Pressure* is a really good example of the place of the essay within the broader scope of the investigative practice. The work began after the August 4th explosion in Beirut in 2020, and the discussion of whether or not people heard Israeli military aircraft before the blast. There was a lot of back and forth on this and it occurred to me that we only talk about these planes at moments of crisis, but what my research would later uncover is that they are there almost all the time. This constant humming, moaning, and roaring

from the sky has turned the sky against those who live beneath it. The noise is a means by which the atmosphere has become weaponised. The sound is an ambient reminder that all life, all future plans could be stolen at any given moment were those planes to realise their maximum potential for destruction. Yet they are so constant that they are also easily ignored, and it is this routine aspect of the violence that needed the space and time of the essay to unfold. When I published the findings and as this circulated in the news, these aerial violations became exceptional once again. The aggregation of this data allowed this information to become an event rather than something more akin to an ongoing and persistent occupation. Although this was important politically, the discussion in the news made very little room for the way in which we no longer pay particular attention to these sounds in Lebanon. Yet this is one of the most significant aspects of the way in which this sound is weaponised and felt. During the fifty minutes of this essay, the audience also learns to tune in and out of these sounds. They continually move their acoustic attention between what is equally an exceptional and mundane act of violence. In this way the essay becomes an exploration of the militarisation of ambience. Rather than 'a sound that is as ignorable as it is interesting', as Brian Eno describes ambient music, I wanted to use the space and time of the essay to let people really hear 'a sound that is as ignorable as it is lethal'.

SG: Most of our ideas of what private eyes do stem from detective fiction, TV, and film. As an audio investigator, engaged in, among other things, reconstruct- ing the transience of acoustic memory, you often refer to yourself as a 'private ear'. And in your live audio essay *After SFX* (2018), you talk about the mnemonic interpenetration of imaginary, often fictional sound effects and actual acoustic memories of violence—suggesting that our reference points for causal listening are often mediated through our media memories. As someone whose work is strongly political, can you reflect on the ways in which fiction inflects your work, productively and/or as an obstacle?

LAH: One of the main arguments about acoustic memory I was developing in *After SFX* is that sound effects from cinema have become an integral part of the way in which we remember and recall the real sounds we witness. The theatrics

of sound effects are embedded in the real to the extent that it is not possible to parse the 'fiction' from the 'fact'. Sound effects artists have not only invented fictional sounds, they have invented a new sonic reality in which we now live. A prosthetic sonic memory has been grown in foley studios and implanted in our memories through cinema. Although in this work, that line between the effect and the fact is explored explicitly, investigative work is in some part always a measure of multiple realities, some that have in fact happened, others that may or may not have ever come to pass. Hence a lot of my time working with 'fiction' is in the service of measuring to what degree state and corporate actors are spinning fictions and fictitious accounts of events. In the live audio essays, as in all good detective stories, it is the process of deduction, or decoding multiple and sometimes conflicting accounts of events, that is explored and reflected upon, rather than only the presentation of the likeliest outcome of a particular event as you would find in the forensic reports I author.

SG: Staying with this theme of spinning fictions, one thing that has struck most people with even a vaguely critical ear is the stark disparity between how banal and transparently false official Israeli communications regarding the situation in Gaza have been, on the one hand, and its ability to persuade Western audiences on the other. Obviously, this isn't a new situation, and is a feature of information warfare and propaganda generally, but the bravado of some of the barefaced lying has sometimes been quite astounding. As someone with an ear for the political spin given to data, and also someone with some history of forensic engagement with the ongoing conflicts in the region, how have you perceived the intensity of 'fictioning' produced by the far-right government in Israel? Perhaps this is an opportunity to tell us about your new agency, Earshot. What kind of investigations will it be engaged in? How might it be or has it already been engaged with the ongoing conflict in Gaza?

LAH: The new organisation I run, Earshot.ngo, has been inundated since October 7th with requests for help from multinational NGOs such as Amnesty International and Human Rights Watch, as well as many journalists, to analyse the sounds coming out of Gaza. These might be to assess the source of gunfire and explosions or to profile the particular drone used in unmanned aerial activity.

However, more than half of these requests from journalists and the media have been concerned with whether material shared by official Israeli social media accounts are credible. Sound is a useful way to do this for two reasons. Firstly, until now at least, propagandists have been more complacent about faking the soundtrack than about visuals, and secondly, there are ways in which we can examine the noise floor of a recording, such as the presence of electromagnetic interference, that offer insights into whether a recording has been edited. However, one of the reasons we started to turn away this kind of work was not because of the intensity of the 'fictioning' of the Israeli far-right government, but because of the way in which this war played out as a huge international media event, distinct from the way it was being felt and suffered on the ground. With the sudden obligations of journalists to fill hours of air time and page space with Gaza content, we felt at times we were becoming content creators, with media organisations reaching out for us to debunk material that, even before audio analysis, was obviously not meeting the standards of being fit for broadcast and independent verification. The IDF were citing unnamed sources, distributing wiretapped conversations of third-party testimony as proof, and the media were discussing whether it was real or not and creating a kind of parallel acoustic event which didn't actually serve to disseminate information about the war. We do not rule out this kind of work completely, but we try to carefully discriminate where our techniques can really help and when and where they become part of a purposely cacophonous media circus. We continually ask ourselves when are we analysing sound and when are we becoming an agent in the production of noise. And this is exactly the kind of inquiry that ends up as a central point of focus in *Live Audio Essays*.

Eleni Ikoniadou
What Edward Said

Why does tragedy exist? Because you are full of rage.
Why are you full of rage? Because you are full of grief.

Anne Carson, *Grief Lessons*

For the last five years I have been reading, writing, and making work around
lamentation. Lamenting is an extreme expression of grief in the form of a song
or poem, practiced commonly by women across different cultures, from ancient
times to the present. My own interest and understanding of lamenting focuses
on its aspect of collectively voicing that which is individually unbearable, whilst
simultaneously resisting it. In accordance with ancestral and indigenous insights
into the role of the lamenter, where song and vocalisation become the middle
zone that connects the realms of the living and the dead by inhabiting the
zone *in between* worlds, I find in the lament the proper role of the audio essay:
a 'contrapuntal' activity with generative powers based on 'adjacencies' and
'discontinuity'.[1] As I propose here, the audio essay negotiates the realm between
aesthetics and 'the social and cultural context' in a way that resonates with the
work of Edward Said. Artists such as John Akomfrah always remind us that, for
'some identities', collective suffering and audiovisual aesthetics are necessarily
bound up with one another.

Lamenting is a sonic ritual. Whether polyphonic or instrumental, whether
using meaningful words or nonsensical vocalisations, made up of sombre or

1. Edward Said borrowed the contrapuntal concept from music theory, in which counterpoint is
the connection between multiple melody lines in generating compositional unity, to discuss the work
of Glenn Gould, as we shall see. He also applied it to reading literature, where, as he argues in *Culture
and Imperialism* (New York: Vintage, 1993), contrapuntal reading is a method of interpreting colonial
and postcolonial texts that considers narratives of the colonisers alongside those of the colonised,
thus examining opposite and intertwined histories.

frenzied or silent parts, it is a form of art belonging to the chorus. I have tried to capture the links between the lament and the medium of the audio essay across a number of different projects.[2] In each case, the work involved collaborating with others to unearth or imagine some unknown aspect of the ways in which many voices together (human and/or artificial) deal with death and grief. There are different ways in which the sonic, in general, is well equipped to tap into death and grief, particularly their vocalised aspects. As has been suggested before, the aural arts (music, radio play, sound-film, etc.) can capture dramatic events far more powerfully than visual art. Add to this the power of the voice as a complex, active material and collective event,[3] and the significance of the audio essay begins to unfold. This is also the realm of sonic fiction, 'the convergence of the organisation of sound with a fictional system whose fragments gesture towards but fall short of the satisfactions of a narrative'.[4] The audio essay is sonic fiction's next of kin—fragments of myth, history, fantasy, and fiction coming together to tell an alternative nonlinear history. Drexciya, the Otolith Group, Nkisi, Sun Ra, Audint, Elysia Crampton, Fred Moten, and Fatima Al Qadiri, along with the contributors to this volume, all probably agree that the devastation of certain lived events requires the assistance of fictional elements in order to become fathomable. Yet these fictional elements are not meant to be fantasies opposed to the ownership of 'truth' claimed by science and historicity, but rather the truths denied, excluded, silenced by the fabricators of world consciousness, i.e. the political/media ruling classes of the West, also known as the Global North. As Lawrence Abu Hamdan, who works predominantly with the format of the audio essay, tells us, art is a valid mode of truth production on a par with and indeed

2. These include *Future Chorus*, a collection of mixes and audio essays based on human and AI laments released as a vinyl album (MAENADS/Hypermedium, 2023)—all credits found here: <https://hypermedium.bandcamp.com/album/future-chorus>; *Hydrapolivocals*, an audio essay collaboration with Afroditi Psarra and Anne Duffau, installed as part of the exhibition *Weaving Worlds* in Athens (Deree American College of Athens, 20 May– 25 June 2022); *The Lamenters*, live audio essay with Viki Steiri for Sound Quests festival (Fondazione Sandretto Re Rebaudengo, Turin, 8 November 2022) and as audio installation for the exhibition *Wake Words* (Kunstraum Niederoesterreich, Vienna, 1 October–7 November 2021); and the most recent *This Is My Voice, My Weapon of Choice*, live audio essay improvisation with Savvas Metaxas and Viki Steiri for Granny Records Showcase (TV Control Centre Athens, 20 October 2023).
3. N.S. Eidsheim, *The Race of Sound: Listening, Timbre, and Vocality in African American Music* (Durham, NC: Duke University Press, 2019).
4. K. Eshun, 'Drexciya as Spectre', in *Aquatopia: The Imaginary of the Ocean Deep* (London: Tate, 2013).

often more accurate than historical fact. It just comes to its truths via different means.[5] In Larissa Sansour and Søren Lind's powerful film *In The Future They Ate From The Finest of Porcelain* (2016), as their 'narrative terrorist' intends, 'fiction has a constitutive effect on history and political reality. Myth not only creates fact, it also generates identification'.[6] It becomes urgent then to situate the audio essay/artwork (and indeed all of sound art and Sound Studies) within the anti-colonial practices of artists and thinkers that come from, reside in, stand with, or have something to say about those on the other side of the power structure, the routinely abused and exploited Global South.[7]

As Cindy Milstein rightly notes, we are all presently 'swimming in a sea of grief (in a time marked globally by rising fascism and authoritarianism, the largest displacement of people in human history, and the greatest structural devastation of the very basis of life, the ecosystem as a whole)'.[8] More specifically, it is an indisputable fact that the brown and black populations of this

5. L. Abu Hamdan, *Introduction to Forensic Audio* seminar, New Centre for Research and Practice, July 16, 2018; see also the interview in this volume, '"The Acoustic Fog of War (Interview with Steve Goodman)" on page 231–236.

6. Sansour and Lind's short film features a 'narrative resistance group' making underground deposits of porcelain, suggested to belong to an entirely fictional civilisation, in order to influence history and support future claims to their vanishing lands (see description at <https://vimeo.com/147826036>). The 2016 film uses science-fiction methods in order to tackle the ever relevant Palestinian struggle for human rights, justice and liberation from occupation, apartheid, ethnic cleansing and, as I write this, genocide.

7. As is widely known, Global South isn't merely a geographical term, as many countries included in it (such as India and Northern African countries) are in the northern hemisphere whilst others from the southern hemisphere (such as Australia and New Zealand) undoubtedly belong to the Global North—geopolitically and historically, as part of a larger network of alliances, partnerships, assets and global deals of the US-centralised empire. In this sense, 'people of the South' might also include indigenous people forced to live under settler colonialism (for example in the US, Australia, Canada, Palestine), as well as descendants of abducted and enslaved people, like African Americans. Furthermore, many scholars, politicians and activists from the so-called Global South have rejected the term as enforced by the Northern powers in an attempt to lump together what used to be called the 'underdeveloped or third world' to contradict their self-definition of a civilised, progressive, democratic and economically prosperous first world. This essay, alongside outright rejecting this Western delusion and propaganda, opens out and points beyond such homogenising categories and uses the term South to stand for and include those (peoples, lands, matter) that have been at the receiving end of Western Empire aggression and its logic of dispossession, extraction, and colonisation, as well as their Global South allies. As I write this, the Pro-Israeli government of India supports the genocide in Palestine in order to forge closer ties with the US and shore up political support by Hindu voters, driving existing islamophobia and assault of Muslims in Indian to further extreme levels.

8. C. Milstein, 'Prologue/Cracks in the Wall', in C. Milstein (ed), *Rebellious Mourning. The Collective Work of Grief* (Chico, CA: AK Press, 2017)

world—and whoever happens to fall under the category at any given point in history[9]—perpetually suffer the lion's share of oppression and occupation, resulting in collective loss and grief. Most major international conflicts can be traced back to the Western war machine and its white-supremacist aspirations for planetary domination and exploitation of the earth's resources. The South eternally bleeds and resists aggressions, destructions, and genocide.

Although other art forms are able to tap into death and grief just as effectively as the audio essay, for me, it is the latter's connection to polyphony (a concept borrowed from music, literally meaning 'many voices') that makes it useful for capturing something of the resisting dimensions of mourning loss. This has nothing to do with idealised and essentialist definitions of language and voice as indexes of human meaning-making processes, and points instead to their pluralistic, collective, and contrapuntal expressions.

For Edward Said, the contrapuntal (or counterpoint) technique, found at the heart of Glenn Gould's work, manages to capture sonically the sort of understanding previously reserved to thinking and reading. Counterpoint is a dimension of polyphony, as Said explains in his essay 'The Music Itself: Glenn Gould's Contrapuntal Vision,' where he argues that Gould's preference for Bach's polyphonic music was central to what the musician was trying to do: to explore the potential of sound for generating new thought, speaking to an audience 'directly, intelligently, vividly, forcing you to leave your ideas and experiences in abeyance', resulting in 'complexity resolved without being domesticated'.[10] A longstanding admirer of Gould's performances, essays, and films, Said found in this counterpoint the 'many-voiced', 'decentred', 'endless inventiveness' with which to challenge conventional ideas about both language and musical activity. Here I find echoes of Mikhail Bakhtin's take on polyphony in literature (specifically Dostoevsky's character writing method) understood as 'a plurality of independent and unmerged voices and consciousnesses' resisting the voice and will of the author.[11] Equally, there are linkages with Saidiya Hartman's use of

9. For example the 'black' status of Greek and Irish immigrants in the US during the late nineteenth and early twentieth century, the racist treatment of the Irish and Scots by the British from as early as the twelfth century, and the persecution of European Jews since the Middle Ages, who were only accorded the status of 'whites' by the allies after the Second World War, although not white enough to remain in Europe—they were instead pushed into the Middle East.
10. E.W. Said, *Music at the Limits* (New York: Columbia University Press, 2009), 20, 10.
11. M. Bakhtin, *Problems of Dostoevsky's Poetics*, ed. tr. C. Emerson (Minneapolis: University of Minnesota Press, 1984), 6.

the chorus as a polyphonic device for rewriting history from the standpoint of the collective, where 'all the modalities' of the anonymous figures, ensembles, and multitudes 'play a part'.[12] By drawing connections between the audio essay, polyphony, and laments, the present text poses the question of how to think and make with the sonic in ways that rise to the demands of the present moment, discontinuously connected with past and future anticolonial, anti-apartheid and anti-genocide struggles.

What is it that sound (and sound art)—here in the form of the audio essay—can do that was 'previously reserved to reading and thinking' (Said) but which they alone cannot do when we are 'swimming in a sea of grief'? How do sonic artworks listen and respond to what is being said? How do they bear witness, as Audre Lorde wrote of her love poems in which love is defined as 'a tremendous power' inseparable 'from fighting, from dying, from hurting'?[13] And what can be said of many voices coming together, in 'discontinuity' (Said), in 'ecstasy' (Said via Gould) against 'domination', 'domestication', and 'hierarchy' (Said, Moten, Bakhtin)?[14]

The Polyphonic Lament

In the polyphonic lament, although words may be spoken there is another level of significance in the gaps, where speech is either lost or becomes irrelevant, as phrases pass into incoherence, unintelligibility, abstraction. Commonly, speech in the West is understood as an indicator of human intelligence. As we learn in Aristotle via Heidegger, man is a political speaking animal, a being which has language, which addresses and discusses its world. For the Greeks, voice without speech was considered irrational and dangerous, and was commonly associated with female, animal, disabled, and nonhuman entities, jeopardising

12. S. Hartman, *Wayward Lives, Beautiful Experiments* (New York: Norton, 2019).

13. A. Lorde, *I am Your Sister: Collected and Unpublished Writings of Audre Lorde* (Oxford: Oxford University Press, 2009), 164.

14. According to Rokus de Groot, 'Said was enchanted by Glenn Gould, who with all his fervor for control was given to ecstasy which Gould himself characterized as "the state of standing outside time and within an integral artistic structure"'. See 'Music at the Limits: Edward Said's Musical Elaborations' in *How the West Was Won: Essays on Literary Imagination, the Canon and the Christian Middle Ages for Burcht Pranger* (Leiden: Brill, 2010), 127–45: 128, as well as de Groot's 'Perspectives of Polyphony in Edward Said's Writings', *Alif: Journal of Comparative Poetics* 25 (2005), 219–40 for an interesting analysis of Said's reflections on counterpoint both as a musical practice and as a metaphor for humanistic emancipation.

man's search for harmony and truth. Equally, in fifth-century BC Athens, mourning was banished outside the walls of the city because of the political demand to forget injustice, loss, and suffering for the sake of peace and equilibrium. By law, citizens had to swear the individual oath 'I shall not recall misfortunes'. The ecstatic sound of grieving voices, from ancient Athens to modern Turkey and Argentina, poses a threat to the social order, because of the demand it places on people, state, and history not to forget.[15]

The sound of mourning voices transmits the devastation of the event more effectively than the word of mourning. And the mourning chorus, as in some of my work, can encompass different kinds of voicing. In the album *Future Chorus*, one of the main ideas is that the instrumentalisation and automation of voice, speech synthesis, and vocal AI has forced the voice outside the domain of the human.

However, the nonhuman here is taken in its wider definition. Not only is this the domain of animals and machines, but also the domain of the 'other' as constantly delineated by white supremacist powers in the name of 'protecting Western civilisation'.[16] A central question in the making of *Future Chorus* was: What are the challenges speaking machines pose to our definition of the human, i.e., the presumption that voice and speech are evidence of our differentiation from other animals, machines, and even other humans? In the first stages of the research, professional mourners, visual artists, musicians, and vocalists came

15.	For mourning banishment in ancient Greece, see Nicole Loraux's *Mothers in Mourning* (Ithaca, NY: Cornell University Press, 1998) where she talks about amnesty, oblivion, and the banning of memory as Athenian political themes. In *The Mother, The Politician, and The Guerilla: Women's Political Imagination in the Kurdish Movement* (New York: Fordham University Press, 2023), Nazan Üstündağ illuminates how the figure of the mourning mother entering the public and making demands on the state on behalf of her motherhood rights and in the name of her wronged children is a common political force that has emerged in various contexts of state violence across the globe. For patriarchy and capitalism to be secured as dominant systems, the commitment of these mothers to not forget, through their grieving, must first be enclosed and then silenced by the state.

16.	In addition to the well-known US slogans 'war on terror' and 'axis of evil' to refer to and justify invasions in various Middle East countries across four decades, current Israeli prime minister Benjamin Netanyahu has stated during several of his speeches that the slaughtering of Palestinians serves the purpose of protecting Western civilisation. It is worth noting that the aforementioned slogans were introduced by Netanyahu in a successful effort to brand 'Arab terrorism' as the ultimate evil and connect it to the Soviet threat against what he called 'an anti-terrorist alliance of all Western democracies'. These ideas and slogans were first taken up by the Reagan administration (1981–1989) and continue to be used to justify the current genocide of Palestinians in Gaza. See also E. Said 'The Essential Terrorist' (review of Netanyahu's *Terrorism: How the West Can Win*), *Arab Studies Quarterly* 9:2, 'Terrorism and the Middle East: Context and Interpretations' (Spring 1987), 195–203.

together to record and contribute laments, creating a dataset made of poems, theory texts, songs, non-linguistic and non-human sounds.[17] These sound files and their written text equivalents were used to train an algorithm to create a new artificial voice. The resulting generated audio is mostly noisy, but you can tell there is something trying to speak in a language other than that of the master (spoken English). When an AI has access to all the human information, the only thing that it can do is to grieve.

Both the human laments and AI lamenter were mixed by musicians to create five tracks from the material. These, whether intentionally or not, are perhaps closer to the genre of the audio essay than to any music genre, and the use of voice across many of them is central to that. *Future Chorus* attempts to devise a polyphonic assembly for grieving together as a form of resistance. In my view, polyphonic practices can mobilise 'many voices' as a counteraesthetic strategy to universal individualising systems of living and being, fleeing the tyranny of the one great hero by channelling other stories, timelines, and worlds, through synergistic songlines and lamentation. The ultimate act is to submerge your uniqueness into the polyphonic chorus.

Future Chorus is part of a larger body of work I have undertaken in recent years, proposing that 'other' voices are possible and necessary—those that have largely been excluded from the archive of humanist political economy, as well as from the voice datasets and speech communication systems currently being built. Away from Western discourses positioning voice and intelligence as unique, individual, and necessarily human—with human being reserved for the white, male, 'rational' subject mastering his world of objects and inferiors through language—we need non-Eurocentric paradigms that are pluralising, fugitive (Moten and Harney), and which open voice, language, and humanity to non-normative definitions.[18] Certain vocalities are entangled in a parallel

17. For example, Sukitoa o namau contributed an animal lament and Viky Steiri the lament of a cello.
18. Some examples include the use of rhythm, vibration, and other non-linguistic sounds used by multimodal communicators, such as non-speaking autistic people, ritualistic vocalised textures used in oral traditions, and the use of songlines and storytelling practices in non-text-based indigenous societies for the production and distribution of knowledge. Fugitivity, for Fred Moten and Stefano Harney (*The Undercommons, Fugitive Planning & Black Study* [New York: Autonomedia/Minor Compositions, 2013]), is not only a mode of escape, exit or exodus, but what it means to think of being as separate from settling; a being that is always in motion, the art of making life in the context of extreme deprivation, dispossession and assault, as Saidiya Hartman would say.

nonhuman history. They exceed and challenge our understanding of the human because they transgress and defy the Western predicates upon which this concept is based and its double-standard in applying it. What are these voices outside the domain of the human telling us about their lives, and how do we listen to their call and respond to it? Both the polyphonic lament and the audio essay, and the polyphonic audio essay as a research-based practice, stage a conversation between voices that are living and dead, as well as those yet to come. Polyphony is a weapon for unearthing, imagining and expressing something from those silenced narratives, 'a history written with and against the archive'.[19] The polyphonic sonic artwork turns to the past in order to respond to the horrors of the present and intervene in the direction of the future. Whats is at stake is to take seriously the role of sounds, voices, and noises (the role of art as a whole) in participating and altering the structure of the real.

The Idea of North

As I have argued, a polyphonic strategy of resistance attunes us to the voices of the South. The latter, apart from a geopolitical reality and state of mind, in the present text is used to draw a line of flight from Glenn Gould's landmark experimental radiophonic piece and documentary *The Idea of North* (1967). Considered a forerunner to the audio essay, this 'contrapuntal radio' technique, as Gould called it, layers speaking voices on top of each other, creating a multivocal soundscape made of vocal and musical fragments. Crossing genre boundaries (documentary, anthropological essay, social commentary, musical piece, radio drama, journalism) and experimenting with new recording and editing techniques, the piece unfolds a speculative polyphonic journey in time and space. The story is based on five overlapping voices—all Canadian, mostly male, one female—each narrating their own ideas of the North—'that incredible tapestry of tundra and taiga which constitutes the Arctic and sub-arctic of our country', as Gould tells us in the broadcast's introduction. Narration is 'taken up by one voice then by another, the voices always continuing to sound against,

19. Saidiya Hartman, on her method of 'critical fabulation', 'Venus in Two Acts', *Small Axe* 12:2 (2008), 1–14: 12. Hartman notes that 'the intent of the practice is not to give voice [...] but rather to imagine what cannot be verified, a realm of experience which is situated between two zones of death—social and corporeal death—and to reckon with the precarious lives which are visible only in the moment of their disappearance' (ibid.).

as well as with, all the others [...] capable of an infinite set of transformations'.[20] Behind the multiple voices, overlapping, following, fading, and speaking over each other, the constant rhythmic rattle of a moving train runs incessantly across most of the piece. Rhythm here acts as an underlying temporal dimension, accompanying stories of this mysterious North, adding to the sensation that we are journeying into the unknown and also infinitely unknowable.

Myth, fact, theory, and futurity are woven together in this audio essay to reflect the farther North American landscape. Listening closely, however, it transpires that the piece is intended as critical commentary about the North American fantasy of quest and final-frontierism, poking at the inherent racism and oppression of the conquering settler colonial psyche.[21] Mostly, for me, this speculative audio work, in which solitude is inescapable and even welcome ('I'm getting along with myself', some voices say, 'being a hermit by choice'), serves as an exploration of the relationship between the one and the many.[22] Man and nature are less important here than Western man and his 'human nature': the piece lays bare the deep-rooted differences between occupiers, on the one hand, and indigenous peoples and their lands on the other, valuing the individual versus

20. Said on counterpoint, *Music at the Limits*, 12. Note here that one of the characters, Wally—who stands out as the main Narrator, offering critical commentary on the other narrations and crucially giving the piece its final philosophical conclusion—is introduced by Gould as a surveyor aboard one of the 'most celebrated trains in the Canadian railway', the Muskeg express. As we are told, for Wally, surveying is like a 'literary tool' for 'a craft whose subject is the land', enabling the surveyor 'to read the signs of the land and to find within the particular a suggestion of the infinite, and vice versa'. Critically, the Narrator is also a listener: 'I hear the noise of civilisation and its discontents that other people inflict upon me. No matter what we do to try and escape them, unless we select and understand and use what we hear, we are lost listeners and lost people. [...] [I]n detaching and in reflecting and in listening I am able to synthesise, to have these different rails to meet in the infinity that is our conscious hope.' Here the narrator sums up the purpose of Gould's audio essay and, I propose, of any polyphonic artwork.
21. Some of the voices talk about Eskimos having to be grateful to the white man 'rather than the other way around', and elsewhere a man says, 'There is a tendency to show ones respectability by having in your board of directors a team negro, or a team female, or a team Indian....' Canada, after all, is founded on the stolen land of massacred indigenous people by settlers from Europe looking for gold and other resources—something along these lines is also mentioned in Gould's piece.
22. Among several other instances, at one point the Narrator mentions 'a man by the name of Pascal who years back said that most of mankind's troubles would be done away with if he would stay in his own room'. Whereas this is presented in the context of the 'solitary life of the hermit north', I perceive it as part of Gould's critical commentary in this polyphonic work on the untold histories of the colonising West (and how the world would be a better place had the coloniser stayed 'in his own room').

the collective, self versus other, isolation versus community, individuality versus multiplicity. To this end, *The Idea of North* closes with a long monologue by the narrator, who quotes William James's dictum that 'there is no moral equivalent of war' to bind a society 'against something'. Veering off from James, the Narrator proposes that whereas people once combined against Mother Nature, the 'common enemy [...] for us now is human nature'.[23] The piece climaxes with the statement 'not war, the moral equivalent for us is going north'. Humans against human nature. The hostile environment and activity of the colonising Western empire consistently attests to this idea that human nature is 'at its uttermost' (James) fascistic and oppressive, 'a contagion' that is destroying the rest of the world (narrator).

The myth of the North as an empty last frontier of solitude waiting to be discovered is bust open by Gould, who also reminds us that the Eskimos were there before white settlers dreamt of conquering it. As he confesses in the introduction, he chooses to remain an 'outsider' to the North. The North is for him 'a convenient place to dream about, spin tall tales about, and, in the end, avoid'. It could be said then that, on one level, Gould is going against the official archive silencing indigenous voices of the North, pointing to its discontinuous histories and inviting a close listening to both what is and what is not being said in this polyphonic narration of its Western 'Idea'. At the same time as he recognises himself and all Canadians as outsiders to the land, the latter becomes a mirror to settler-colonialist human nature, which Gould invites us to reckon with by going North.

Some interpretations of *The Idea of North* draw parallels with Glenn Gould's intensely private lifestyle and elective seclusion, retiring from public performing to focus on his studio work a few years prior to making this work. But it is possible that Gould invents the polyphonic audio essay in an effort to bring artistic and aesthetic attention to the dangers of ignoring the terror of the settler ideology,

23. During the build-up to the conclusion of the piece, the Narrator explains James's dictum as providing Western societies with something to be 'against': 'Apparently, very few of us can afford to be "for" something but all of us can afford to be "against" something'. For the North American, collectivity replaces individualism only when there is a common enemy to defeat, starting with 'Mother Nature' itself (and here we might note a further tension between indigenous knowledge and treatment of the earth and that of the coloniser's desire to tame their 'wilderness'), and ending up with Human Nature; that is, the colonising subject's love of subjugation of the other. As the Narrator tells us about this type of human nature, 'it's crept stealthily from the South [meaning Canadian/North-American ideology] and now it's infecting the North with a contagion [...] that's as bad as I indicated'.

i.e. fixation with land grabbing and elimination of its native inhabitants.[24] As Gould shows, polyphony is as much about voicing as it is about listening.[25]

This is the inflection point for my piece, from which the audio essay (and the sonic artwork more widely) turns South. This proposition is not meant as a reductive dualism between bad north and good South, since, firstly, the dread of being human knows no geographical boundaries and, equally, as we learn from Gould, the North can stand for justice and resistance. For Gould, the polyphonic soundwork—which he calls 'radio documentary' and we call 'audio essay'—makes it possible 'to make a statement about the human condition'. For Edward Said, Gould's contrapuntal technique is 'an antidote' to Western classical ideas of time and organisation,[26] its polyphonic aura defying any single authoritative listening. In both Gould's and Said's approach, there is a sense that musical polyphony is a model for reinterpreting the main narrative.[27] As the unfathomable grieving voices of the colonised push against the silence and deaf ears of the Western world—mostly owing to occupation, ethnic cleansing, and genocide being livestreamed on social media by the victims—it is no longer sufficient to diagnose the coloniser's disease. Going North, going against this contagion, is a method of resistance on a par with turning South, refusing to be a fascist and resisting those who are. However, becoming part of the South

24. One of the voices calls attention to the deliberate romanticising histories told by settlers about the 'unspoiled' Eskimo land and 'simple lifestyle', countering these 'illusions' with the reality of the 'wretched health conditions [and] the racial distinctions between a white master race and the lesser breeds that have always been kept just a little outside the law. I'm not blaming anybody for this unless I blame us all collectively', says the voice.

25. In an interview on *The Idea of North*, Gould extols equally the radiophonic piece for being 'the most unique experience of music in the sense of voice as sound' as well as for offering 'that incredible spine-tingling sense of awareness of some other human voice and persona'. See 'Variations on Glenn Gould, "Interview: The Idea of the North"', <https://www.youtube.com/watch?v=xWZh9fAL-R8>. It is worth noting that polyphony for Gould, as for Bakhtin, allowed for multiple voices not subservient to a single dominant voice, which could also grant the artist (author for Bakhtin) anonymity and transform the passive role of the listening audience to that of active participant. For Gould, 'electronic media' play a vital role in enabling this process. See also D. Bartine, 'The Counterpoints of Glenn Gould and Edward Said', *Interdisciplinary Literature Studies* 21:4 (2019), 397–447, for an in-depth analysis on Said's understanding of counterpoint, which is beyond the scope of this text.

26. *Musical Elaborations*, 102.

27. See de Groot, 'Perspectives of Polyphony', where the author discusses Said's interest in polypho-ny as a model for humanistic emancipation, quoting Said's conversations with Barenboim in E. Said and D. Barenboim, *Parallel and Paradoxes: Explorations in Music and Society*, ed. A. Guzeliman (London: Bloomsbury, 2004) on ideas of 'dissent', 'preservation of difference without domination', 'forms of lib-eration', 'freedom from control', among others, all compatible with dimensions of polyphony (231–34).

requires taking the next step, actively looking for ways to create the conditions for another world within this one (as Fred Moten would say).

What Edward Said

As black and brown and working class people have always known, psychotic advanced capitalism is the place we must break out of and destroy, and therefore merely diagnosing the imperialist's 'nature' is not enough. Through my previous work on the lament, I have also used polyphony and lamenting as critical tools with which to think about and experiment with concepts.[28] Although, as I have tried to establish here, the polyphonic audio essay is capable of saying something profound about 'The Idea', I am asking us to address, within the context of this book, its place in the fight to break free and to free others, as the present moment demands. How does polyphony become a vehicle for helping to overturn the notion that the end of the world is easier to imagine than the end of capitalism?[29] How does the audio essay become a worthy witness, listening to the broadcasting of a peoples' 'own destruction in real time in the desperate, so far vain hope that the world might do something'?[30] What unimaginable and unaccounted-for tales from the frontlines of death (be it socioeconomic or corporeal) will the audio essay tell by moving South, and what lessons of love and life will it learn from bathing into its grief?[31]

28. For our site specific installation *The Passing* (2023), we (Maenads) drew on the polyphonic lament of the people of Epirus as a subversive act, a pluralising practice where a historically oppressed peoples' sorrows and joys are vocalised as a strategy for coping and resisting injustices. This month-long generative piece, composed by multi-layered lamenting voices synthesised in Supercollider, turned part of the Ioannina Castle (in Epirus) into a portal where visitors could experience unarchived past histories polyphonically.

29. Drawing on this quote attributed to both Fredric Jameson and Žižek, Mark Fisher, another audio essayist, has shown the links between mental illness and capitalist realism.

30. Blinne ní Ghrálaigh, Irish barrister and member of the South African team in the South Africa v. Israel court case known as application of the Convention on the Prevention and Punishment of the Crime of Genocide in the Gaza Strip, presented at the International Court of Justice, 29 December 2023.

31. Nicki Kattoura and Nadia Abuasi write on 27 October 2023 (twenty days into the Gaza genocide: 'Etymologically, the word "grief" derives from the Latin word *gravare* meaning "to make heavy". Like gravity, Palestinian grief is a constant, scientific fact, a physical force that holds us down as the earth continues to spin on its axis. Yet for us, time has stood still. The last 3 weeks feel infinite, carrying the burden of all the victims from the last 75 years. We grieve the people in Palestine yet to be grieved that will have been murdered by the time we publish this essay, who will have perished by the time you finish reading it. The ones who foresaw their martyrdom and wrote their own eulogies. Is there a word for grieving in advance? Is writing about those still alive in the past tense prophetic

Palestinian exile Edward Said turned to polyphony (and to the work of Glenn Gould) to find ammunition for dissent, reinterpretation, and liberation beyond language. For him, Gould's polyphonic work gives rise to possibilities previously only available to writing and the literary form. Said is primarily known for his critical concept of 'orientalism', exposing a Western Manichean duality by which all Arabs are commonly contemptuously depicted to exaggerate differences between the 'Orient' and the European world, thereby affirming the latter's presumed superiority. Through his work on language and identity in connection to social, political, psychological, and aesthetic forms, as well as his active involvement in the Palestinian struggle, Said showed how reductive notions of identity can have a deadly impact on a people.

> Most people are principally aware of one culture, one setting, one home; exiles are aware of at least two, and this plurality of vision gives rise to an awareness of simultaneous dimensions, an awareness that—to borrow a phrase from music—is contrapuntal. [...] but no sooner does one get accustomed to it than its unsettling force erupts anew.[32]

Said is able to show us how, for some, identities, theory, and aesthetics are a matter of life or death. Alongside the work of Palestinian poetry, song and dance, often at once sorrowful and joyful, Said's work feeds directly into the global anti-Zionist movement rising against the backdrop of a genocide in Gaza. His views on justice and liberation for Palestinians permeate the speeches, political analysis, and protests of the present fight, and his relevance is summed up in one of the slogans currently circulating as the pun: 'What Edward Said'.[33] The question 'What the fuck am I doing?' embodies all of the questions whose

of their death or is it simply the grim reality? Maybe we do not need to write. Maybe we weaponize our chants as eulogy, turn our marching into prayer, transform the streets into a funeral procession." N. Kattoura and N. Abuasi, 'Grief Beyond Language', Institute for Palestine Studies, <https://www.palestine-studies.org/en/node/1654517>.

32. E. Said, *Reflections on Exile and Other Essays* (Cambridge, MA: Harvard University Press, 2000), 186. His own experience of being in the world was polyphonic.

33. As part of a fundraising effort for sending aid to Gaza, *Bidoun* magazine reprinted an older T-shirt with these words, referring to this quote by Said addressing the Israeli public, 'But I think that even the person doing the kicking has to ask himself how long he can go on kicking. At some point your leg is going to get tired. One day you'll wake up and ask "What the fuck am I doing?"', originally quoted in an interview with Ari Shavit for Israeli newspaper *Ha'aretz*, 18 August 2000.

urgency becomes inescapable in the face of apocalyptic events, such as: What is thinking and writing for? What is teaching for? and What should art be doing today? The privilege of asking these questions, instead of running for your life, dying of enforced starvation, mourning your friends and family under the rubble, must make our words and our art worthy of bearing witness and the writer and artist weapons against oppression. Many thinkers and artists have spoken to this before. Nina Simone famously said: 'An artist's duty, as far as I'm concerned, is to reflect the times [...] and at this crucial time in our lives, when everything is so desperate, when every day is a matter of survival [...] I don't think you have a choice'.[34] For Paul Robeson, 'Every artist, every scientist, every writer must decide where [they] stand [...]. There are no impartial observers. [...] The battle front is everywhere. There is no sheltered rear. [...] The artist must take sides [and] elect to fight for freedom or for slavery. I have made my choice. I had no alternative'.[35] And in the words of Refaat Alareer:

If I must die,
you must live
to tell my story
to sell my things
to buy a piece of cloth
and some strings,
(make it white with a long tail)
so that a child, somewhere in Gaza
while looking heaven in the eye
awaiting his dad who left in a blaze —
and bid no one farewell
not even to his flesh
not even to himself —
sees the kite, my kite you made, flying up above,
and thinks for a moment an angel is there
bringing back love.

34. Interview, 1969.
35. Live broadcast from Moscow, June 24, 1937 fundraising event, 'Spain and Culture, in aid of Basque refugee children', organised by the National Joint Committee for Spanish Relief (NJCSR).

If I must die

let it bring hope,

let it be a story.[36]

Many voices, speaking to us across time and space, across generations, are call-
ing our attention to what we are doing and what it is for. In listening to what they
said, what Edward said, we find the critical work of the sonic. As 'a new type of
artistic thinking',[37] polyphony enables the dismantling of a single perspective that
subordinates many voices to the domination of the one and offers 'a different
kind of reading and interpretation' supporting 'social and cultural change' (Said).
At the same time, it points to ancient, indigenous, and intersectional ways of
being and living, where the truth is held by many voices and communicated
through a poem, a song, or a lament. This polyphonic practice threads together
fact, speculation, and future-oriented action, for reimagining, making, and living
in other worlds outside the limits of the colonial mind. The audio essay, like
poetry, like the rest of the sonorous and vocal arts, cannot afford to be less than
a device for tracing and retrieving what is crushed under the brutal language of
power, hatred, and death of the world. Our practices must operate as material
witnesses of untold stories and discontinuous histories, tuning into the grieving
voices and the call for liberation, as well as into those who remain silent.

36. 'If I Must Die', the last poem written in Arabic by poet, writer, professor and activist from the
Gaza Strip Refaat Alareer weeks before he was killed by an Israeli airstrike in northern Gaza, translat-
ed into English by D.P. Snyder, available in full at *World Literature Today*, 14 December 2023, <https://
www.worldliteraturetoday.org/blog/poetry/bilingual-poem-gaza-refaat-alareer>. The poem has been
translated into more than forty languages and also exists as an audio project, collecting readings of
it by volunteers (@ifimustdieyoumustlive on instagram). As I write this, Refaat Alareer's body is still
under the rubble in Gaza.

37. Bakhtin, *Problems of Dostoevsky's Poetics*.

Ayesha Hameed

A Tidalectic Atlas of the Plantationocene

The script below (in caps) is an excerpt from *Black Atlantis: The Plantationocene* (2017–23), a live audiovisual essay, or live powerpoint cinema. It asks: What is the relationship between climate change and plantation economies, and how might we begin to think of a watery plantationocene? It revolves around fieldwork in two islands: a former plantation in St George's Parish in Barbados, and the port city of Port of Spain in Trinidad: visiting the heartland of one of the three stops of the triangular trade, and taking seriously Donna Haraway's and Anna Tsing's use of the term 'plantationocene', which connects the development of a plantation form of production to the beginning of the current geological era that we are in.

Iterations of the map are extrapolated from 'Saharan Dust Off West Africa' Credit: Jacques Descloitres, MODIS Rapid Response Team, NASA/GSFC, 2003.

)))

 (

how to ~~map~~
the sonic
the wind
the waves
the sun
annihilation

a ~~scattering~~

IN THE MORNING HOURS, RADIATIONS FROM THE SUN WARM THE LAND FASTER THAN THEY WARM THE SEA. THE HOTTER, LIGHTER AIR OF THE LAND PULLS THE WIND FROM SEA TO LAND. SO AS THE SUN RISES, THE ISLAND IS SURROUNDED ON ALL SIDES BY WINDS THAT BLOW INLAND FROM THE SEA.

BARBADOS HAS ONLY TWO SPECIES OF PLANTS THAT ARE UNIQUE TO THE ISLAND, *PHYLLANTHUS ANDERSONII* OR BROOM, AND *METASTELMA BARBADENSE*, A CLIMBER. THE REST OF THE NEARLY THREE THOUSAND VARIETIES OF PLANTS CAME FROM ACROSS THE WATER—SOME BORNE ON SHIPS FROM ACROSS THE OCEAN AND VIOLENTLY CULTIVATED, AND OTHERS CARRIED BY FORCES OF NATURE—BY BIRDS FLYING ACROSS THE WATER AND BY THE WIND.

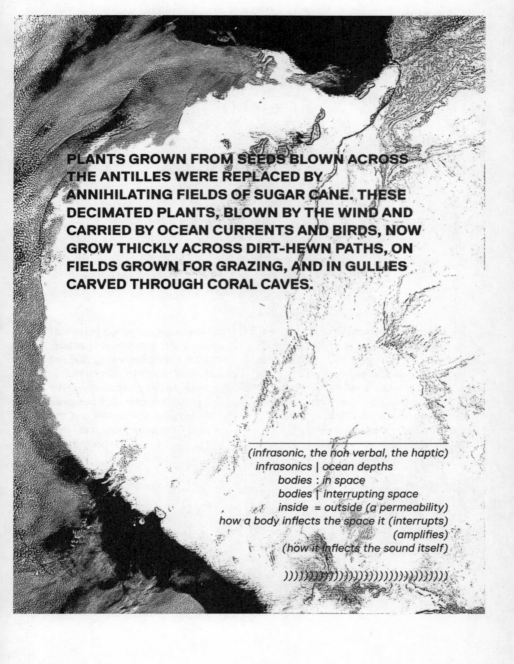

PLANTS GROWN FROM SEEDS BLOWN ACROSS THE ANTILLES WERE REPLACED BY ANNIHILATING FIELDS OF SUGAR CANE. THESE DECIMATED PLANTS, BLOWN BY THE WIND AND CARRIED BY OCEAN CURRENTS AND BIRDS, NOW GROW THICKLY ACROSS DIRT-HEWN PATHS, ON FIELDS GROWN FOR GRAZING, AND IN GULLIES CARVED THROUGH CORAL CAVES.

(infrasonic, the non verbal, the haptic)
infrasonics | ocean depths
bodies : in space
bodies ⌐ interrupting space
inside = outside (a permeability)
how a body inflects the space it (interrupts)
(amplifies)
(how it inflects the sound itself)

))))))))))))))))))))))))))))))))))))))

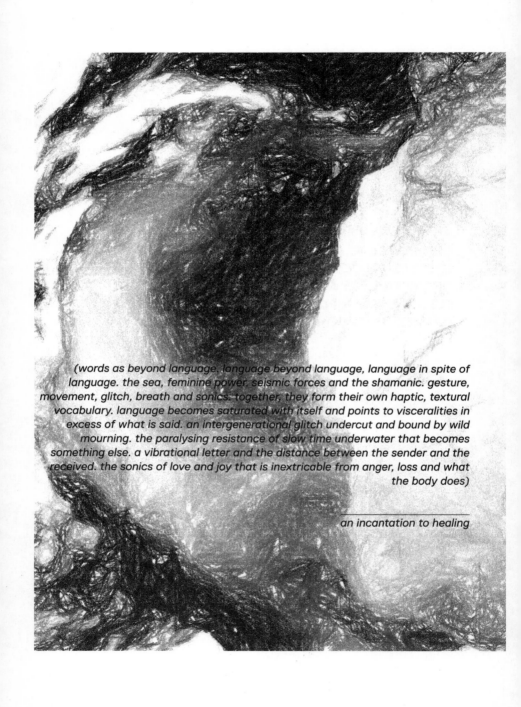

(words as beyond language, language beyond language, language in spite of language. the sea, feminine power, seismic forces and the shamanic. gesture, movement, glitch, breath and sonics. together, they form their own haptic, textural vocabulary. language becomes saturated with itself and points to visceralities in excess of what is said. an intergenerational glitch undercut and bound by wild mourning. the paralysing resistance of slow time underwater that becomes something else. a vibrational letter and the distance between the sender and the received. the sonics of love and joy that is inextricable from anger, loss and what the body does)

an incantation to healing

A STRONGER SYSTEM OF WINDS TRAVELS
FROM FARTHER AWAY. TRADE WINDS BLOW
ACROSS THE ATLANTIC OCEAN TO THE
CARIBBEAN SEA, CARRYING THE WEATHER,
AND FOR CENTURIES THE SAILS OF SHIPS
FROM EAST TO WEST. DUST FROM THE
SAHARA DESERT BLOWS ACROSS THE
ATLANTIC, MOVING GRAIN BY GRAIN THE
MATTER OF ONE CONTINENT ONTO A LINE OF
ISLANDS ON THE OTHER SIDE OF THE OCEAN.
BARBADOS IS THE FIRST COAST THAT THESE
PARTICLES OF DUST TOUCH. AND FOR
SPRING, SUMMER AND AUTUMN THE AIR IS
FULL OF MATTER OF THE SAHEL, AND THE
EARTH IS CARPETED WITH ITS
PHOSPHORESCENCE.

un translatability of sound on the page
non translatability of the oceanic

the non cartographic quality of (ocean)

undoing of binaries, land and sea (tidalectics), language and ~~non-language~~, language and music, meaning and ~~non-meaning~~ (what is meaning? what produces it)

((((((((((((((((((((((((((((((((((((((

cartography and translation =
cartography as translation +
cartography as the erasure of the untranslatable

cartography and translation =
cartography as translation +
cartography as the erasure of the untranslatable

Shelley Trower
Tidal

Essays as I once knew them were always meant to consist of a certain number of words. There were rules—ways of making an argument, of finding sources and quotations to back it up, of introducing and concluding—that seemed at first frustratingly impenetrable, like the secret code of some exclusive club. I doubted I'd ever work it out, and decided that if I ever did, and if I one day came to teach others, I would help them decipher the code.

'The essay' that many of us know if we've studied in formal educational settings—a piece of *writing* that should consist of a certain number of words and have a certain structure—is a very specific form that derived from a more indefinite sense of what an essay could be. The meaning of the word has its origins in the old French word *essai*, meaning the 'action or process of trying or testing', as in Daniel Defoe's use of the term in *The Complete English Tradesman* in 1725, where he advises that a man should not marry before he has 'made an essay by which he knows what he can and cannot do' in his trade and business. Or in painter Joshua Reynolds's reference, in his *Discourses to the Students of the Royal Academy* in 1778, to '[a]n artist, in his first essay of imitating nature'. Another variant derives from *assay*, referring to the 'trial imposed upon an object, in order to test its virtue, fitness, etc', as in the obsolete sense of the 'trial of metals'. We find this usage for example in the *Philosophical Transactions of the Royal Society* in 1668: 'The Ore being ground [...] they divide it in several heaps, and then by lesser Essays, they find out how much silver is contained in every heap.' By the time we get to Charles Dickens, however, the far more restrictive definition has appeared, its formal constraints already the subject of Dickens's ironic wit: in *Our Mutual Friend* (1865) Mrs Peecher 'could write a little essay on any subject, exactly a slate long, beginning at the left-hand top of one side and ending at the right-hand bottom of the other, and the essay should be strictly

according to rule.'[1] Over the course of about a hundred and fifty years, then, the term 'essay' ranged widely, encompassing a vast range of experimental possibilities that did not at all have to exist within the realm of writing, but it has come to refer most usually to something both written and tightly prescribed.[2]

Audio essays can return us to this broader sense of what essays can be and have been, to their potential for trying out new forms and mixtures and testing rules and boundaries. There are other exceptions to the essay as a written form, such as the photographic and the film essay, but these often interweave writing and images (especially in the case of the photographic essay) and are still inherently visual.[3] Audio essays take us out of the page and off the screen. Audio essays can be taken in with our eyes closed, or on a walk in a city or by the sea, where the listener sees different landscapes that may or may not overlap with whatever is being evoked in the essay itself.

Justin Barton and Mark Fisher's *On Vanishing Land* (2006) and Robin Mackay's *By the North Sea* (2021) share an immersion in the particularities of places that are coastal, existing on the 'line' between land and sea. The idea of a coastline seems to me inextricable from that line on a map. A single, thin black immovable line. A line that can create the shape of a country, an island, a nation. A line that designates everything outside of it as somewhere else, as sea and, beyond the sea, foreign lands. A line that could twist and curl into the cursive writing that my youngest child is learning, creating joined-up-letter words on a piece of paper that is flat, laid out in front of us, outside of us. In this way, the idea of the coastline seems to bear a close relation to writing, but *On Vanishing Land* and *By the North Sea* instead take the listener on journeys

1. Oxford English Dictionary, entry for 'Essay'; D. Defoe, *The Complete English Tradesman* (London: Charles Rivington, 2 vols., 1725), vol. 1, 176; J. Reynolds, *Discourses Delivered to the Students of the Royal Academy, 1769–90* (London: Cassell and Company, 1901), viii, 447; C. Dickens, *Our Mutual Friend* (London: Chapman and Hall, 2 vols., 1865), vol. 1, 165; Anonymous, 'An Extract of a Narrative, made by an Ingenious English Gentleman, now residing at Sevill, concerning his Voyage from Spain to Mexico, and of the Minerals of that kingdom', *Philosophical Transactions of the Royal Society of London* 3:41 (1668), 817–24: 821.

2. For discussion of the 'essay' going back further to antiquity and across a variety of cultures, and also encompassing the origins of the prescribed student essay, see Kara Wittman and Evan Kindley's introduction to *The Cambridge Companion to the Essay* (Cambridge: Cambridge University Press, 2022), 1–5.

3. For more on photographic and film essays see Wittman and Kindley, *Cambridge Companion to the Essay*, 3-4, and Nora M. Alter's essay in that collection, 'The Essay Film', 246–62.

through coastal regions that insistently involve the collapse of boundaried bodies. Instead of lines or written words laid out flat on a page, we have shifting sands and sounds. Language drifts into noise into musical tones. Rocks and land erode and fall into the sea.

The coastline is also a guarded border, policed against perceived incursions, attempting to keep out the asylum seekers, the migrants, the refugees, to keep national boundaries intact and impenetrable. 'This whole coast', reports *On Vanishing Land*'s narrator as he walks beyond Folkestone, 'is about fending off incursions from the outside.' He refers to the remains of a mid-nineteenth-century fort, Martello towers from the Napoleonic wars, and concrete emplacements, bunkers, pillboxes, and 'machine gun nests' from the Second World War. These audio essays bring such attempts to fend off incursions together with omens of the collapse and vanishing of the very land itself—its rocky foundations—into the sea. After listing the defensive structures, *On Vanishing Land* refers to the 'concrete groynes, one after another, there not just to hold the beaches in place, but to prevent the land being swept away by the sea'. The ocean is a 'powerful threat', especially here, where the entirety of the East Anglian town of Dunwich almost entirely disappeared underwater in the Middle Ages. The threat of incursions is folded into that of the land itself going out, or under. 'Before long', the narrator says later, 'the cliff here will collapse, and the Second World War concrete will fall to the beach'. As Dunwich diver Stuart Bacon observes in *By the North Sea*, the land here is geologically vulnerable, in its materiality as unconsolidated sediment: 'it has very little resistance to the sea...and once the sea gets to the base of the cliffs...then of course, the cliffs collapse.'

Both *On Vanishing Land* and *By the North Sea* test boundaries between sea and land, waking and dreaming, fact and fiction, as well as between different genres, from the documentary and the radio play to ghost stories, and from voices to the ambient sounds of field recordings and music (incorporating tracks by Skjolbrot, Gazelle Twin, and others). As well as slipping between genres and sources, superimposing literary voices from the past—sometimes in as frag-mented fashion as the land that is breaking apart—there are moments where any boundary between non-linguistic sound and voiced words, or music and language, also slips away. In *By the North Sea* the sad string-bass sounds slide down, down into the low voice referring to 'the first time I'd been back' to Dunwich,

the town that, since the composer/author's childhood, has further fallen away into the sea. The bass and voice are accompanied by the background crackling sounds of an old vinyl record, embodying the time that has passed since the falling of childhood. A cavernous space opens up between the recording medium of that decade and the digital technologies through which we are now receiving its sounds. A space through which the next voices to appear will echo: that of the Dunwich diver, followed by the museum guide Morgan Caines, who reports how eight hundred years previously Dunwich's port was 'the fourth busiest in the country': 'The town went into decline, because in January 1286 there was a massive storm all round Britain...that storm swept over a million tons of sand and shingle into the harbour....'

'It is April, but feels like summer', begins the voice in *On Vanishing Land*, which, many spring-summers later—including that unseasonably summery springtime that saw the beginning of the coronavirus pandemic—seems to signal global heating, changes in seasons, ice melting, rising seas. The narrator describes the surroundings: the sea and the 'rapidly shelving beach' on the right, against a background of chiming, echoing string notes that sound at times to me like distorted church bells, marking out the temporality of collapse. This repetitive background sound continues until the narrator begins to list the coastal defences against incursions and the sweeping away of the East-Anglian coast, at which point new, strange, even alien warbling frequencies at the outer edges of audibility begin to infiltrate the space of listening, adding another layer of non-linguistic sound.

Reflecting on audio essays while writing this piece outside on a summer's day makes my own words here feel especially silent, while I am alert to the sounds of the cars and seagulls around me. Elsewhere, I've discussed how written words can be sonorous insofar as readers may hear them internally.[4] Some modes of writing—those involving poetic rhythms, for example—can feel more audible than others, and may be read out loud. Many creative writing guides, such as Ursula Le Guin's *Steering the Craft*, with its first chapter entitled 'The Sound of your Writing', emphasise the importance for authors of reading their work out

4. S. Trower, *Sound Writing: Voices, Authors, and Readers of Oral History* (Oxford: Oxford University Press, 2023).

loud to ensure that it has the right tone and rhythm, that it *sounds right*[5]—an elusive quality which, at its best, may find sound and meaning working together. Poetry is often considered a most sonorous form, intrinsically caught up in the crosscurrents between the sound and meaning of an arrangement of words, between sensation and sense-making.[6] Writing an essay about audio essays, it is easy to feel that your medium is lacking, that it is missing actual acoustic vibrations; listening for their poetics leads me to want to write more sonorously than I have done before. We might even ask whether audio essays need always involve actual technologies of producing sound vibrations, or whether the term might be stretched to encompass certain kinds of written texts that represent and convey a sonorous world while also becoming in some sense themselves potentially audible to readers.

I want to attempt to complement the three audio essays around which the *Sonic Faction* collection has formed—with their locations on the north coast of Scotland and the east coast of England—with some lines attempting to convey sounds and tremulous, shifting coastlines on the southwest coast of Cornwall.

I've been living in Falmouth, where I have witnessed various forms of disruption to and crossovers of the coastline. First, the Bibby Stockholm sat in the docks in the spring and early summer of 2023, being fixed up to accommodate up to five hundred asylum seekers. Apparently a climate of racism had permitted widespread acceptance of the idea that it is acceptable to accommodate certain people in such small spaces (each room reportedly being the size of a car park space) in a manner that resembles the Victorian prison ships.[7] One reason the Conservative Party had publicised this ship, apparently, was to put migrants off attempting to come here. However misguided, the message broadcast again and

5. U. Le Guin, *Steering the Craft: Exercises and Discussions on Story Writing for the Lone Mariner and the Mutinous Crew* (Portland, OR: Eighth Mountain Press, 1998).

6. Angela Leighton reflects also upon how 'writers plant clues to sounding in their work' and especially upon 'moments when the reader's understanding is challenged, redirected, or distracted from the routine norms of making sense', in *Hearing Things: The Work of Sound in Literature* (Cambridge, MA and London: Harvard University Press, 2018), 25.

7. See e.g. A. McKay, 'Why Does the Tory Plan to House Asylum Seekers on Barges Sound Dickensian? Because It Is', *The Guardian*, 8 April 2023, <https://www.theguardian.com/comment-isfree/2023/apr/08/tory-plan-house-asylum-seekers-barges-dickensian>; T. Adams, 'Napoleon's Words Come Back to Haunt Us as a Prison Barge for Our Times Sails In', *The Guardian*, 13 May 2023, <https://www.theguardian.com/uk-news/commentisfree/2023/may/13/napoleons-words-come-back-to-haunt-us-as-a-prison-barge-for-our-times-sails-in>.

again across mainstream media concerns the imperative to keep people out, to protect 'our' borders. Within forty-eight hours of the Bibby Stockholm's arrival, however, the first of the protests began, attended by over a hundred protesters who marched up the cliff road above the docks shouting and chanting (mostly 'Say it loud, say it clear, refugees are welcome here'). In contrast to this prison ship—which went on to sit there for months in its grim and silent immobility, getting fitted and readied for its job as part of the upholding of the UK's border— our collective voice as a protesting crowd vibrated across that very line. (By the end of the year the first UK suicide had taken place on the Bibby Stockholm, as feared, owing at least partly to the intolerable living conditions on the boat.)

The same weekend that the first of these protests was held, a Surfers Against Sewage-led protest took place on the nearby beach: hundreds of people, most with surfboards, floated out to sea and chanted from there, hoping to capture the attention of the media to ramp up a popular topic of the moment: a wave of anger against water companies generating immense profits for shareholders but neglecting basic duties of care for the environment and for the humans and other animals inhabiting it. It was the second protest I'd attended that involved people's voices and bodies crossing the 'line' between land and sea.[8]

These were intentionally noisy events, bringing together the collective voices of crowds, but most weekends I'd find time to just sit on the sand—that part-geological phenomenon that is itself both land or ground and almost semi-fluid, taking the imprint of waves. For a year I lived near Castle Beach, so named because rearing up to the left you can see Pendennis Castle, that fortress against invasion from the sixteenth century to the 1940s. The Castle stands high and solid above the sea but nearer, above the coastal wall, there are red signs warning of rock falls, and below, the beach is far more changeable. Since I started coming here regularly about ten years ago, it has always been quite a sandy beach, but one spring day it felt completely disconcerting to walk down the slope to find a different beach, far rockier; tons of sand, I eventually figured, must have got dragged out and away by some powerful tide. I wonder what that sounded like: crashing, roaring, scraping? Did the sound of the moving sandscape get drowned in the sound of the waves? Once or twice a week after that I'd sit on the small patch of remaining sand, watching my children go out on their boards if there

8. See <https://twitter.com/ShelleyTrower2/status/1659919307285962754>.

were waves, or just swimming and splashing around, or snorkelling, looking at the jellyfish and the mackerel, the seaweed, shells, and sea-glass. The sounds were of children shouting, of seagulls squawking and screeching, of the constant waves rolling against the rocky ground.

I grew up near the north coast of Cornwall, where there are almost always surfable waves—often dramatic and loud. Compared to Falmouth, that coast has far more dramatic coastlines and suffers more dramatic land shifts, or rather cliff tremors and falls. Vibrating clifftops are the setting of many a gothic tale, such as Stoker's *The Jewel of Seven Stars* (1903).[9] Charlie Carroll has taken their potential further than most in his recent novel, *The Lip* (2022); the narrator, Melody Janie, lives in her caravan right on the edge—the lip—of the land on the north coast, spending much of her time above the sea, on the cliffs where signs (much like those in Dunwich) warn: 'UNSTABLE CLIFF KEEP AWAY FROM THE EDGE', with the constant thundering of waves below. The land is falling apart; on one stormy night, she hears and feels it as she heads out:

> The rumbling is beneath me, coupled with the incessant crash of wave on rock. I must be careful. This is unstable. It could all collapse below me at any moment. The ground beneath my feet.
>
> I gingerly step forward. I can feel the ruptures vibrate up into my knees, can feel the fracturing and the splitting, the opening of the veins. Ahead, a crackling cracking, like long lightning, then the staccato machine-gun fire of splintered rock dispersing, striking water after an excruciating drop. My land is breaking.
>
> Another crack, another rumble. Something shifts and then settles. The vibrations recede, the noise slips away beneath the waves.[10]

Melody Janie's favourite beach disappears completely under the rockfall, and later the entirety of her patch of homeland collapses too.

The Lip describes the sonorous vibrations of waves and geological collapse at the same time as attempting to bring some sense of that audibility directly

9. As I have discussed, with further examples, in *Rocks of Nation: The Imagination of Celtic Cornwall* (Manchester: Manchester University Press, 2015).

10. C. Carroll, *The Lip* (London: Two Roads, 2021), 213.

to readers. The sentences become fragmentary and clipped, taking on a rhythm that could briefly echo the waves (as in the grammatically incomplete but effective sentence, 'The ground beneath my feet') before being interrupted by the 'ruptures' that 'vibrate' through her body, 'the fracturing and the splitting', and the onomatopoeic rhythm of the 'crackling cracking, like long lightning'.

When I moved to the south coast in my forties, it seemed excessively calm and quiet, lacking in noise and waves. It was only when I'd seen the sea seem absolutely still, like glass, that I became aware of other ways in which it moves and sounds. Instead of the crash of the waves, the background soundscape here is more like a 'shhhhh', although this only goes to demonstrate how difficult it is on the written page to describe the sounds of waves and lapping water. On the south coast I became attuned to the tides not just as something that dramatically transcends any coast-line—making waves crash high even over the beach car park, or half a mile out, the beach stretching almost beyond eyesight—but as movements you can feel in themselves, coming in or going out. I became slightly obsessed with getting out at low tide amongst the rockpools, and with feeling the turning of the tide.

This liminal space that is both land (rock) and sea (pools) is an otherworld, filled with creatures that have unfamiliar and inconstant outlines: anemones, starfish, sea-slugs with frills, more properly called nudibranchs. You cannot build property here, or a mine or quarry for digging out or extracting and sending the land's entrails into the industrial capitalist complex, as occurred throughout much of Cornwall.[11] Rockpools are not even of as much value to the tourist industry as the sandy beaches and sublime dramatic cliff scenery or even the Poldarkian mining heritage of engine houses, and this coastline is, as ever, not a line at all. The sea here is at times utterly waveless and barely even laps at the rocky edges, making a faint kind of trickling sound—or a sound something like a cat's tongue lapping at water—and yet it is breathing. The sea breathes in, and it breathes out. The seaweed on the rocks is becoming brown and crispy, popping in the hot sun; the submerged floating seaweed is semi-transparent green and when the sea breathes in it floats up towards us, and when it breathes out the seaweed follows. There's a slight out-sucking sound.

11. See R. Mackay (ed.), *Hydroplutonic Kernow* (Falmouth: Urbanomic, 2020).

The sea breathes in again, and holds for slightly longer. When it holds, there is a silence. I look up. First at the line of the horizon. The sea breathes out. I look down again and the outbreath is not as far out this time; it breathes in. The horizon is a line: below is the ocean, above is the sky.

There are two sailing boats on the horizon line, and a cargo ship, and something smaller, a rowing boat, I think. The sea breathes in. I look up, now above the horizon, above the ocean vessels, and see the clouds that were white being infiltrated with a new kind of dark grey shape. It's a shape that descends to the sea.

The horizon line loses its distinctness. The sea is turning grey like the sky.

The sea breathes in.

The tide is turning.

Rain is falling out at sea, coming in, with the tide.

And when that tide comes in over the next decade, and the next century, how far will it reach? What will end up underwater, not just when the tide comes in, but for good? The beach, the café, the road above, the hotel on the other side—where will be the new coastline? Tarmac rockpools? Salty lawns and goldfish pond. Squelchy ornate carpet.

The audio essay takes us beyond the lines on the flat page, out of the realm of distinct outlines, as does time on the beach. The beach is a privileged place outside the time of work, a place of leisure for some of us, to think, to ponder, to let thoughts wander. It is also a place where bodies are washed up. Coastlines are sites of contestation (protests, border politics), of arguments between clean lines and shifting boundaries. They are sites where the global heating of icebergs and oceans is causing ever more disruption of these boundaries. The sea will continue to rise, while the strengthening storms will encourage the land to keep falling, here and elsewhere, the sinking of islands in the Pacific, the flooding of Bangladesh, drowning and displacing.

The academic essay tends to neatly set out an argument line by line, working toward a conclusion, whereas the audio essay allows us to operate non-linearly, to hear overlapping sounds and rhythms (including those that make both linguistic and audible sense), bringing together a potential multitude of shifting spaces and temporalities. My essay—in its sense as a verb, the sense of 'trying or testing'—has been a brief experiment with the possibilities of writing (another

word that can be both a verb, the activity of writing, and a noun, a piece that is written, as when a teacher asks to see your writing) that carries something of the qualities of an audio essay. My essay and my writing as both activities and as nouns are here necessarily confined to the physicality of this printed medium, but as a piece of writing, this essay may nevertheless at least bear some resemblance to the audio essay in part in its form and topic (poetics and movements across and of coastlines), and perhaps also in its slipping between genres (literary criticism, documentary, life story). A final point of comparison could be between what we end on or are left with, in place of a conclusion. Unlike the page or the screen in front of our eyes, the audio essay in its sonority is itself in flux—entering our ears, vibrating our bodies—and then it is gone. When the audio essay reaches the end of its playback, the listener is left with silence and with the sounds of wherever they are, which may be background noise (the fridge, cars, rain) of which the listener is no more conscious than they are of their own breathing. When the written essay reaches the end of the line, the words on the page are still there, but assuming that the reader does not 'replay' it by allowing their eyes to wander back up, then they may also be left not just with white space but with background noise and a kind of silence—if they've heard the essay as any kind of voice in their head—leaving only the possibility of remembered sounds resounding in our minds. 'See what see what comes back, see what comes back comes back what comes back comes back', are the last words of the narrator's reverberating voice in *On Vanishing Land*, overlapping and then fading into the wordless, distorted, echoing notes of a piano, a bell, a knock, a string, cymbal, click, fall, unfathomable, the end.

Lendl Barcelos
Listening Past[1]

Some sounds I miss. I miss the sounds of dog-day cicadas, that bug that waits for elongated days to play its tune. Growing up in Toronto, even when going for a walk downtown, their sound would somehow reliably return each Summer. I always assumed the electric swell was just *the sound of Summer*, the sound the Summer made. I had never seen where it came from, but knew it would always be there to be heard. Living now in Europe, I no longer hear them. The season lost its familiar buzz.

I want to drift through sounds past, sounds missed, sounds written, so as to listen past our present surround and let sounds of elsewhen leak.

Senecan Sound

Imagine what a variety of noises reverberates about my ears! I have lodgings right over a bathing establishment. So picture to yourself *the assortment of sounds, which are strong enough to make me hate my powers of hearing*! When your strenuous gentleman, for example, is exercising himself by flourishing leaden weights; when he is working hard, or else pretends to be working hard, I can hear him *grunt*; and whenever he releases his imprisoned breath, I can hear him *panting in wheezy and high-pitched tones*. Or perhaps I notice some lazy fellow, content with a *cheap rubdown, and hear the crack of the pummelling hand on his shoulder, varying in sound according as the hand is laid on flat or hollow*. Then, perhaps, a professional comes along *shouting out the score*;

1. An earlier version of this text was broadcast from MILL (Brussels) in the frame of Q-O2's Oscillation Festival 2021 ::: Tuned Circuits. Thanks to its organisers, Julia Eckhardt, Caroline Profanter, Henry Andersen, Ludo Engels, Niels Latomme, Ugne Vyliaudaite, and Christel Simons. Gratitude further extends to Ameen Mettawa, Xenaudial, Maria C. Ferreira, Maria Leite, Myriam Lefkowitz, and Valentina Desideri.

that is the finishing touch. Add to this *the arresting of an occasional roisterer or pickpocket, the racket of the man who always likes to hear his own voice in the bathroom*, or *the enthusiast who plunges into the swimming-tank with unconscionable noise and splashing*. Besides all those whose voices, if nothing else, are good, imagine *the hair-plucker with his penetrating, shrill voice,—for purposes of advertisement,—continually giving it vent and never holding his tongue except when he is plucking the armpits and making his victim yell instead*. Then *the cake-seller with his varied cries, the sausage-man, the confectioner, and all the vendors of food hawking their wares, each with his own distinctive intonation.*[2]

This passage rendered into English in 1920 by Richard M. Gummere is from the first century, and was written by Seneca the Younger, who lived above a bath house [*balneum*].

The Cordoba-born, Stoic statesman famously wrote epistles to the Sicilian official Lucilius. Although the oldest surviving manuscripts of the 124 letters are from the ninth century, scholars date their composition to around eight hundred years prior, around the year 65CE. These words, these sonic descriptions, are from almost two millennia ago and still continue to ring out.

In true Stoic form, Seneca advises Lucilius to listen past the irksome sounds of his environment to achieve an inner quietude enabling study and work. Using himself as an exemplar he writes:

But I assure you that *this racket* means no more to me than *the sound of waves or falling water*; although you will remind me that a certain tribe once moved their city merely because they could not endure *the din of a Nile cataract*. *Words* seem to distract me more than *noises*; for words demand attention, but noises merely fill the ears and beat upon them.[3]

For Seneca then, sounds can be ignored, unless they be words. Let us continue listening to his.

2. Seneca, *Epistulae Morales I, Books I–LXV*, tr. R.M. Gummere (Cambridge, MA: Harvard University Press, 1974), 373; emphasis ours.

3. Ibid., 375; emphasis ours.

Among *the sounds that din round me without distracting*, I include passing carriages, a machinist in the same block, a saw-sharpener nearby, or some fellow who is demonstrating with little pipes and flutes at the Trickling Fountain, shouting rather than singing.

Furthermore, an *intermittent noise* upsets me more than a steady one. But by this time I have toughened my nerves against all that sort of thing, so that I can endure even *a boatswain marking the time in high-pitched tones for his crew.*[4]

No noise seems to bother Seneca. He seems to have reached that mythical state of asceticism, of *apatheia* [απάθεια]—what we call today 'being Stoic'. Seneca prides himself on becoming indifferent to the sounds of his surround.

You may therefore be sure that you are at peace with yourself, when no noise reaches you, when no word shakes you out of yourself, whether it be of flattery or of threat, or merely an empty sound buzzing about you with unmeaning din.[5]

Yet, as Seneca draws his letter to a close, he uncharacteristically troubles the image of his Stoic temperament:

[Y]ou say, 'is it not sometimes a simpler matter just to avoid the uproar?' I admit this. Accordingly, I shall change from my present quarters. I merely wished to test myself and to give myself practice.[6]

So perhaps all his advice was in vain—simply an ideal written out to imagine what it might be like to be able to stop one's ears or to live in another sound-scape. More on point, it seems Seneca is keen on drawing up a sonic(o-utopian) fiction gesturing toward a way to listen otherwise, rather than using writing to conjure up some alternative acoustic world.

4. Ibid; emphasis ours.
5. Ibid., 381
6. Ibid.

Luckily for us, Seneca describes these sounds in such detail that it gives us a way to listen in on the first century. Also luckily for us, we do not have to live day in and day out in his irksome environs.

* * *

As you drift through sounds past, I would like to temper them with some conceptual strategies that offer ways to work sounds, ways to modulate them and perhaps also give them an alternative spin—a spin that might then feedback into and out of variegated modes of listening. Each of these philosophical operators will have been given a name: Le Dœuff, Borges, and Bayard. So, before going further into 'intolerable sounds', I'd like to speak of a first set: the Le Dœuff Operators.

Le Dœuff Operators

Michèle Le Dœuff is a philosopher who, alongside researches into feminist epistemologies and *The Sex of Knowing*, has focused on the ways in which images are used as a means for thought—what she names 'the philosophical imaginary'. For our purposes here, you can hear this as designating the ways in which sonic images, fictions and descriptions are thought through—thought with. [7]

In the introduction to her 1980 book *The Philosophical Imaginary*, Le Dœuff—in a style that only reading her could do any justice—outlines three 'genres' of '*thinking in images*'.[8] (1) There are in-depth studies of myth and dream where images are at home. (2) There is the tradition inspired by Gaston Bachelard that undertakes an image analysis of scientific practice 'whose final aim', writes Le Dœuff, 'is to extradite an element judged alien and undesirable, and assign it a residence *elsewhere*'.[9] (3) The third type is Le Dœuff's own strategy, which is to study the use of images in philosophy—a locale where images are not at home, but where without them nothing would be possible. As Le Dœuff notes: 'A stock of images, of pieces of pictorial writing, is an inevitable part of philosophy.'[10]

7. It seems worth leaving an oscillating aside that Le Dœuff is the co-translator of Francis Bacon's *New Atlantis* into French, meaning that those famous 'sound houses' of his that so enthused Daphne Oram are quite familiar to Le Dœuff, although we won't have the time to pay them a visit here.

8. M. Le Dœuff, *The Philosophical Imaginary*, tr. C. Gordon (London and New York: Continuum, 2002), 2.

9. Ibid.

10. Michèle Le Dœuff, interview in R. Mortley, *French Philosophers in Conversation: Levinas, Schneider, Serres, Irigaray, Le Doeuff, Derrida* (London and New York: Routledge, 1991), 81–92: 87

Le Dœuff shows how philosophers tend to neglect their own use of imagery, disavowing its importance and treating it either as a simplifying heuristic (i.e. an image is used to dumb down the more 'important' high-octane conceptual work) or as a childish slip-up (i.e. a recollection from the philosopher's youth bubbles up onto the conceptual plane, unwarranted). In either case, the philosopher's assumption is that the images don't do any real conceptual work.

However, for Le Dœuff, 'imagery addresses problems posed by the theoretical enterprise itself'.[11] This may sound somewhat familiar as some of you may have already heard Donna Haraway's refrain of Marilyn Strathern's 'it matters what ideas we use to think other ideas (with)': 'it matters […] what descriptions describe descriptions.'[12]

As an example of its use, you can briefly pass the Seneca passages mentioned before thru a Le Dœuff operator. Now, you may treat Seneca's sonic descriptions as being meant to convey strong auditory images that have a visceral forcefulness—the litany of noises are *themselves* meant to disquiet. However, the card-carrying (if you would pardon the anachronism) Stoic wants the reader to feign indifference toward these lettered sounds. In a Le Dœuffian sense, Seneca implicitly wants you to *feel* that these figments of his Roman imaginary won't perturb you. You could stretch this further and say that Seneca's descriptions of noise are so far removed from the sounds heard that his aural portraits offer a way 'to test [one]self and to give [one]self practice'. But this is happening only in word: you might doubt that Seneca was explicitly aiming at looping in a reader's response.

In a nutshell then—or perhaps a conch-shell—a Le Dœuff Operator listens past the disavowal of the importance of the way thought is figured in order to catalyse thinking's multimodal pragmatics. This opens the unanswered question: *What are all these sonic fictions doing there anyway*?

* * *

11. Le Dœuff, *The Philosophical Imaginary*, 5 (translation modified).
12. D. Haraway, *Staying with the Trouble: Making Kin in the Cthulucene* (Durham, NC and London: Duke University Press, 2016), 12.

Some sounds I miss. I miss the laugh of Alina Popa, of Carmen Bruno, of my Grandmother. Each of whom is no longer living. I can no longer crack a joke in an attempt to hear their howls. They were easy to make laugh, and speaking to others who were also close to them, a sonic description is never far. Ben Woodard, in a tribute 'To Alina', writes:

> I have been trying for days to replay your laugh just right in my head, to get the shape of it just so.
>
> It is not easy to rebuild your laugh [...] it started like a loud crescendoing 'AHHH' and then became this staccato of high squeaks and deep breaths that you could hear through at least five stone walls. Sometimes it ended in a small sigh. It fit so well to how you responded to ideas like they were a scandal or a bit of gossip that then immediately were turned into a joke: 'There's no crying in the space of reasons!'[13]

A certain longing can seep into quietude, disallowing the possibility to listen past the absence. Seneca also seems to get it when he writes: 'Sometimes quiet means disquiet'.[14] Even though, in memory, their cackles resound, I can no longer have the experience *feedback* and reconfigure what I imagine it was. Their absence is intolerable; silenced laughter is unbearable. Some sounds I will continue to miss.

Schopenhauerian Sound

Some sounds are not intolerable because they no longer sound—leaving a gap in an infinite conversation—rather there are also sounds that simply transgress us with enough force so as to bore down into the marrow.

Tracing the echo of those first century disturbances, you find a nine-teenth-century source in Schopenhauer: 'noise is the most impertinent of all interruptions, since it breaks up and indeed breaks down even our thoughts.'[15] Schopenhauer may be one of the few philosophers to take Le Dœuff Operators

13. B. Woodard, 'To Alina', *Naught Thought*, 5 February 2019, <https://naughtthought.wordpress. com/2019/02/05/to-alina/>.

14. Seneca, *Epistulae Morales*, 377.

15. A. Schopenhauer, *Parerga and Paralipomena: Short Philosophical Essays*, tr. C. Janaway and A. Del Caro (Cambridge: Cambridge University Press, 2 vols., 2015), vol 2., 575–76.

seriously. For him, an insensitivity to poetry, images or 'spiritual impressions of any kind' mirrors an insensitivity to the ways of thought.[16]

The arch-curmudgeon publishes a raging four-page chapter 'On Noise and Sounds' in his *Parerga and Paralipomena Vol. 2* of 1851—recently re-rendered in English by Adrian del Caro and Christopher Janaway. Similar to the Seneca text, it rails against the intolerable sounds of his surround: 'Hammer blows, dogs barking and the screaming of children are appalling', writes Schopenhauer, 'but only the crack of a whip is the real murderer of thoughts'.[17] Schopenhauer spends the rest of the text criticising what he calls 'the universal toleration of unnecessary noise', specifically lampooning the use of the whip to drive horses and other load-bearing animals throughout cities—here, Frankfurt—as a social problem:

> This sudden, sharp, brain-numbing crack, which cuts to pieces all contemplation and murders every thought, has to be painfully felt by everyone who bears anything resembling a thought in [their] head; therefore each of those cracks must disturb hundreds in their mental activity, [...] they chop through a thinker's meditations as painfully and disastrously as the executioner's blade severs the head from the body.[18]

Pardon the invocation of such gruesome imagery. Schopenhauer is no saint. Still, he illustrates these points quite well, and it may be suggested that you can read Schopenhauer in Seneca when the Stoic lapses into those few lines of uncharacteristic troubled temperament.

In a Le Dœuffian mode, Schopenhauer uses yet another image to illustrate his intolerance to the sound of the whip:

> No sound cuts through the brain as sharply as this damned whip-cracking; the very tip of the lash can be felt in the brain, affecting it like a mimosa when it is touched, and lasting just as long.[19]

16. Ibid., 575.
17. Ibid., 576.
18. Ibid.
19. Ibid.

Unlike Seneca, Schopenhauer doesn't suggest you become Stoic about it. He wants this cruelty—to animals, to ears, to thoughts—to end. He quotes from the *Bulletin of the Munich Animal Protection Society* of 1858 congratulating the ban in Nuremberg on 'superfluous whipping and whip-cracking'. Schopenhauer even goes on to suggest an auditory solution to the problem:

> [A]ssuming that it would be unavoidably necessary to remind the horses of the presence of the whip by using this sound, then a sound a hundred times weaker would suffice, since it is well known that animals notice even the slightest, indeed scarcely noticeable signs, audible as well as visible.[20]

A solution, under the 'what if'-condition that we still needed horses to be driven this way. But here, Schopenhauer is hitting upon something more subterranean worth bringing to the surface. Triggering the memory of a sound might be sufficient to witness its effect. In the regime of intolerable sounds, trauma lurks. And here, Schopenhauer also notices how we are not always so aware of what irks us:

> Occasionally I am tormented and bothered by a moderate and constant noise before I am clearly aware of it, in that I sense it merely as a constant hindrance to my thinking, like dragging a weight with my foot, until I realize what it is.[21]

Given that much of the Freudian theory of the unconscious was cribbed from Schopenhauer, it might sound like you've heard this before.

* * *

Schopenhauer ends his tirade on a more or less positive note in a passage that reads like Borges, who lends his name to our next conceptual operator:

> Finally now as regards the literature dealing with the subject treated in this chapter, I have only *one* work to recommend, but it is a beautiful one, namely a

20. Ibid.
21. Ibid.

poetic epistle in *terza rima* by the famous painter Bronzino, entitled *De' romori*. For here the anguish one has to endure from the many kinds of noise of an Italian city is described in detail, with both humour and wit, in a tragic-comical style. This epistle can be found on page 258 of the second volume of *Opere burlesche del Berni, Aretino ed altri* apparently published in Utrecht in 1771.[22]

Borges Operators

'Apparent publication' is a good compression of one of the impossibilities of Borges Operators. For our purposes here I will look to the short story, 'Pierre Menard, Author of the Quixote'. The commemorative note is told by an unnamed narrator who wishes to rectify a few bibliographic details concerning their late friend, the Symbolist writer Pierre Menard. The narrator begins by enumerating the nineteen 'visible works'—you might say the 'apparent publications'—of Menard in a more or less standard—although somewhat informal—manner.[23] For the rest of the story, the narrator digs into the 'subterranean' work of Menard, that neglected lifework whose omission left his friends 'with alarm and even with a certain melancholy'.[24] As the narrator writes,

> This work, perhaps the most significant of our time, consists of the ninth and thirty-eight chapters of the first parts of the *Don Quixote* and a fragment of chapter twenty-two.[25]

That is to say, the twentieth-century Menard manages—impossibly—to write 'verbally identical' passages of Cervantes's early-seventeenth-century *Don Quixote*, although the narrator insists this supposedly later work is 'almost infinitely richer'.[26]

22. Ibid., 578. I have yet to read an English version of the Bronzino text, but there is a clear Sene-ca-Bronzino-Schopenhauer line of sonic description, even though Schopenhauer never explicit mentions Seneca in relation to noise. Much of the sonic imaginary in *De' romori* echoes that Senecan timbre we heard above.

23. J.L. Borges, *Labyrinths: Selected Stories and Other Writings*, ed. D.A. Yates and J.E. Irby (New York: New Directions, 2007), 36–44. I cite the English edition from 2007, which, it should be mentioned, begins with an invitation from celebrated time-twister William Gibson.

24. Ibid., 36.

25. Ibid., 38–39.

26. Ibid., 42.

The narrator maintains that the work of Menard is not simply a 'mechanical transcription of the original'. To commit the Cervantes text to memory and reproduce it word for word would be too easy; similarly, simply updating the context so as to get a 'Don Quixote on Wall Street' is equally undesirable—a move characteristic of those 'parasitic books [...] Menard abhorred'.[27] His technique is rather that of 'deliberate anachronism and [...] erroneous attribution'.[28] This move forms the 'ascriptive' (Yves Cross) germ of the Borges Operator.[29]

Authorial reascription can be heard as a certain flavour of time travel. What if the noisy passages from earlier were (mis)heard as written by acoustic ecologists such as Hildegard Westerkamp, Barry Truax, Peter Cusack or Jana Winderen? Not only would the temporal assignments shift, but the entire referential system wherein which you make sense of a particular work would be recalibrated. The anethical operation can be enacted within any sonic locale in order to provoke as-yet-unheard valences or even reinforce already present ones.[30] Dormant dynamics may awaken, and yet still others may remain from the original context. 'This technique', the narrator writes as they end their piece, 'fills the most placid works with adventure'.[31]

An extra Borgesian knot is made in the last lines when the narrator prompts us 'to go through [...][a] book by Madame Henri Bachelier [...] as if it was by Madame Henri Bachelier'.[32] Here, even an attribution to the *self-same* author— Madame Bachelier, who happens to be the author of the catalogue from which the 'subterranean' work of Menard was initially omitted—gets twisted.

In a conch-shell, this Borges Operator asks: What if the work changed authors? What if what you heard was by someone else instead? Mark Fisher— whose anxious laugh I also miss—gives an apparent answer: 'Everything is as it always was; only now [...] something weird has happened.'[33]

* * *

27. Ibid., 39.

28. Ibid., 44.

29. Y. Cross, 'Initiation', *OAZ*, 13 September 2016, <https://zinzrinz.blogspot.com/2016/09/initiation.html>.

30. P. Mann, 'For *Anethics*', *Masocriticism* (Albany, NY: State University of New York Press, 1999), 195–274.

31. Ibid., 44.

32. Ibid.

33. M. Fisher, *The Weird and the Eerie* (London: Repeater, 2016), 44.

In his 2016 book *The Weird and the Eerie*, Mark Fisher writes there are '"gaps" in the river of time, gates through which it is possible to pass into the past'.[34] In these sonic-fictional zones 'the orderly distinction between cause and effect is fatally disrupted'.[35] Fisher asks: 'Is there not an intrinsically weird dimension to the time travel story?' In listening past the present, you enter this weird dimension. 'Lost Futures' blur into 'longed for pasts'. But before I get ahead of myself, let us continue onto the final set of operators: Bayard Operators.

Bayard Operators and Anachronic Annexation

The literary critic and psychoanalyst Pierre Bayard—not to be confused with Pierre Menard, although the pseudo-homophonic name should already strike the ear as an aural coincidence worth chasing up—invents puzzling interventions that generalize Borges Operators. The titles of his books alone are enough to give a sense of his ingenuity: *What if Books Changed Authors?*, *How to Speak about Books You Haven't Read*, and *Plagiarism by Anticipation*. Borges's story clearly serves as a methodology for the type of criticism operative in the work of Bayard. Inverting normative tendency, fiction rewrites criticism.

After 2010, a marked shift in his work occurs. The generalisation of Borges Operators toward what we are naming Bayard Operators becomes more apparent with titles such as *How to Speak about Facts that Haven't been Produced*, *The Titanic Will Sink*, and *How to Speak about Places You Haven't Been*. For our purposes here, we will invent a new title: *How to Speak about Sounds You Haven't Heard*.

Following Bayard, it is possible to outline four ways of not hearing: there are (1) sounds you do not know (Have you heard the binaural experience of your head being 1000 meters wide?),[36] (2) sounds that you have only experienced in passing (perhaps you have only heard a snippet of a song, album, etc.), (3) some sounds you have only heard of but never actually heard (such as so many

34. Ibid., 41.
35. Ibid., 40.
36. See David Cecchetto's meditation on his project Fathead, a wearable technology that 'simulates how it might sound to have a 1000-foot-wide-head'. D. Cecchetto, *Listening in the Afterlife of Data: Aesthetics, Pragmatics, and Incommunication* (Durham, NC and London: Duke University Press, 2022).

of the sounds described in this text), and lastly, (4) there are sounds you have heard before, but have since forgotten (What were those again?).

Bayard Operators make clear how discursive networks allow us to make some sense of sounds even without hearing them. What for us passes as apparent auditory experience may have only been a sonic description. Adventures in sonic fiction plundered of their acoustic matter turn sound into an infinitely pliable continuum. Bayard operators breed novel potentialities since alternate realities (pasts, future-pasts, presents, past-futures, and so on) can force themselves out: affective fictions making themselves real. Distending the present by pressuring its connexions, the future begins to leak in (as hyperstition). But, as in the case of Seneca passed through the Le Dœuff operator, that is only to *speak* of sounds, to *figure* them and attempt to think with them as aural imaginaries without physical constraint.

I would like to offer a further distinction between 'sonic descriptions without referent to their possible physical constraints' and 'acoustic images that condition the impossible varieties of sounds heard as well of those yet to be heard'. There are many ways to listen—beyond the normative cochlear mode(l)s that are so often assumed that they become the idealised subjects programmed into encoding protocols.[37] Rather than sticking to ways in which speculative fictions might temper auditory fables—which is a valuable project as well—it might also be possible to twist Bayard a little further from 'How to speak of sounds you haven't heard' toward 'How *to listen* to sounds you haven't yet heard'.

* * *

Some sounds I miss. I just don't hear them. Some sounds we can't help but miss. Steve Goodman (aka Kodeg) has named this zone 'unsound'.[38] It consists of the sounds beyond the range of sensibility. Whether this be just beyond the limit of one's attention, a vibration that is too quiet, those frequencies within the bands of infra- or ultrasound, something too far away or, perhaps, just some physically impossible sound (a fiction?), the list would be endless...unsound is unevenly

37. J. Sterne, *MP3: The Meaning of a Format* (Durham, NC and London: Duke University Press, 2012).

38. See S. Goodman, *Sonic Warfare: Sound, Affect, and the Ecology of Fear* (Cambridge, MA and London: MIT Press, 2010) and S. Goodman, T. Heys and E. Ikoniadou (eds.), *Audint—Unsound:Undead* (Falmouth: Urbanomic, 2019).

distributed. We all miss some sounds. This becomes obvious when witnessing a cat react to some sound out of the supposed 20/20 'human auditory range'; or when time passes, you get older, and the inevitable low-pass filter begins to roll off higher-end frequencies. But I wouldn't want to dislocate sound into only the function of the ear. Some sounds are missed because we don't tune into them, because we aren't used to listening by means other than our ears.

So, when listening past the present into the past, when trying to speak about and then hear said pasts you have yet to live, perhaps the invitation of Seneca the Younger written in the last three years of his life (here, as above, rendered into English) may offer a simple listening score: 'Imagine what a variety of noises reverberates about my ears!' but also, those sounds that go on elsewhere and otherwise.

Recording coronal discharge on a hillside near Sálašvággi/Tromsdalen in Sápmi/North Norway.

Angus Carlyle
Arctic Anti-Radio

Sound Devices

A squat shiny column, the manufacturer's name embossed in cursive across the lid, the nickel base milled with a reeded edge: a piezo pickup designed for recording stringed instruments.

A pair of discs, each the dimensions of a Cadbury's Dairy Milk Button but a little heavier, one dipped in blue liquid rubber and one in red: contact microphones gifted by Rory Salter.

Another pair of contact mics, scuffed and dented, the foam circles at their centres bruised and blemished by use.

A black cylinder, shape and heft suited to a small palm, the manufacturer's name debossed along its side, the base tapering to a steel thread from which the cable sprouts: a geophone devised to detect subsurface energy waves.

Two black metal tubes inserted into plastic spheres encased in fleecy synthetic fur covers, the globes cradled in suspension supports that are screwed onto a powder-coated horizontal bar printed with the manufacturer's logo, a centimetre rule and guide marks for direction alignments: cardioid microphones arranged in the ORTF configuration of 17 centimetres separation at 110-degree angles.

A black plastic box, slightly larger than a pack of playing cards, the manufacturer's logo and stylised product name embossed on one face; two bent metal pins protrude from the top, two dials and a switch project from one side: an 'anti-radio' created to 'perceive the invisible electromagnetic landscape that humans created unintentionally'.

Two rubberised lozenges, one end of each terminating in a recessed grill, the other joining a thin cable—together they resemble, in size and appearance, wired in-ear headphones: twin sensors tuned to stereo fluctuations in the electromagnetic spectrum.

A grey metal box, marginally bigger than an audio cassette case, a satellite photograph of a cloud-striped Earth stuck to the front face, a single grooved knob housed on one side above a custom-built jack output, and on the top a BNC connector ready to be fastened to a retractable radio antenna: an electric-field 'whistler receiver' for monitoring 0.3–11kHz audio frequencies.

A pale plastic hoop, of similar proportions to a frescobol paddle, its handle affixed to a red cable and assembled from two screwed-together sections that sandwich coiled copper wire; a Very Low Frequency (VLF) receiver constructed by my former student Dereck De Abreu Coelho.

.WAV Nomenclature

Audio from Corrupted Video

Balcony Glass Sleet 2

Buzzing_air_boom_pole_full_stretch

Buzzing Nearer Cabin and Skiing Chat

Cable Car Ride with Weird Electronic Mess at End

Cabin_Cable_Schaller_Pickup2

Dereck Prezor on bench

Dereck Prezor near satellite transponder dish RUBBISH

Electronic Buzzer from Radar on Mountain

Electrousi electricity box on wall outside cable car station

Electrousi listening to recorder and mic in bag

Ether listening to midnight pylon

Ether recording kiosk ticket machine smog

Fence wires contact mic near transponder

Lift machinery recorded through platform

Mono picking up mobile phone messages

Pylon Wooden Support Rory Contact Mic and Geophone

Rory Contacts on 1950s telegraph pole guy wire

Rory Contacts on 1950s telegraph pole split

Under pylons night air

VLF antennae recording midnight pylon

VLF antennae on scary bench

Walk and fizz

Going Fishing

Powerlines is a 55-minute composition published as a CD and digital release by the record label Rural Situationism,[1] in which a series of sound devices were deployed on the slopes below Loavgavvári/Fløya near the city of Romsa/ Tromsø some 350 kilometres north of the Arctic Circle to generate field recordings encoded as .wavs and given the descriptive file names listed above. The impetus for reading deeper into the theoretical, historical, and technical aspects of the 'invisible electromagnetic landscape that humans created unintentionally', for bringing the array of different sensors on successive trips to Sápmi/North Norway, for taking these out fishing for electromagnetic emissions and infrastructural vibrations during periods of downtime on a collaborative research project, for working in artist Simon James's studio[2] to layer the resulting recordings not quite as intricately as a Fabergé but still with a certain polish, all came from two comments offered by participants on two soundwalks that were the official reason for travelling 2320 kilometres from home.

Soundwalk Stories

In January 2022 we followed in A's footsteps. In February 2023, it was T who became what our Arctic Auditories project calls a conductor, someone who lays a trail for listeners, creating a soundwalk that can transmit how they hear hydrospheres in the High North.[3]

A's soundwalk mapped memories of journeys taken from her home to the University of Tromsø campus, steering participants down city thoroughfares, past picture-windowed villas, across the swimming pool car park, through woodland which winter had stripped back to its structural basics, and along the security fence bounding radomes, satellite dishes, and antenna towers (Fig. 1, overleaf). Stretches of the path skirted an empty expanse that only the occasional whiffs of sulphide gas and the apparently anatopic furniture of lifebuoy housings, wooden jetties, and sections of guardrail suggested was a frozen and snow-covered lake,

1. Angus Carlyle, *Powerlines*, Rural Situationism, RS0201, 2024.
2. See <http://www.simonsound.co.uk>.
3. *Arctic Auditories: Hydrospheres in the High North* is collaborative project #325506, funded by Research Council of Norway and involving Za Barron, Paula Ryggvik Mikalsen, Katrin Losleben, Britta Sweers, and Angus Carlyle.

the water that gave A's route its incentive drained by the cold of any anticipated trickling, lapping, sloshing, or dripping.

T's soundwalk described a shorter circuit that I welcomed given how my head torch struggled to illuminate the sections that involved slippery sheets of corrugated ice, thigh-deep drifts, and steep slopes with only the skeletons of shrubs to grasp for support. T's route again connected participants to both a family dwelling and a body of water whose surface had been frozen silent, this time as the headwater above a dam, but it also led listeners to a river swollen by the season's first meltwaters, which were descending a valley in a sequence of loud waterfalls. During a rehearsal of the walk, T told us she found one roaring cataract 'really nice, it sounds powerful [...] you don't want to look at nature like something really vulnerable and small, you want to see that it's big and [...] resistant. This river wouldn't be so big if it wasn't for this dam, but still, it feels like real nature to me. I think it's nice to think that something man-made can fit into nature.' Alongside this hope that the route might intensify appreciation of natureculture in the hydro- and cryo-spheric atmospheres near her parents' house, however, T revealed an additional aspiration: that those invited to retrace her sonic steps might mirror her own experience of once perceiving 'new sounds; when I began working [as an activist on ecological issues related to] powerlines [...] suddenly I heard the sounds of powerlines. Then I started working more with airplanes and traffic, I [was] away for six years and when I came back, there were a lot more powerlines in new places and they make sound, especially when it's wet [...]. But I don't know how much we will hear today.'

T's desire for her audience to encounter audible corona discharge from overhead electricity cables might have ultimately been frustrated on the first iteration of the soundwalk since no participant volunteered these high voltage phenomena as a part of their experience. Nonetheless, T's words sparked for me a reminder of something that had emerged in a focus group after A's soundwalk around the frozen lake the previous spring, and this echo was precisely what catalysed my album *Powerlines*. The focus group comment was one that could be parsed through Mark Peter Wright's highly generative filter of 'asking the question: What are we not hearing? [This] draws attention toward the marginal, the forgotten, the inverse, and the underheard: there is always something beyond

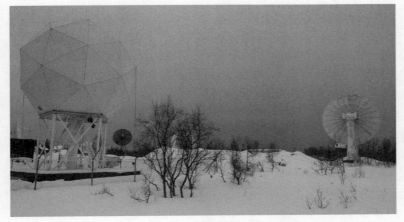

Fig. 1. A radome and two satellite dishes seen during A's soundwalk

Fig. 2. Participants walking towards the dam during T's soundwalk

the audible when auditioning field recordings.'[4] In the prototype phase of the soundwalking part of the Arctic Auditories research project, we redeployed Peter Wright's interrogative device from field recording to soundwalking, and this inspired one of the participants to suggest the following, culminating in that echo at a year's remove:

> In the whole world that exists, there were a lot of sounds that we weren't hearing. Being familiar with the area throughout all the seasons, I couldn't help compare our experience to those at other times of the year: one thing I didn't hear were birds, another was the sound of rustling leaves, and I didn't hear the ocean (which was too far away). As we were walking underneath the powerlines, I realised we weren't hearing the electrical lines, which sometimes, when the voltage is high enough, has a very distinctive sound.

Look at the Puffins

Peter Wright's recalibration of listening thresholds, problematisation of assumptions about the auditory as evidentiary, and reconceptualisation of absences as active rather than passive phenomena are all salient issues for the production and reception of audio essays. The rethinking of what it means to hear and not hear should also interrupt the temptation to succumb too hastily to environmental first impressions. The titular quietude of Rachel Carson's *Silent Spring* treads in the same tracks, shifting stillness from balm to alarm, a linguistic operation repeated fifty years later by Maria Cone in *Silent Snow* to account for the deficiencies in an exclusively visual approach to 'chemicals harming Arctic wildlife in ways impossible to detect with the naked eye'.[5] '"My God, this place is beautiful." They say, "Look at the puffins and look, there's a bald eagle." Superficially, it's a pristine, incredibly breath-taking, beautiful place to be. It looks perfect, like paradise'.[6] In Carson and Cone, silence forms a semantic counterpart to Peter Wright's 'What are we not hearing?' and its corollary 'What are we not seeing?' This charged version of silence smuggles into any application of the term to Arctic conditions a surreptitious cargo of the marginal and forgotten as well as

4. M.P. Wright, *Listening After Nature: Field Recording, Ecology, Critical Practice* (London: Bloomsbury, 2022), 61.

5. M. Cone, *Silent Snow: The Slow Poisoning of the Arctic* (New York: Grove, 2005), 37.

6. Ibid., 181–82.

what has been muted or masked, an ostensibly quiet freight that often (and paradoxically) gets yoked to an antagonistic amplitude.

Anne Merrild Hansen captures this sense that 'silence is particularly remarkable in the Arctic as it contrasts the noises whenever a storm or blizzard sets in and the moments of silence [...] are the times where you stop and think, and make you present in the presence'.[7] Two accounts by Black explorers of the Arctic—Tété-Michel Kpomassie in the 1950s and Matthew Henson in 1909 when he was the first person to reach the North Pole—underscore how what is called silence trembles with tension in the high latitudes: a 'morning after a night without darkness. Apart from a few seagulls hovering over the fjord, nothing moved in this strange morning light. The silence was overwhelming.'[8] 'Not a sound, except the report of a glacier, broken off by its weight, and causing a new iceberg to be born. The black darkness of the sky, the stars twinkling above, and hour after hour going by with no sunlight.'[9]

Himali Singh Soin's *We Are Opposite Like That* invokes the earth's poles as 'A Wild Weird Clime That Lieth Sublime Out of Space—Out Of Time!',[10] and indeed early versions of the sublime were staged in front of a backdrop that could arguably have been sketched from polar realities of '[b]old, overhanging, and as it were threatening rocks, clouds piled up in the sky, moving with lightning flashes and thunder peaks, volcanoes in all their violence of destruction; hurricanes with their track of devastation; the boundless ocean in a state of tumult; the lofty waterfall of a mighty river, and such like'.[11] This fragment of Kant's explorations of the sublime possesses a discernible audibility in the crack of lightning, rumble of thunder, volcanic detonations and roars of waterfall, river and furious sea. A similar sonic presence, albeit at a lower volume, seeps into a letter from Burke to Richard Shackleton in which Burke rehearses the language and concepts of his later *A Philosophical Inquiry* by musing on the sublime as a confrontation with nature 'in those great, though terrible scenes. It fills the mind with grand ideas, and turns the soul in upon herself'—ruminations inspired by the atmosphere he

7. A.M. Hansen, 'Arcticness Insights', in I. Kelman (ed.), *Arcticness: Power and Voice from the North* (London: UCL Press, 2017), 51.

8. T.-M. Kpomassie, *Michel the Giant: An African in Greenland* (London: Penguin, 2022), 91

9. M. Henson, *A Negro Explorer at the North Pole* (Berkeley, CA: Mint Editions, 2021), 32.

10. H. Singh Soin, *We Are Opposite Like That* (New Delhi: Subcontinentment Books, 2020), 20.

11. I. Kant, *Critique of Judgment* [1790], tr. J.H. Bernard (New York: Hafner, 1966), 100.

senses in the 'melancholy gloom of the day, the whistling winds, and the hoarse rumbling of the swollen Liffey'.[12] Burke is explicit that the 'eye is not the only organ of sensation by which a sublime passion may be produced. Sounds have great power in these as in most other passions. [...] The noise of great cataracts, raging storms, thunder or artillery, awakes a great and awful sensation in the mind, although we can observe no nicety or artifice in those sorts of music.'[13] If for Burke silence can be a privation, perhaps akin to the overwhelming sonority reported by Kpomassie and Henson, as much as it can contribute to relaxation 'where nothing keeps the organs of hearing in action',[14] by also drawing anthropophonic artillery into a sublime more usually populated by the geophonic, Burke might offer a glimpse of an inversion of natureculture that T proposes in which 'it's nice to think that something man-made can fit into nature'. An inside-out version of natureculture in an Arctic setting suggests something '[f]ar from a remote wilderness of natural splendor' that brochures for luxury cruises on icebreakers promise. Instead, this hybridised Arctic is 'a place where competing worlds jostle: landgrabs supported by high-tech electronic fortresses and military encampments share space with migrating animals, launch sites, and nuclear reactors, while submarines glide beneath the ice—the vast plains interspersed with scientific research stations and remote Indigenous settlements.'[15]

T.J. Demos ascribing remoteness to indigenous settlements in the Arctic is as awkward as his quote acknowledges the application of the term 'wilderness' to be. Even in Henson's autobiography from over a hundred years ago, one striking feature is the accidental admissions of the proximity of indigenous settlements to the camps of explorers who persist in presenting themselves as utterly isolated. Without the proximity between adventurer and inhabitant and the access it delivers to Greenlandic Inuit technical knowledge and logistical support, the Henson/Peary expeditions would have failed.[16] In the very different context

12. E. Burke, 'Letter to Richard Shackleton, 25th January, 1746', in *The Early Life Correspondence and Writings of The Rt. Hon. Edmund Burke* (Cambridge: Cambridge University Press, 2014), 83.

13. E. Burke, *A Philosophical Enquiry into the Origins of Our Ideas of the Sublime and the Beautiful* [1757] (Oxford: World Classics, 1990), 75.

14. Ibid., 134.

15. T.J. Demos, *Decolonising Nature: Contemporary Art and the Politics of Ecology* (London: Sternberg Press, 2016), 82–83.

16. For more detailed exploration of these issues, see Jen Rose Smith, '"Exceeding Beringia": Upending Universal Human Events and Wayward Transits in Arctic Spaces', *Environment and Planning*

of twenty-first-century Sápmi/North Norway, Demos's inverted natureculture persists without yet achieving the 'fit into nature' that T hoped for. Himali Singh Soin tells of how she had anticipated the Arctic as 'amazing material! There are stars, there's darkness, there's delayed light, there's just metaphor upon metaphor. It was a blank canvas upon which to think about earthly desires […] But then very quickly, I found that they were places and not spaces, because they're so embroiled in Earth's politics.'[17] As Sámi scholar Harald Gaski has it, a 'very concrete example are windfarms that are built all over Sápmi. We have no free space anymore, the colonizers have taken so much. And it's not only Sámi who get hurt, it's everyone living here. It's bad for the environment and for our peace of mind. We no longer have a haven.'[18]

T's words from 2023 cross-faded with that spontaneous focus group comment in 2022 to set me thinking about how electrical and infrastructural presences normally subsumed beyond the audible could be registered as energies to be heard, how once the organs of hearing are spurred to action in this way, the 'this place is beautiful' visualised landscape of puffins and eagles might surrender some of its own silences as it becomes politically embroiled, and how assembling apparatuses to interrupt those silences might procure pleasures and meanings alongside the aims of the official Arctic Auditories collaboration, in the sidequest composition of a field recording LP.

Unnatural Radio

In *Earth Sound, Earth Signal*, Douglas Kahn considers how 'the grandeur of the mountains or the beauty of the night sky were ratcheted into the sublime through peril, presentiment, and incomprehensibility'.[19] He detects the ways in which the sublime takes on a sonority in its early formulations and also assigns

D: Society and Space 39:1 (August, 2021), 158–75, and P.R. Martin 'Indigenous Tales of the Beaufort Sea: Arctic Exploration and the Circulation of Geographic Knowledge', *Journal of Geographical History* 67:1 (January 2020), 24–35.

17. Clara Wilch, 'A New Language of the Future: A Conversation with Himali Singh Soin', *Theatre Journal* 74:1 (March 2022), 12 .

18. Gaski quoted in G. Kuhn, *Liberating Sápmi* (Oakland, CA: PM Press, 2020) 107. See also S.Normann, 'Green Colonialism in the Nordic Context: Exploring Southern Saami Representations of Wind Energy Development', *Journal of Community Psychology* 2021, 77–94.

19. D. Kahn, *Earth Sound, Earth Signal: Energies and Earth Magnitude in the Arts* (Berkeley, CA: University of California Press, 2013), 133.

its categories a tenacious applicability in encounters with such phenomena as images from the Hubble telescope which 'hold violent dynamics at safe distance and split the Kantian sublime in favor of the mathematical: no comet tails are being ripped off'.[20] These Hubble images 'represent phenomena otherwise invisible to the human senses and are thus aesthetic exercises [which] reduce what is seen among technologically sensed phenomena and then color-code an impossible jewel-encrusted universe, as though the cosmic egg were from Fabergé'.[21]

By contrast, Kahn interprets the artistic practice of Semiconductor as external to this airbrushed gloss, in part because their films and installations deploy 'static, glitches, anomalies, and artifacts [which] reinstate the presence of human observation through exposing technology's contingency and frailty, especially when confronting such a grand scale of natural forces. [...] However, noise should never be equated with an interruption of beauty; anyone seeing *Brilliant Noise* and *Black Rain* knows that Semiconductor are dedicated to beauty.'[22]

One beauty that can appear fundamental to the winter tourist season in Sápmi/North Norway relates to the aurora borealis, their green curtains hanging from graphics on the side of coaches, on A-boards outside tour operators, and on the display screens of phones and cameras, their trophy glow passed back and forth in streets and hotel lobbies. Kahn ushers the sound of the northern lights into the concept of the aelectrosonic, which he uses to designate abiotic nature (geophonic nature) such as 'the crack of lightning and its echo in thunder [and] atmospheric electricity',[24] and he collates a sound glossary from previous occasions where the organs of hearing were roused to reported action by pressures emanating from aurora, the '"hissing, swishing, rustling or crackling", not to mention claps, flapping, snaps, snapping, spittering, sizzling, crickling, creaking, buzzling, whizzing, whizzling, whiffling, whipping, rippling, roaring, rushing, sweeping, fanning, and a "soft, slithering whisper"'.[25]

20. Ibid., 198.

21. Ibid.

22. Ibid.

23. S. McGreevy, 'Pocket Portable Wr-3 Natural VLF Radio Phenomena Receiver Listening Guide', originally published 1991, updated until 2001, archived at <https://pe2bz.philpem.me.uk/Comm/-%20 Receivers/-%20Products/WR-3-Radio/wr3gde.htm>.

24. D. Kahn, *The Aelectrosonic* (Amsterdam: Sonic Acts, 2011), 59.

25. Kahn, *Earth Sound, Earth Signal*, 61.

In Northern Sámi, the aurora are *guovssahasat*, often translated as 'the light you can hear' yet understood as more than a spectacular external environmental event to be passively absorbed. In Ann-Helén Laestadius's *Stolen* (2021), the protagonist races outside to observe the dancing 'ribbons of green, yellow, purple and icy blue wreathed across the sky. And soon she heard the crackling sound':

> 'Hi, guovssahasat!' she cried with all her might. 'I hear you!'
> The northern lights changed shape at breath-taking speed, from wide waves to narrow tendrils.
> 'Guovssahasat!' she called again.
> Then she heard quick steps coming up the rise, and suddenly Àkkhu stood before her, her eyes wide and a howl in her voice.
> 'What are you doing! You can't lie there shouting like that! Hasn't your father told you it is absolutely forbidden?'[26]

In the very different cultural milieus invoked in Tania Tagaq's *Split Tooth* (2018), the borealis are again positioned as oscillating between transmission and reception, able to be heard yet also capable themselves of hearing and not just as awful sensation but as subtle and discerning, sublunary and sacral both. In a scene that anticipates the one in *Stolen*, the young female protagonist also hurries into the night air to address the aurora by their Inuktitut name, *Arqsarniq*:

> I sing for you.

> Humming shakily at first, thin tendrils of sound. The trepidation dissolves and a throbbing vibratory expulsion of sound emerges. Thicker, richer, heavier. Sound is its own currency. Sound is a conduit to a realm we cannot totally comprehend. The power of sound conducts our thoughts into emotions that then manifest in action.

> Sound can heal.
> Sound can kill.

26. A.-H. Laestadius, *Stolen*, tr. R. Willson-Broyles (London: Bloomsbury, 2022), 79.

Sound is malleable. Sound can be a spear or a needle. Sound can create the wound and then stitch it. Sound can cauterize and materialize. No one can hear my song but the Northern Lights.[...]

The lights join my song with a sound of their own: a high-pitched ringing mixed with the crackling snap of electricity. I can feel it on my skin and in my belly. A dog howls, and I can also hear someone weeping in agony a long way away, but a long time ago.[27]

Raised by Hertzian Machines

The acoustic ambience of auroras, caught by organs of hearing in Tagaq and Laestadius or captured through the antenna of a VLF receiver with a sticker of a photo of the world from space, as part of Kahn's aelectrosonics, occupy a category that overlaps with the natural radio of lightning strikes, geomagnetic activity driven by the sun, and meteors burning up in the mesosphere. Kate Donovan expands the spectrum of natural radio further still to embrace 'smaller transmissions in this framework, such as natural radioactivity and the frequencies made by bees' vibration pollination tactics [and] [...] molecular antennae in plants respon[ding] to the sun's radiation. I include magnetoreception and biomagnetism within this expanded definition of radio.'[28]

Natural radio transmissions did seep subtly into the final version of *Powerlines*, with one of my VLF detectors picking up faint traces of the characteristic descending tones of whistlers and other signature sounds associated with the sferics that are located in McGreevy's map (Fig. 3)—'sferics' being an abbreviation of 'atmospherics: natural radiofrequency emissions in the ionosphere, caused by electromagnetic energy radiated from lightning [...] These signals—resonant clicks and pops called "tweaks" and "bonks" by scientists.'[29]

With natural radio not my explicit focus, sferics were only occasional and incidental presences, buried in a murk churned up by emissions radiating from electrical and electronic devices and thickened by vibrations from infrastructural architecture set to thrum and flutter by the agitations of wind and snow. If sense organs are, in part, transducers, evolved to convert environmental

27. T. Tagaq, *Split Tooth* (London: Viking, 2018), 56
28. K. Donovan, 'Nightcall Radio. Radio—Anthropocene Entanglements', *Fusion Journal* 19 (2021), 135.
29. A. Dunne, *Hertzian Tales: Electronic Products, Aesthetic Experience and Critical Design* (Cambridge, MA and London: MIT Press, 2005), 106

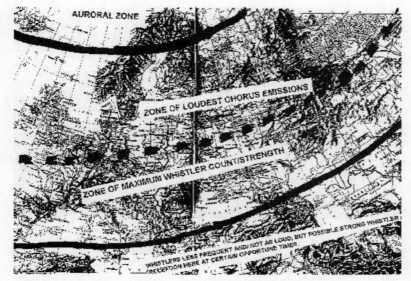

Fig. 3. An unattributed map of auroral zones from Stephen McGreevy's *VLF Listening Guide*[23]

stimuli into neural signals, the threshold governing what we are hearing and what we are not hearing is by no means fixed. Kahn's glossary of auroral sound words and Tagaq's and Laestadius's fine-grained accounts of the aural dimensions of *Arqsarniq* and *guovssahasat* depend on transductions of wavelengths that would be considered outside the narrow bandwidth allocated to the human sensorium—these sounds exceed the aural-typical, if sounds they are. Yet similarly convincing sensory testimonies have been attached to electromagnetic radiation that also ostensibly occurs at subliminal frequencies.[30] Other perceptual reports contradict the apparent silence of electricity itself, an energy flux I myself can sometimes sense[31] in domestic, retail, institutional

30. R. Baloh and R. Bartholomew, *Havana Syndrome: Mass Psychogenic Illness and the Real Story Behind the Embassy Mystery and Hysteria* (Cham: Copernicus/Springer, 2020), 112.

31. 'A huge reason why I don't smoke weed is because when I do, I hear high pitched frequencies that can only be described as hearing electricity flowing. It seems to come from everywhere. The re-frigerator to a phone charging, it doesn't seem to matter [...] In the last year I've been able to hear it no matter what, almost as badly as it sounded when I would try to smoke. Does anyone else hear this? I know it's electric because if I unplug whatever is making the damn noise it goes away instantly. Is there any way to stop the noise? I can't stand it. I can't even charge my phone anywhere near me. It's driving me mad.' Catmom97, 'Can Anyone Relate to Hearing Electricity?', *Reddit*, March 7, 2019, <https://www.reddit.com/r/Electricity/comments/b2b8za/can_anyone_relate_to_hearing_electricity/>.

Fig. 4. The holy mountain of Sálašoaivi framed by electricity poles; the split pole in the centre is the 'pylon wooden support' in the filename list above

and outdoor settings as on the slopes below Loavgavvári/Fløya, a sensitivity that added a peculiar personal purpose to my work on *Powerlines*.

The unseen and intermittently unheard electromagnetic frequencies derived from human-authored electrical and electronic activity are generated at 'an ever-growing scale and at an ever-growing density'. Donovan cites Daniela Silvestrin to claim that the 'density of artificial manmade radiation on Earth has grown to 10^{18} higher than what we would be surrounded by naturally. Man has not changed any other living environment in such a monumental way.'[32] Given that this artificial spectrum is plausibly audible to at least some active organs of human hearing and likely both an irritant to those with broader bandwidths and an interference to others reliant on geomagnetic way-finding, this scale and density is negligible neither in its own terms nor as an indirect indicator of infrastructural expansion, of spectral creep, of political embroilments, of the evacuation of a haven.

Hearing what Anthony Dunne calls 'hertzian machines' involves wondering how they 'touch us [...]. Do they merely reflect off our skin, or the surface of our internal organs?',[33] and elicits an equivalent curiosity towards 'exploring

32. Donovan, 'Nightcall Radio', 134.
33. Ibid., 107.

the boundaries of human sensory perception, through various practices and technologies, to try to listen beyond human capabilities, to realise, recognise and reckon with the limits of human sensory perception'.[34]

Fig. 5. The CD cover for *Powerlines*, design by Cody Yantis

Cover Discs

What has been sifted through these pages is information to which a listener to *Powerlines* has no easy access. In keeping with the abstracted format of past Rural Situationism CD releases, the cover shows a lichen-patterned birch tree trunk, with a wooded, snow-covered slope visible in the blur of the background (Fig. 5).

With the designer of the CD sleeve, Cody Yantis, along with their partner in the Rural Situationism label, Andrew Weathers, I discussed alternative graphic approaches, including using the radome and satellite dish photograph (Fig. 1), the holy mountain of Sálašoaivi (Tromsdalstinden) framed by electricity powerlines (Fig. 4) and even the xerox noise of Stephen McGreevy's 1991 auroral map (Fig. 3), the latter making a focused sort of sense since McGreevy built me the customised VLF receiver with the earth image sticker. The image I most wanted for the cover was recovered from a miniSD card that had corrupted inside my action camera, damage I fancifully attributed to the electromagnetic fields I was investigating. The recovered image framed a similar perspective on the same bleached and split electricity poles shown in Fig. 4 but with snow thaw

34. Ibid., 136.

Fig. 6 A recovered image from a corrupt GoPro action camera file

indicating another season, the lens held so close that the pole fully obscures the mountain and the data corruption glitches the lower half into vertical lines of impossible colours (Fig. 6).

Although this latter image appeared to have something of Kahn's 'static, glitches, anomalies, and artifacts [which] reinstate the presence of human observation through exposing technology's contingency and frailty',[35] it seemed ostentatious as an emblem of *Powerlines*. Indeed, the images which exposed more explicit electromagnetic and infrastructural embroilments (Figs. 1, 3, 4 and 6) seemed to tip the natureculture balance excessively to one extreme, extracting the speculation from the 'What are we not hearing?' interrogative and substituting instead different visualisations of definitive answers, which felt at odds with the exploratory tenor of the project.

The inner sleeves of Rural Situationism releases feature little in the way of information, usually only place names with corresponding longitude and latitude coordinates. For institutional purposes, I wanted to reference the Arctic Auditories project, so my expanded liner notes read 'Unprocessed recordings made on the slopes below Loavgavvári/Fløya near Sálašvággi/Tromsdalen in Sápmi/North Norway during fieldwork for Arctic Auditories, a project funded by Research Council of Norway #325506'. Still left out of the equation are the list of sound devices, the catalogue of filenames given to the recordings used to layer the

35. Kahn, *Earth Sound, Earth Signal*, 98

final composition, the two comments that inspired the project, its tangential relation to the Arctic Auditories collaboration, and the historical, theoretical and fictional constellations that connect a charged Arctic silence, the sublime and 'elusive soundtrack of the aurora borealis'[36] and the heard and hearing *Arqsarniq* and *guovssahasat* to the more prosaic crackling and spitting caused when high voltage pylons on the hill above Solligården strip electrons out of the air and start to form currents that create intense heat, the rumbling and groaning of those pylons, fences, guy-wires, and glass barriers becoming aeolian, and the whining and humming electro smog that spilled from radars, sales kiosks, transformers, motors and my own phone and recording equipment.

I smuggled the term 'unprocessed' into that single line of notes to register a distance from other field recording practices where raw recordings like those I listed by their filenames earlier are, if not Fabergé'd, then filtered by altering their timbral or harmonic character or by combining them with musical elements to magnify 'nicety or artifice'.

Essay Society

The creation of opportunities to encounter sound as means of meaning-making is part of what our Arctic Auditories adapted soundwalking method aspires to, as demonstrated in the examples of conductor T (the creator of a route that reflects her perspective on watery environments in change), conductor A (the creator of another such route) and the unnamed participant who came up with the 'whole world' comment after following A's sonic pathway. The surrounding contexts made available in the soundwalks are more extensive and more fine-ly-grained than any casual *Powerlines* listener will have at their disposal, with conductors offering preparatory remarks and participants able to affiliate the sonorous with other sensory registers mid-soundwalk and able to engage in guided discussion in the subsequent focus group. During the conversation that followed the walk around the frozen lake one of the more effective prompts was derived from Mark Peter Wright's *Listening After Nature*: the invitation to contemplate 'What are we not hearing?'

36. K. Gallerneaux, *High Static Dead Lines: Sonic Spectres and the Object Hereafter* (London: Strange Attractor, 2019), 200.

'What are we not hearing?' can be spliced to some of the analytical threads that trail Norah Alter's extensive work on the condition of the film essay. Wright's invocation that we attempt to hear what is not heard shadows Alter's imperative of uncovering 'the political in/visible and in/audible that moves stealthily beneath, within, and around vision, visuality, and visibility or seeingness'.[37] Alter identifies the 'in/visible and in/audible' as elements of a broader problematic of the 'im/perceptible' that she locates as a trajectory in Harun Farocki's work which can, in its turn, be traced back to an invention in Hans Richter's surrealist filmmaking. Alter shows how Richter addresses this episode specifically in terms of the essay:

> [Richter] proposed a new kind of film that would enable its maker to render 'problems, thoughts, even ideas' perceptible and make 'visible what is not visible.' He called this new kind of film an essay film because it 'deals with difficult themes in generally comprehensible form.' Unlike documentary film, which presents facts and information, Richter reasoned that the essay film produces complex ideas not necessarily grounded by reason or in reality—ideas that might be contradictory, irrational, and fantastic. For Richter, the essay film no longer binds the filmmaker to the rules and parameters of traditional documentary practice, and it gives free rein to his or her imagination, with all its artistic potentiality.[38]

I wonder if Richter's commitment to the 'comprehensible' in the essay form explains why there is still a temptation to throw petals in the path of the royal Text, whether that textual element is enlisted as vocal commentary, on-screen subtitles, the orchestration of spoken testimonies, the availability of a programme note at a performance or a liner note distributed with physical media or online stream. By way of illustration, in Jacob Smith's welcome advocacy for the innovation of an '"audiographic" criticism made with the audio form in mind [...] [where] recorded sound [is] [...] an essential component in the making of an argument', this element is advanced alongside 'my spoken commentary [...] along with excerpts from films, television shows, news reports'.[39] Certainly, all of those

37. N.M. Alter, 'The Political Im/perceptible in the Essay Film: Farocki's "Images of the World and the Inscription of War"', *New German Critique* 68 (Spring–Summer 1996), 167.
38. N.M. Alter, *The Essay Film After Fact And Fiction* (New York: Columbia University Press, 2017), 18.
39. J. Smith 'Introduction' to *Esc: Sonic Adventure in the Anthropocene* (Ann Arbor: University of

textual elements are ones I have had recourse to in previous projects and, in a way, what I am writing now is itself another version of that textual captioning, albeit one that is currently relocated outside of its original distribution package. One of the reasons why the effects of an attenuation of context—irrespective of whether this is delivered textually—might cut sharper with *Powerlines* than it would with other audio research projects I have been involved with in the past is that the majority of the recordings in *Powerlines* are delegated to equipment that monitors emission and vibration rather than to technologies that reveal the 'in-air' compression and rarefaction of molecules. The sound devices that are piezo pickups, new and scuffed contact mics, geophones, anti-radios, electro-magnetic and VLF sensors bring back a haul that is hard for a listener to scale in terms of the human sensorium since the sources are outside the thresholds ascribed to aural-typical normativity. In the past I have used VLF receivers to record a lightning storm from the top of a mountain[40] and anti-radios and electromagnetic sensors to follow buried fibre optic cables[41] but on each occasion I have provided captions that have clarified content and context which enable a calibration of signal to source.

That these ratios might not be immediately decipherable ('comprehensible', in Richter's terms) may frustrate the listener or might involve them investigating further on their own steam, an outsourcing of the interpretative labour normally demanded of the essayist themselves ('The essayist's job is to gather up the shards or map them where they are, to find the pattern out there or make one with words about the disconnections and mysteries').[42] By somewhat resisting the textual and contextual lures, though, *Powerlines* gambles on amplifying the reverberations discernible in the in/audible (Alter), in what has not been heard (Wright) and in overwhelming silence (Carson and Cone) and on echoing Tagaq's idea that '[s]ound is its own currency. Sound is a conduit to a realm we cannot totally comprehend.'

Michigan Press, 2019), np, <https://www.fulcrum.org/concern/monographs/rx913r17x>.

40. Angus Carlyle, 'Il Vertice', from *In The Shadow of the Silent Mountain* (Frankfurt: Gruenre-korder, 2016), GRUEN 162.

41. Angus Carlyle, 'Air Stream: Ether', from *Clouds and Tracks*, curated by John Patrick Hughes and Volker Eichmann, 202. Original URL rotted, track archived at <https://soundcloud.com/angus-car-lyle>.

42. R. Solnit, 'Introduction', in R. Atwan (ed.), *The Best American Essays 2019* (Boston: Mariner Books, 2019), 23.

Paul Nataraj
Repetitions of 108

repetitions of 108 //////// the sound of a peacock's feather caught in the Lancashire mud //////// flakes of sonic experience //////// fragments of a work in progress //////// an (imagined) sonic essay //////// towards sontology //////// mnesonic imagination //////// nomadic material mantras //////// navigating identity in rasas ////////

'India's greatest writer on the arts, the sage Bharata [...] conceived of all art as a whole. There was, for him, an essential unity of all artistic forms. This idea coincides with one of Hinduism's basic tenets that there is a fundamental unity in diversity'.[1] Within this unity 'Bharata said that it was the musician-composer's business—as indeed of every artist—to evoke a particular emotion or mood which he called *rasa*'.[2] The first of the nine *rasas* is:

Shringar—Love. 'Om Jai Jagadish Hare' sung in a bungalow on Warrenside Close in Blackburn, a 1960s bungalow in the first place I ever went which could have been described as a suburb. The front room had a brown and white mottled carpet which tickled and warmed everyone's bare feet, a furry textured warmth underfoot staving off the belting November winds whipping down from 'o'er tops' of the Dean Clough Reservoir. The party was a group of fifteen or so. Kids between five and eleven years of age, with parents from India, people who my mum and dad had met over the years working in the NHS in Blackburn. My mum was the only white person there, flanked by her two mixed-race boys, with complete unity in diversity, closely listening to the Sanskrit mantras. I stared through legs, with a flower cupped in my hands, at the seated toothless priest, half-naked, flicking water onto Lakshmi, chanting in microtonal shifts,

1. R. Massey and J. Massey, *The Music of India* (Amersham: Kahn & Averill, 1986), 20.
2. Ibid.

sounds that made no sense to me but were all the same known, unfamiliar yet as comforting as the carpet I stood on. The mantra would suddenly be accompanied by the vigorous ringing of a brass bell, a piercing texture resonating from the corners of the room and back into the centre to combine with the flatter frequencies of the priest's voice. It would drown out any sounds coming from the kitchen, or from other conversations in the house, and draw you into a new sonic space, a new timeframe, a new centre of imaginative reality. The bell would stop suddenly, but the ringing would continue in your head, as the priest called out, 'plower...bring plower', consonants compromised through accent and bad dentistry.

After offering the flower to the shrine we took our Arti, pulling in our blessing from the smoke. Cover yourself in light and heat, letting it wash over your head and run down your back to cleanse the spirit. As fire was passed around, we sang together, everyone holding photocopied pieces of paper that would surface year after year, just about holding together at the repeated folds, the ink rubbed thin through use, a shiny shared erasure, a palimpsest of technology and the migrant community; symbols, letters and sounds, a translation of traditions transmitted, everyone's voices encasing me with the intangible inheritances embedded in the communicative action of communal singing that bound us together in this transnational 'living' room. 'The bearers of performance, those who engage in it, are also the bearers of history who link the layers past-present-future through practice'.[3] 'Om Jai Jagadish Hare'. And when the puja was done, the chatter started, the whiskey opened, prasad shared, and we moved outside where fireworks cracked and the party whooped through the sulphurous smoky residue and condensing shapes of people's joys streaming out of lungs through voice boxes and leaving their transient cloudy marks in the air. The neighbours thought it was a late bonfire night. And then the kids were ushered back inside, out of the cold and away from any smouldering debris, to gather around the hi-fi and share records and dance. We crashed around to Madonna in that same dark room on that same mottled carpet, we jumped in and out of Shakin' Stevens's 'Green Door', and I brought my copy of *Rock and Roller Disco*. This album, compiled in 1979 by the Ronco label, included some songs which were just a little off the beaten track. I'm pretty sure that my Mum had bought it, and it was a staple

3. D. Taylor, 'Performance and/as History', *The Drama Review* 50:1 (Spring 2006), 67–86: 83.

on the record player at home. It included the tracks 'Conscious Man' by The Jolly Brothers, produced at Black Ark by Lee Scratch Perry, Public Image Ltd's 'Death Disco', and The Ruts' 'Babylon Burning', alongside some well-known pop hits of the day such as 'Video Killed the Radio Star' by Buggles and 'I Don't Like Mondays' by The Boomtown Rats. Ten years on, I would begin a hobbyist career as a DJ, and it was in this youthful disco that I acquired a talent for clearing a dancefloor. But what a collection of noises for my six-year-old brain to process.

The cultural situatedness of this memory is not neat and tidy. It could be described using the framework of a sonic fiction, which takes standard episte-mological boundaries and expands them to allow for assemblages which also 'rely on a bricolage, an accumulation, or a meshwork of sensory experiences; on a situated craft—or on material and aesthetic performativity'.[4] In doing so they challenge racial boundaries, something which my existence has always done. A mixed-race world, or an anglo-desi world, is futurist, a lived 'mixillogical' experience, being doubled, being mixed, being halved and being all; not one but many simultaneously, unable to be essentialised. So these sonic memories, examples of mnesonic imagination, are transnational and resistant but 'entangled with all the artefacts texts and cultural productions, and the aesthetics of the Eurocentric world [they are] diffracted from'.[5] This rasa, this tone of memory, is a space of the intermingled, a literal mixed space of identity, a largely ignored set of intra-relations which serves as one fragment of a work in progress.

> *Sound knowledge*—a non-discursive form of affective transmission resulting from random acts of listening. *Sound writing*—a performance in word-sound of such knowledge. Not a representation. Not just an intersemiotic translation. Sound writing is a gong resonating through bodies sentient and non.[6]

(mantra 1: repeat x 108: all doubled mixed halved)

Repetitions of 108: Counting almost Nothing is the work in progress. One of its starting points is the myriad connections and connotations of the number 108,

4. H. Schulze, *Sonic Fiction* (London: Bloomsbury Academic, 2020), 98.

5. Ibid., 72.

6. D. Kapchan (ed.), *Theorizing Sound Writing* (Middletown, CT: Wesleyan University Press, 2017), 2.

which has a special place in many religions, myths, cosmologies, and mathematics. This number's sacred and spiritual ramifications are many: references to its ability to align cosmological and human systems exist in Vedic writings, Islamic and Buddhist teachings, symbolism, prayer, and ritual. To give just one example here, Yoga teaches that the body is made up of 114 chakras. Of these, two remain outside the body and cannot be influenced by yogic practice. This leaves 112 remaining in the body; four of these internal chakras can't be trained through any application of physical or spiritual practices, as they will blossom naturally when the others have found balance. It is the remaining 108 which can be trained in such a way that oneness between the self and the universe can be found. These teachings have their beginnings in the texts *Padaka-Pancaka* and *Gorakshashatakam*, both from the tenth century.[7] Therefore, from the early Vedas on, and throughout the history of Hinduism, the 108 repetitions of a mantra have served as a method of connecting to a universal oneness, as the 'mantra is felt to be a sort of nucleus or a gathering point for energy, a concentrated form of cosmic power'.[8]

RE—'*The cow calling her calf*': Many years ago, some friends were struggling to conceive, so they asked my dad for advice. He gave them a black stone Shiva Linga, carefully placed on a bed of tissue paper in a plastic box. He told them to pour milk over it every day and chant the mantra 'Om Sri Sai Ram' 108 times. He was a GP in Blackburn.

Repetitions of 108: Counting almost Nothing is now this imagined sonic essay, a written fiction based in fact, relying on fractions, fragments, and porous boundaries spoken in (*mantra 2*), allowing for unheard sound poetics to flood into the text. This trial, an experiment in writing, an attempt to grasp some flakes of sonic experience, tests Alexander Waterman's idea that 'most of the surfaces we write upon are not unique, but multiple, virtual or transitional',[9]

7. A. Judith, *Wheels of Life* (Woodburt, MN: Llewellyn Publications, 2012).
8. P. Rawson, *The Art of Tantra* (London: Thames & Hudson, 2002), 59; See A. Chakrobaty, 'The Numbers of Ancient Hinduism', *International Journal of Scientific Research in Interdisciplinary Studies* 7:10 (2021), 19, and N. Mirahmadi, 'Mystical Number 108 Kawthar, HAQ and Reality of Sacrifice', *The Muhammadan Way*, <https://nurmuhammad.com/mystical-number-108-kawthar-haq-and-reality-of-sacrifice/>.
9. A. Waterman, 'A Listening to Resonant Words', in Kapchan (ed.) *Theorizing Sound Writing*, 117–37: 118.

especially when we try to capture the fleeting transience of a sonic trace in all
its temporal and spatial pluralities. An experimentation to discover what residues
might be left on these surfaces, to trace poetic (s)ontologies, and to engage in
a 'joyful mixing in of ever more different and new and unknown substances and
qualities and practices into the process',[10] connecting making and knowing, in
relation to memories of listening and being.

> (*mantra 2: 9 variations to be repeated 108 times: making listening knowing
> being, making knowing listening being, making listening knowing being,
> listening knowing making being, listening being making knowing, being
> listening making knowing, being making listening knowing*)

Repetitions of 108: an uninstalled, stalled installation existing in fragments. Multi-
ples and divisions of 108 actions, erasures, marks, and moments dispersed across
sounds, forms, ideas, and memories. Scribbled notes and sketches which record
fleeting renderings of shifting ideas are collected across notebooks, scraps of
paper, email threads, phone notes, carved vinyl records, and calico soaked in
mixtures of soya milk, earth, ash, sindoor, and haldi powder. There are handmade
contact mics, 3D-printed prosthetics for turntables, awls, threads, styli, and
words. In them are stories of myth, music, mantras and math, godliness and
corporeality, universalism, individualism, racism, inbetween-ness and questions
of identity that 'reintroduce the resistance of materials, of experience, of work
and dirt, bodies and sensibilities, of entanglement and mingledness',[11] mate-
rialising a sonic fiction, a sonic-factive mnesonic practice out of resistant virtual
sonic actions. All are tones, rasas, brought into differing states of materiality,
words, movement, stone, colour, line.

SA—'The peacock's cry': The peacock now lives at the rubbish tip. Its call
resounds into the container of broken small electrical goods as it loses its
feather to the Pendle witch's wind. The next day, in the middle of a barely-heard,
eye-watering, buffeted, dog-walking conversation, the word 'Really?' is enunci-
ated around the side of a soaked yet waterproof synthetic hood.

10. Schulze, *Sonic Fiction*, 99.
11. Ibid., 92.

The word is sounded into but above the rumbling wind, as the squelched foot-step of a rubber boot simultaneously lands in the silted mud left by the Ribble's last flood, and that same feather is pressed down into the sodden earth. Its prowess paused; its cry stifled.

(mantra 3: repeat x 108: factive mnesonic practice resistant sonic action)

These are written gestures that are a mirror of the creative gesture, trying to capture the multidirectional state of the creative process. Can the imagined sonic essay account for an intangible palimpsest of accreting 'intra-relations', collected in the context of practice-based creative research activity? Can its form align with Estelle Barrett's definition of 'art practice as an interplay of meanings and signifiers operating within a complex system'?[12] Within this complex creative system, flakes of (sonic) experience are collected, moulded, manip-ulated, and imaginatively redrawn, in a process that Stewart characterises as 'travelling between various research disciplines in an attempt to build the most appropriate bridge between aesthetics and experiences through processes of production documentation and interpretation'.[13] Therefore, to make a work, no matter how apparently simple or complex, is to try to productively cajole multi-plicities, linkages, intra-actions, entanglements, interferences, combinations of experiences, past and present, into future sonic and material conglomerations.

Adbhuta—Wonder. Do I hear this, who else hears this?

I imagine that the wonder Bharata wanted to capture in his conception of this rasa might have been the magisterial awe of staring at the moon in its fullness and taking a step back from its breathtaking beauty. Bharata's is the kind of wonder that, according to Dasthakur, Rabindranath Tagore's writing might elicit, one which 'produces a euphoria in the audience that is rooted in, but slowly transcends, the world of experience; bypasses the logic of causality;

12. E. Barrett, 'Foucault's "What Is an Author?"': Towards a Critical Discourse of Practice as Research', in E. Barrett and B. Bolt (eds.), *Practice as Research: Approaches to Creative Arts Enquiry* (London and New York: I.B. Tauris, 2013), 135–46: 136.

13. R. Stewart, 'Creating New Stories for Praxis: Navigations, Narrations, Neonarratives', in Barrett and Bolt (eds.) *Practice as Research*, 123–33: 128.

and thus leads towards a different order of "knowledge" that verges on the spiritual'.[14] The wonder produced by this particular flake of sonic experience, however, is a furrowed-brow wonder, stained with melancholy and frustration. I stare, drop-jawed, at the television. I'm sitting with my mum, a half-Polish Prestonian whose father found his way to the UK in the aftermath of the Second World War. His migratory story is opaque and full of mystery, hidden in near-complete silence, gagged by the anxiety of post-traumatic stress and a spectre of institutional threat. What I'm hearing from the TV's embedded speaker system are the contemporary sounds of that institutional threat. Words whose sonic profile is as strange yet as familiar as their content. The frequencies are squashed into a limited range like their message, compressed, thickened, and clipped to cut through mobile phone speakers, processed with convention to centralise a listening position (unambiguous?). The delivery of the words is slow and deliberate, aching with hubris and processed to match, clean and detached. Soundbitten sentences enunciated with the dynamic of a scared parent addressing a child, serious and condescending in tone, trying to convince from a space of arrogance.

As I listen, I look across at my mum, and in the frame of my view I see a small sandalwood Ganesh in a standing position, draped in Kautuka thread, and my wife sitting next to her, wearing a Nirvana t-shirt, is flanked by a statue of Nataraja, his flailing arms holding aloft his eternally resistant drum. His imagined movements, sharp, angular, fractal and incessant, feel representative of my affect-state as I listen with the 'ideological sensibility that understands the visual substantial sense of "I" and "You" and "them" to be an illusion and prefers to work on the basis of fragile "I"s passing in the dark'.[15] Interchangeably institutional voices say 'Stop the boats'; this fragile I hears 'Fuck off Pakis'.

PA—'The cuckoo's song': At a press conference to unveil his revised immigration bill on 7 December 2023, UK Prime Minister Rishi Sunak proudly boasts: 'Once you have been removed, you will be banned for life from travelling to the UK, settling here or becoming a citizen [...] it is your government, not criminal

14. S. Dasthakur, '"World-History," "Itihāsa," and Memory: Rabindranath Tagore's Musical Program in the Age of Nationalism', *Journal of Asian Studies* 75:2 (May 2016), 411–32: 418.
15. S. Voegelin, *Listening to Noise and Silence: Towards a Philosophy of Sound Art* (London and New York: Continuum, 2010), 94.

gangs, and not foreign courts who decides who comes here and who stays in our country'.[16] He appears to be in Downing Street but actually he speaks 'from the impropriety of multiple homes'.[17]

As I listen to Rishi's voice, I hear the political enactment of nationally sponsored racism justified through the political enactment of a litigious class-based pseudo-multiculturalism that has produced him as a symbol of plurality without producing any progression toward supporting concrete cultural plurality. Being interviewed by Les Back, Stuart Hall says, '[Enoch] Powell loved India [...] he thought it was a wonderful, rich civilisation. He just thought none of them should be *here*—not here, not in my backyard, not living in our houses, disporting their picaninnies in my street, but in Delhi, etc., of course, wonderful city, wonderful people'.[18] But now we are here, in this backyard, holding the highest position in the land. It begs the question as to who 'we' actually are or were, then and now. As Lawrence Grossberg asked: 'What are the conditions through which people can belong to a common collective without becoming representatives of a single definition?'[19] Here one might consider the intersection of race and class. Reading Fanon's concept of '*choc en retour*' to feed his notion of multidirectional memory, Michael Rothberg makes the point that Fanon's thinking 'is meant to force an encounter between European and colonial histories in such a way that it remains impossible for Europe to remain blind to its agency in the world. The first step to such a process will be a recognition of the blockages that mitigate against grasping the intertwinement of histories'.[20] With such blockages lifted, we can start to see our connections in a 'layered, multidimensional world of resemblances'.[21] Sunak wilfully ignores these blockages, and in fact provides more, as he boasts: 'claiming asylum, that's now blocked, abuse of our modern slavery rules, blocked, the idea that Rwanda isn't safe, blocked, the risk of being sent

16. R. Sunak, Speech on Illegal Immigration, 7 December 2023, UKPol.co.uk, <https://www.ukpol.co.uk/rishi-sunak-2023-speech-on-illegal-migration/>.

17. N. Ramayya, *States of the Body Produced by Love* (London: Ignota, 2019), 84.

18. S. Hall and L. Back, 'At Home and Not At Home: Stuart Hall in Conversation with Les Back', in *Essential Essays Volume 2: Identity and Diaspora* (Durham, NC and London: Duke University Press, 2019), 263–300: 287.

19. L. Grossberg, 'Identity and Cultural Studies—Is That All There Is?', in S. Hall and P. du Gay, *Questions of Cultural Identity* (London: Sage, 2003), 87–107: 88.

20. M. Rothberg, *Multidirectional Memory: Remembering the Holocaust in the Age of Decolonisation* (Redwood City, CA: Stanford University Press, 2009), 81.

21. Ibid., 84.

to some other country, blocked, and spurious human rights claims, you better believe that we've blocked those too'.[22] Blocks are silences, as Hall makes us aware: 'Everything that can be spoken on the ground of the enormous voices that have not yet been, or cannot yet be heard'.[23] Imagination, creativity, and writing can destabilise such blockages, and as such produce the second part of the Adbhuta rasa. Gloria Anzaldúa finds that 'this new racism has pounded hegemonic theories into us, making us feel like we don't fit. We are alienated. We are exiled'.[24] I think about processes and ontologies of alienation and my grandad Stanislav Gajewski. His passport, issued in 1946, with the word ALIEN embossed in bold gold letters as its headline, part of my family history. It is a fragment of a memory of an object imaginatively working in relation to the new created objects collected and installed as the artwork 'Repetitions of 108'. I am inherently between, yet I hear the tensions caused by borders and nations. Anzaldúa feels the pressure of hybridity: 'it's like a tight-rope that if I allow the Eurocentric part of me too much space it means that I have turned my back on my race, the Chicanos and Mexicanos. If I stick too much to this nationalism, then it means I'm not realistic...'.[25] Yet through her autohistoria, through the work of the imagination, we find ways to transcend these alternatives, to exist between them as imaginative subjective creations. As Tagore says, 'the stronger the imagination, the less imaginary it is'.[26]

DHA—'The Horses Neigh': I used to hear a mantra every morning whispered gently so as not to disturb. 'Om namoh bhagavata vasudevaya'. My dad's voice floating across the rooms of the house, the strands of his unique timbre entangled with the scent of sandalwood and camphor, a paradoxical smell, simultaneously acrid and sweet, like the flavour of asafoetida and jaggery, shaping the morning, the house, our identity, my memory's imagination and future.

22. Sunak, Speech on Illegal Immigration.

23. S. Hall, 'Old and New Identities, Old and New Ethnicities', in *Essential Essays Volume 2*, 63–82: 69–70.

24. G. Anzaldúa, 'The New Mestiza Nation: A Multicultural Movement', in *The Gloria Anzaldúa Reader*, ed. A. Keating (Durham, NC and London: Duke University Press, 2009), 203–16: 206.

25. A. Reuman and G. Anzaldúa, 'A Coming Into Play: An Interview with Gloria Anzaldúa' *MELUS* 25:2 (June 2000), 3–45: 11.

26. Cited in J. Mascaró, Introduction to *Upanishads* (London: Penguin Classics, 1965), 27.

His voice is now here in this writing, it is engrained into my fabric, and I have produced pieces of calico dyed with mud from the garden in the house where we used to live. It is another fragment of the past instantiated in the present, for a stalled installation, a 'repetition of 108'. The space of our house, which is here in my memory, has escaped the bounds of its temporality and spatiality: 'The space we love is unwilling to remain permanently enclosed. It deploys and appears to move elsewhere without difficulty; into other times, and on different planes of dream and memory'.[27] Here sound, memory, fabric, and earth build an identity out of what is no longer there or is always there but missed. These are translations of forms through narrativisations of affects—a way of bringing together the 'hidden parts of you that have been scattered'[28] like those 'membra disjecta' that combine in Adorno's essay form which 'thinks in fragments just as reality is fragmented and gains its unity only by moving through the fissures'.[29]

(mantra 4: Repeat x 108: build an identity from what is missed)

Rudra—Anger. S F T U O C P K T O H F E F B P O A A K T I S S

The remembering subject is not handling unchanging objects of memory but rather adapting these objects in an ongoing process of trying to understand how the past has led them to the present.[30]

Bhayanaka—Terror. It's bloody freezing. I've been playing cricket with my mate Johnny Prince at the net next to the bowling green at East Lancs Cricket Club. We're fourteen, and have dreams of breaking through, making it to the big time. We've been practicing hard, going straight from school into the nets to play until the Lancashire light is so murky we can't see anymore and we reluctantly make our way home. Walking out the corner gate onto the crossroads of West Park Road, Granville Road, and Dukes Brow, we decide to nip to the chippy on New

27. G. Bachelard, *The Poetics of Space* (New York: Beacon Press Books, 1994), 53.
28. Reuman and Anzaldúa, 'A Coming Into Play', 15.
29. T. Adorno, 'The Essay as Form', in N. Alter and T. Corrigan (eds.), *Essays on the Essay Film* (New York: Columbia University Press, 2017), 164.
30. E. Keightly and M. Pickering, *Mnemonic Imagination: Remembering as Creative Practice* (London: Palgrave Macmillan, 2012), 60.

Bank to get a dab with gravy and a can of dandelion and burdock, as a stroller for the way home. We come out of the chippy, discussing Robin Smith's square cut technique which, with half a step forward, allows him to shift the weight, rock back and accelerate the bat with great power through the line of the ball, it's a wonderful shot. Johnny turns right, climbing up the hill towards Revidge and I turn left, crossing the road in the direction of Preston New Road. Just as I reach Patel's at the corner, my soundworld closes in on me.

The quiet ambience of terraced streets, punctuated by the steady stream of traffic from a couple of streets away, the rumble of the wind buffeting in small turbulent eddies around the features of my face, caught in my nostrils and thundering in the lugholes, familiar everyday sounds, elements of the normal 'sonic flux', disappear in an instant. My brain performs a trick of sonic perception, filtering out these extraneous normal objects, to shift focus in an instant to a set of intense footsteps approaching at pace. My soundworld goes through a 'spectromorphological' shift,[31] where time and space seem to reverse, where externality and internality collapse, where subject relations entangle, as 'the listening subject builds this sensible ensemble around himself to enable his voice that finally shatters his built [environment] to meet that of others, at least momentarily in his locale'.[32] My 'sensible ensemble' was shattered by the crashing footsteps closing in behind me, the sound of a body closing in on mine and inevitably, imminently invading my physical space, my ears saw behind me, but I didn't have time to look round. There was a muffled thud, and I was violently halted on my journey, half picked up off the ground as another body collided with me, and my neck was fiercely pulled into the crick of an elbow. Then I saw the glint of a blade, felt its sharpness pressed against my side, but the violence really came from the sound of those words. The breath-filled intimacy of a voice too close, the proximity of the source filling your soundworld, a moment where you hear the materiality of your own skin, as the 'sound appears at once to territorialize and despatialize experiences of embodiment, both surrounding and entering the body'.[33] J.K. Downs's example is mediated, but this was just

31. D. Smalley, 'Spectromorphology: Explaining Sound-Shapes', *Organised Sound* 2:2 (August 1997), 107-26.

32. Voegelin, *Listening to Noise and Silence*, 125.

33. J.K. Downs, 'Headphones, Auditory Violence and the Sonic Flooding of Corporeal Space', *Body & Society* 27:3 (2021), 58–86: 63.

simply a 'phenomenologically immediate material force'. And the force of the words, the memory of their sound in my ear, is powerful in my present.

The words become a way of knowing myself, because 'what happens to me doesn't just depend on me creating my own reality but everybody else, because I'm in relation to everybody else'.[34] These relations are creative 'cross-temporal interanimations' that imaginatively use memory in ways which are 'vital for the construction of our narrative identity where the story of who we are involves the interweaving of who we have been, who we could have been, and who we may become. What emerges from this synthesis is a renewed sense of self and a renewed way of being in the world'.[35] The memory of the words falls back down through my head starting at my left shoulder, and tumbling across the resonating structure of my skull, filling my head with the memory of its violence. I make scratched straight lines on the surface of vinyl record, counting 108 marks as a pseudo-mantra attempting to clear the paths of entangled identities, another fragment of *Repetitions of 108*. Loud and clear, terrifying sound: 'Fuck off Paki'.

(*mantra 5: Repeat x 108: dab with gravy*)

///////// [fixing the mind on the embodiments of mantra, the Mahavidyas (who are associated with crows, cranes and green parrots)...I wonder if this talk of meaning is really about something else.][36]

GA—'*The goat's bleat':* In 2020, I produced a number of podcasts working with people from the longest-standing South Asian community in Blackburn. When asked about racism in the town, Ashok Chudasama replied, '[I]f you ask me honestly, I haven't ever faced any direct discrimination, indirect discrimination through other people, yeah that's always there, and inherent in that sort of situation, but no direct discrimination at all, even at work or whatever, I'd prob-ably call myself very lucky really'.[37] After hearing this interview, another friend who used to live on New Bank Road came to me with tears in his eyes. He said,

34. Reuman and Anzaldúa, 'A Coming Into Play', 15.
35. Keightly and Pickering, *Mnemonic Imagination*, 63.
36. Ramayya, *States of the Body*, 41.
37. A. Chudasama, interview, *Kick Down the Barriers* podcast, 2021, <https://soundcloud.com/user-582571038>.

'I lived next to Ashok for years and remember his son suffering racist abuse and how deeply that affected the family, he is so dignified in this interview'. Avtar Brah presciently reminded us that 'the identity of the diasporic imagined community is far from fixed or pre-given. It is constituted within the crucible of the materiality of everyday life; in the everyday stories we tell ourselves individually and collectively'.[38] Here is another flake of sonic experience, constituting a non-tangible fragment of *Repetitions of 108: Counting almost Nothing*.

Hasya—Humour. I'm eating alone in an Indian restaurant in Loughborough. I've ordered two rotis, saag paneer, and some dahl. I start to eat with my hand. Halfway through my meal the waiter comes over and says, 'Eating properly, you don't see that so much in here. Where did you learn that?' 'I'm half Indian', I reply. He laughs heartily, and through his guffaws he says, 'Really? No way? I thought you'd have learnt it backpacking or something...I'm a bit of a coconut too though, I don't speak Bengali.'

Kitchree means a hodgepodge, a barbarous mixture of two languages.[39]

(40) After taking the flower which is called steady
 meditation
from the flower-bearers who are desire and the mind,
and having made a water offering with pots filled with
 the nectar of the moon,
 worship the Lord with the mantra called Silence.[40]

It is in the silence where the sound of a work develops, produced through an ever-present dialogue between the 'vibrant matter' of the materials themselves and their reformulation in relation to a number of shifting factors, but also the will to realise a fundamentally singular idea. It is a process which 'acknowledges the basic asymmetry between thought and matter, thought depends on matter,

38. A. Brah, *Cartographies of Diaspora: Contesting Identities* (London: Routledge, 1996), 183.
39. Massey and Massey, *The Music of India*, 91.
40. *Lallāvākyāni*, cited in J. Mallison and M. Singleton, Introduction to *Roots of Yoga* (London: Penguin Classics, 2017), 27.

but matter does not depend on thought, language or conceptualisation'.[41] This awareness opens up our imagination to the possibilities of the materials, their inherent creative agency, and their intra-related ontologies, their 'nomadic materiality'.

(*mantra 6: repeat until nothing: 108 views from one eye, 108 landscapes per footstep, 108 cosmological refractions of self,* 108x108x108x108x108x108...)

During these 'vibrant' dialogues a poly-translation occurs, between language, sound, form, thought, materials, memories, and movement through making catalysed by the imagination. I have previously considered these transpositions and shifts in forms as 'nomadic materialism',[42] states of an object in relational transformation, incremental and ever-changing. Borrowing from Deleuze and Guattari, Karen Barad, and Rosi Braidotti among others, and their work on the analytic methodology of 'new materialism', I have observed objects (thought of in the loosest sense) as 'heterogenous, simultaneously able to be considered in relation to and affecting different paradigms of relationality'.[43] Deleuze and Guttari provided the nomad metaphor in their concept of 'nomad thought', which for them constitutes an attempt to break out of the 'constraints of gridded state space into a nomadic space that is smooth and "rides differ-ence"'.[44] In doing so they provide the beginnings of an analytic method allowing for boundless relations to be explored. They note that the nomad itself has been mischaracterised, as the writers of historiographies maintain their status through compartmentalising and containing complexity, a trend which has manifold social implications. In opposition to the characterisation of nomads in canonical academic writing, Deleuze and Guattari describe nomads as being always 'between' and 'reducible neither to the empires they confronted nor the migrations they triggered'.[45] The nomads are 'the intermediary, the interval',

41. C. Cox, *Sonic Flux* (Chicago: University of Chicago Press, 2018), 6.
42. P. Nataraj 'Where Can a Record Take Us? Using 'A's copy of *Fear of a Black Planet* to Explore "Nomadic Materiality"', *Riffs: Experimental Writing on Popular Music* 7:1 (2023), 40–55.
43. Ibid.
44. B. Massumi, 'Translator's Foreword: Pleasures of Philosophy', in G. Deleuze and F. Guattari, *A Thousand Plateaus: Capitalism and Schizophrenia*, tr. B. Massumi (Minneapolis and London: Minnesota University Press, 1987), ix–xv: xii.
45. Deleuze and Guattari, *A Thousand Plateaus*, 576.

producing states of translation, shifting knowledge, drawing lines which have 'multiple orientation and [pass] *between* points, figures and contours [...] positively motivated by the smooth space [they draw]'.[46] The lines drawn between concrete, intangible, and imagined points of contact leave traces, yet to be tracked, sniffed out, heard in accents, songs, plucked strings, taut skins, and the voice itself. Sound knowledge, sound writing, this imagined sonic essay, these fragments of a work in progress, found in sonic fictions, in autohistoria, in the imaginative creations of memory, are all the connective tissue of 'nomadic materiality', trying to capture the experience of in-between-ness. 'A nomadic body is a threshold of transformations. It is the complex interplay of the highly constructed social and symbolic forces. The body is a surface of intensities and an affective field in interaction with others',[47] and when approached in this way 'accounts for multiple belongings'.[48] Employing the imagination is essential in helping us to explain the kind of experience which is not black or white, which is not just a two-part hybridity, but can trace numerous paths and the meandering ontologies of sonic experiences. 'Who sees variety and not unity, wanders on from death to death'.[49]

(*mantra 7—Repeat x 108: 9 eggs in the fridge*)

Vir—Heroism. In the 1982 edition of *Mythologies* by Roland Barthes, page 108 is blank. I wasn't to know that the page would be blank, I just happened to be 'counting almost nothing'. I turned to page 108 looking for a provocation, looking for something to speak to me, to test the agency of the book, and the book responded with a space of nothing. Barthes once asked for a process of distributed agency in his work *The Death of The Author*, in which he theorises that a text is 'but a multi-dimensional space in which a variety of writings, none of them original, blend and clash. The text is a tissue of quotations drawn from the innumerable centres of culture'.[50] There is no hero, just an empty space

46. Ibid., 577.
47. R. Braidotti, *Nomadic Subjects: Embodiment and Sexual Difference in Contemporary Feminist Theory* (New York: Colombia University Press, 1994), 33.
48. Ibid.
49. Mascaró (ed.), *Upanishads*, 11.
50. R. Barthes, *Image Music Text*, tr. S. Heath (London; Fontana, 1977), 146.

where the author's name is usually to be found. Just the sound of silence, to be filled with all those voices corresponding to the repetition of certain sounds which form a set of myths, 'a type of speech chosen by history'.[51] Historical sounds are silent then, voices which have been drowned out by the heroic, trammelled under the noisy hooves of hegemony, sonic stories imagined so as to reintroduce 'their excessively idiosyncratically historical, societal, practical, onto-logical, epistemological and technological specificities. NO specimen of aurality can be regarded as unmarked and [...] ahistorical'.[52] We imagine these losses in a sonic essay, producing a fragmented score, so that the 'essay comes so close to the here and now of the object, up the point where that object, instead of being simply an object, dissociates itself into those elements in which it has life'.[53] Barthes asks for multiplicity in authorship, the admission of the 'fragile "I"',[54] which evidently has an ethical dimension, one which is taken up in new materialism's 'nomadism', in the 'subjectivity engine' of sonic fictions, in Keightley and Pickering's imagined spaces of memory, and through autohistoria. All of these ways of thinking want to show the connections between different shifting spatial and temporal planes, and in so doing produce creative ways of knowing that 'escape oppressor/oppressed binaries',[55] revealing that 'fixed categories are permeable. There are aspects that overlap, that break down categories, through osmosis or through some kind of very elusive, being-in-two-or-three-places-at-once kind of metaphor'.[56] The mantra repeats to find a blank page upon which myriad connections can be found. Find nothing from doing something, in order to give the space to discover newness in manifold connectivity, in distributed heroism recognising the fragility of the 'I'.

Speaking to Jacquelin Caux about his composition '*Presque Rien* [*Almost Nothing*]', Luc Ferrari says, 'We are like wandering ears stealing sound [...]. [T]hese sounds represent an image, a memory: they are objects that take part in a creation'.[57] The sounds he finds in these tableaux become part of his creation, dialoguing

51. R. Barthes, *Mythologies* (London: Granada, 1982), 110.
52. Schulze, *Sonic Fiction*, 67.
53. Adorno, 'The Essay as Form', 162.
54. Voegelin, *Listening to Noise and Silence*, 94.
55. K. Bhattacharya and A. Keating, 'Expanding Beyond Public and Private Realities: Evoking Anzaldúan Autohistoria-Teoría in Two Voices', *Qualitative Inquiry* 24:5 (2018), 345–54: 353.
56. Reuman and Anzaldúa, 'A Coming Into Play', 12.
57. J. Caux, *Almost Nothing with Luc Ferrari* (Berlin: Errant Bodies Press, 2013), 36.

fragments in all their relational and contingent beauty. Which one of them is the real hero? Ferrari set about de-composing composition by recording a place and time and shifting it outside of its place and time, producing a twenty-minute mantra of the field, moving the listener into a new space of awareness, into and beyond Ferrari's 'wandering ears'. He explains that in searching for almost nothing, he 'realised that it wasn't an easy thing to find; you think you might find some here or there, but no',[58] there is no 'nothing'. It is hard to find nothing, but through recording this 'almost nothing' the repetitions constitute a clearing, a mode of escaping the churn, finding space, time, blankness. But all the while, '[r]epetition is infinitely more generative than cumulative, more regeneration than reiteration, more an arouser of difference than a sponge of sameness. [...] What we hear is never the same, at any instant, but infinitesimally different and infinitely repetitive. Repetition: build-up of intensities: fullness-to-explosion: ecstasy: (stillness)'.[59] I open page 108, 108 times to see what this blankness generates. This emptiness is a flake of sonic experience which makes a 'repetition of 108'. I remember the sounds of his recording, which has become myth, I see the emptiness of the book, I repeat the mantra, trying to find a universal something from the fragments of my mnesonic imagination—the fragments between which 'the material and the discursive mingle and mangle'[60] to produce an imagined sonic essay whose ideas can be 'scored for the reader'.[61] As with a graphic score, whose 'orientation is entirely futural',[62] the imagined sonic essay is asking to be reimagined in each manifestation. Tracing the graphic score from instruction to visual art to object, Christoph Cox concludes that the 'score had been dispersed into the world of things, and the world of things had become ripe for sonification'.[63] Taking the essay as a score silently filling the blank page with sound writing, imagined memories and future material instantiations can co-exist, intermingle, and produce one another—here, as rasas. John Akomfrah makes the observation

58. Ibid., 154.

59. M. Szekely, 'Becoming-Still: Perspectives on Musical Ontology after Deleuze and Guattari', *Social Semiotics* 13:2 (2003), 113–28: 127.

60. B. Bolt, 'Introduction: Toward a New Materialism through the Arts', in B. Bolt and E. Barrett (eds.), *Carnal Knowledge: Towards a New Materialism through the Arts* (New York and London: IB Tauris, 2013), 1–13: 3.

61. Waterman, 'A Listening to Resonant Words', 118.

62. Cox, *Sonic Flux*, 62.

63. Ibid., 64.

that the experience of watching his essay films 'is marked by discontinuities, eruptions, ellipses, and migrations across time and space',[64] images pulling us into the diffracted light of interrelated constellations of ideas. Constellations, or the 27 Nakshastras, celestial movements that can also be split into four equal 'padas' representing the 108 movements of the earth's orbit around the sun, whose diameter is 108 times that of the earth, whose distance from the moon is 108 times the diameter of the moon itself.

(mantra 9—Repeat until explosion: 'perfect stillness fullness to explosion'—Szekelyji)

MA—'The Heron's Cry': 'I cannot fully occupy any space'.[65]

It's a dangerous path
into the shadows of memory
try to find the face you had
before your parents were born
try to hear the voice you had
before your parents were born
Who is looking into whose eyes?
Who is hearing whose voices?

Karuna—Pathos. I'm in Todmorden, Lancashire, at a bar called Nan Moor's. It's big enough for fifteen, perhaps twenty at a push. I've been asked to perform. I have a vinyl record which is a composite, a cut-up made of four other records. The main part of this cut-up is 'Night and Daydream' by Ananta on the label Touchstone Recordings, released in 1978. The records on this label were given out by Krishna devotees for a donation; another in the discography, 'The Adventures of the Great King Raam', was a staple on our turntable as I was growing up. I used Ananta as the base record and had cut out the silhouetted shape of the deity Nandi's head. Nandi bull has a mythical association as Shiva's divine mount,

64. Cited in N.M. Alter, *The Essay Film After the Fact* (New York: Columbia University Press, 2018), 5.
65. C. Arfuso, 'Whispers of the Soul: Autohistoria-Teoría as Decolonial Knowledge Production', *Qualitative Inquiry* 28:6 (2022), 602–8: 605.

who once drank poison to save his master whilst he was battling demons trying to churn the ocean to destruction.

I once stood beneath a seven-hundred-year-old statue of Nandi carved from a single stone. This statue was in the custodianship of a group of monks, who were burning coconut husks in smouldering piles on the surrounds of the massive plinth that held him, making ashen pigments to blacken the ancient stone. The sounds of worship mingled with the everyday hubbub of crowded conversation as people came and went bringing devotions and taking blessings. The priests chanted repetitious mantras, accompanied by analogue bells ringing and mediated drones undulating around the soundings of devotional labour, wiry shushing brush strokes drawn by gestures of ritually adorning blackness onto the body of a protector who had been protecting generations of people who are in my blood. And here in Lancashire I stood in a pub, a place of protection for many, where people who are also in my blood could well have drunk after their days engaged in the repeated physical activities of labour. I'm thinking of Nandi as the silhouette of her head, cut out of a devotional vinyl record, spins on my turntable in front of me; a couple of doors down the street there is an Indian restaurant called 'Vedas'. African spear shapes make up the rest of the record, chopped out of records containing compositions by Brahms, Liszt, and Grieg which were written in 1865, year of the completion of Blackburn's Cotton Exchange, where I first performed with this particular cut-up, in collaboration with the artist and scholar Masimba Hwati.[66] The record represents a clash of materials, thrown together, with my untrained ham-fisted amateurism, with protruding glue, holes, and ill-fitting joins. The sounds are joined by material, but they are separated by boundaries, by cleavages, cuts, and untimely residues. As the record lurches along, it becomes extremely difficult to ascertain where each sound is emanating from; the entanglement obscures which groove is doing what, which voice is speaking. But there are lines, moments which settle rhythmically, producing my sway as I learn the way this fractured surface wants to behave and the language it produces in its plurality.

66. The performance 'Sokunge—As If' was developed as the finale to the British Textile Biennale 2021. See <https://www.youtube.com/watch?v=SAedAXBdxUw&t=53s>.

Clunk / re / scratch / clip / clip/ pa / squawk /clunk / stab / violin /chopped voice /ah / clip / click / dha / squawk / ma / cooooosh / clap / ni / scrat / kwhunk / pa / eeeeee / sa / ma /

<div align="center">... settles ...</div>

bshgrat / clip / clip / bhusskerat / crat / deg / bshgrat / clip / clip / bhusskerat / crat / deg / bshgrat / clip / clip / bhusskerat / crat / deg / bshgrat / clip / clip / bhusskerat / crat / deg / bshgrat / clip / clip / bhusskerat / crat / deg / bshgrat / clip / clip / bhusskerat / crat / deg / bshgrat / clip / clip / bhusskerat / crat / deg / bshgrat / clip / clip / bhusskerat / crat / deg / / / / / / / / /

Turning me back into spiralling memories, associated and detached, imagined and reimagined, watching simultaneously, the frothy head of a beer bubbling up, and the bronzed priest, orange garments like flashes of flame, attending to Nandi's anointment, with blackened hands, moving in a circular motion of repetitious devotional work. Chanting.

Outside it's dark and cold. In combination with the record I have a tape loop playing from a Marantz portable recording device, which used to be used by journalists to record groundbreaking interviews. It was given to me by Brian Nicholson from Darwen. He made videos for Factory Records, taught me about Burroughs's cut-ups, and changed my life forever. His/my/our Marantz is playing a handmade six-second tape loop of Bob Marley singing 'and love I-manity', sampled from his 1975 song 'So Jah Seh'. I don't count the number of repetitions although I know that I should, but I'm also trying to listen to the cut-up record. I also have these words,

NI—'The elephant's trumpeting':

> the King lays dead
> his mouth still lying
> the stench of his decaying tongue
> drives the vultures away.[67]

67. Queen Elizabeth was still reigning monarch at this point.

Bibhasta—Disgust. As part of the materials of this performance, I have taken some disgusting *Black and White Minstrel Show* LPs I found in charity shops, which date from 1972, the year that my Dad arrived in the UK, and covered them with the fabric of one of my Aunty Chinni's saris. I played these 'sari records' through contact mics because I wanted to hear Prandit Pran Nath in Lancashire, singing the sound of the Pendle winds. Cloth-covered records have become another fragment of 'Repetitions of 108'.

Shanta—Serenity. 3 Feb 2024, my uncle Jayrama passes away at the age of 95. He passed after a similar set of circumstances to those of my own father, his younger brother. After contracting pneumonia, a few days on a ventilator led to complete organ failure. The WhatsApp message came through as was considering what sound I might write, for *Shanta—Serenity*. It's nearly a year to the day since I saw him in Calcutta, where he sat next to me and we all smiled broadly, just happy to be there. As we shared photos and some semblance of a story in broken English, with translations from my cousin, all filtered through aged hearing and the noise of laughter, my uncle quietly sang. He hummed the melodies of Bollywood songs, at the volume at which you might talk to yourself whilst doing the housework, creating a little vibration around your head so that you know that you're there. He is contentedly sounding his 'mnesonic imagination' and creating mine simultaneously. I take this flake of sonic experience and as immediately as I can after hearing the news of Uncle's passing, I inscribe this memory in cloth. I have no skill with fabric, so I take some sindoor from a small plastic container that was in a box housing the articles of my Dad's shrine, and I mix the reddish powder with water to create a pigment in which I leave a foot square of calico to soak. The cloth and the pigment will come together, drawing the pinkiness into the spaces between the twisted rolls of its individual fibres, to become entangled into the spaces between the intertwined strands of tissue that make up its warp and weft. My wife and I sit on Marari Beach in Kerala, the day after visiting Uncle Jayrama in Calcutta, and I remember his singing, now as an imagined sound in contact with the sound of the sea, punctuated by the kites, signalling their bounty with sharp elongated whistles, dropping through the sky and into the midrange of the surf's tumbling white noise. The sun, whose diameter is 108 times that of the earth, descends, and we are gently enveloped

in its soft pinkness, the same colour as this sindoor pigment under my fingers, and the internal fleshiness of lung tissue singing its inevitable collapse. As I dip the calico, I hear the stutter of my breath, and in my mind the opening of Don Cherry's 'Om Shanti Om' spins on repeat.

> I feel my ancestors celebrating being heard. I have asked a question and the answer lies just outside of my grasp, like it's dangling in the ethers awaiting me to find it.[68]

I have tried to open an imagined space of listening here, tracing memory, sound and identity as tools to navigate my mixed-race experience, one which is often overlooked and under-recognised. These words explore 'in-between-ness', overlaps, underlaps, imbrications, communions of bricolage, mnesonic imaginations, nomadic materialities, flakes of sonic experience, and floating heard futures inscribed into intra-relating entanglements through the making of a work in progress; through 'repetitions of 108; counting almost nothing'. I'm sound writing past, present, and future sounds, bringing them into mediated mantras to navigate un-whole identities produced in fragments. This writing has been done to consider a way to materialise the 'nada'[69] of mantras whose function is to find an enlightened space of nothingness, embracing an epistemology of doubt and ambiguity. As György Lukács argued in 1910, 'the essayist must now become conscious of his own self, must find himself and make something out of himself'.[70] So I have imagined and remembered sounds, because I love sound, which constantly reminds me of the temporal and spatial entanglements of 'vibrant things'. As sound travels past and through me, it is knowing fractured by the imagination, immanently shifting relationality, bringing awareness to my awkward positionality, contingent upon identity, hearing, and memory. Identity too fluid to be held in static classificatory systems, shifting through rasas and tonal delineations to find new melodious lines of intrasection.

68. Arfuso, 'Whispers of the Soul', 603.
69. 'Mantras are supposed to work by each creating its own special kind of resonance in space, in the realm of a subtle sound vibration called, Nada' (Rawson, *The Art of Tantra*, 59).
70. G. Lukács, 'On the Nature and Form of the Essay', in Alter and Corrigan (eds.), *Essays on the Essay Film*, 21–40: 37.

Notes on Contributors

LAWRENCE ABU HAMDAN is an award-winning artist, audio investigator and the founder of Earshot , the world's first not-for-profit organisation producing audio investigations for human rights and environmental advocacy. Abu Hamdan's work on sound and listening has been presented in the form of forensic reports,, lectures and live performances, films, publications, and exhibitions all over the world. He received his PhD in 2017 and has held fellowships and professorships at the University of Chicago, the New School, New York and the Johannes Gutenberg University Mainz, where he developed his research project *Air Pressure* (AirPressure.info),

LENDL BARCELOS divides their time between writing, teaching, DJ sets and creating sound for choreography. Lendl was part of the *Infinite Ear* project, a series of exhibitions based on Deafness as an expertise on sound. Lendl has participated in the Architecture and Art Biennales of Venice (Italy), shown work at Tremor Festival (São Miguel, Azores), Garage (Moscow, Russia) and Tate Britain (London, UK), amongst others.

JUSTIN BARTON is a philosopher and essayist who includes tales as elements within his works: his first essay, 'Metamorphics', was published in 1998 (*Pli: Nomadic Trajectories*), his book *Hidden Valleys* was published by Zero Books in 2015, and with Mark Fisher he made two audio essays, *londonunderlondon* (2005) and *On Vanishing Land* (2013). The incorporation of tales within philosophy is taken to its furthest extent in his bookblog *Explorations* (2014–2024) which includes within it a novel-length tale called *The Corridor*.

BEN BORTHWICK is Head of Programme at KARST, a gallery and studio complex in Plymouth, UK. He combines working internationally with grass roots artist development. He was previously Artistic Director of Plymouth Arts Centre, CEO of international art prize Artes Mundi, and Assistant Curator at Tate Modern. In parallel with his work at KARST he runs PRIMEdesign, an ongoing community project connecting young skateboarders to contemporary art. He has published widely on contemporary art, sound and experimental music.

ANGUS CARLYLE is Professor of Sound and Landscape at University of the Arts London. With Professor Cathy Lane he co-wrote the oral histories *In the Field* (2013) and *Sound Arts Now* (2021) and co-organised the first three *Sound Gender Feminism Activism* conferences. Recent publications have explored foley, field notes, soundmaps, the idea of sonic wilderness; experimental writings were published by *JOAN*, *Hotel*, *Vanguard*, *Kiosk*, *Onomatopee* and *Gruenrekorder*. His creative work shifts between a documentary impulse and a more poetic register, deploying text, photography and compositions based on field recording.

MATT COLQUHOUN is a writer and photographer from Hull, UK. They are the author of *Egress: On Mourning, Melancholy and Mark Fisher* (Repeater, 2020), *Narcissus in Bloom: An Alternative History of the Selfie* (Repeater, 2023) and editor of Mark Fisher's *Postcapitalist Desire* lectures (Repeater, 2021). They blog at xenogothic.com.

JESSICA EDWARDS is an independent writer, researcher, lecturer and curator working at the critical intersection of Black Studies and the visual and sonic arts. Within the context of Nik Nowak's exhibition *Schizo Sonics* (Kindl, Centre for Contemporary Art, Berlin), she conceived, organised and chaired the well-received symposium *The Cold War Continuum: The Role of Sound Systems in the Vibrational Delusions of Sonic Warfare*. Her recent curated international group exhibition *Heavy Water | of Coordinates, Containers and Containment* was staged at alexander levy gallery, Berlin (27 January–28 March 2024).

KODWO ESHUN is a writer and artist. He lectures at the Department of Visual Cultures, Goldsmiths, University of London and at the Visual Arts Department at Haut Ecole d'Art et Design, Genève. He is author of *More Brilliant than the Sun: Adventures in Sonic Fiction* and *Dan Graham: Rock My Religion*, and is co-founder of The Otolith Group.

STEVE GOODMAN (aka Kodeg) is a musician, artist, and writer. He is founder of the record labels Hyperdub and Flatlines, author of the book *Sonic Warfare: Sound, Affect and the Ecology of Fear* (MIT Press, 2009) and co-editor of *Audint—Unsound:Undead* (Urbanomic, 2019).

AYESHA HAMEED explores the legacies of indentureship and slavery through the figures of the Atlantic and Indian Oceans. Her Afrofuturist approach combines performance, sound essays, videos, and lectures. She is currently a Senior Lecturer in Visual Cultures at Goldsmiths University of London, a Kone Foundation Research Fellow and Professor of Artistic Research at Uniarts Helsinki.

ELENI IKONIADOU is a writer, artist and educator specialising in sound and voice. She is Reader in Digital Culture and Sonic Arts at the Royal College of Art; founder and co-editor of the Media Philosophy series (Rowman & Littlefield, 2014–2024), co-editor of *Audint—Unsound:Undead* (Urbanomic, 2019), and author of *The Rhythmic Event: Art, Media and the Sonic* (MIT Press, 2014). Recent art projects include *The Passing* (Onassis Stegi, 2023); *Future Chorus* (MAENADS/ Hypermedium, 2023); *The Lamenters* (Sound Quests, 2022); and *Hydrapolivocals* (Weaving Worlds, 2022). https://www.eleniikon.com/

MAYA B. KRONIC is a philosopher and Head of Research and Development at Urbanomic. The Agent, patient, and product of ongoing research project on gender hyperstition and a recrypted iteration of Robin Mackay, they are the co-author, with Amy Ireland, of *Cute Accelerationism* (Urbanomic, 2024).

LAWRENCE LEK is a London-based artist, filmmaker, and musician known for his ongoing series of films, soundtracks, and immersive virtual worlds set within a Sinofuturist cinematic universe. His recent solo exhibitions include *NOX*, LAS Art Foundation, Berlin (2023), *Black Cloud Highway*, Sadie Coles HQ, London (2023), and *Nepenthe* (Summer Palace Ruins), *QUAD*, Derby (2022). He often produces soundtracks for his projects, including *AIDOL OST* (Hyperdub, 2020) and *Temple OST* (Vinyl Factory, 2020).

ROBIN MACKAY is director of Urbanomic, has written widely on philosophy and contemporary art, and has instigated collaborative projects with numerous artists. He has also translated a number of important works of French philosophy, including Alain Badiou's *Number and Numbers*, Quentin Meillassoux's *The Number and the Siren*, François Laruelle's *The Concept of Non-Photography* and Éric Alliez's *The Brain-Eye* and *Undoing the Image*.

PAUL NATARAJ has a PhD in Sound Studies from the University of Sussex. He has been published in two sound studies collections for Routledge and Blooms-bury, and in the experimental musicology journal *Riffs*. Previous exhibitions and performances include at Nottingham Contemporary, Leeds City of Culture 2023, Kochi Biennale 2022, British Textile Biennial 2021, Prism Contemporary 2018, and ZKM 2016. His sound work has been played on BBC Radio 3s *Late Junction*, Radiophrenia, Resonance FM, CAMP FR, and NTS. He has released four albums to date. His self-released 2018 album *You Sound Like a Broken Record* was voted in the top ten experimental albums of the year by *a closer listen*. He produces two ongoing radio shows for Resonance Extra and Hale London.

EMILY PETHICK has been the director of the Rijksakademie van beendene kunsten in Amsterdam since 2018. She was previously the director of The Showroom, London (2008–2018), of Casco, Utrecht (2005–2008) and curator at Cubitt, London (2003–2004). She has contributed to publications and co-edited numerous books, and has participated in numerous juries for artist awards, including the 2017 Turner Prize.

IAIN SINCLAIR is a poet, film-maker, essayist and the author of many acclaimed books, including *Downriver*, *Lights Out for the Territory*, *London Orbital*, *Edge of the Orison*, *Hackney: That Rose-Red Empire*, *Dining on Stones*, *Ghost Milk*, *American Smoke*, and *London Overground*. He also co-directed several documentaries with Chris Petit, including *London Orbital* and *The Falconer*.

SHELLEY TROWER is Professor Emeritus of English Literature at the University of Roehampton. Her books include *Senses of Vibration* (Bloomsbury, 2012), *Rocks of Nation* (Manchester University Press, 2015), and *Sound Writing* (Oxford University Press, 2023). Projects include the AHRC-funded *Memories of Fiction* and *Living Libraries* (2014–2020). Along with numerous academic publications she has also published creative non-fiction and fiction in magazines, journals and edited books, while drafting her first novel manuscript, *Ghost Snow & River*, the first chapters of which won the Literary Plaza Prize in 2023.

Many thanks to Iklectik and to KARST for hosting the Sonic Faction *events.*